A Tree,
A Blade
of Grass

Okumikawa

The Nippon Alps

Photographs
by
Shinzo Maeda

Benedikt Taschen

**Printed on ZANDERS Mega, made from 50%
recycled and from de-inked fibres and
from 50% chlorine-free bleached pulp (TCF).**

© for this edition: 1993, Benedikt Taschen Verlag GmbH
Hohenzollernring 53, D-50672 Köln
© Photographs by Shinzo Maeda
First English-Japanese versions published in Japan
as the three different volumes:
"A Tree, A Blade of Grass" (published in 1983),
"The Nippon Alps Kamikochi" (published in 1984),
and "Oku Mikawa" (published in 1985),
by Graphic-sha Publishing Co., Ltd.
Tokyo, Japan
Printed by Druckerei Ernst Uhl, Radolfzell

Printed in Germany
ISBN 3-8228-9655-1
GB

Biography – Shinzo Maeda

1922 Born in Shimo-Ongata-cho, Hachioji City, Tokyo

1948 Employed by Nichimen Co., Ltd., works there for the next 17 years

1967 Founds Tankei Photo Agency Co., Ltd., becomes its representative and a professional photographer

1974 Publishes "The Four Seasons of a Home Town" (The Mainichi Newspapers)

1976 Publishes "The Colors of Japan" (Ryoko Yomiuri Publishing Co.)
Publishes "Mountains and Rivers of a Home Town" (The Mainichi Newspapers)

1977 Publishes "The Moment of Encounter" (The Mainichi Newspapers)

1978 Publishes "Spring, Summer, Autumn and Winter" (Kokusai Johosha Publishing Co.)
Exhibits at Photokina (Cologne, Germany)

1980 Exhibits at Europhoto (Majorca, Spain)

1981 Publishes "Hokkaido – Poetry of the Earth" (Shueisha Publishing Co.)

1982 Publishes "Scenes from Nature" (Hoikusha Publishing Co.)

1983 Publishes "A Tree, A Blade of Grass" (Graphic-sha Publishing Co.)
Publishes "Shinzo Maeda" (Asahi Shimbun Publishing Co.)

1984 Publishes "The Nippon Alps, Kamikochi" (Graphic-sha Publishing Co.)
Participates in the book "Landscape Photography" (Amphoto, U.S.A.)
Holds the exhibition "A Tree, A Blade of Grass" in Hamburg, Germany, in September, also in Paris, France, in February, 1985
Receives the Annual Award for the Photographic Society of Japan

1985 Publishes "Okumikawa" (Graphic-sha Publishing Co.)
Publishes "Scenes in Four Seasons" (Nippon Camera Publishing Co.)
Publishes "Ambling in Nature" (The Mainichi Newspapers)
Receives Special Award at the Thirty-ninth Mainichi Publications Culture Competition for the book "Okumikawa"

1986 Publishes "Hills of Color – Scenes and Seasons" (Graphic-sha Publishing Co.)
Shinzo Maeda has held many photo exhibitions in Japan, in addition to participating in the exhibitions listed above.

A Tree,
A Blade
of Grass

Photographs
by
Shinzo Maeda

Foreword

Shinzo Maeda and I are both friends and members of the same generation, which makes it easy for me to admire not only the quality of his work but also the energy with which he pursues the spiritual and physical art of photography.

I am a poet not a photographer, but I feel that photography and *haiku* have the same origins, and I am deeply touched by each of the photos of the four seasons in this book; it is as if every photo is a single *haiku*, a complete and substantial work of art.

In the world of *haiku* we always speak of "sketching" the subject well, and that is the basic theory in the creation of *haiku*. The purpose of this "sketching" is to observe the subject, to scrutinize and feel it until we are able to penetrate to its true nature. When we do so, we will find that the truth differs from reality. The truth is not reality; it is, instead, what we find when we break through the husk of external form and pierce the essence of a thing. To put it in another way, finding the truth means shaking up the reality that lies behind the actuality of the subject.

In order to do this, one must undergo the spiritual trial of a very long and intensive observation of the subject. Only after enduring this trial and filtering it through experience we can find the something which we need to make a single *haiku* poem. This is the essence of "sketching".

In each of Shinzo Maeda's photographs I can feel the keenness of his eyes, the sharpness of his observations of nature; and at the same time I feel admiration for the discoveries he makes. In some of his photos there is a strong sense of movement, in one a stillness so deep that I feel the very pulsating breath of the flowers he has captured.

In looking at these pictures, one feels the richness of their sensitivity and the overflowing passion of an artist. The reality which the photographer's mind and eye have captured stirs, excites and finally dazzles with the surprises revealed for us.

As a result of its location in a monsoon area surrounded by the sea and extended like a great arch from north to south, Japan's natural features and climate have been given four distinct seasons by the miraculous providence of nature. I know of hardly any other countries which have such a richness of natural expression, form and spirit.

From Okinawa to Hokkaido, Japan extends from 26 degrees latitude north to 45 degrees, and even though it is a nation of small islands, it reaches to a length about equal to that of the Chinese mainland or the United States. Because of this, there is a great variety in the landscape; trees, flowers, insects, birds and fish abound.

In this country, which not only extends from north to south but has many steep mountains up to six and seven thousand feet in altitude, the flora and fauna of the high mountain areas are completely different from those of the lowlands. Indeed the four seasons in Japan have a richness and complexity of feeling that can in no way be matched by those countries which have only dry and rainy seasons.

The Japanese people, born and raised in the midst of these natural riches, should be more interested in the world of nature surrounding them, – the trees and blades of grass –, and they should give it their love. Nature, we must remember, can exist without man, but man cannot exist without nature. Therefore, we have to cast more sympathetic eyes upon the mountains, rivers, trees and grasses, the birds and beasts, insects and fish. As a *haiku* poet, those have always been my wishes and my view of life. Now my wishes have been fulfilled and my views expressed as wonderful reflections in the publication of this book.

Viewing the pictures in this book was, literally, a breathtaking experience, and the writing of this foreword, a pleasure in itself, has been coupled with a buoyant feeling like some refreshing breeze passing through the world of reflection.

Kenkichi Kusumoto
haiku poet

The Breath of Spring

When the snow melts in early spring,
One of the first flowers to push forth its blossoms
Is the wild butterbur.
Pussy willow and edgeworthia flourish in the wet soil
Along the mountain stream.
Yellow witch hazel blooms upon the hillsides
While wild orchids, harbingers of spring,
Brighten the thickets.

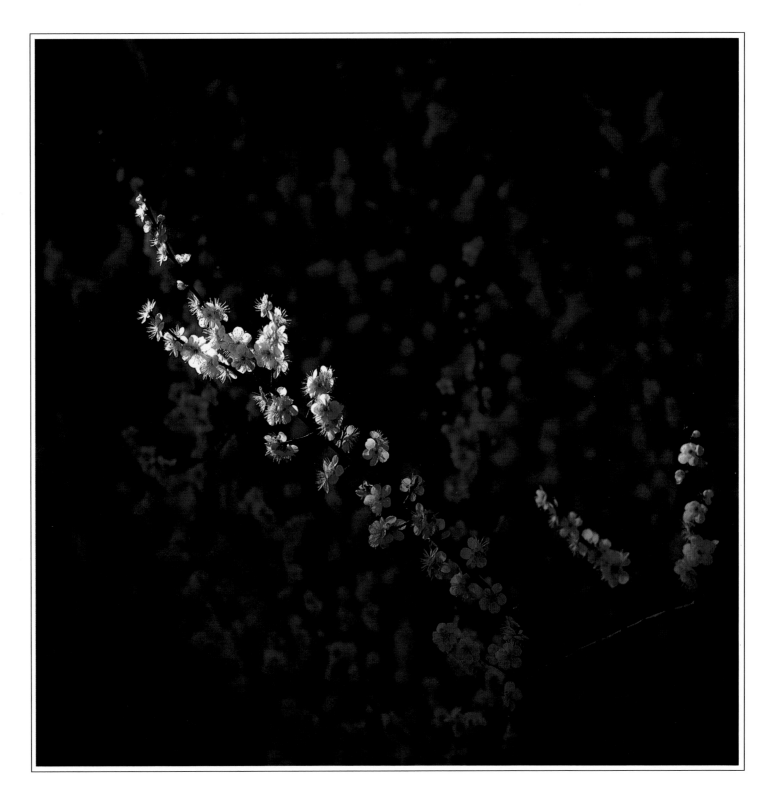

Bright harbingers of beauty

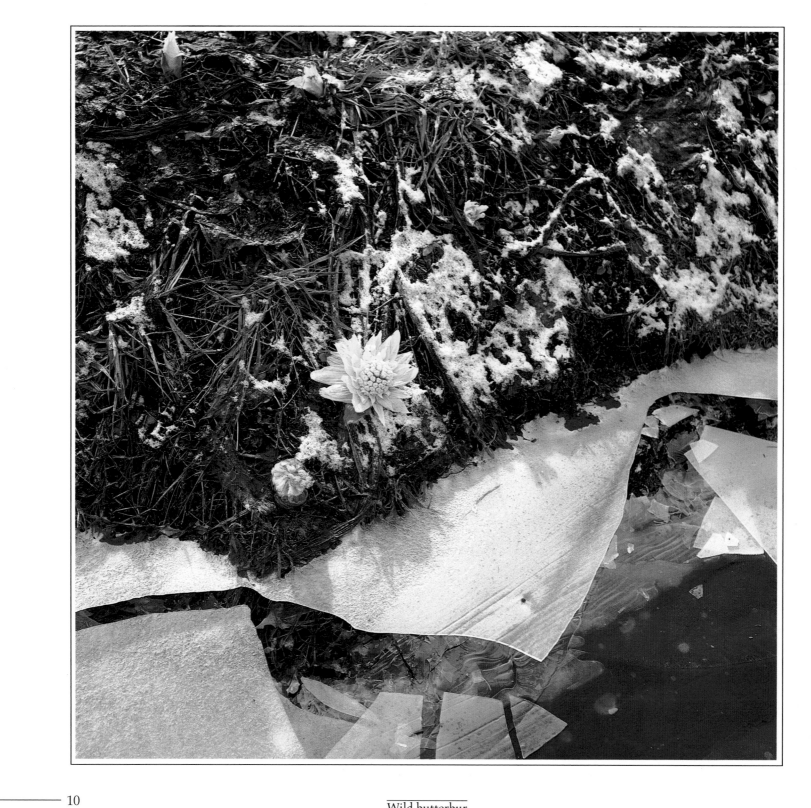

Wild butterbur

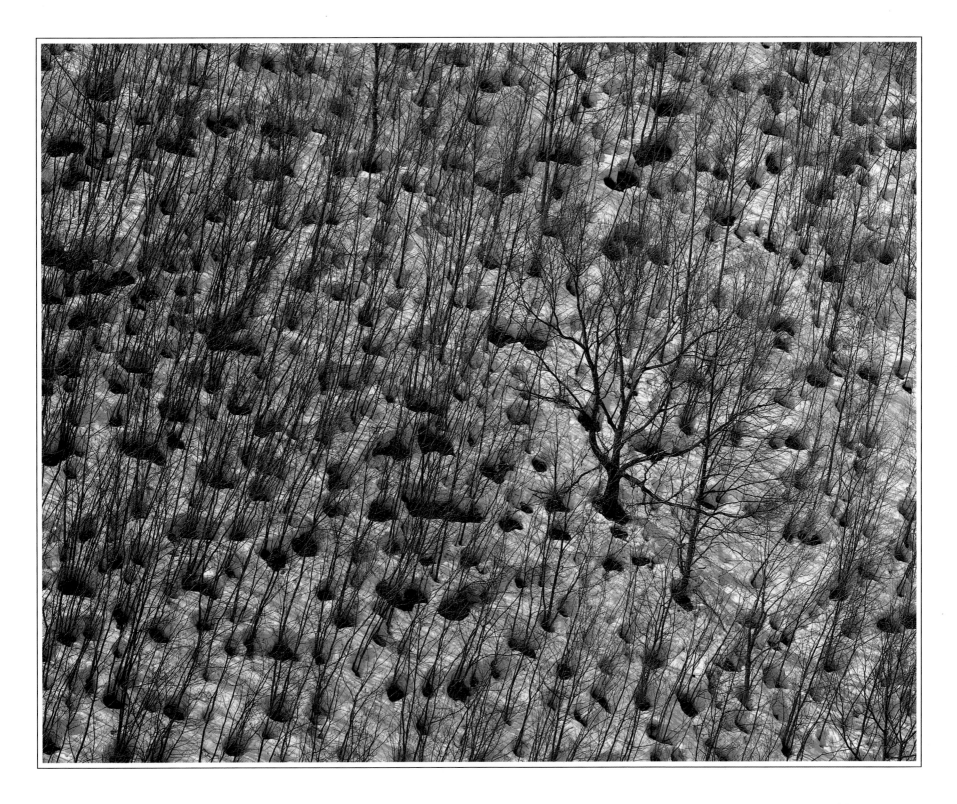

The woods in early spring

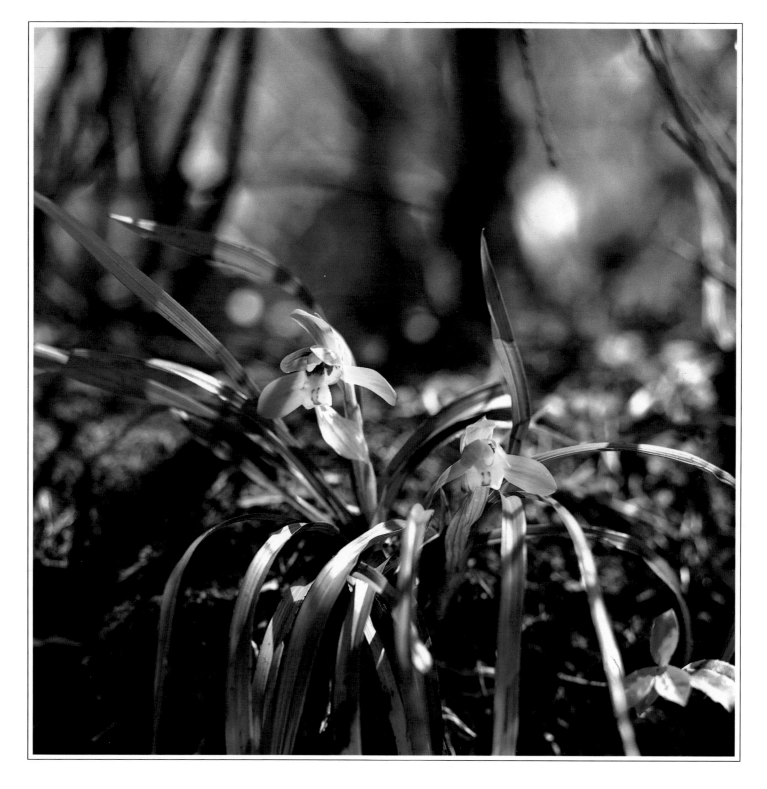

Delicate wild orchids

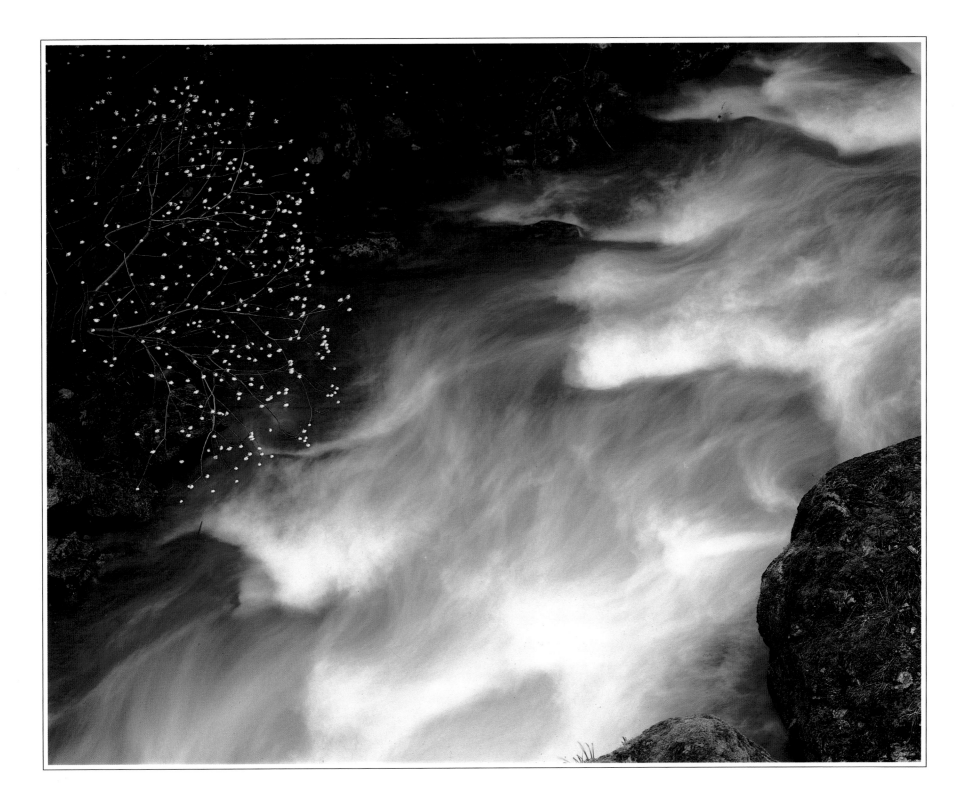

Edgeworthia by a brook

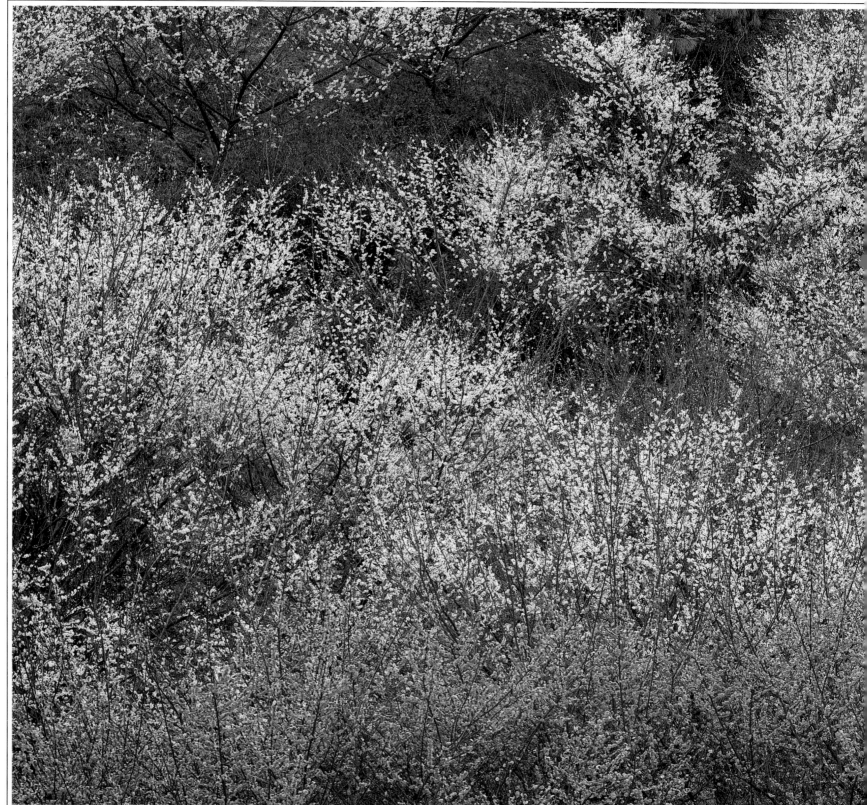

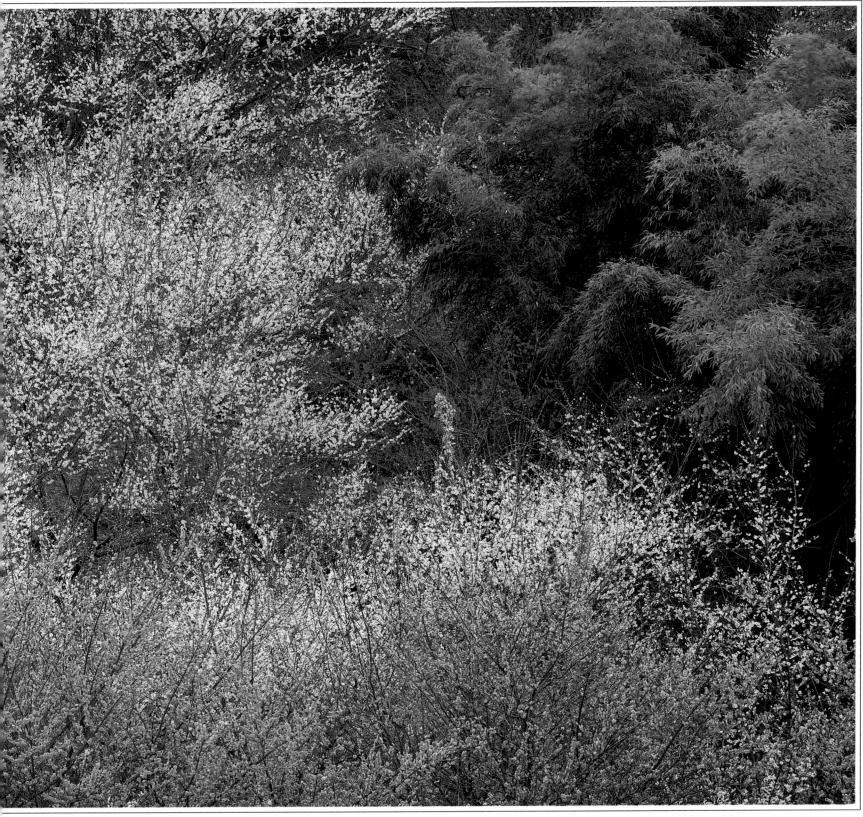

Plum blossoms – fragrant, soft and lovely

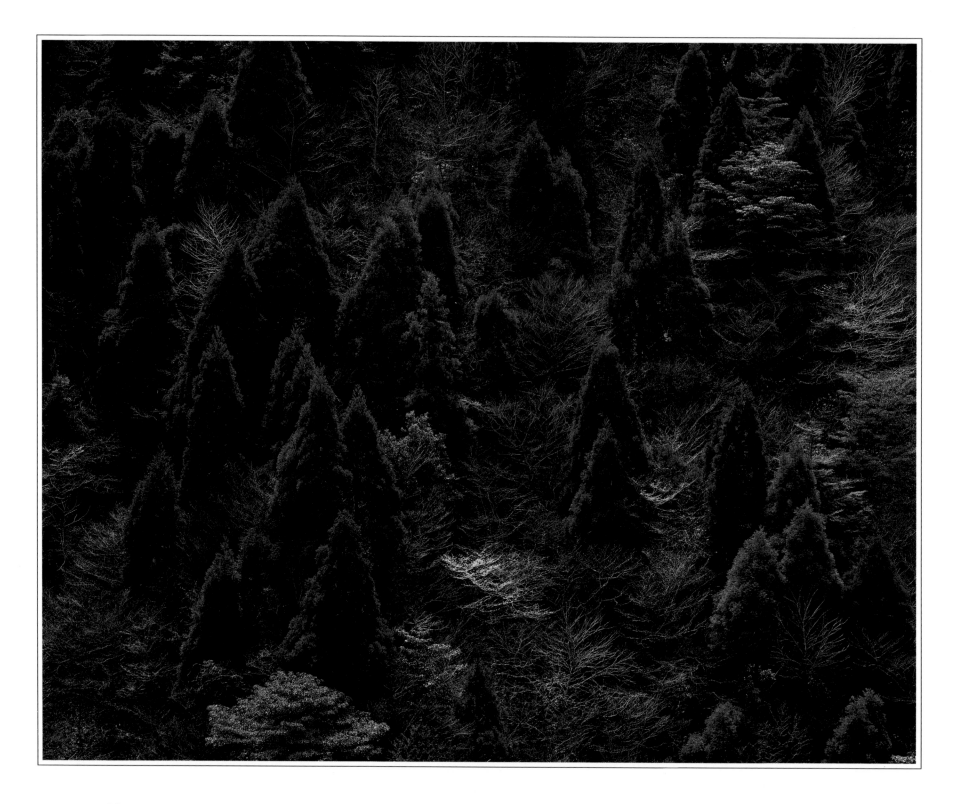

Japanese witch hazel amidst green cedars

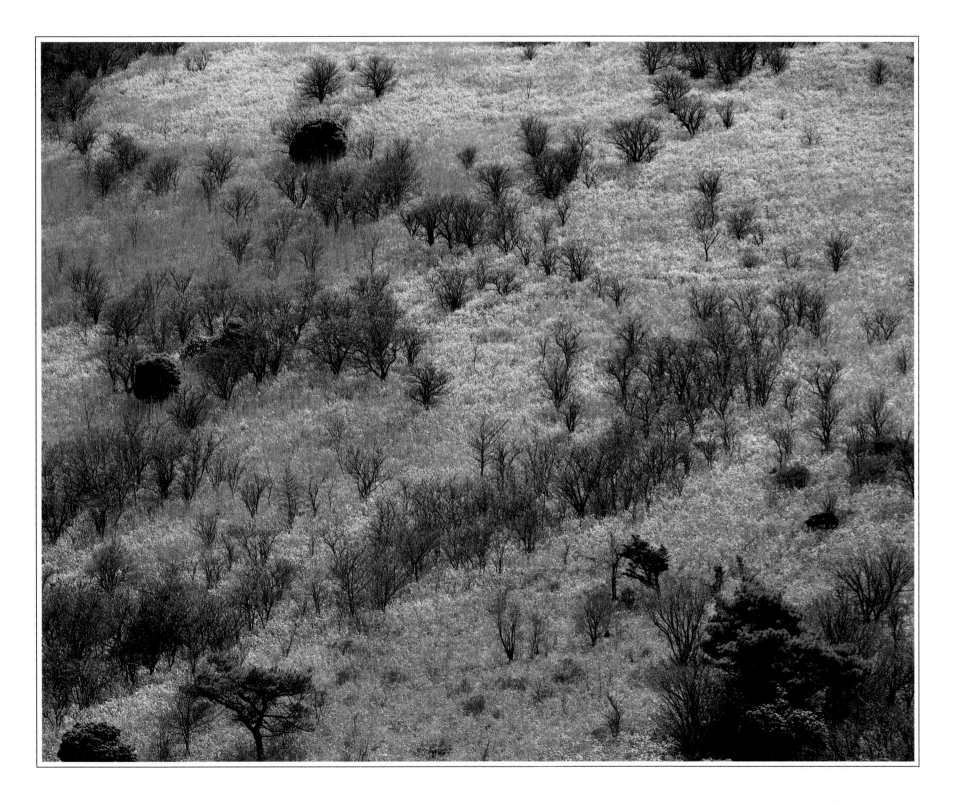

A season for pale andromeda

The Full Blooming of Spring

The Japanese islands extend so far from north to south
That cherry blossoms appear at the end of March in southern Japan
But only two months later in the north.
It is difficult to talk about a cherry blossom season,
So much depends on the trees, the altitude of the land.
But I have had the pleasure, on occasion,
Of unexpectedly coming across gorgeous cherry blossoms
In some unlikely little patch of countryside.

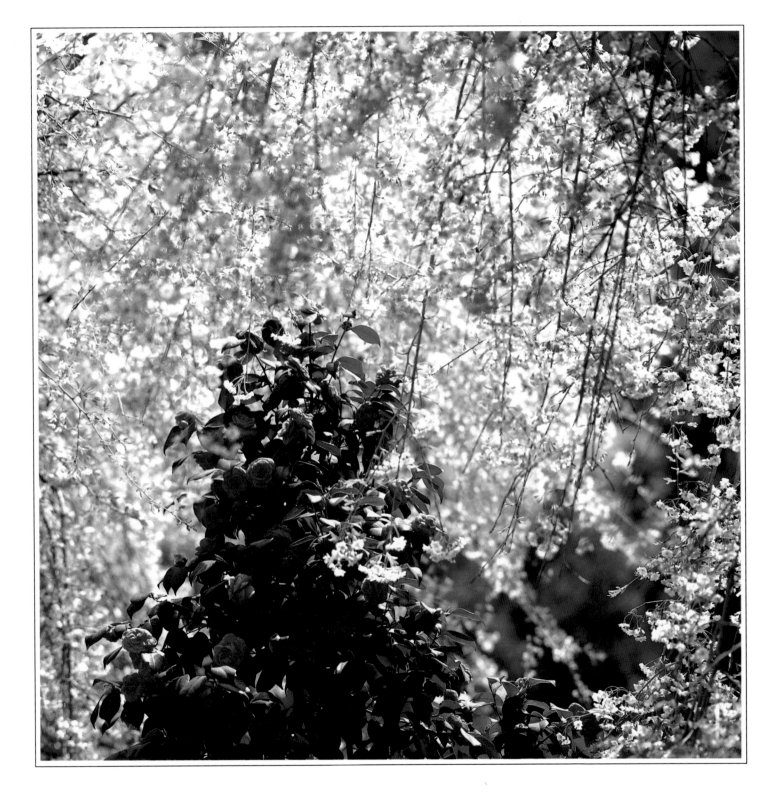

Vernal brilliance

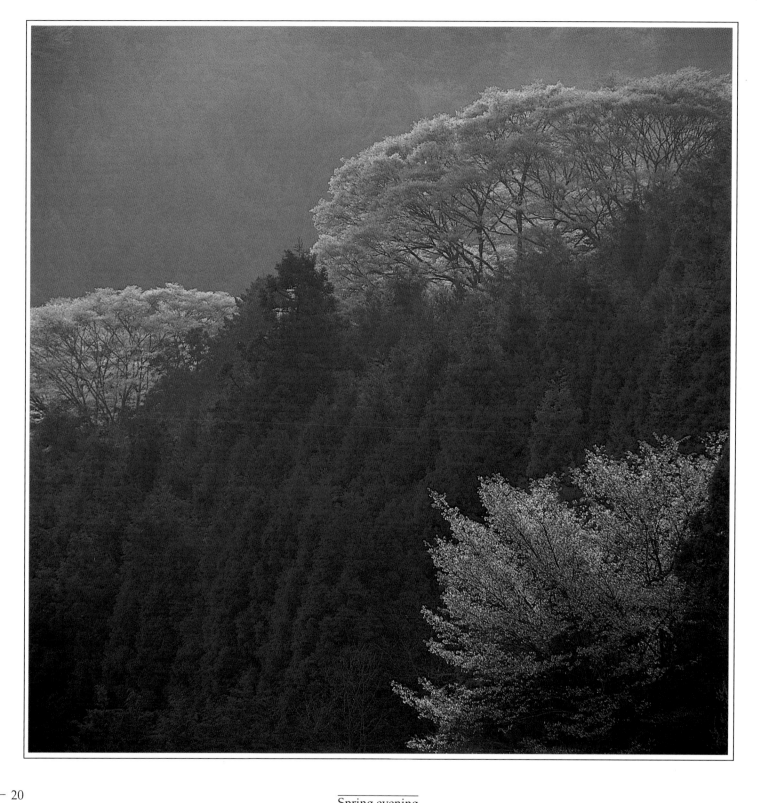

Spring evening

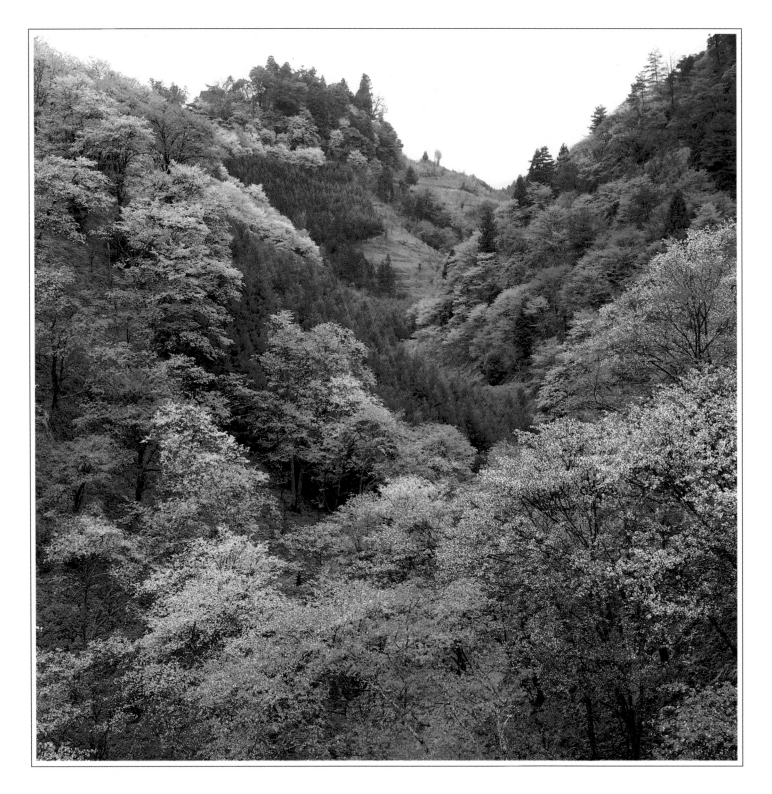

The cherry blossoms of Mt. Yoshino

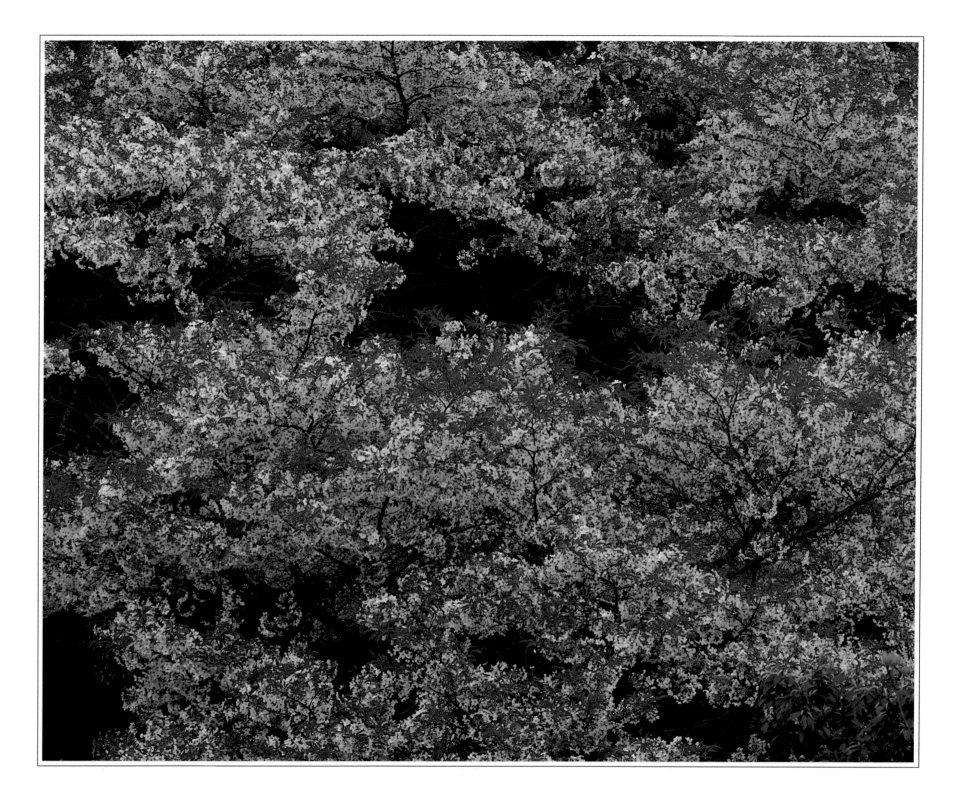

In full bloom

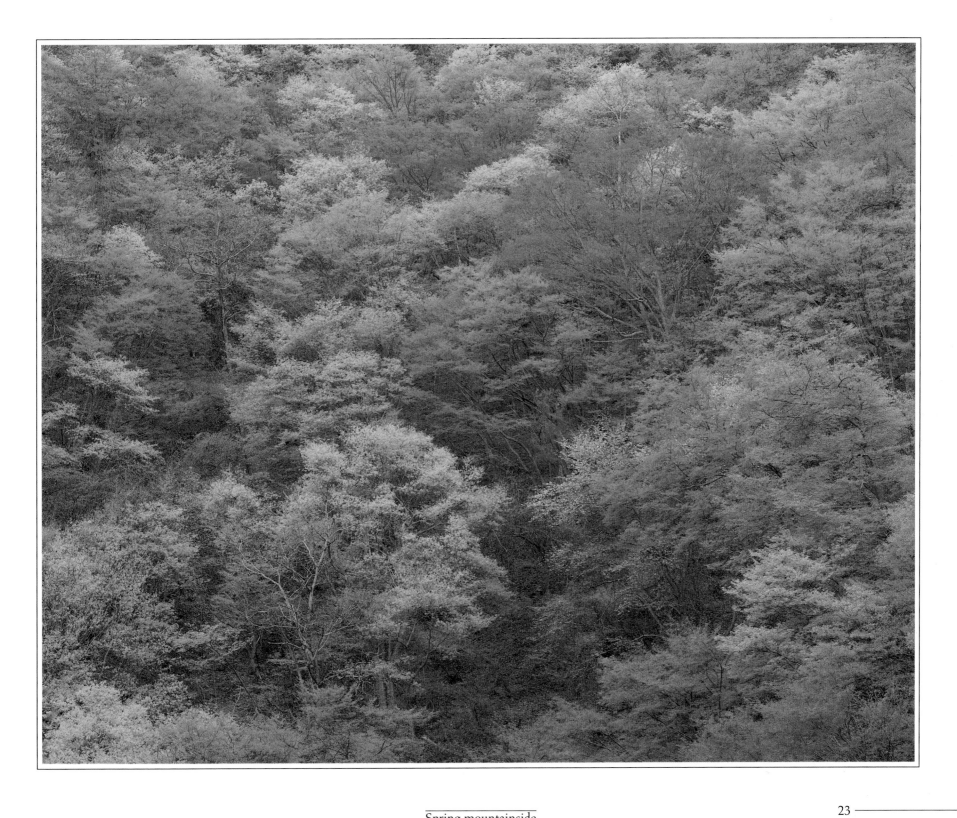

Spring mountainside

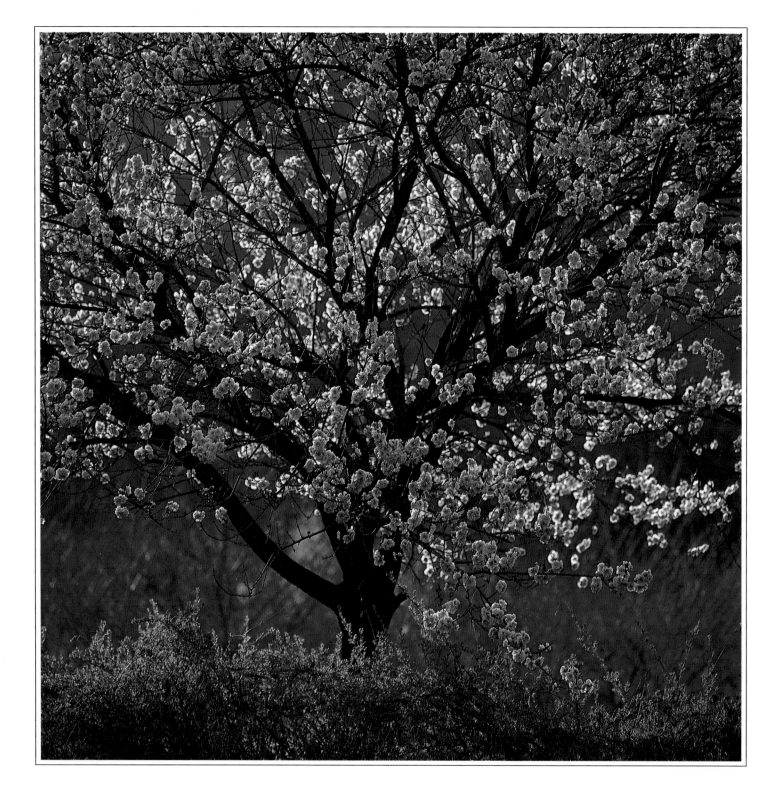

Peach blossom

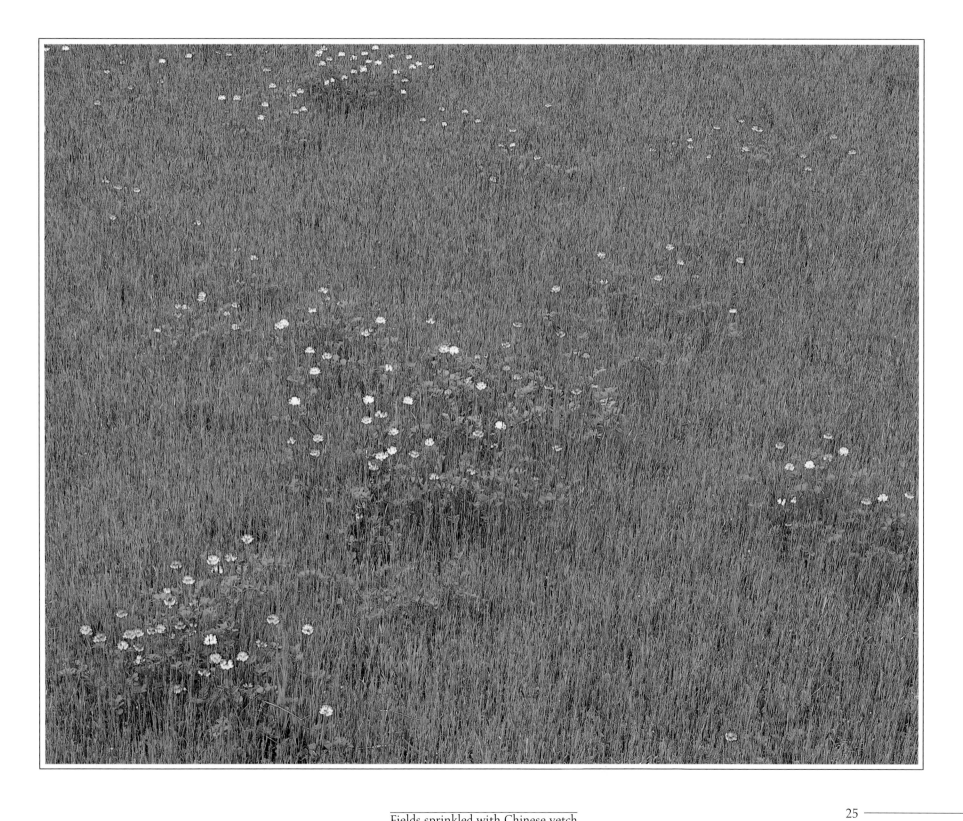

Fields sprinkled with Chinese vetch

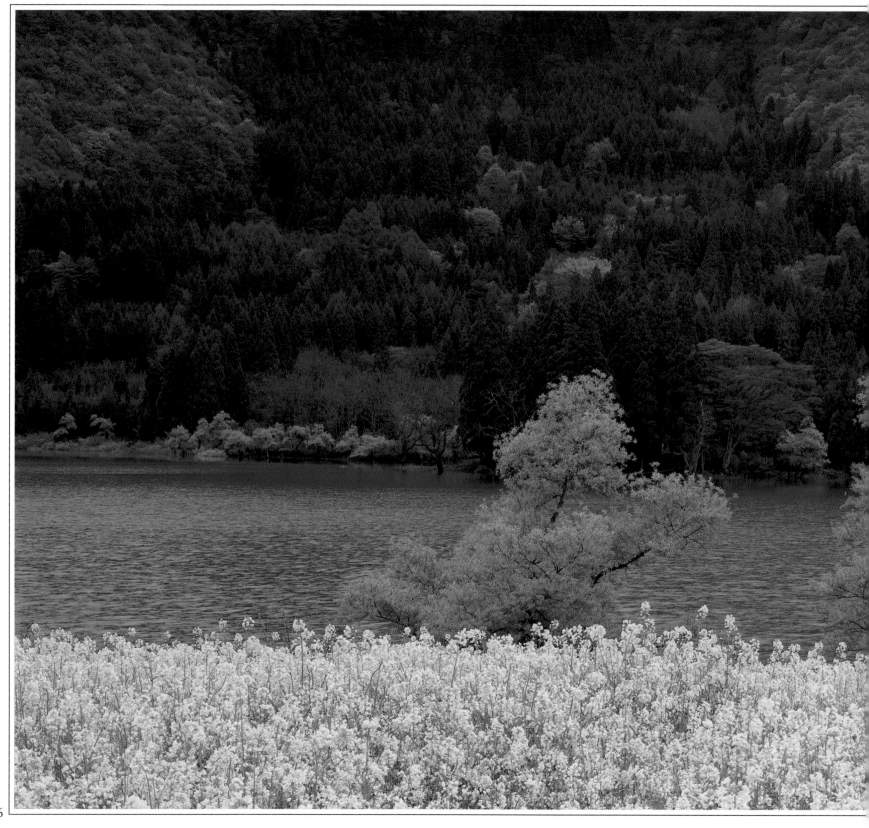

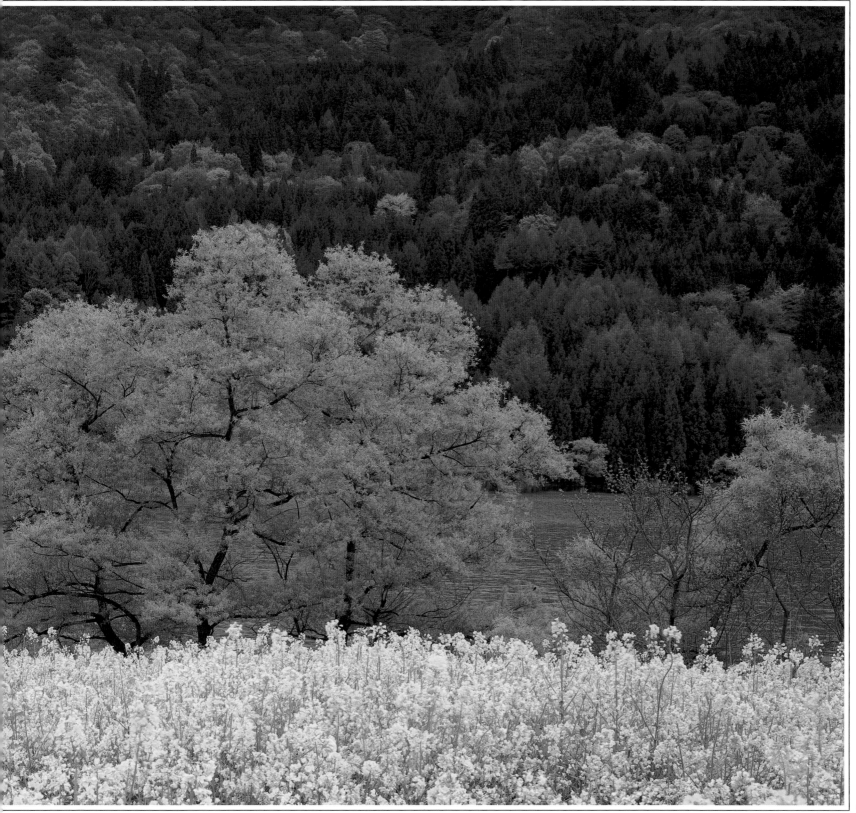

Lake Hokuryu in spring – soft colors, still water

The Splendour of the Land Bursts Forth

Since days of old, men have spoken of Japan's "purple hills
And crystal streams."
How suitable this expression is to describe the brilliance
And the beauty of this season.
The trees are clad in bright young leaves,
The atmosphere so alive and refreshing.
Melting snows run off the high mountainsides
In an ever increasing flow,
And murmuring,
Run down to the gorge below.

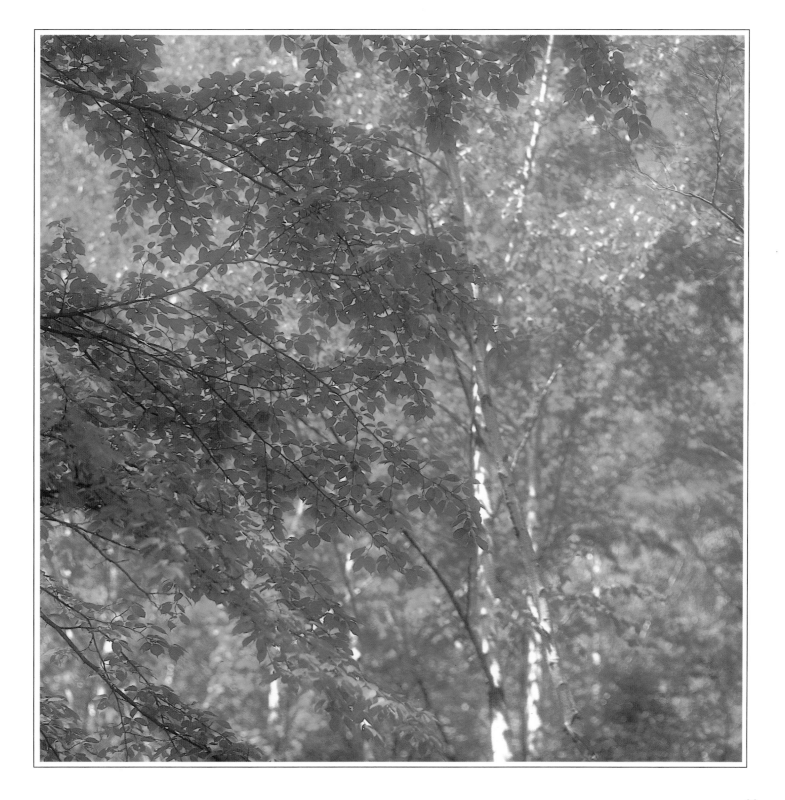

Bright, fresh, young leaves

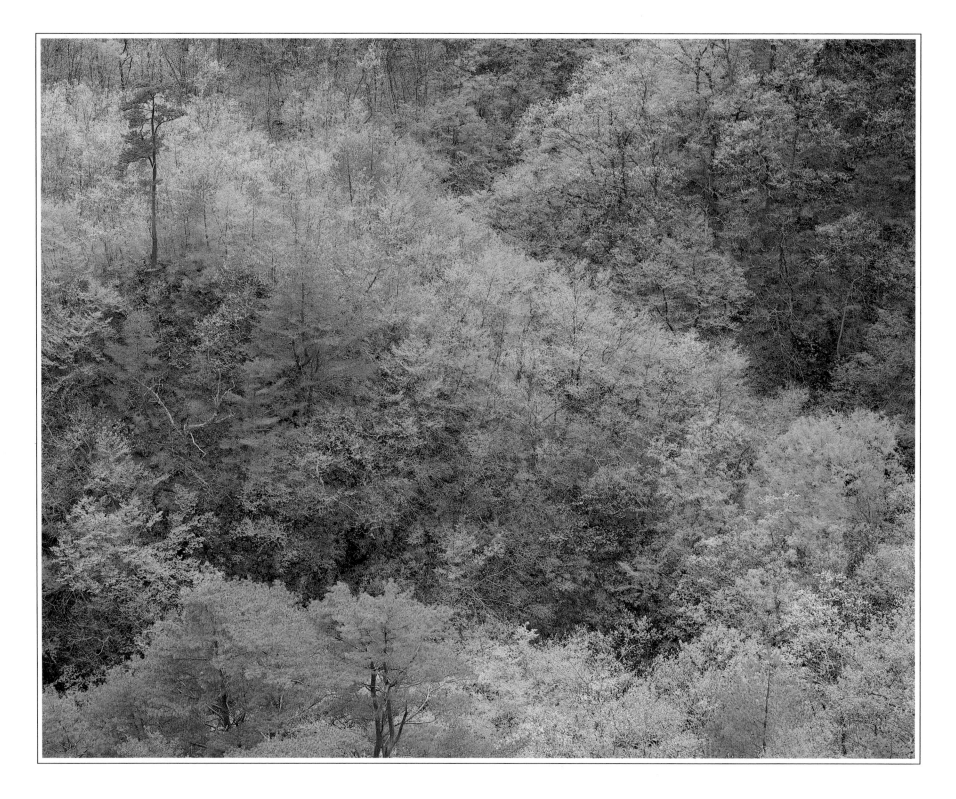

The burgeoning of buds

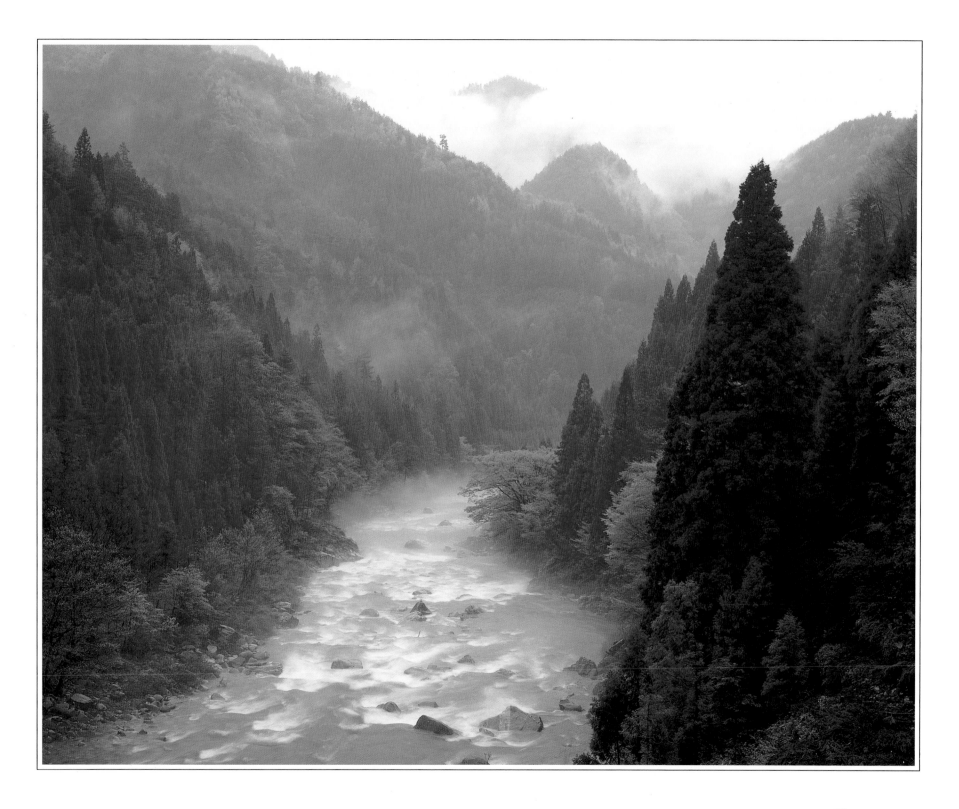

Misty Sugoroku Gorge

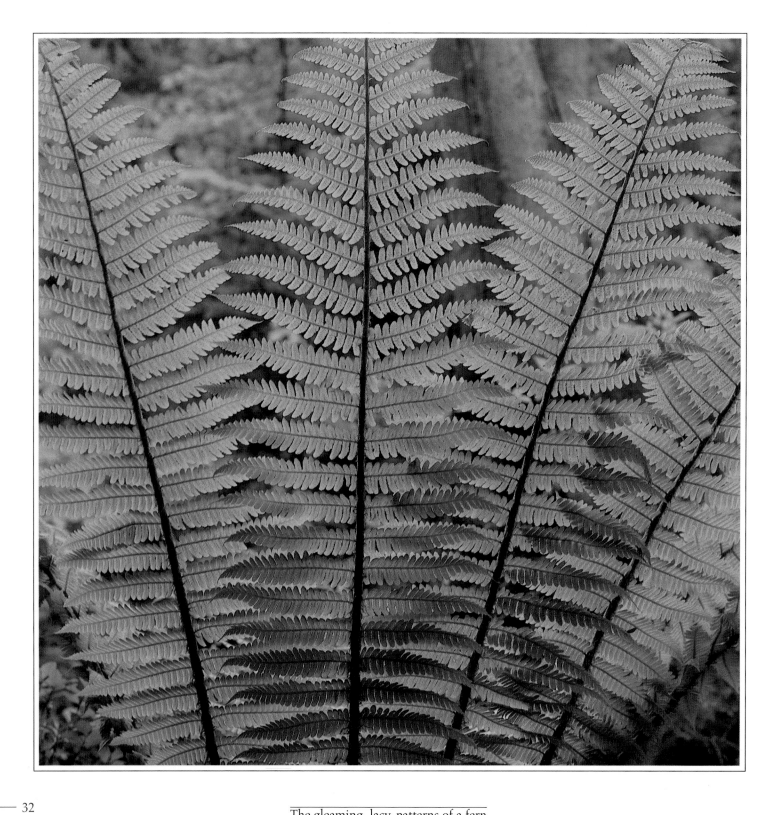

The gleaming, lacy, patterns of a fern

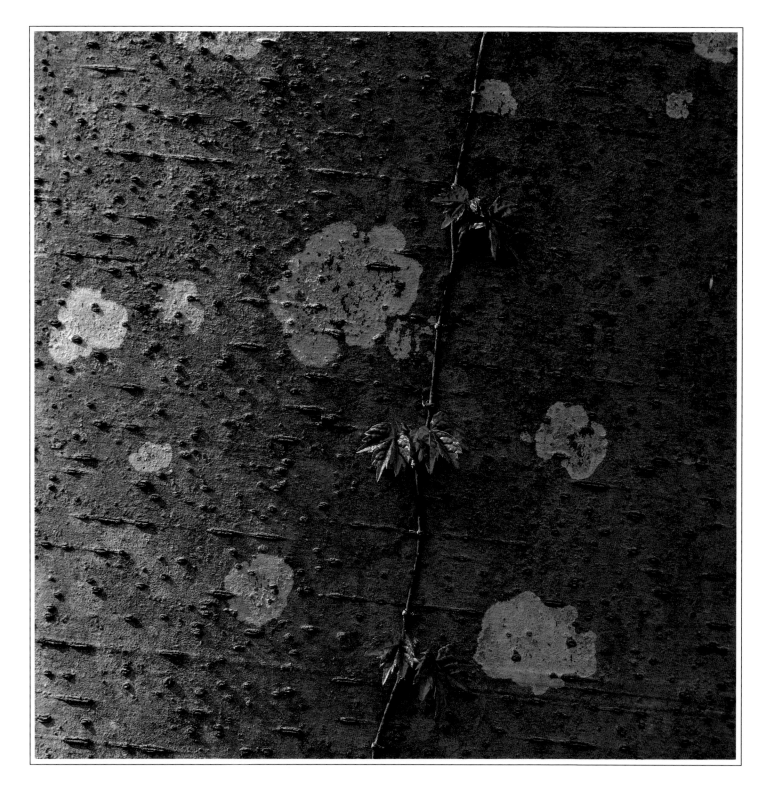

Glowing ivy

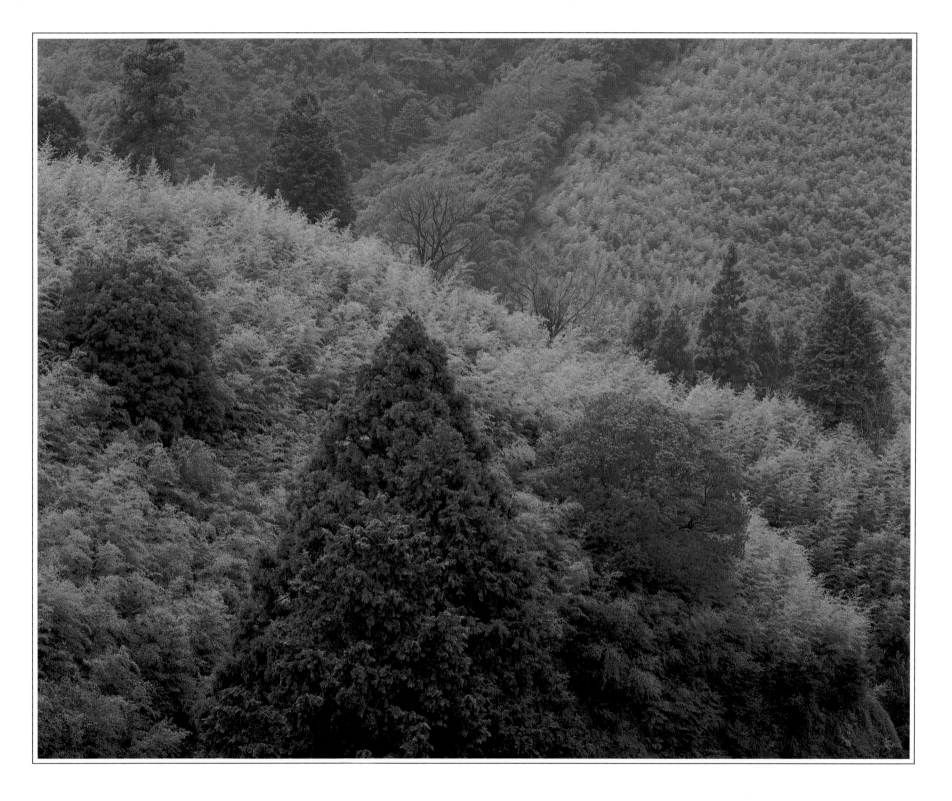

Mountain bamboo grove

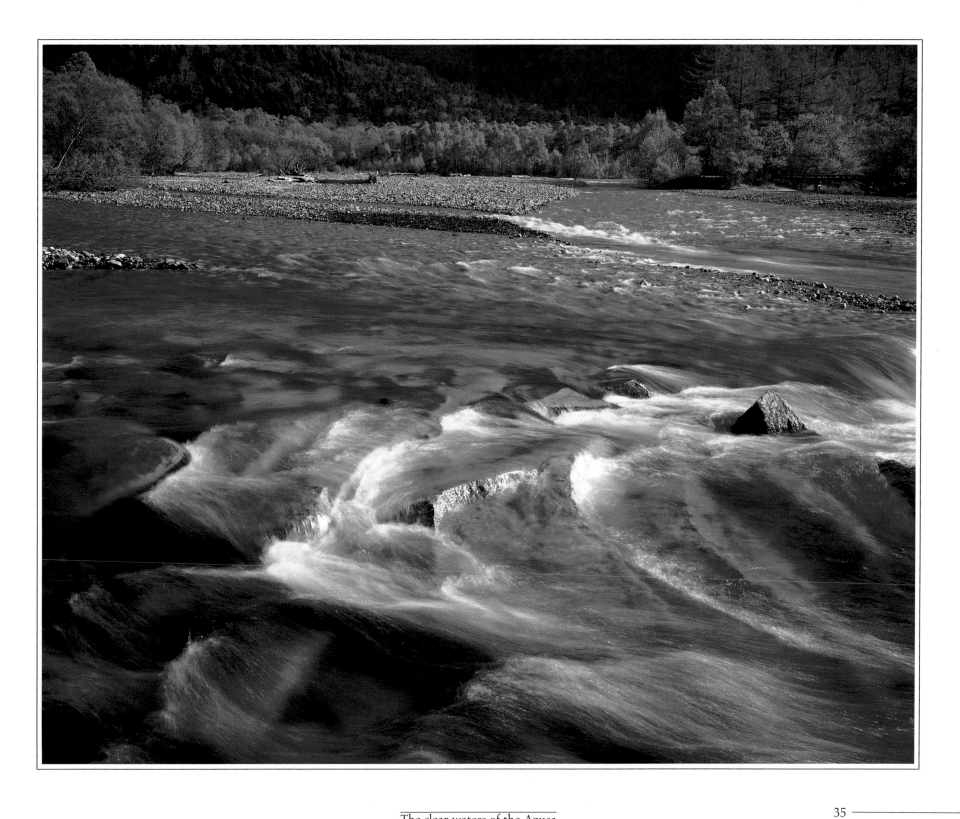

The clear waters of the Azusa

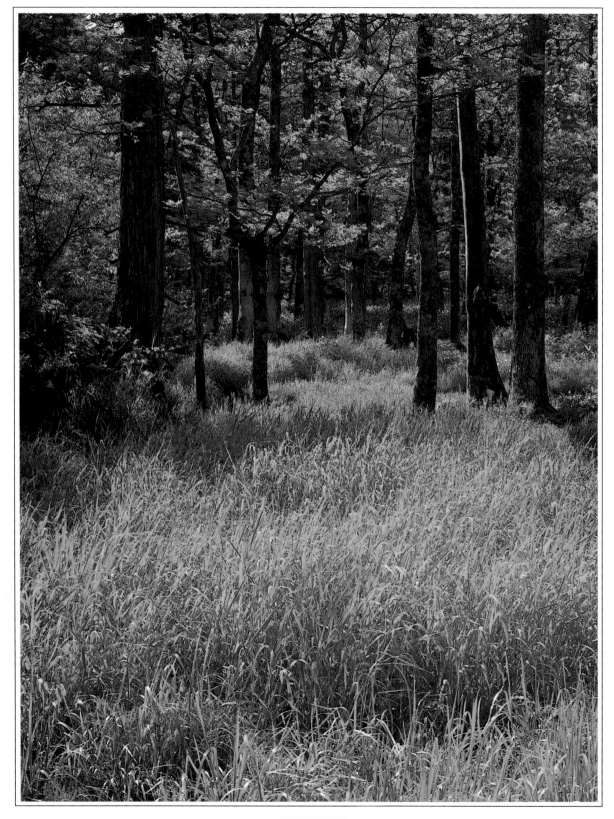

A shady nook

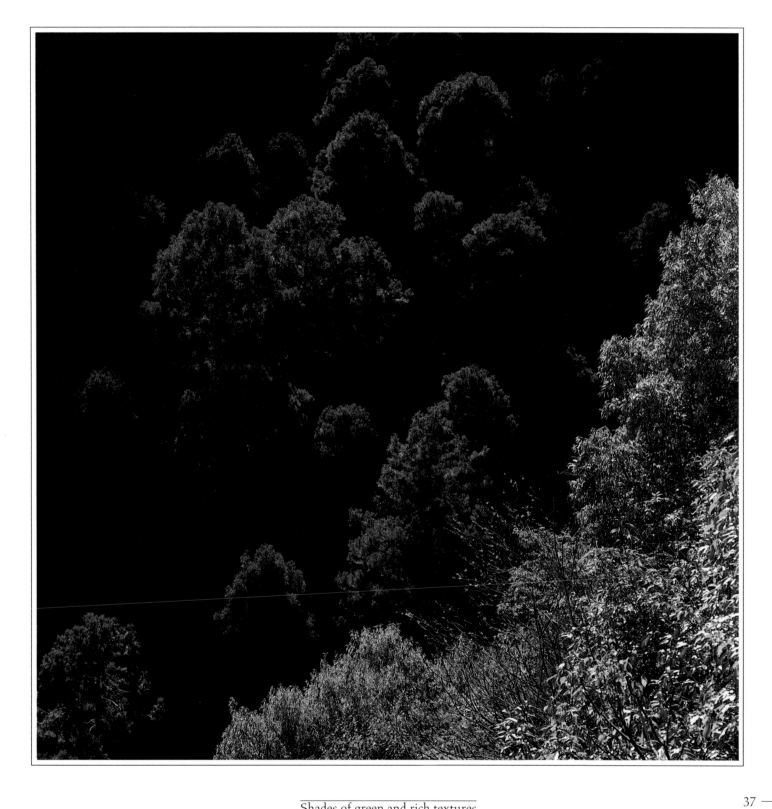

Shades of green and rich textures

Summer's Verdure

By the end of July, the seasonal front has moved north,
And the rainy season ends.
Now the sun shines brightly,
And the real heat of summer is upon the land.
People swarm to the beaches and mountainsides
To avoid the summer's steamy air,
But for plants this is the finest season,
The season of their growth.
Truly this is a time of verdure.

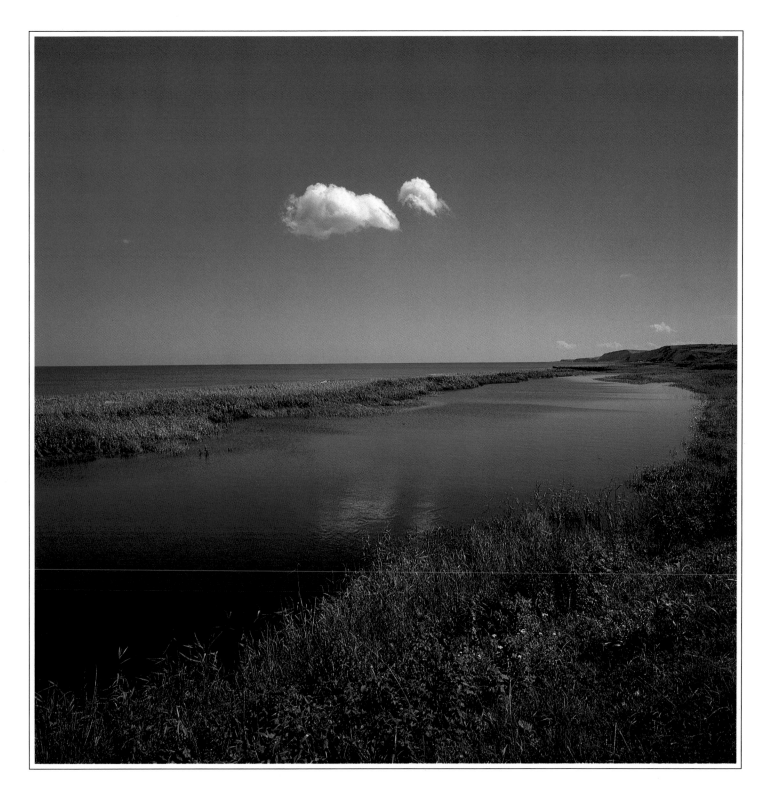

White clouds, blue waters

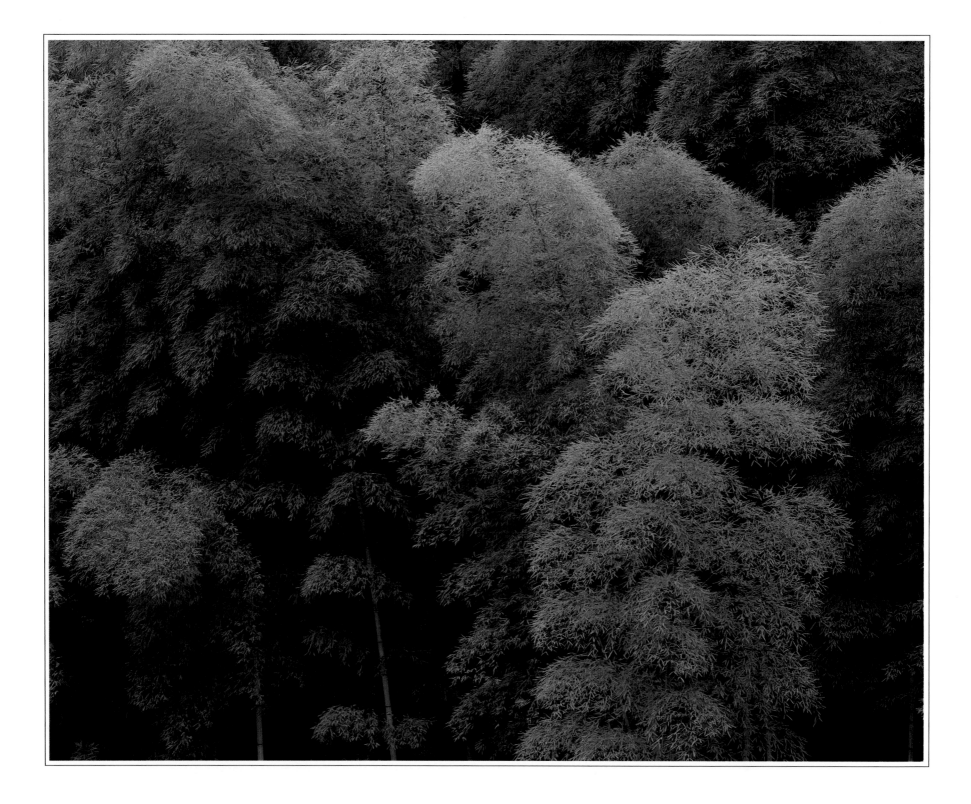

The hush of bamboo

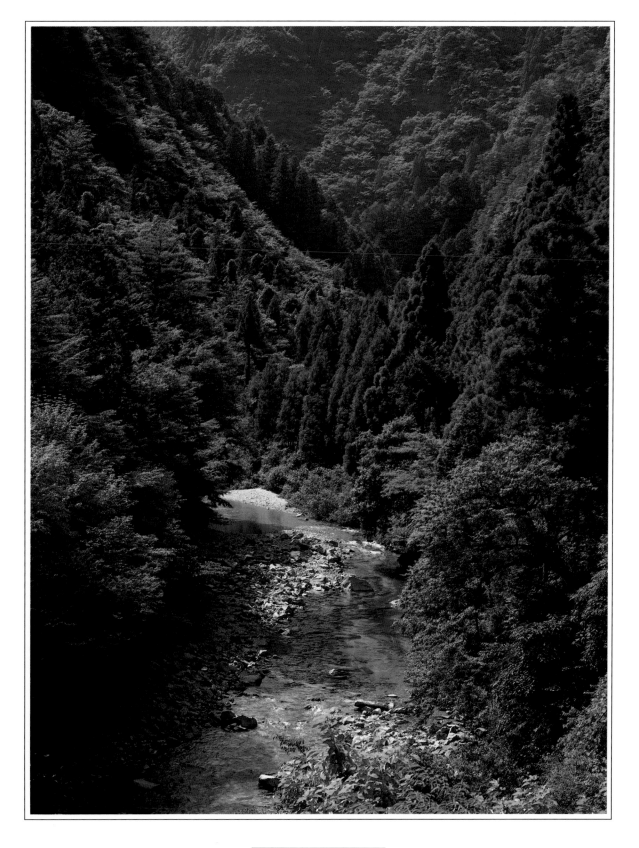

In the coolness of a gorge

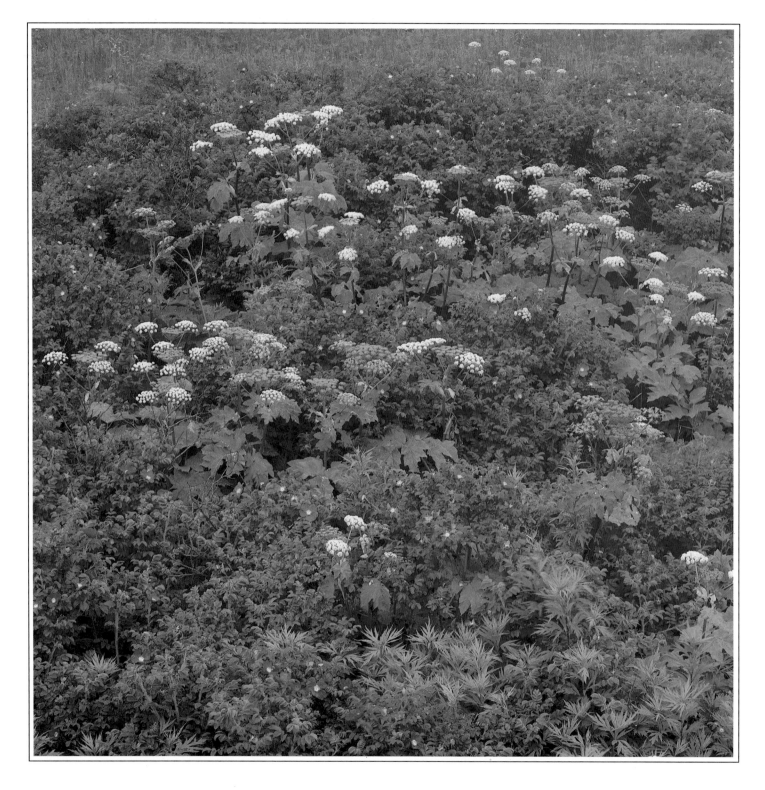

Sweetbrier

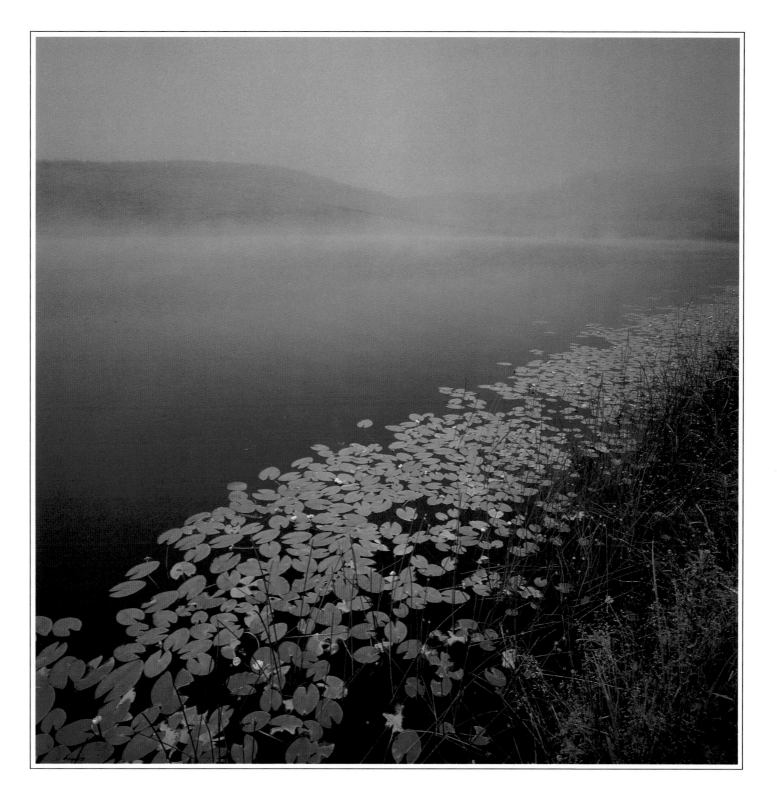

Spatterdock and mist

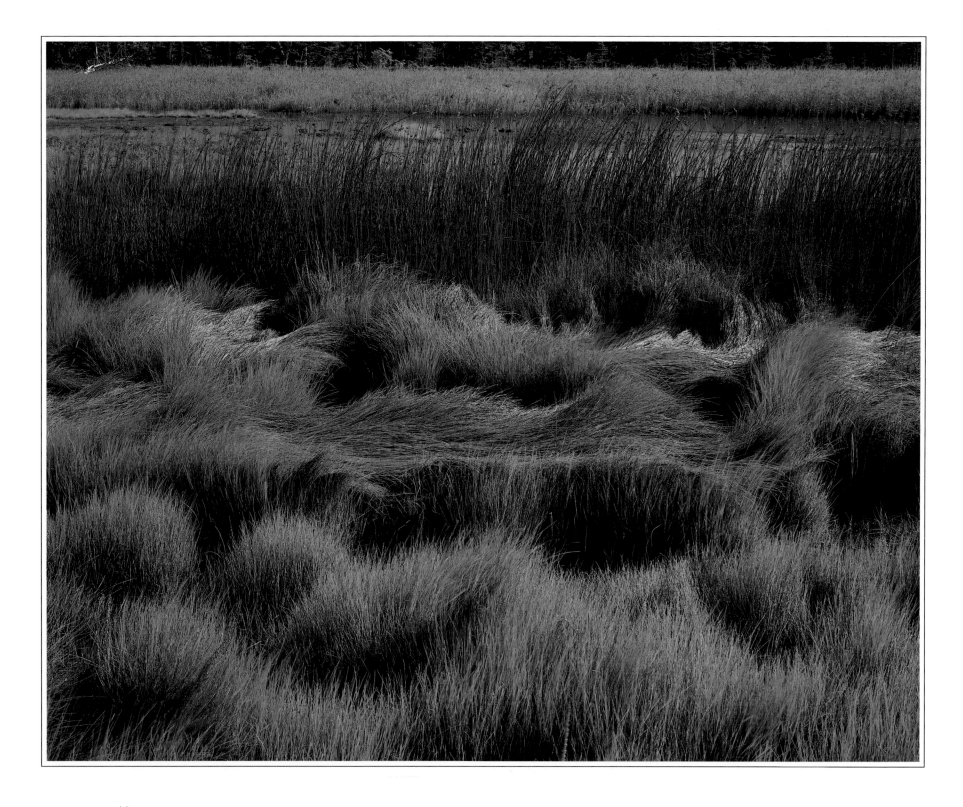

A windswept swamp

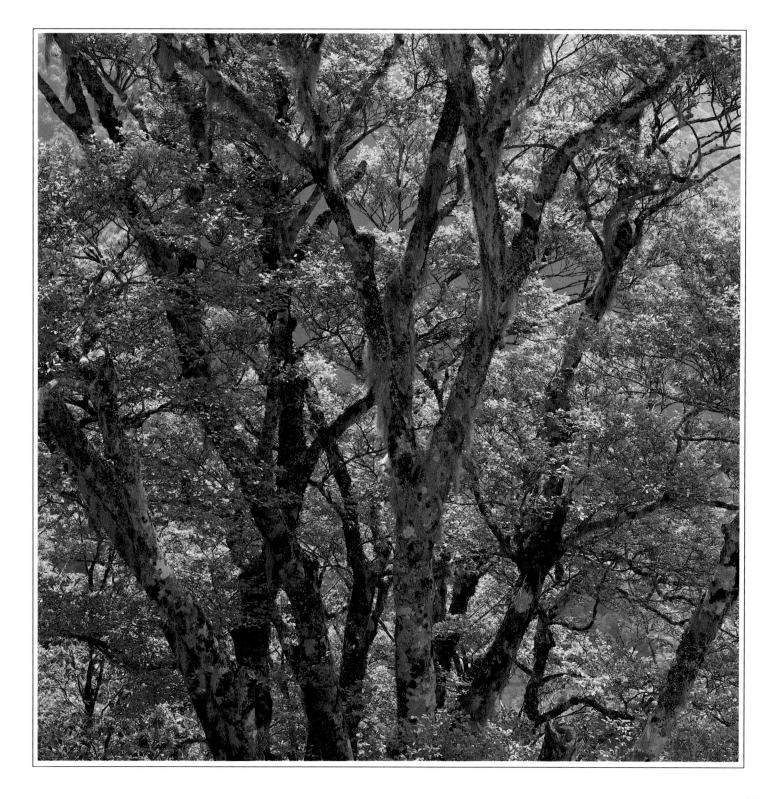

In the forest depths

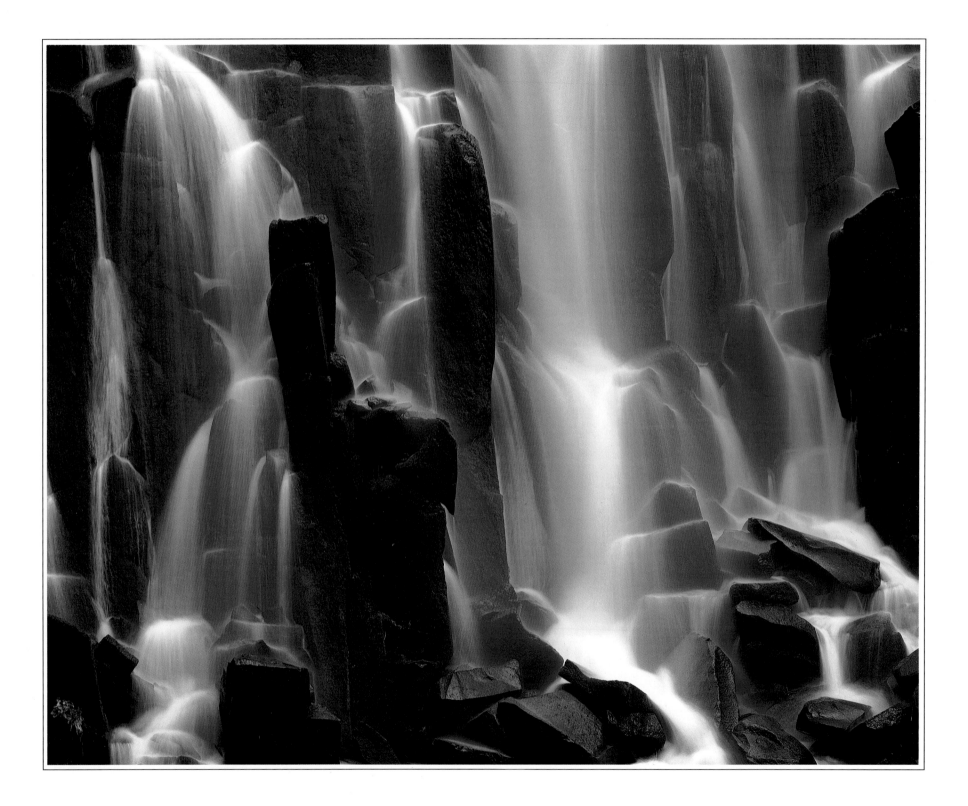

Crystal cascades

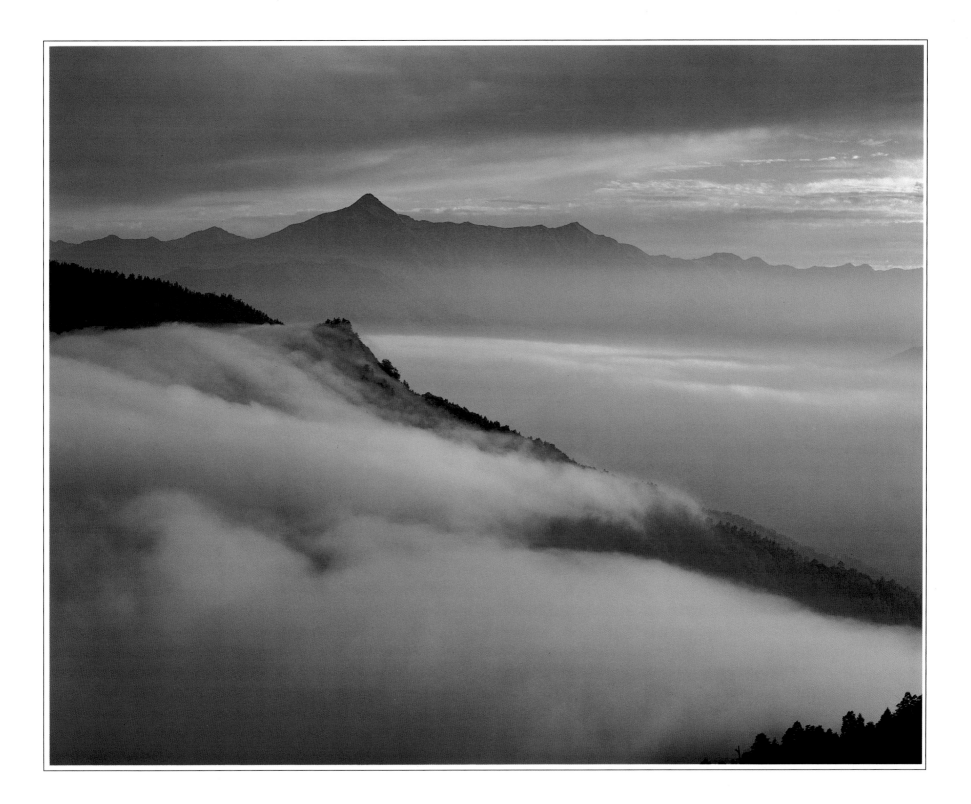

Cloud-covered Mt. Kasa

The Touch of Early Autumn

The end of summer always has its hot days,
But you can sometimes feel the cool of autumn in the air.
Birds acquire their winter plumage,
The hillsides are covered with silver reeds and bush clover,
Trees and grasses change colors,
And even the moon becomes more beautiful.
For man it is the season of the harvest moon festival.

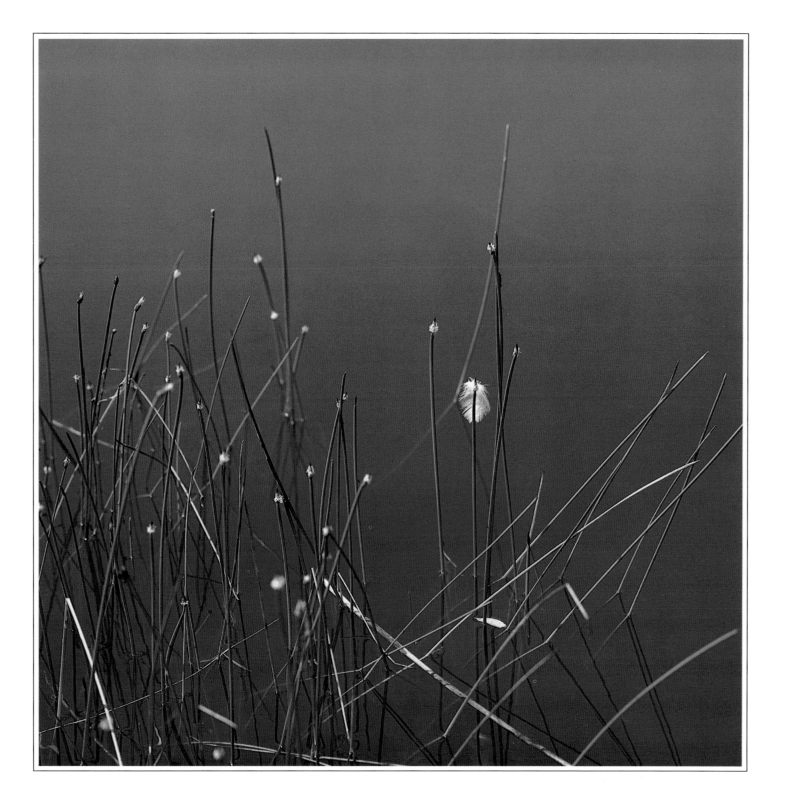

The feeling of a changing season

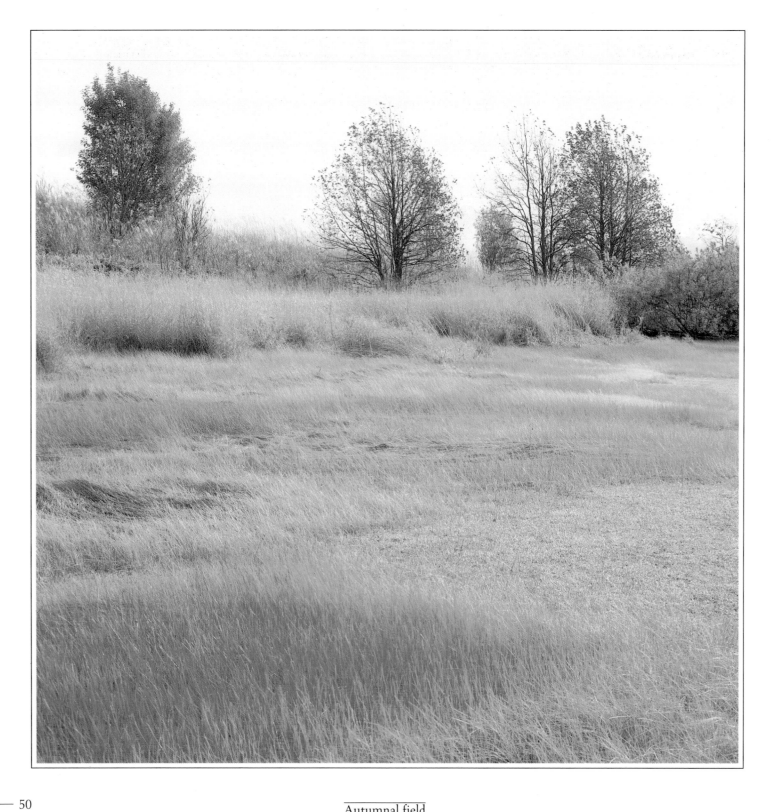

Autumnal field

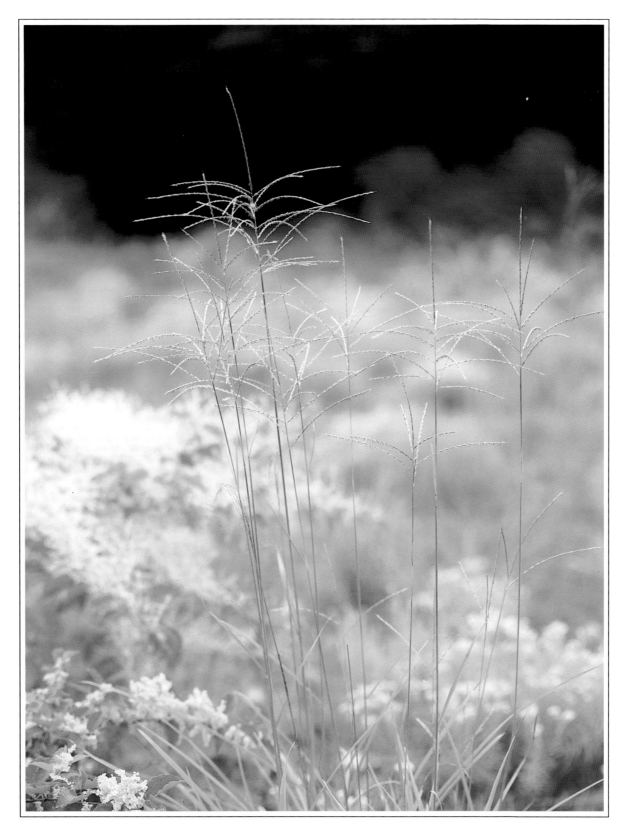

The stillness of an afternoon

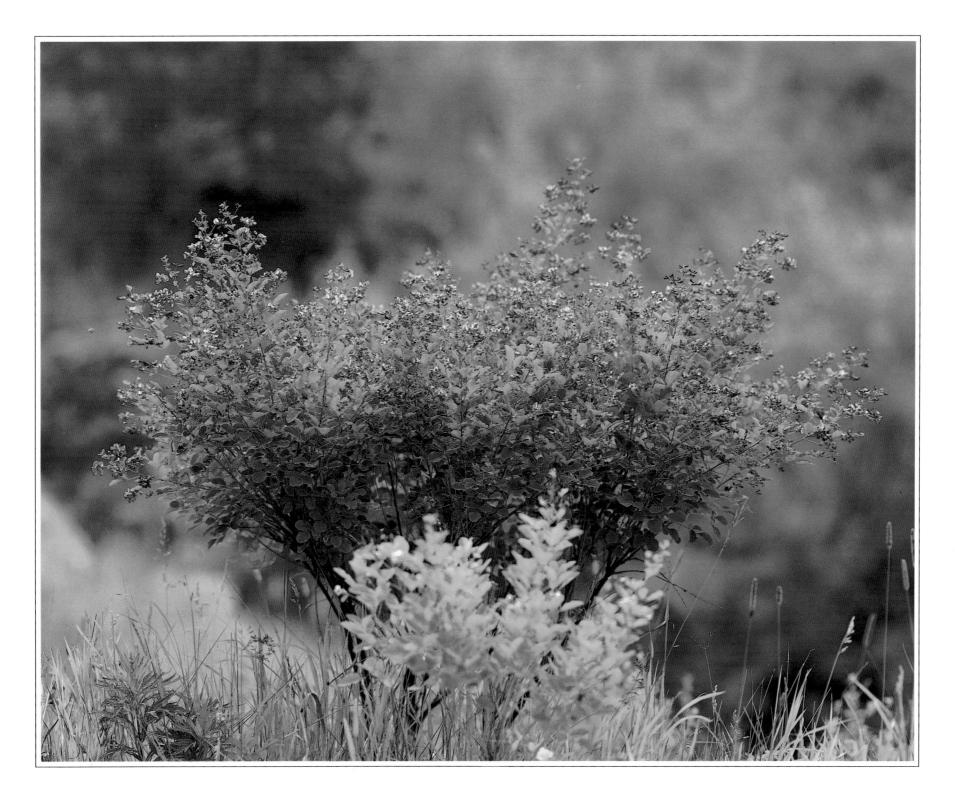

Japanese bush clover blossom

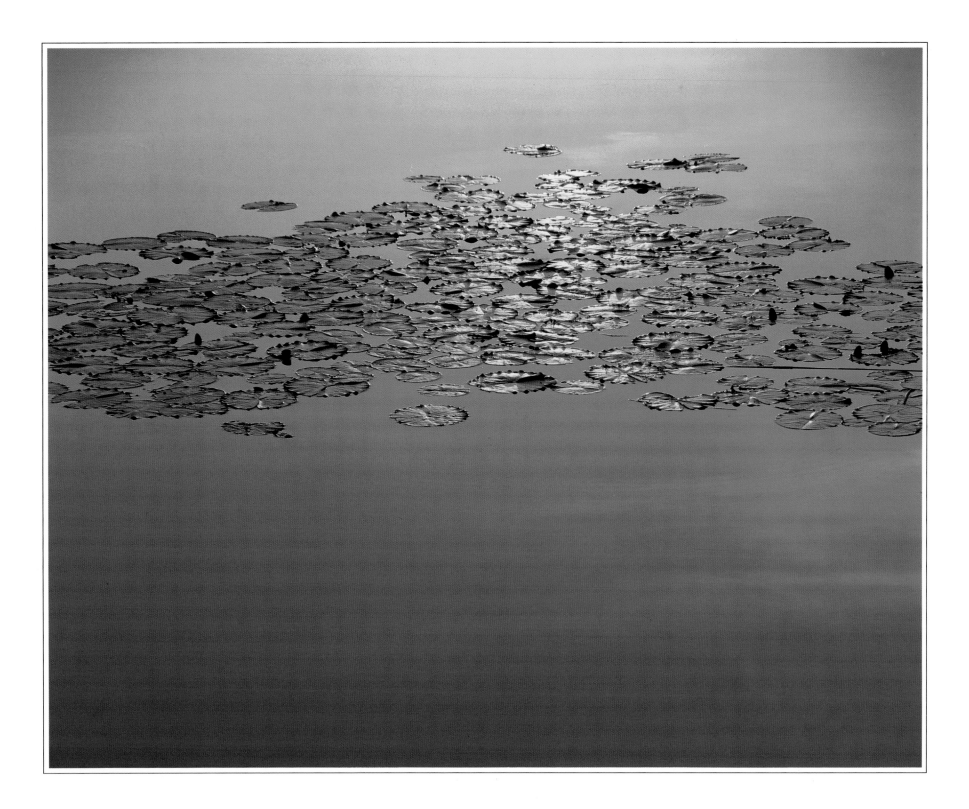

Evening sunlight on lotus leaves

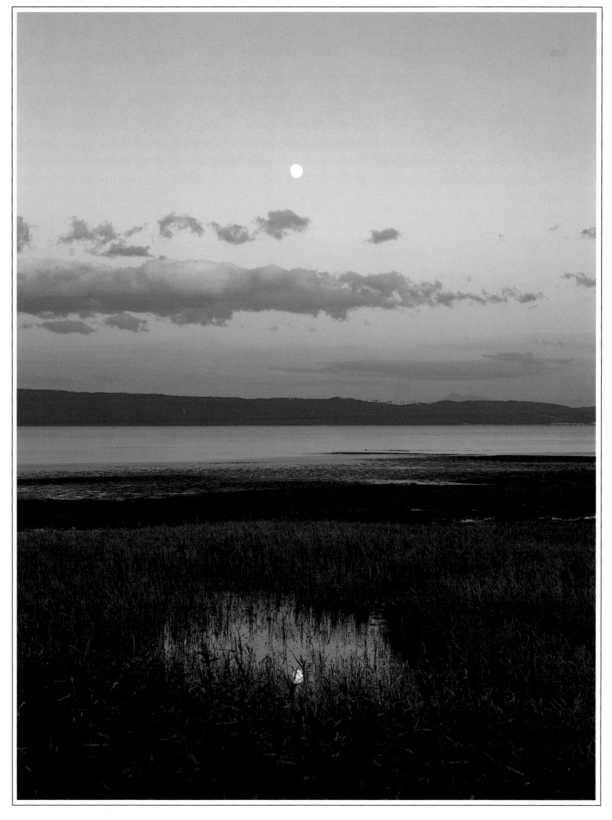

Moon upon a lake

Autumn's Varied Loveliness

The glory of a Japanese autumn
Is like that of a splendid picture scroll.
Its brilliance varies from year to year.
So much depends on the weather,
The wind, the rain, the cold air from the north,
The moods and temper of the fall typhoons.
But an autumn in Japan is radiant and refreshing,
And then there is undeniable beauty.

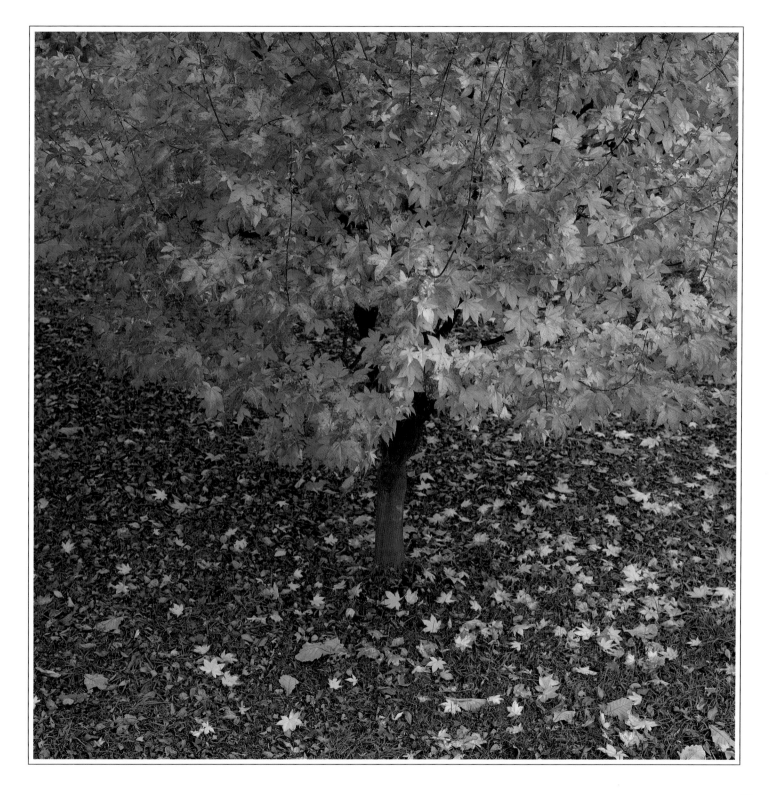

A brilliant shower of leaves

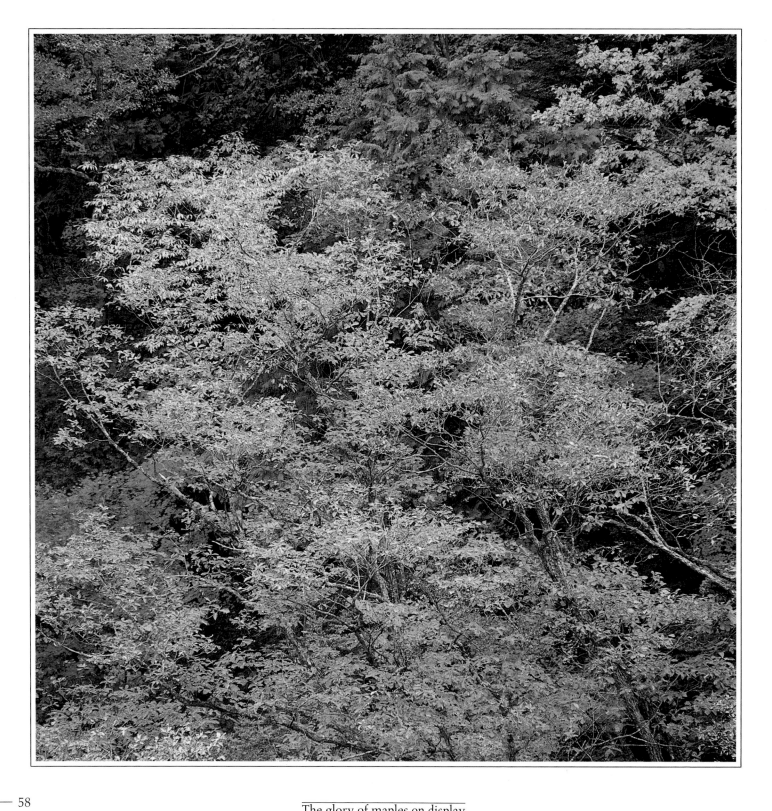

The glory of maples on display

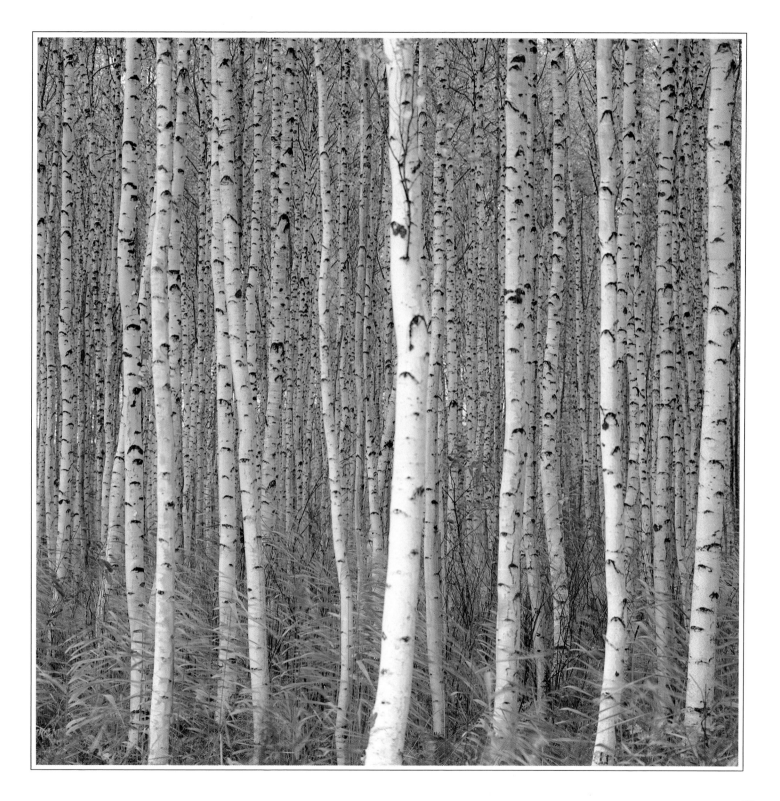

White birches – yellow leaves

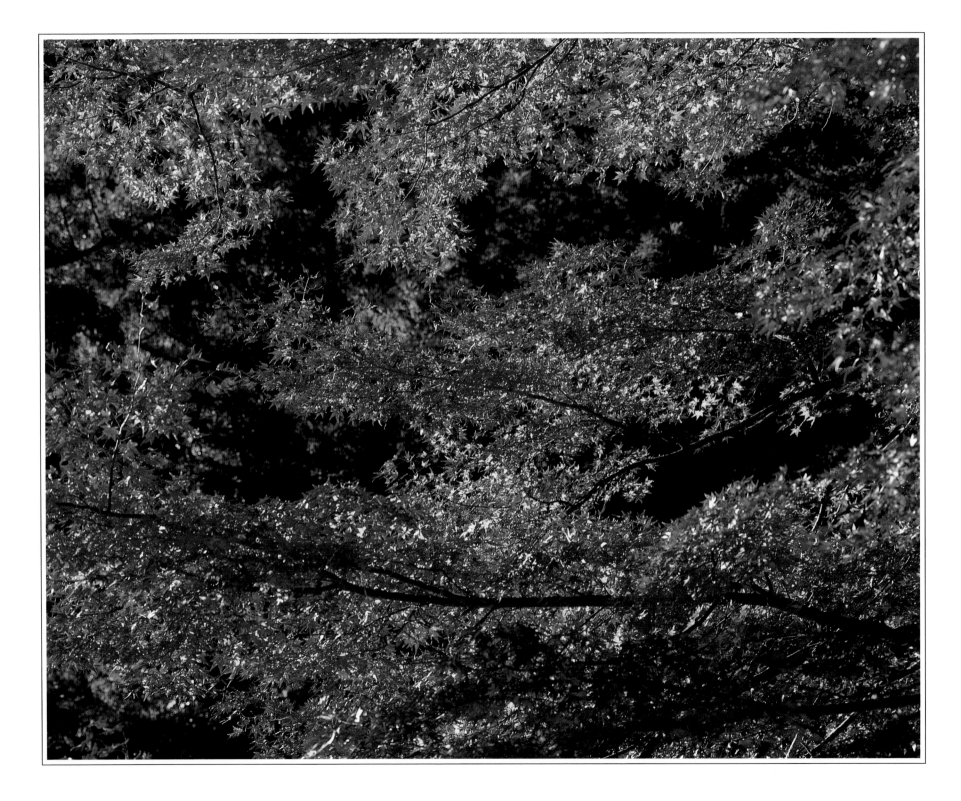

Maples ablaze with color

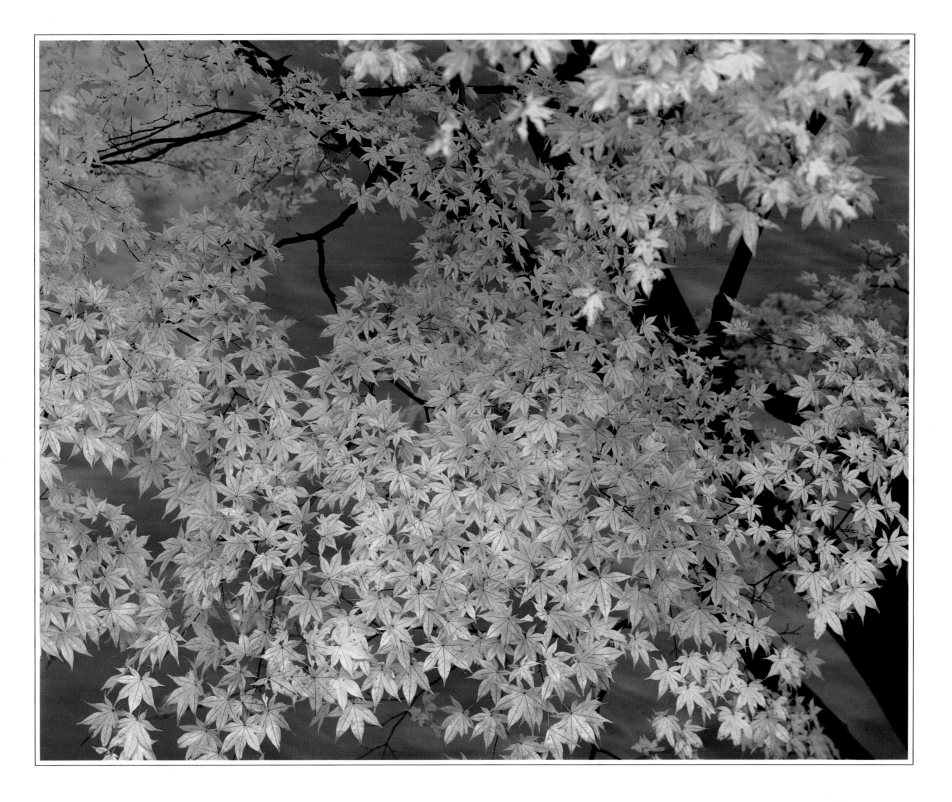

Momentary patterns and tones

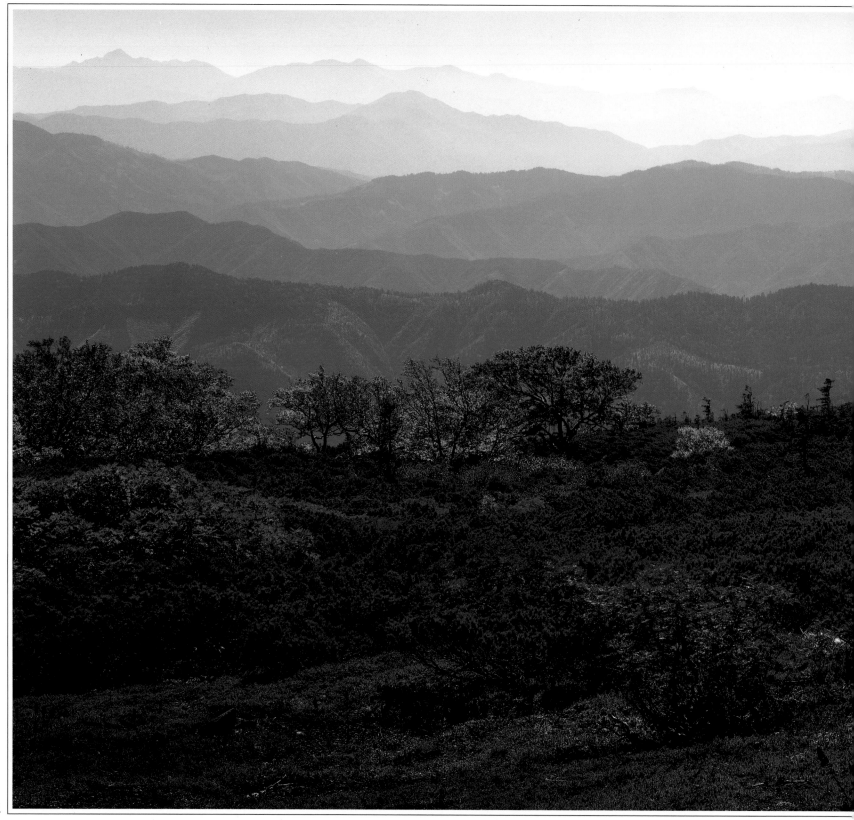

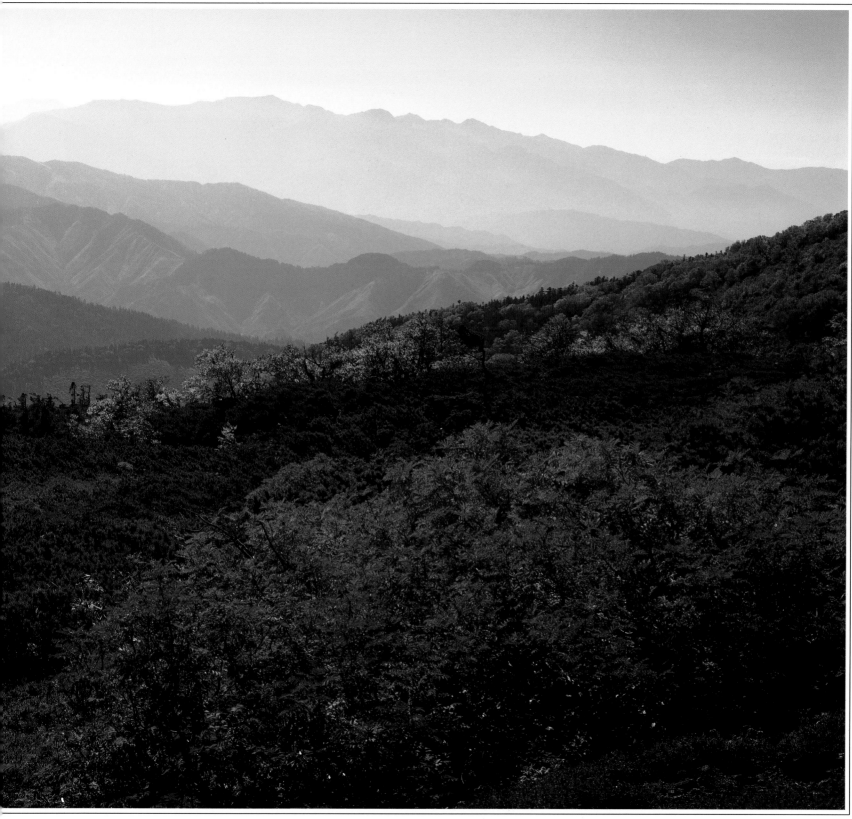

63

Mountains tinged with autumn's shades

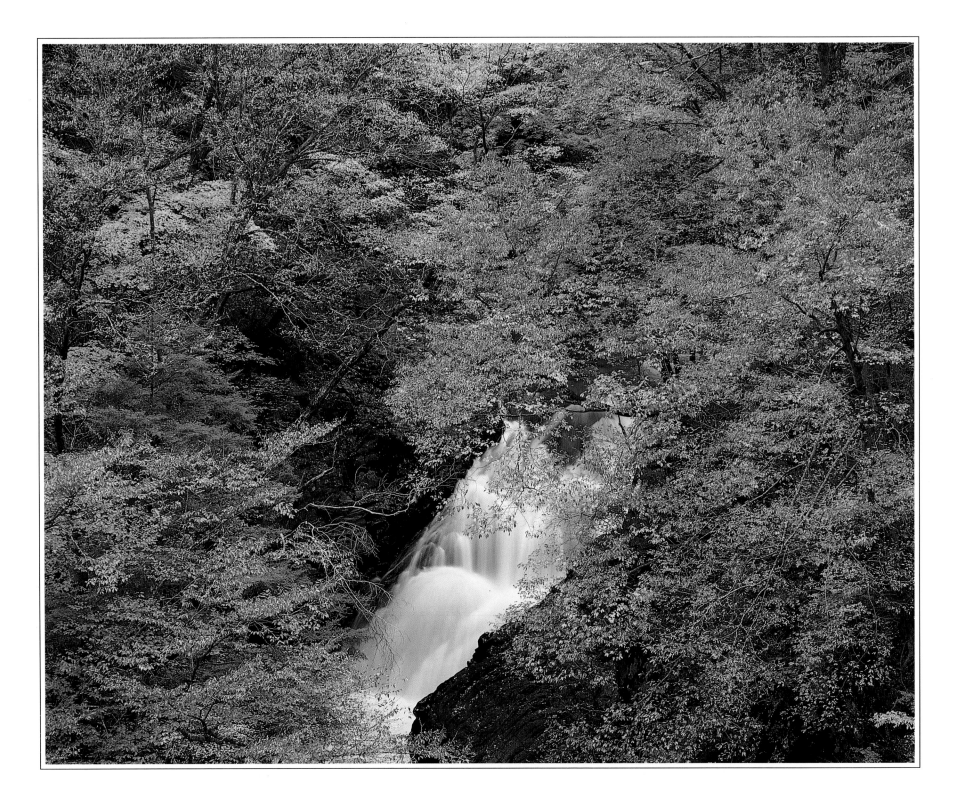

The season gently flows away

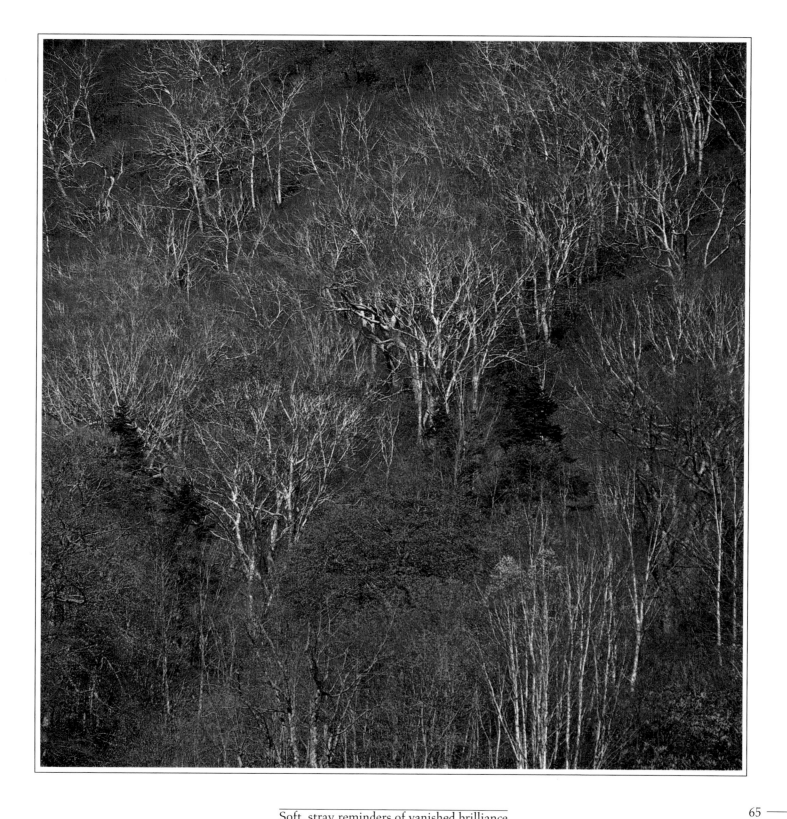

Soft, stray reminders of vanished brilliance

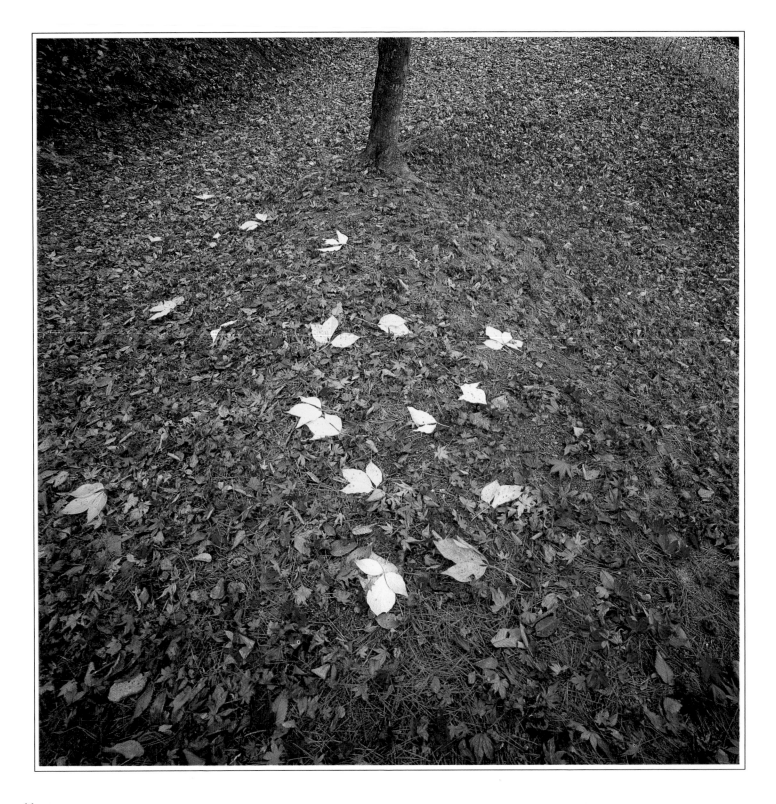

Fallen leaves – a final touch of beauty

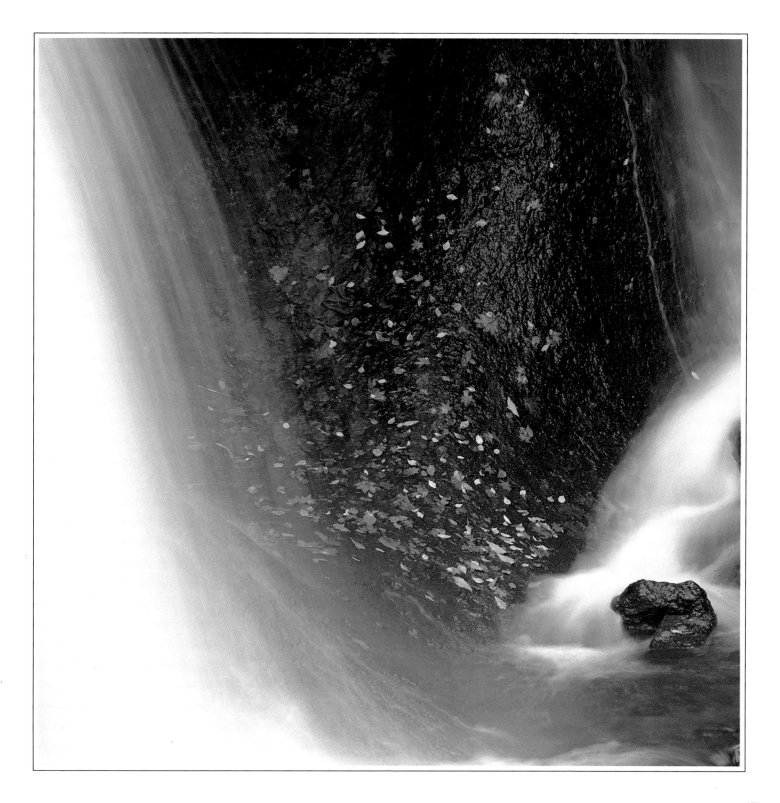

Scattered leaves and falling water

Autumn Solitude

The bright shades of autumn are short-lived.
This season changes quickly;
Winds shake down the leaves from the trees,
Leaving some denuded in a single night.
Then one morning – frost.
Bushes and grasses wither,
And all of nature takes on a bleak and desolate air.
It is a period of severe changes,
Days tinged with melancholy and loneliness.

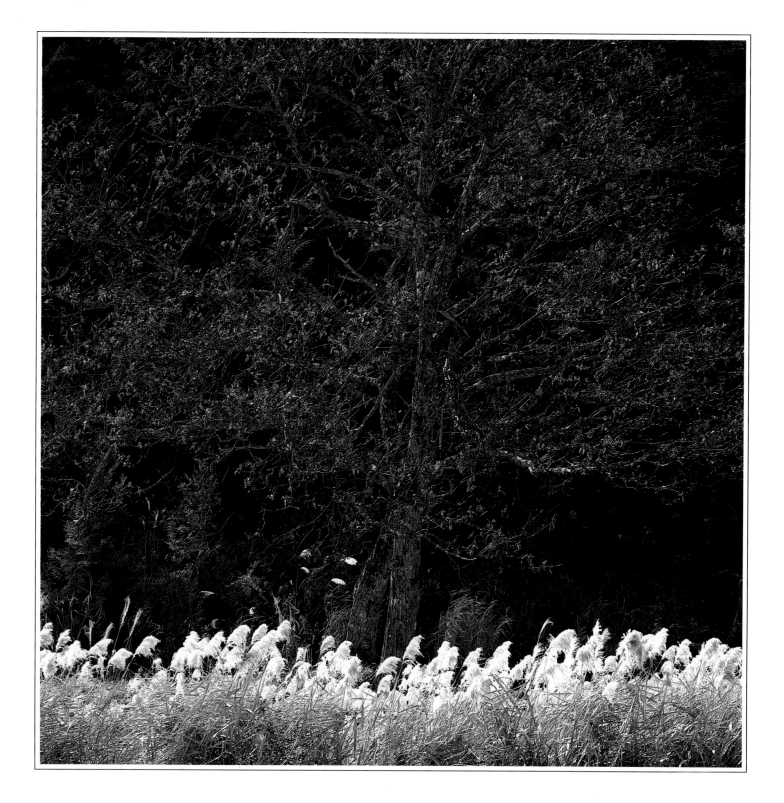

Late autumn light

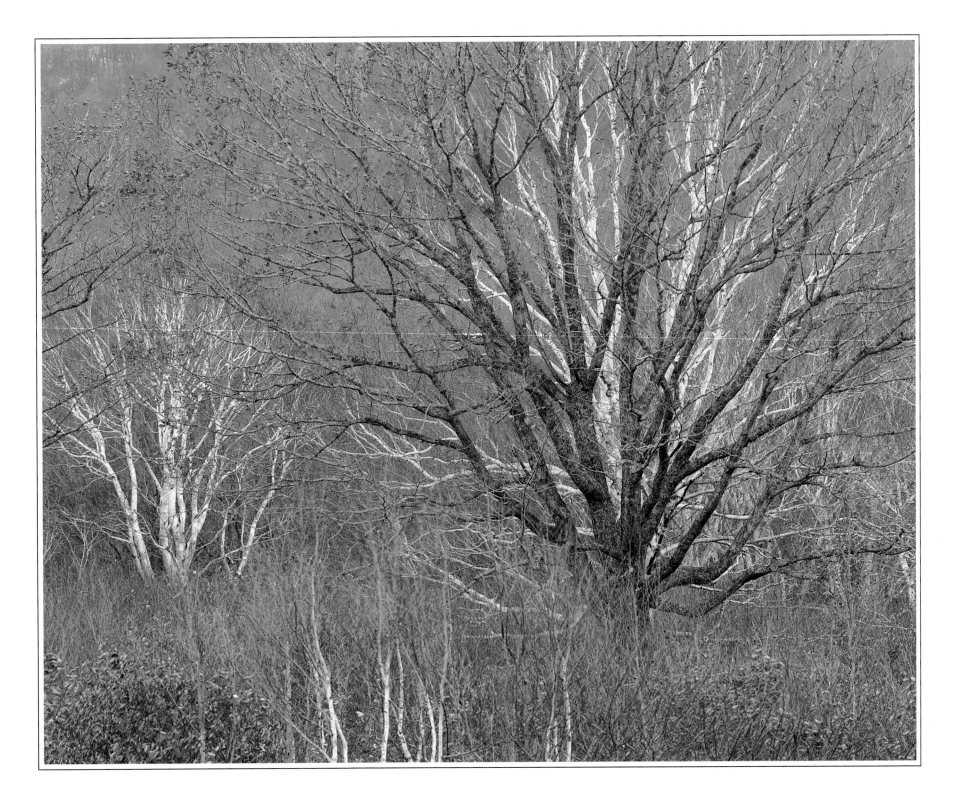

A forest fantasy

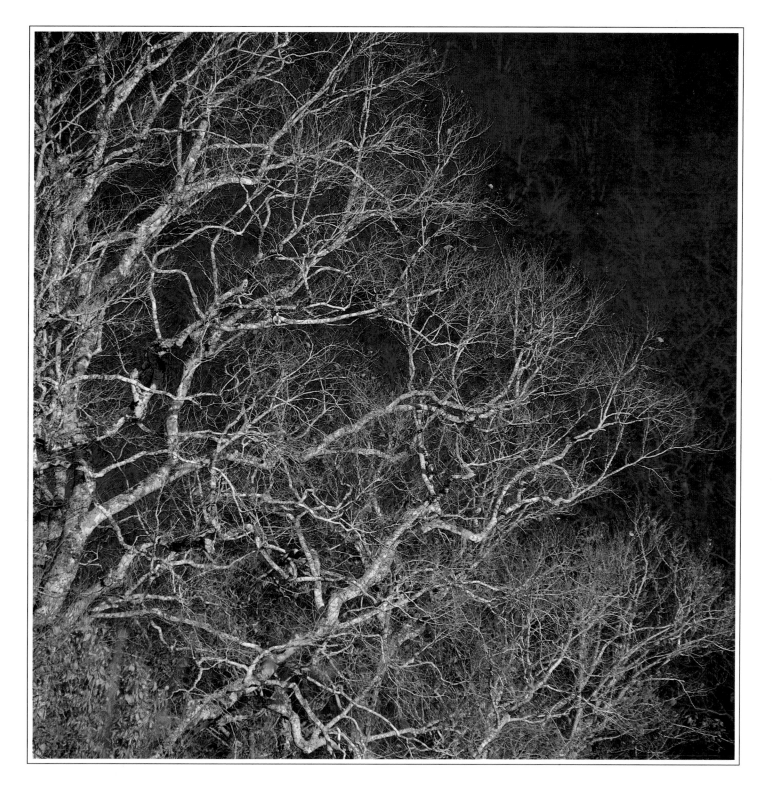

The afterglow

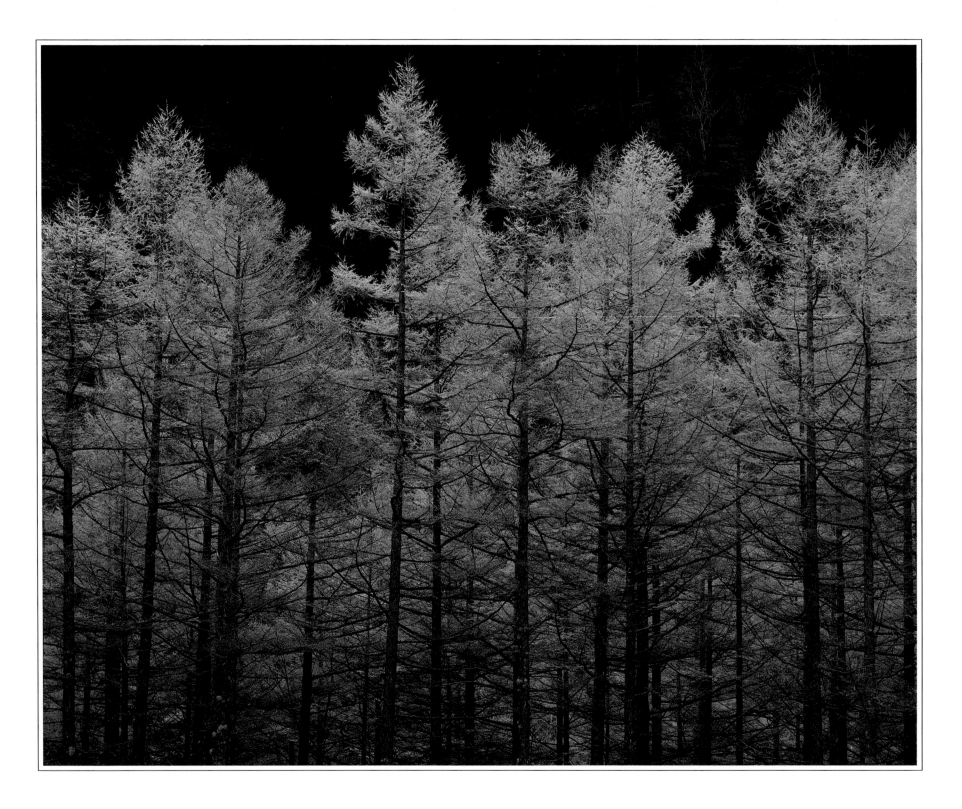

The phantom forms of larches

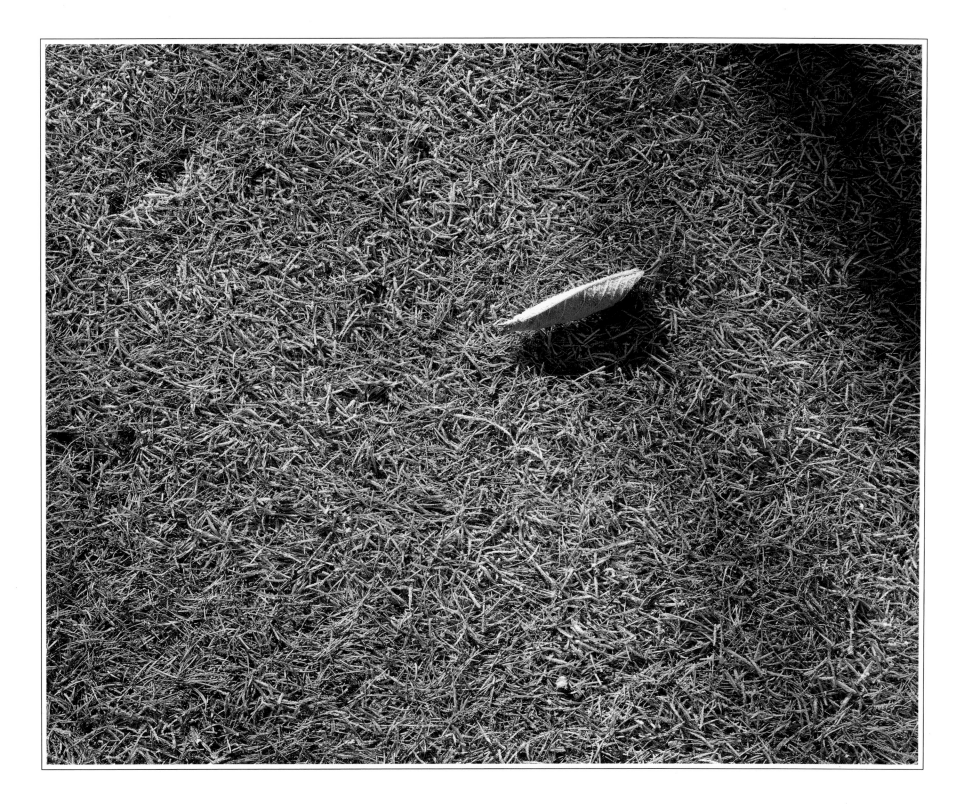

Morning frost

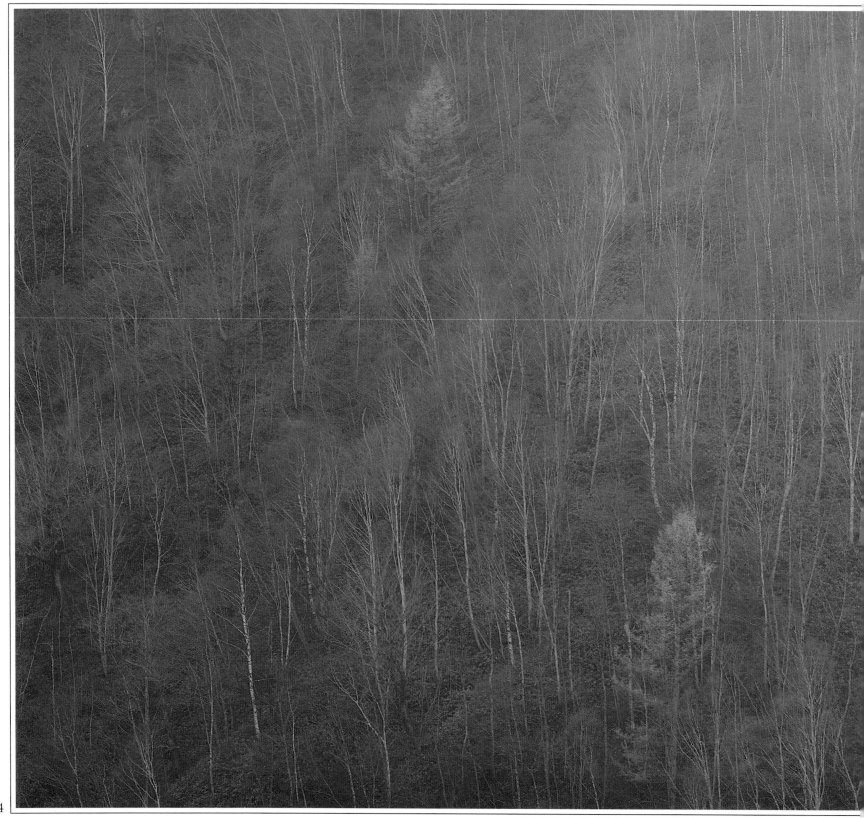

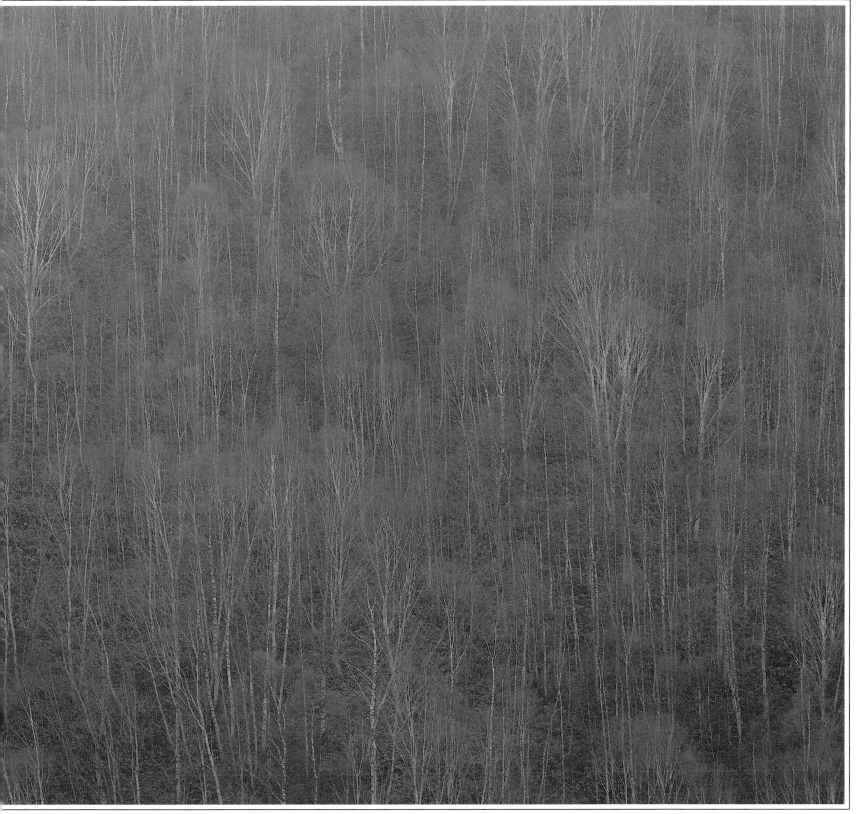

The silent woods

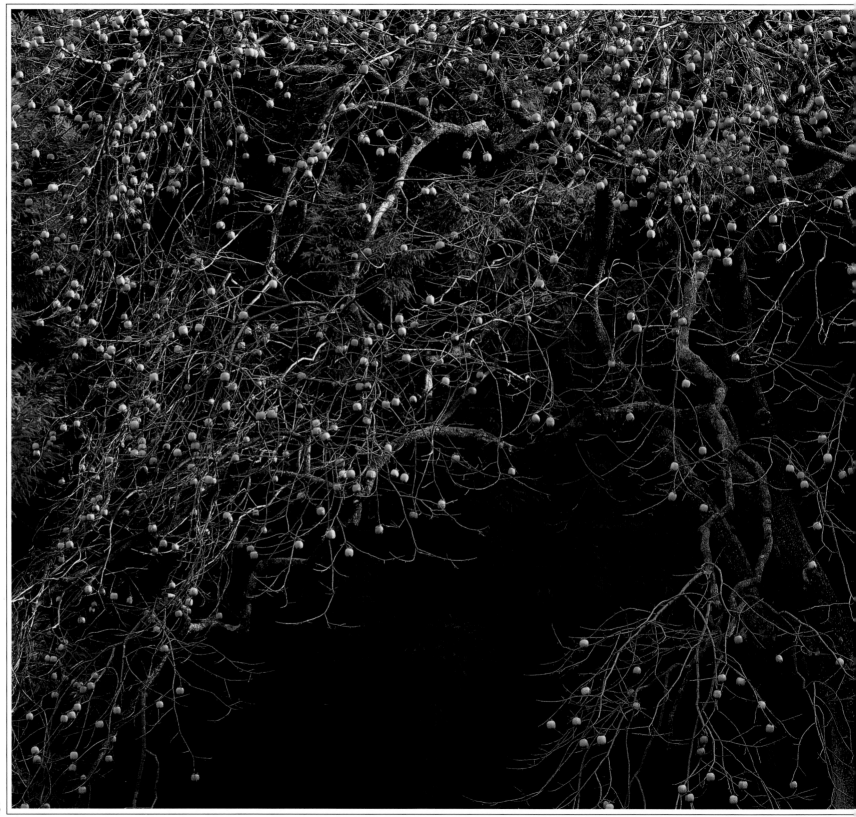

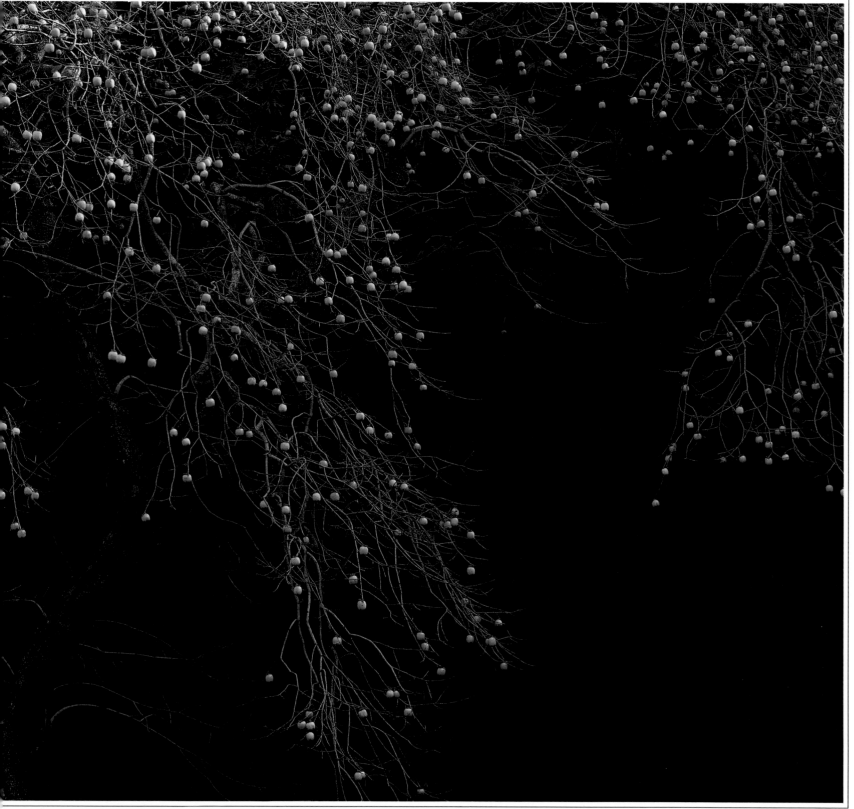

Autumn sunlight

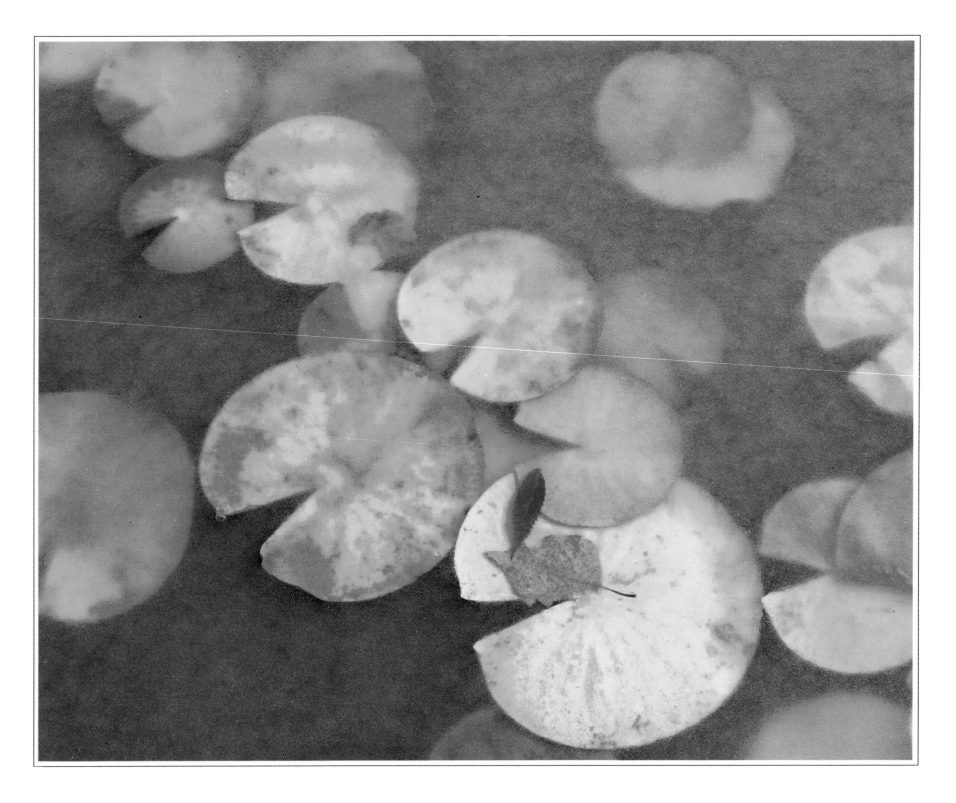

Frozen patterns

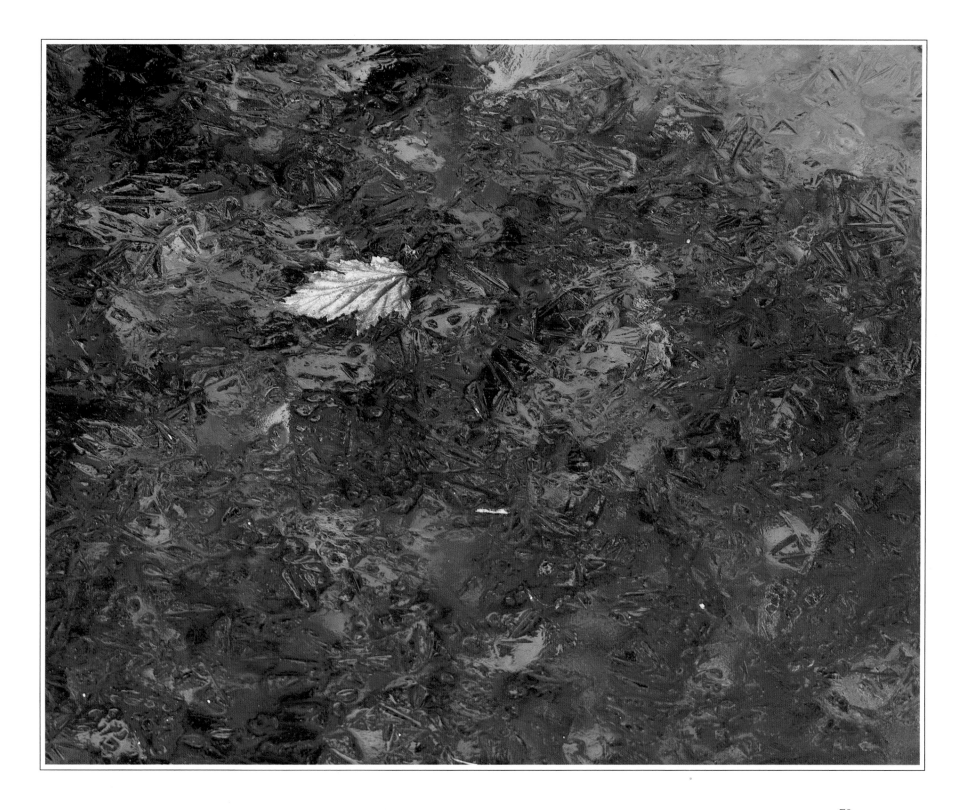

Leaves and river ice

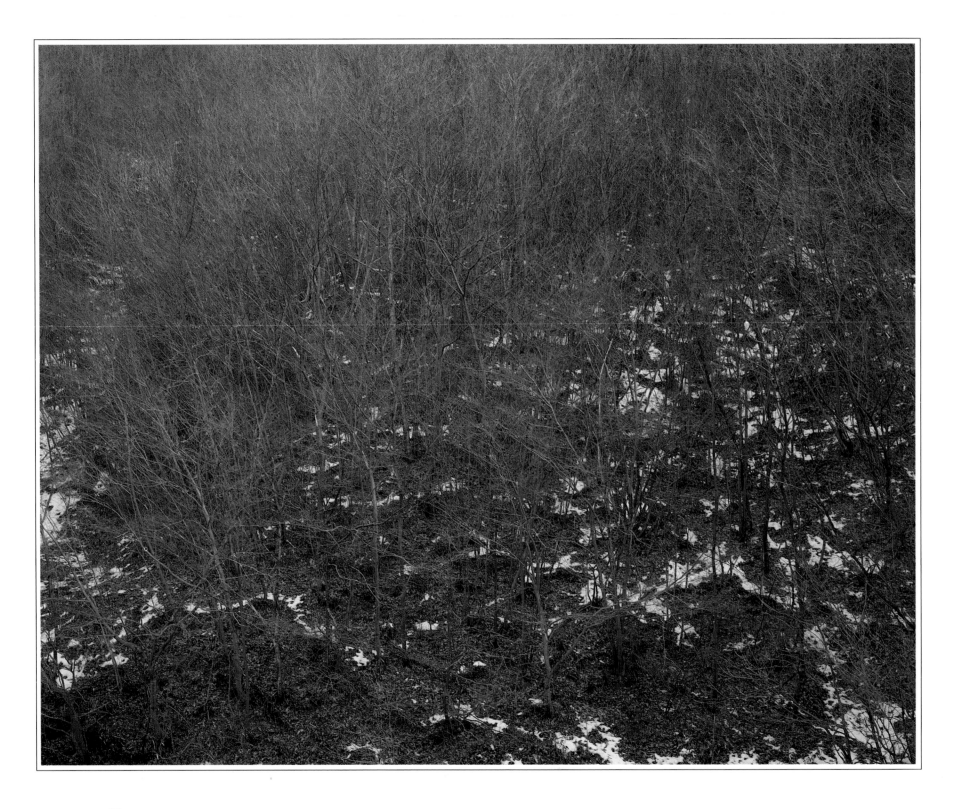

Fresh snow in sparse woods

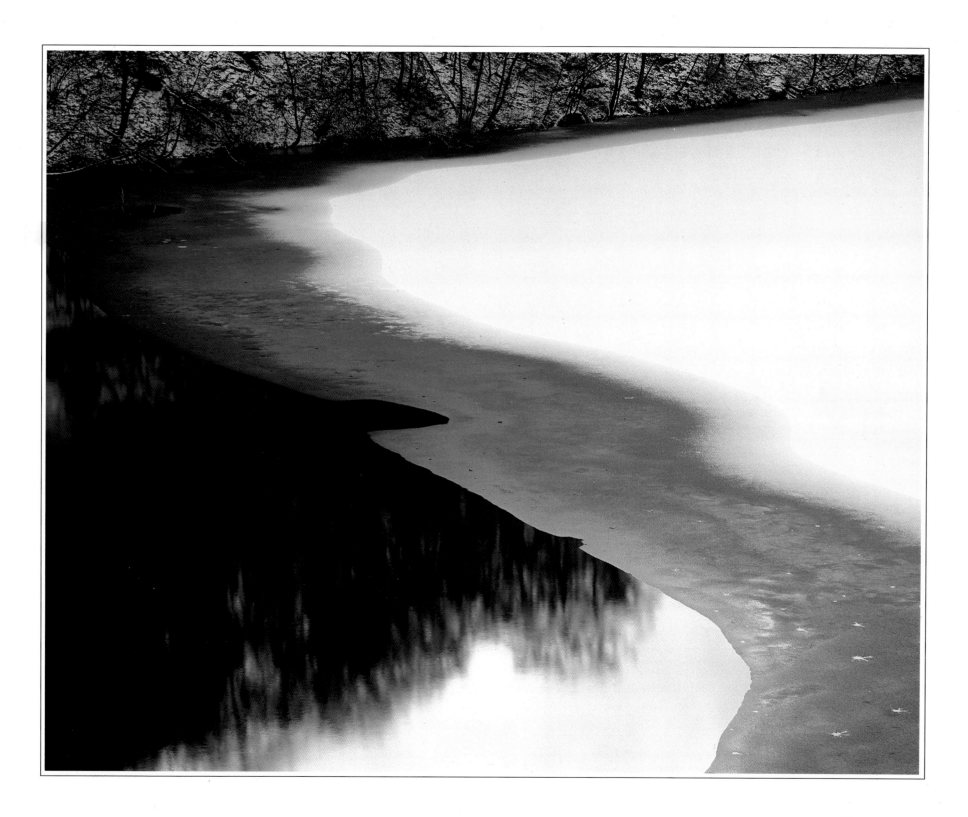

Snow on the surface of a lake

Still Winter's Grace

Japan is a land of heavy snows,
Heaviest in the Sanin and the north, Tohoku and Hokkaido.
Half the country's snow falls there.
Life can be troublesome in the "snow country",
But the soft, white-mantled landscape
Is a thing of grace and beauty.

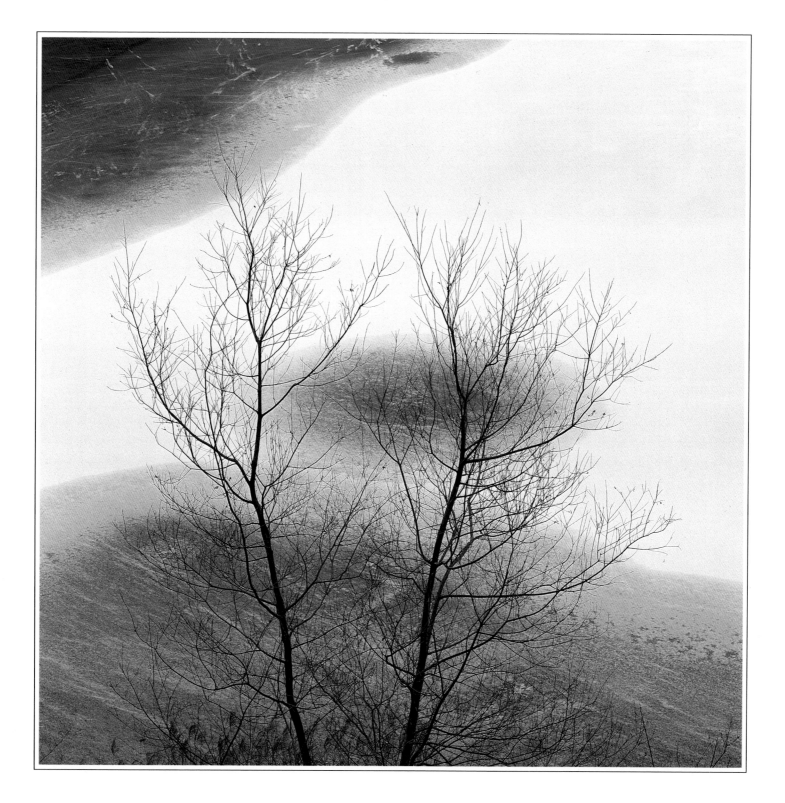

Dark designs above a quiet lake

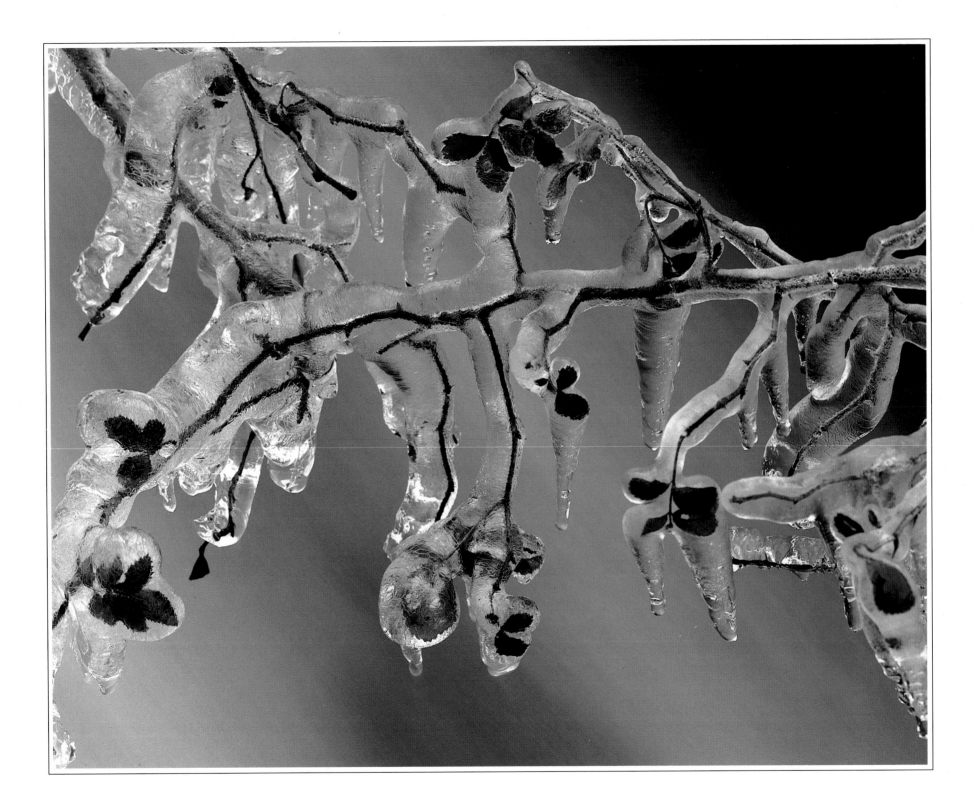

Ice gems

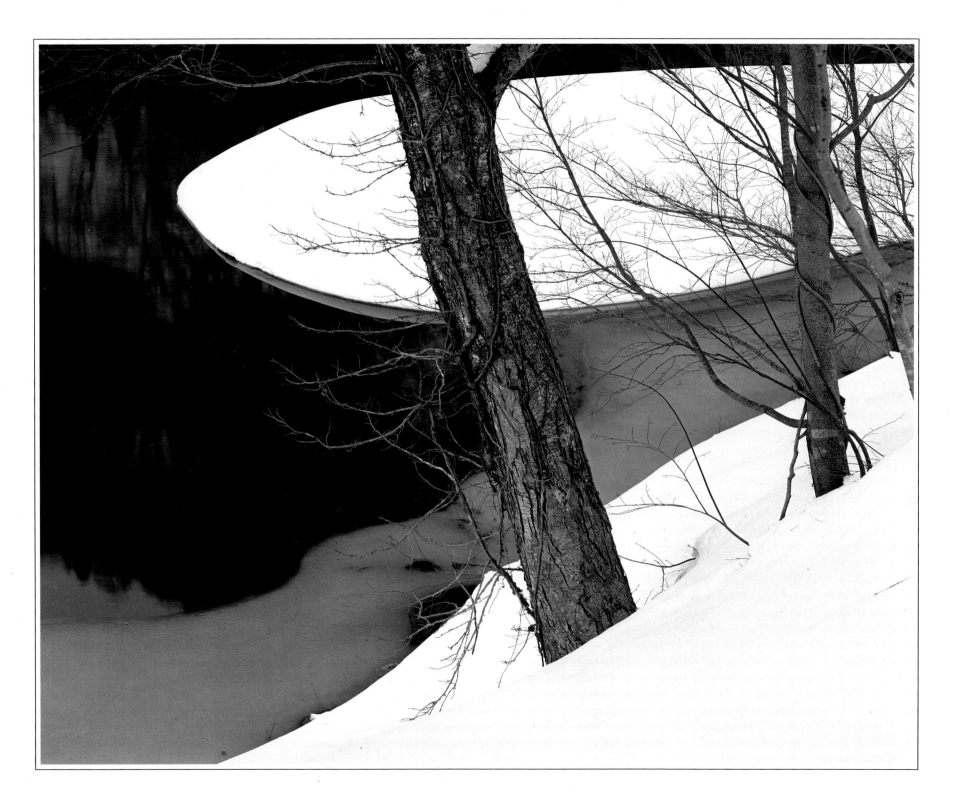

Bright snow at the water's edge

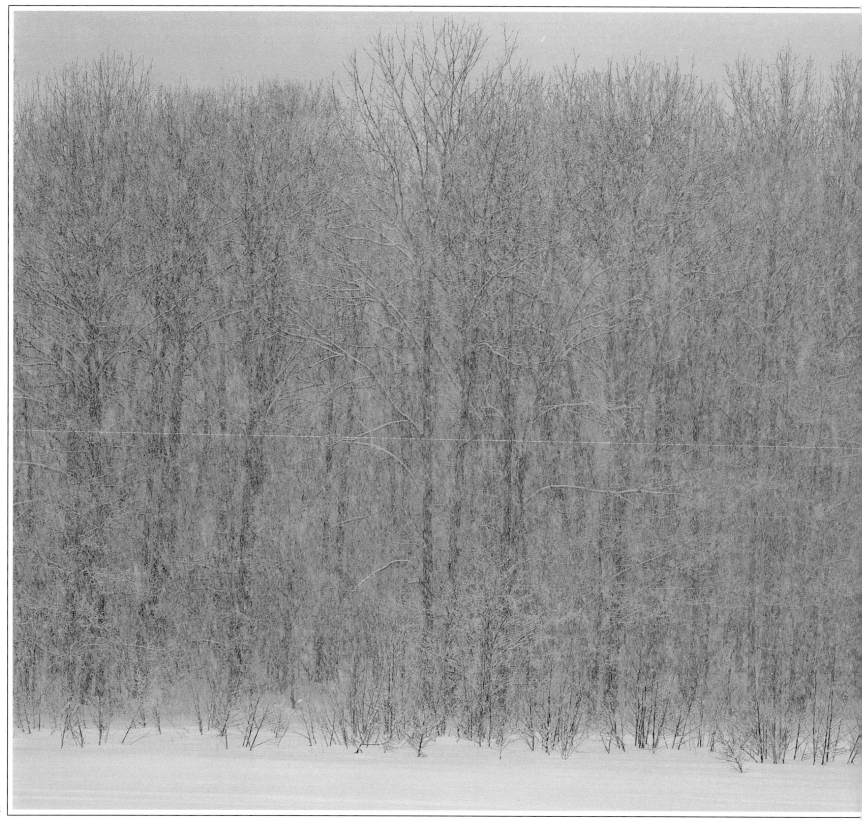

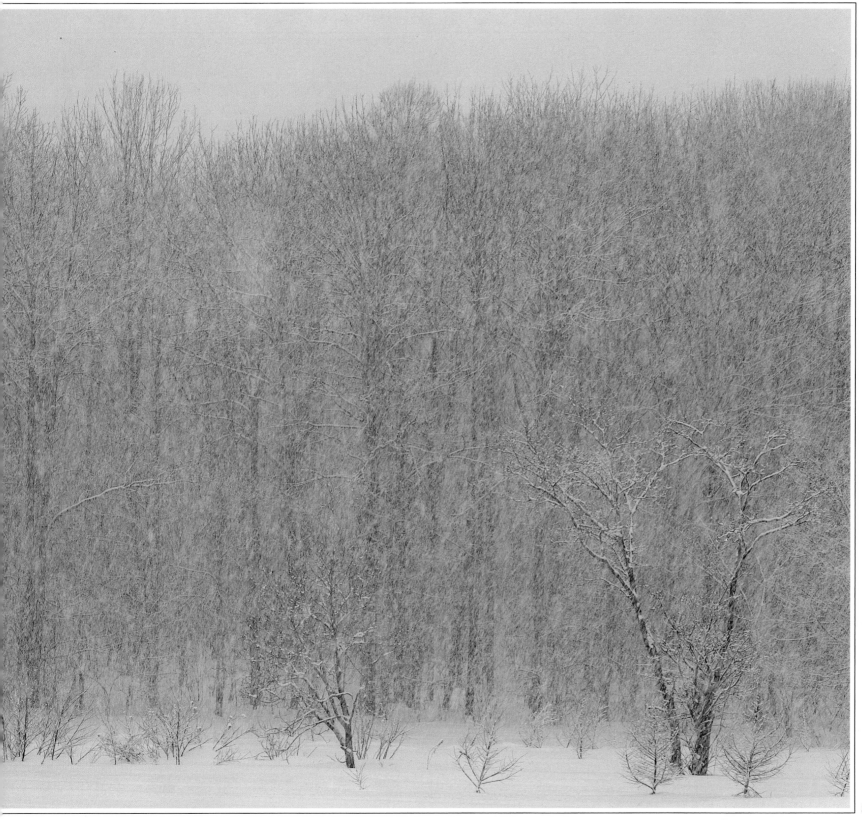

Snowfall in the forest

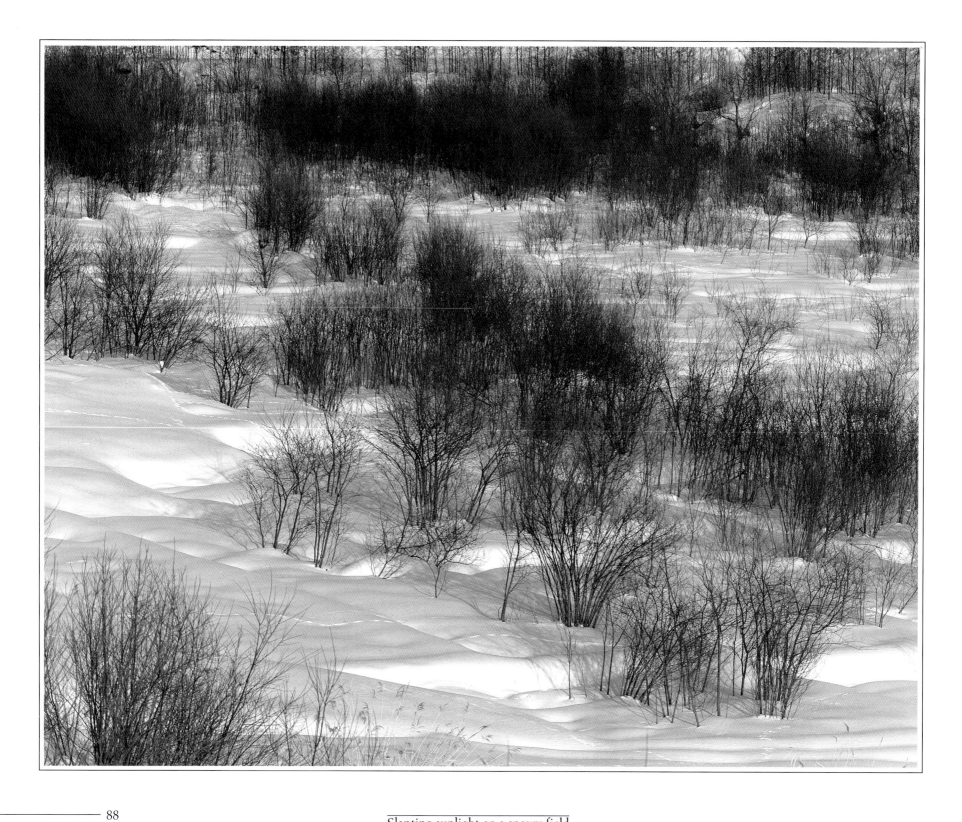

Slanting sunlight on a snowy field

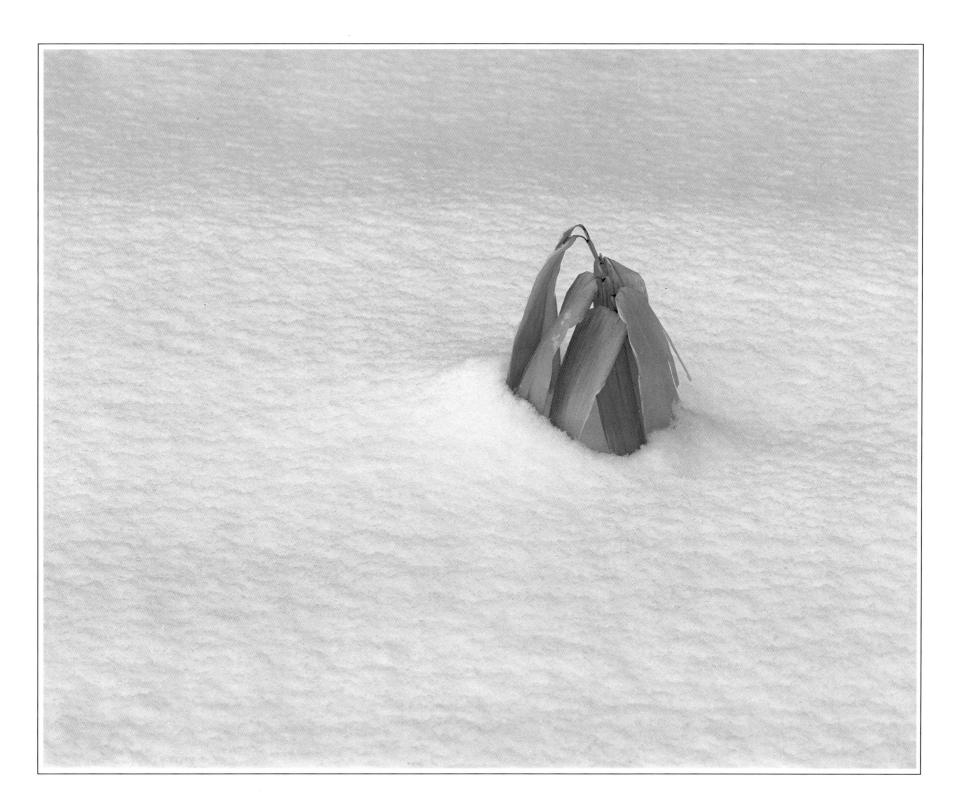

Bamboo grass in the snow

Spring snow

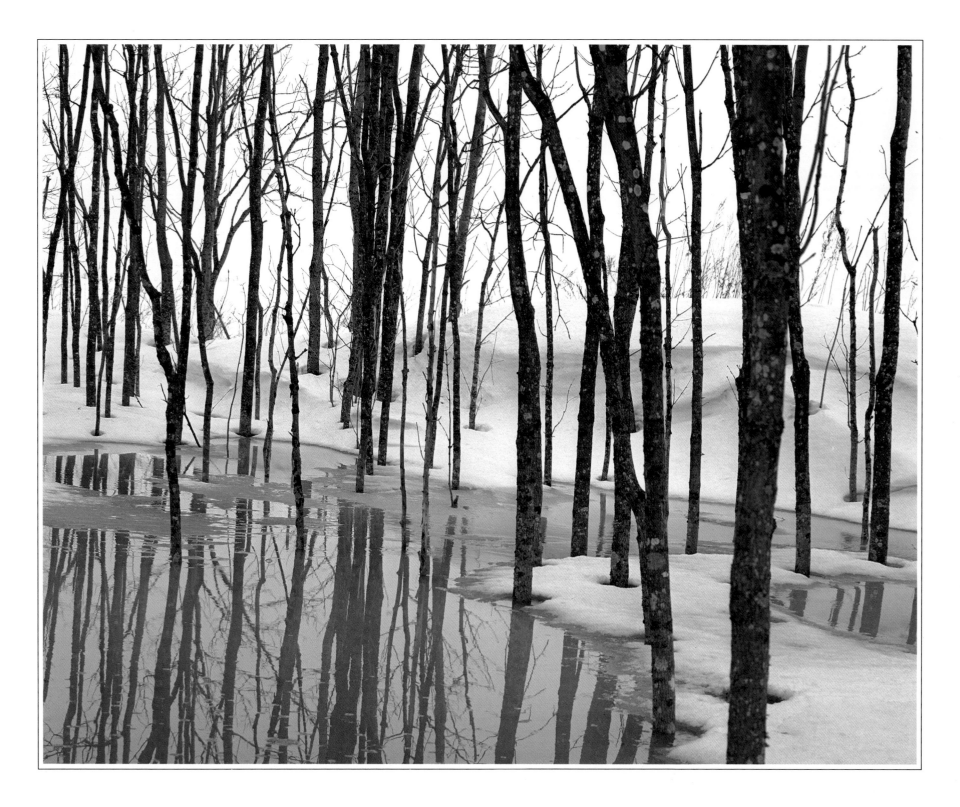

Reflections in the thawing snow

Afterword

Because of the three thousand-kilometer length of the Japanese archipelago, the country has a wide range of temperatures and climate. This fact and the varied topography combine with abundant rainfall to provide ideal conditions for the growth of plant life. More than 70 per cent of the land is forested and the plains, coastal areas and mountains abound with a variety of flora in all seasons.

The first heralds of spring in Japan are the pussy willow and butterbur which bloom here and there along the banks of rivers and brooks. As the weather gradually changes, there comes a time when we have periods of three cold days followed by four warm days, and then we sense that the onset of spring is nearing. When at last, the cherry blossoms burst forth, we know that spring has indeed arrived.

With the ending of the cherry blossom season there is a deepening of the colors of the landscape and when the cuckoos begin to sing, the slopes of the mountainsides turn an even more brilliant green. The month and a half long rainy season that now takes hold ends with thunderstorms that usher in a bright season that is Japan's true summer. There are occasional typhoons during this period, and some bring damage and suffering, but all in all this is the most open-hearted season of the year – the most open-hearted and the noisiest. Noisy, as no Japanese summer would be complete without the loud accompaniment of countless buzzing cicadas.

But the time arrives when the sharp buzz of the cicada is replaced by the chirping of crickets; it is autumn, the season of the rice harvest, and now the hills are ablaze with the reds and golds of maples. The glory is short-lived, however, and fall soon becomes early winter.

When the north wind begins blowing, we know that we are entering months of typical winter weather. The northern districts and the Japan Sea side of the land are covered with snow, while the Pacific shores experience cold, crisp, sunny days. Eventually the weather changes; a low pressure zone passes along the Pacific Coast bringing occasional rains and snow. And then, once again, it is spring.

Indeed, Japan's four seasons change very quickly, and in this book I have simply tried to present glimpses of these changes in various parts of the land. Each photo is but a moment grasped, a flash of something larger, something deeper. And though it was not my original intention, the photos may in some sense recall *haiku*, the traditional Japanese poetry, with its delicate reflections of nature. Readers may look upon each photograph as a kind of *haiku*, revealing the four seasons of the land.

In concluding this afterword, I would like to express my sincere gratitude to Mr. Kenkichi Kusumoto, who wrote the foreword to this book and to the many other people who helped bring it to completion.

Shinzo Maeda

Photographic Data

9: Hasselblad 500C/M, Sonnar 150 mm F4, f11 $^1/_{30}$
10: Hasselblad 500C/M, Distagon 60 mm F3.5, f16 $^1/_{15}$
11: Linhof Super Technika 4 × 5, Fujinon 400 mm F8, f22 $^1/_{15}$
12: Linhof Super Technika 4 × 5, Tele-Xenar 360 mm F5.5, f22 $^1/_8$
13: Linhof Super Technika 4 × 5, Tele-Xenar 360 mm F5.5, f16 $^1/_2$
14/15: Toyo Field 8 × 10, Nikkor 450 mm F9, f45 $^1/_2$
16: Toyo Field 8 × 10, Fujinon 600 mm F11, f45 $^1/_2$
17: Linhof Super Technika 4 × 5, Fujinon 400 mm F8, f22 $^1/_8$
19: Linhof Super Technika 4 × 5, Tele-Xenar 360 mm F5.5, f8 $^1/_{60}$
20: Hasselblad 500C/M, Tele-Tessar 500 mm F8, f22 $^1/_2$
21: Linhof Super Technika 4 × 5, Fujinon 250 mm F6.7, f16 $^1/_{15}$
22: Toyo Field 4 × 5, Fujinon 600 mm F11, f45 $^1/_2$
23: Toyo Field 8 × 10, Fujinon 600 mm F11, f45 $^1/_2$
24: Hasselblad 500C/M, Sonnar 250 mm F5.6, f22 $^1/_8$
25: Linhof Super Technika 4 × 5, Nikkor 210 mm F5.6, f32 $^1/_8$
26/27: Toyo Field 8 × 10, Fujinon 300 mm F5.6, f45 $^1/_4$
29: Linhof Super Technika 4 × 5, Tele-Xenar 60 mm F5.5, f8 $^1/_{60}$
30: Toyo Field 8 × 10, Nikkor 450 mm F9, f45 $^1/_4$
31: Linhof Super Technika 4 × 5, Nikkor 150 mm F5.6, f22 1 sec.
32: Hasselblad 500C/M, Distagon 60 mm F3.5, f22 $^1/_4$
33: Linhof Super Technika 4 × 5, Fujinon 250 mm F6.3, f22 $^1/_2$
34: Toyo Field 8 × 10, Fujinon 600 mm F11, f45 1 sec.
35: Toyo Field 8 × 10, Fujinon 300 mm F5.6, f45 $^1/_2$
36: Toyo Field 8 × 10, Fujinon 300 mm F5.6, f45 $^1/_4$
37: Linhof Super Technika 4 × 5, Fujinon 400 mm F8, f22 $^1/_{15}$
39: Hasselblad SWC, Biogon 38 mm F4.5, f11 $^1/_{60}$
40: Toyo Field 8 × 10, Fujinon 600 mm F11, f45 $^1/_2$
41: Toyo Field 8 × 10, Nikkor 450 mm F9, f45 $^1/_2$
42: Toyo Field 8 × 10, Fujinon 300 mm F5.6, f32 1 sec.
43: Hasselblad SWC, Biogon 38 mm F4.5, f16 $^1/_8$
44: Toyo Field 8 × 10, Fujinon 300 mm F5.6, f45 $^1/_2$
45: Toyo Field 8 × 10, Nikkor 450 mm F9, f45 $^1/_4$
46: Toyo Field 8 × 10, Fujinon 600 mm F11, f45 1 sec.
47: Linhof Super Technika 4 × 5, Fujinon 400 mm F8, f32 $^1/_{15}$
49: Hasselblad 500C/M, Sonnar 150 mm F4, f8 $^1/_{60}$
50: Linhof Super Technika 4 × 5, Tele-Xenar 360 mm F5.5, f22 $^1/_{15}$

51: Linhof Super Technika 4 × 5, Tele-Xenar 360 mm F5.5, f8 $^1/_{60}$
52: Linhof Super Technika 4 × 5, Tele-Xenar 360 mm F5.5, f8 $^1/_{30}$
53: Linhof Super Technika 4 × 5, Nikkor 210 mm F5.6, f32 $^1/_4$
54: Linhof Super Technika 4 × 5, Tele-Xenar 360 mm F5.5, f22 $^1/_{15}$
55: Linhof Super Technika 4 × 5, Nikkor 150 mm F5.6, f11 $^1/_{15}$
57: Toyo Field 8 × 10, Fujinon 300 mm F5.6, f32 $^1/_2$
58: Hasselblad 500C/M, Tele-Tessar 500 mm F8, f22 1 sec.
59: Linhof Super Technika 4 × 5, Fujinon 250 mm F6.3, f32 1 sec.
60: Linhof Super Technika 4 × 5, Fujinon 400 mm F8, f32 $^1/_8$
61: Linhof Super Technika 4 × 5, Fujinon 250 mm F6.3, f22 1 sec.
62/63: Toyo Field 8 × 10, Fujinon 300 mm F5.6, f32 $^1/_8$
64: Toyo Field 4 × 5, Fujinon 600 mm F11, f16 1 sec.
65: Hasselblad 500C/M, Tele-Tessar 500 mm F8, f22 $^1/_8$
66: Hasselblad SWC, Biogon 38 mm F4.5, f22 1 sec.
67: Hasselblad 500C/M, Tele-Tessar 500 mm F8, f22 1 sec.
69: Linhof Super Technika 4 × 5, Fujinon 400 mm F8, f32 $^1/_4$
70: Toyo Field 4 × 5, Fujinon 600 mm F11, f32 1 sec.
71: Hasselblad 500C/M, Tele-Tessar 500 mm F8, f32 $^1/_4$
72: Linhof Super Technika 4 × 5, Fujinon 400 mm F8, f22 $^1/_4$
73: Linhof Super Technika 4 × 5, Nikkor 210 mm F5.6, f22 $^1/_8$
74/75: Toyo Field 8 × 10, Fujinon 600 mm F11, f32 1 sec.
76/77: Toyo Field 8 × 10, Fujinon 600 mm F11, f45 $^1/_2$
78: Linhof Super Technika 4 × 5, Fujinon 250 mm F6.3, f32 $^1/_4$
79: Linhof Super Technika 4 × 5, Fujinon 400 mm F8, f32 $^1/_2$
80: Linhof Super Technika 4 × 5, Nikkor 210 mm F5.6, f32 $^1/_4$
81: Linhof Super Technika 4 × 5, Fujinon 400 mm F8, f32 $^1/_4$
83: Linhof Super Technika 4 × 5, Fujinon 250 mm F6.3, f32 $^1/_8$
84: Linhof Super Technika 4 × 5, Tele-Xenar 360 mm F5.5, f22 1 sec.
85: Linhof Super Technika 4 × 5, Fujinon 250 mm F6.3, f22 1 sec.
86/87: Toyo Field 8 × 10, Fujinon 600 mm F11, f32 1 sec.
88: Toyo Field 4 × 5, Fujinon 600 mm F11, f32 $^1/_8$
89: Linhof Super Technika 4 × 5, Tele-Xenar 360 mm F5.5, f32 1 sec.
90: Hasselblad 500C/M, Sonnar 150 mm F4, f11 $^1/_{60}$
91: Linhof Super Technika 4 × 5, Nikkor 150 mm F5.6, f22 $^1/_8$

Film: Ektachrome, Fujichrome

Contents

Okumikawa

Okumikawa

Photographs
by
Shinzo Maeda

Foreword

Looking back at Shinzo Maeda's photography over the years, I have noticed a definite change in his approach; since his book "Hokkaido – Poetry of the Earth" he has shown a tendency to focus more and more on smaller areas and the details of nature. The tendency is very apparent in this book which introduces the visual splendour of that simple, "ordinary" and yet very beautiful area known as Okumikawa.

Okumikawa is located in north-eastern Aichi Prefecture, a high mountain area from which flow the headwaters of the Toyokawa and Tenryu Rivers. Mr. Maeda has made several visits to Okumikawa, and one may wonder what has attracted him to an area which, until quite recently, was very isolated. The answer may lie in the unique character of the area and its people. There we can find a village with the smallest population in all of Japan and there, to this day, the local people celebrate a 700-year-old Hana Matsuri – Shinto Flower Festival. It is an area with charms all its own. Of the many books by Shinzo Maeda, the one that has impressed me most is "The Moment of Encounter". After reading and looking at that book I realized that Maeda's work is an expression of a man's deeply felt farewell to the rapidly vanishing beauty of our natural environment.

In his pictures, the photographer seems to reveal a sorrow, almost a sense of resignation, at parting with the beauty that will never return again. To me, Shinzo Maeda's photographs seem to be a momentary union of the man and his subject, a crystallization of light and spirit. The capturing of such moments is a difficult task and one that takes its toll on the photographer. I know this because I spent some time with Mr. Maeda at Okumikawa, and I saw how uneasy, how empty and unfulfilled he seems until that moment when he feels he has captured and brought to life what he is seeking to put on film.

In two of his early works, "The Moment of Encounter" and "A Tree, A Blade of Grass", one can see a refined spirit in Maeda, a desire to grasp and appreciate each meeting with nature, each moment of beauty encountered and then lost, never to recur in our lifetime. And now, in this book, Maeda has gone further and included houses and people in his landscapes, something he has never done before. For the first time, he seems to have stepped out of the landscape and into the world of man.

Until recently I have believed that the typical, rustic landscapes of my country have mostly disappeared, swallowed up by our highly developed civilization. But Shinzo Maeda has shown me that such things still exist in Okumikawa. Moreover, in viewing his breathtaking portrayals of the smaller beauties of nature I have come to sincerely believe that "God dwells in the smallest of things". Those who look at Maeda's pictures find that he has cleansed their eyes and changed their point of view.

Mr. Maeda has the ability to paint beautiful pictures of Japan, but he does so not with brushes but with his camera. Through his artistry, he captures the feel, the very aroma of even such ephemeral things as the light and mist which characterize the atmosphere of this country. But Maeda is not just a skilled traditional photographer; his steady eyes take landscapes and turn them into visual poems. It is such genius that makes him so highly qualified to introduce Japan to the outside world, and foreigners will find through this book that, at least in Okumikawa, Japan is still a land where God and the beauty of nature exist in the smallest places and tiniest things.

Daikichi Irokawa
Historian

Spring and Summer

There are two national roads running from north to south in the Okumikawa district. Route 151 runs from Toyohashi north-east to Toyokawa, crossing the Tomei Expressway and going through the central part of Okumikawa to Iida in the Inadani area. Another, Route 257, comes from Hamamatsu and heads north-west to Nagashino, an old battlefield site. It crosses Route 151 and then goes on to Ena in the Kisodani area. Both national roads are mountain roads winding through river valleys and along mountain ridges. Spring begins here with a bright display of witch hazel blossoms. Then plum, peach and cherry blossoms add their various colors to the mountain villages. When summer comes, with its choruses of myriad, droning cicadas, cool breezes blow through the rich, green valleys, and along the streams fishermen cast for the sweet, trout-like *ayu*. This is the season when the mountain villages are most alive with visitors.

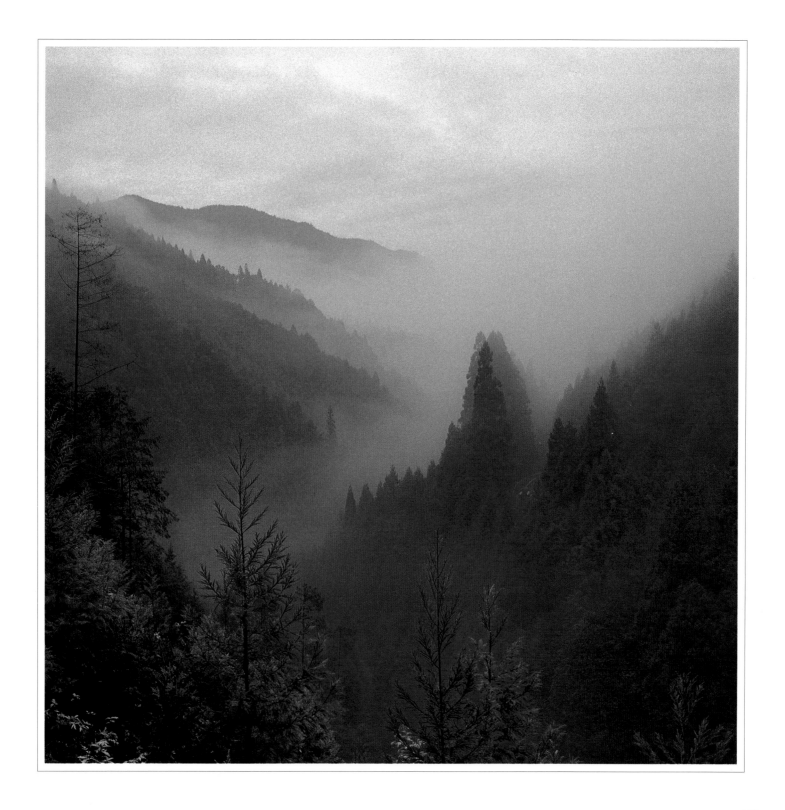

Route 151 shrouded in mist. The Okumikawa road meanders through the cedar forests of the valley.

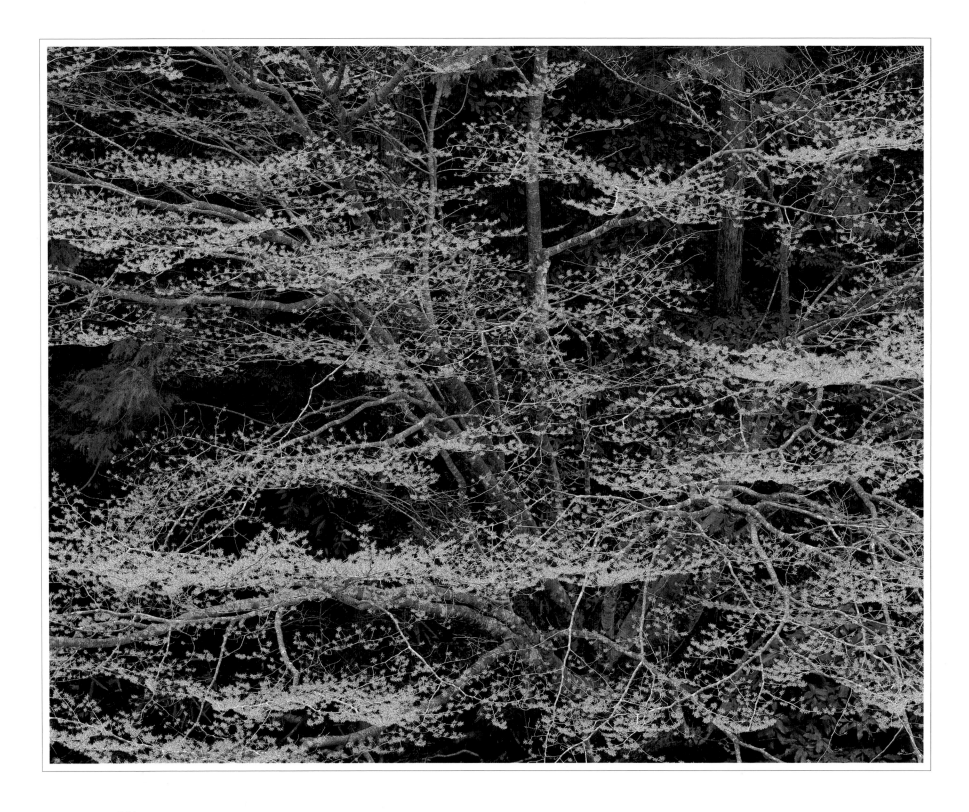

Witch hazel in bloom. The bright mustard-yellow flowers herald the arrival of spring
in the mountain village.

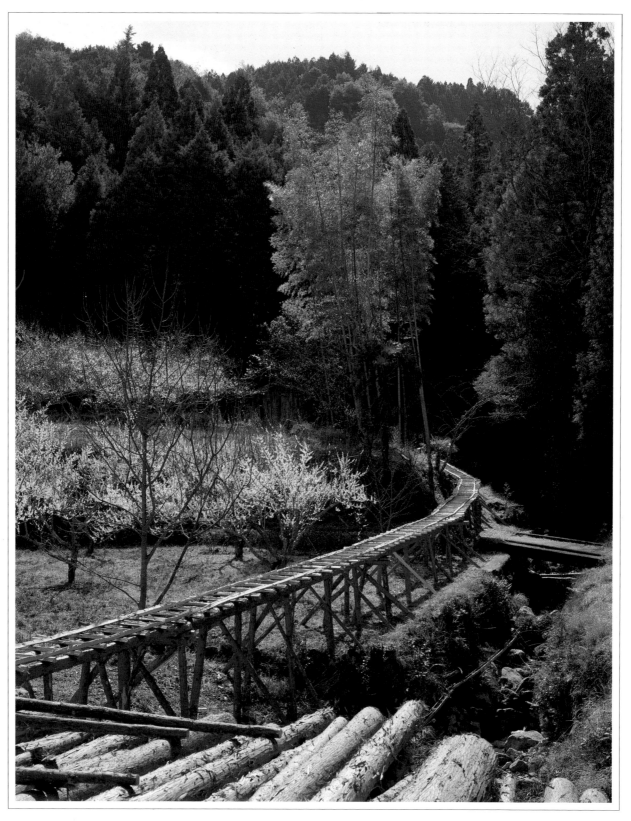

Plum tree blossom brightens an old style logging trail running through the forest slopes.

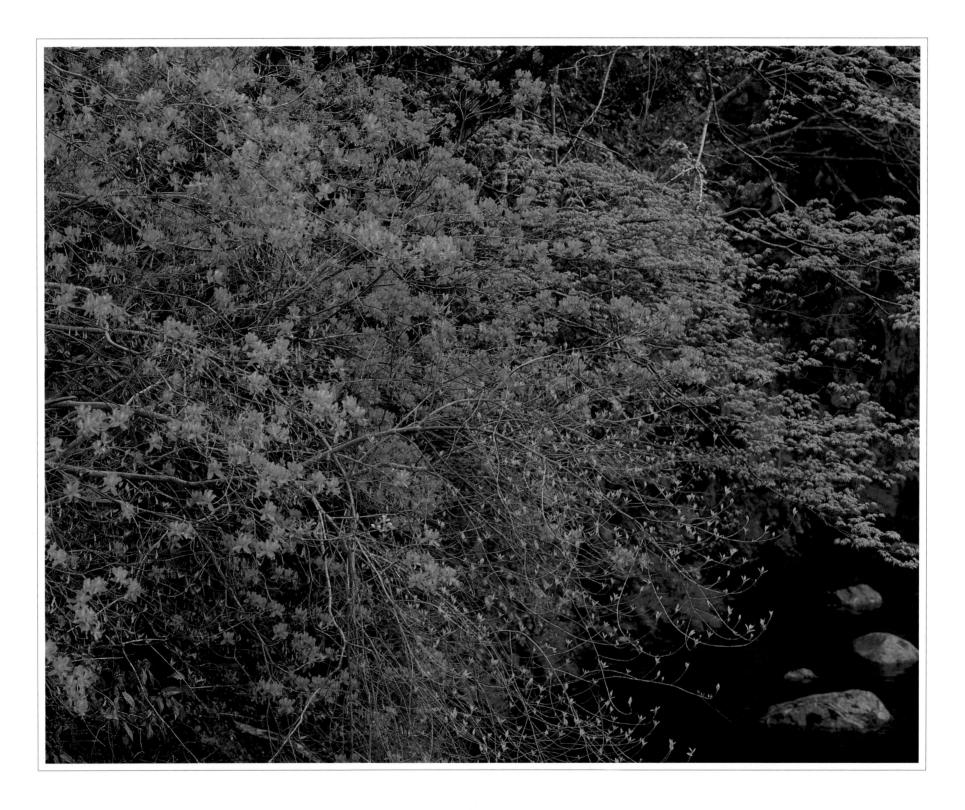

Azaleas by a river bank. Even at a distance, the pink beauty of these early spring flowers
is easily recognized.

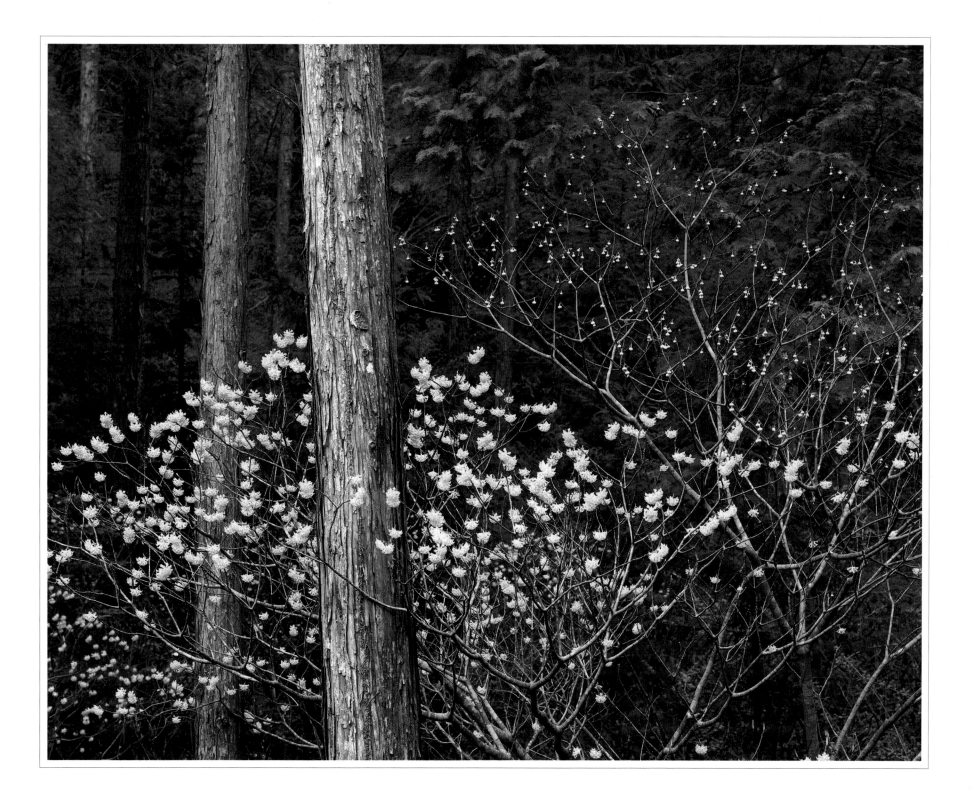

Edgeworthia blooming in a cypress wood. These bushes grow wild in the moist soil
of the forest floor.

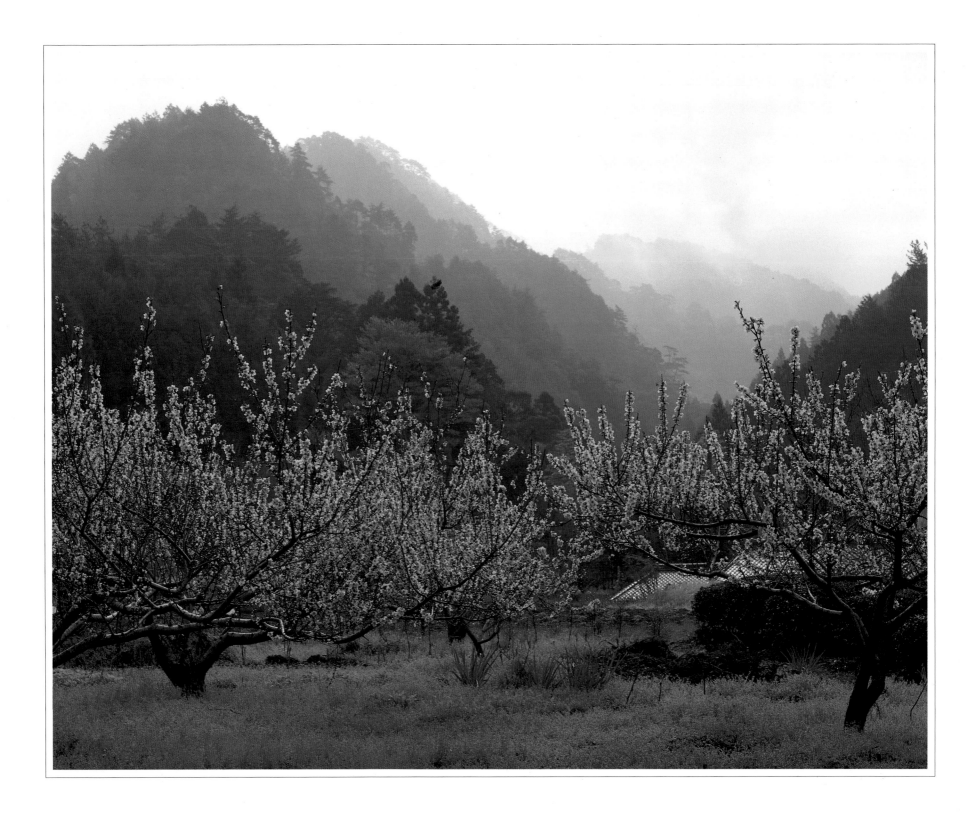

The colors of spring in a mountain village. Fresh peach blossom tells us spring is here.

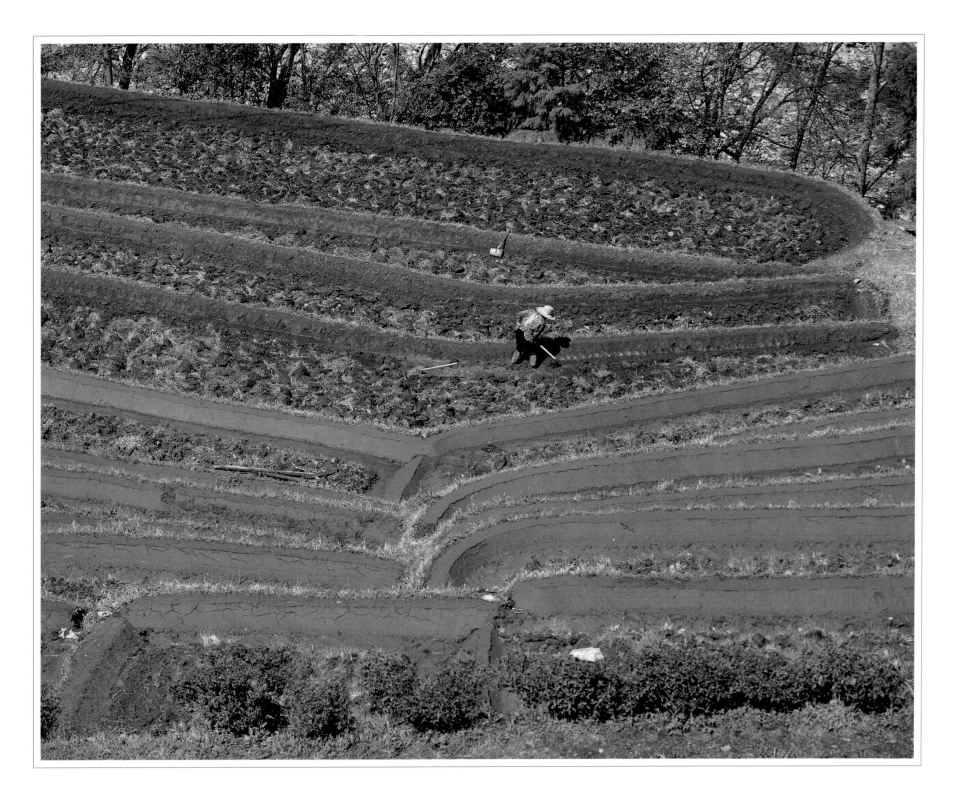

A farm woman at work in a rice field. Mechanized agriculture is fast replacing this kind of farm labor.

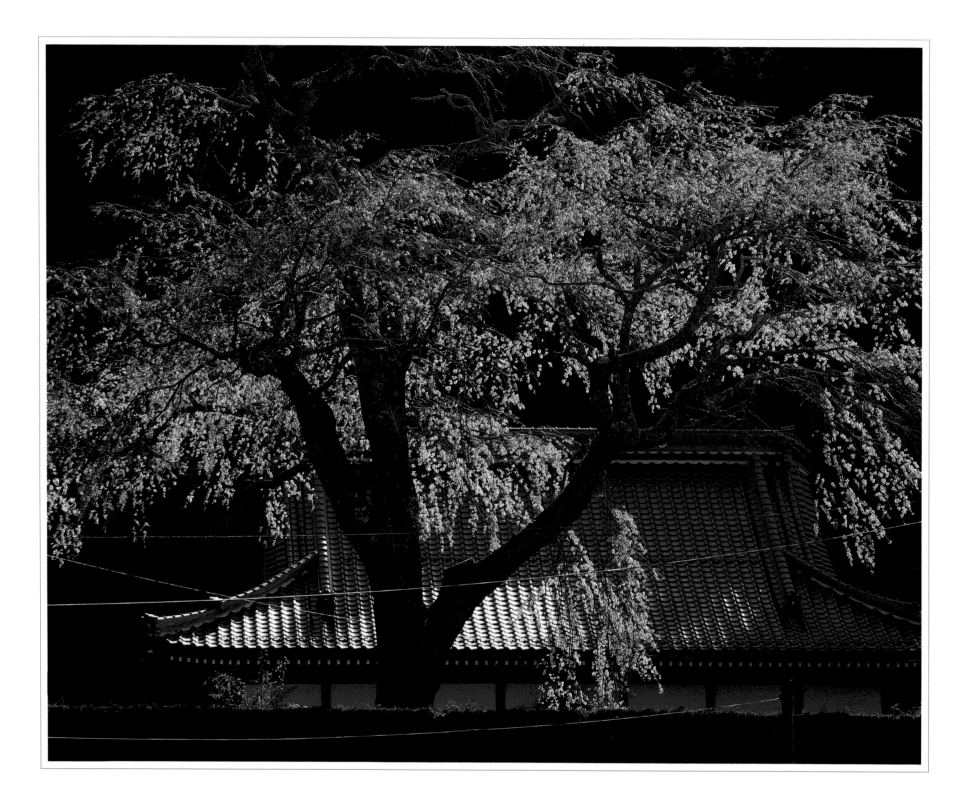

Cherry blossom in the morning sunlight at Kinryuji temple.

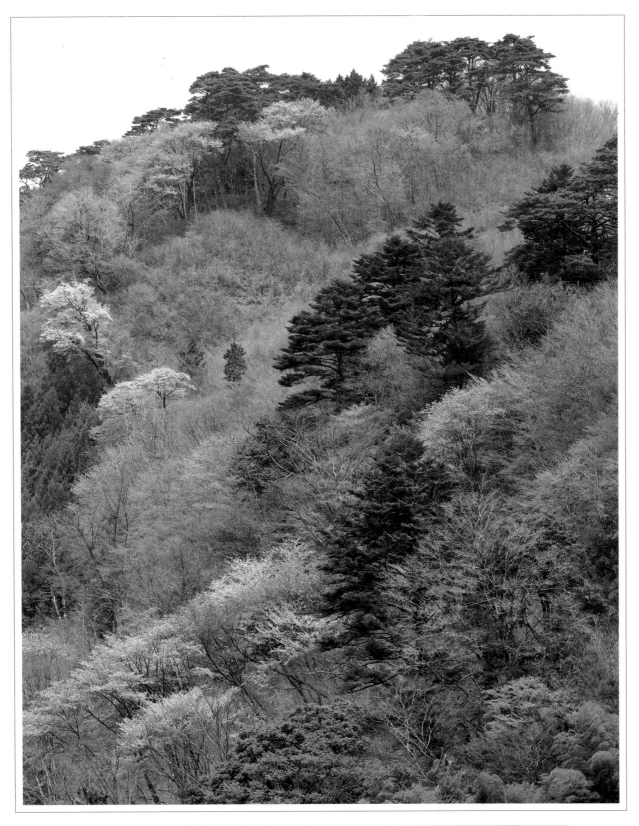

The view from the Kumagais' house – a hillside of varied patterns and contrasting colors.

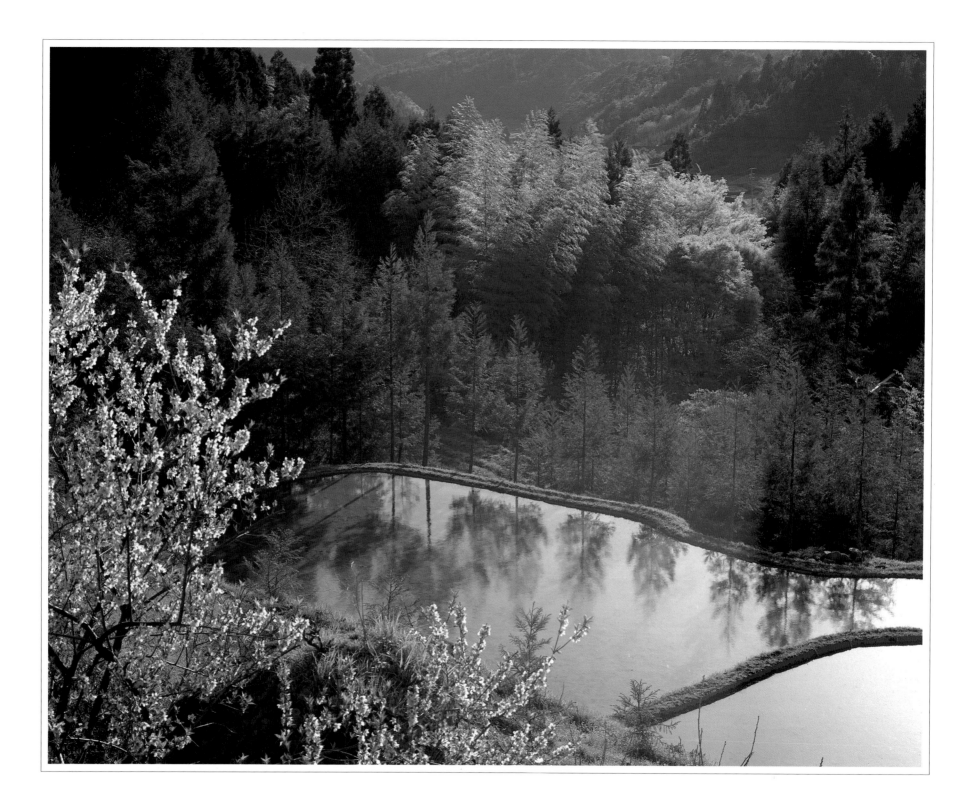

Reflections on the surface of a wet rice paddy. Nearby bush warblers broadcast the arrival of spring.

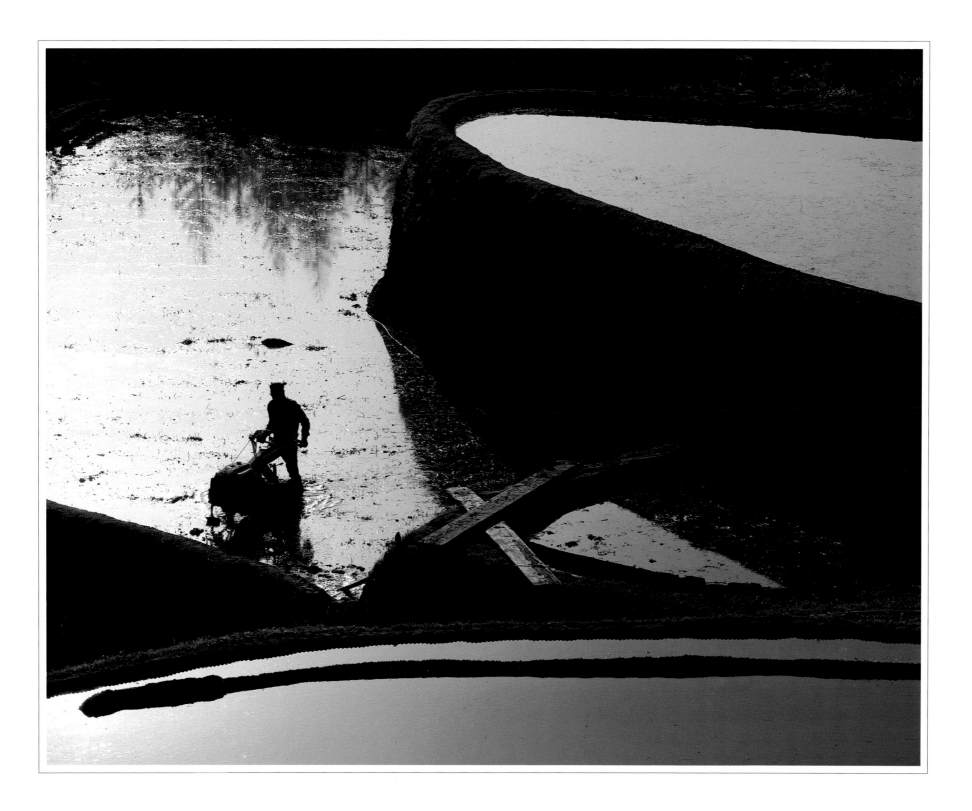

Absorbed in his work, a farmer prepares his wet rice paddies for another planting.

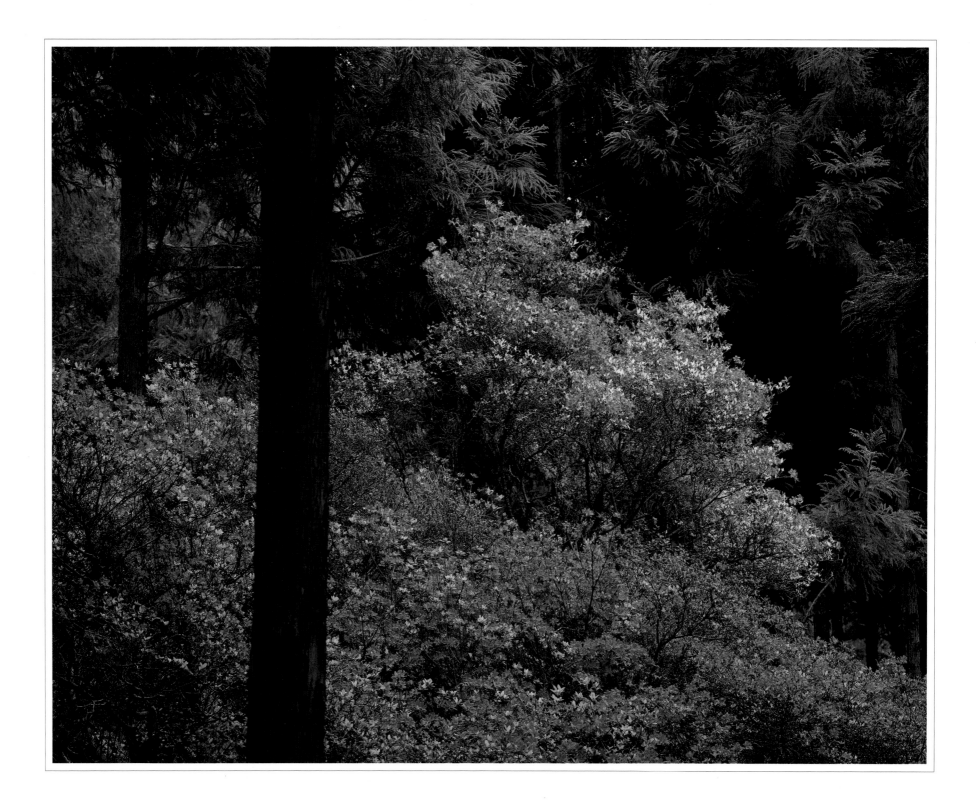

Azaleas in full bloom. Their quiet beauty contrasts with the darkness of surrounding cedars.

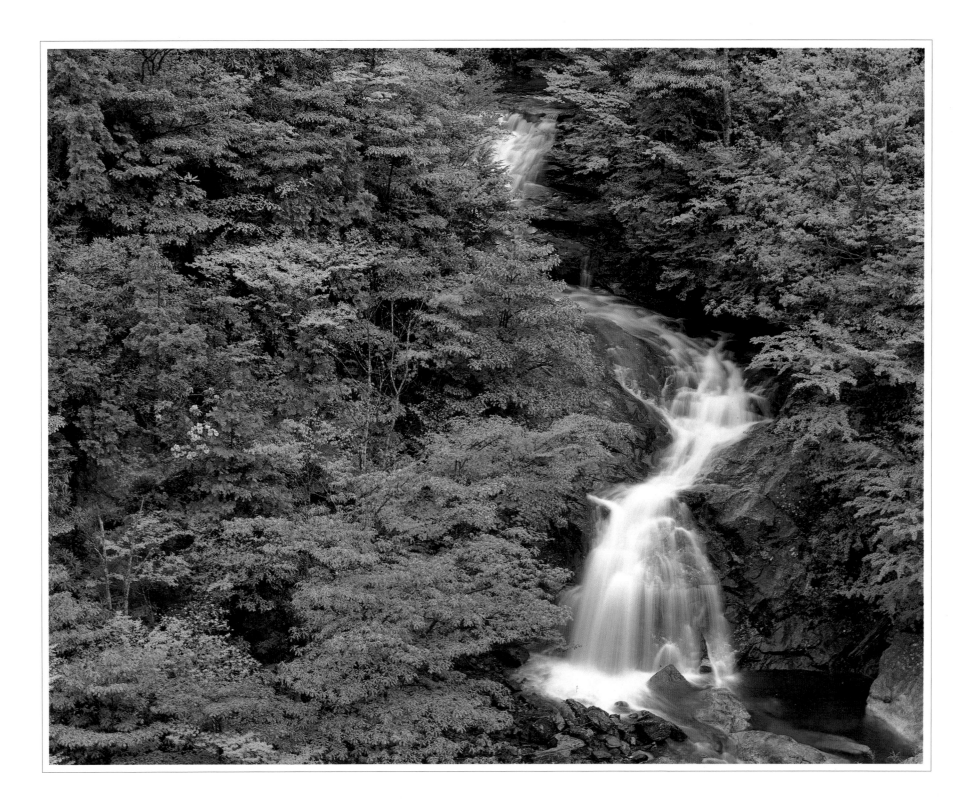

Rhododendron blossom. Here and there it brightens the hillsides by mountain streams.

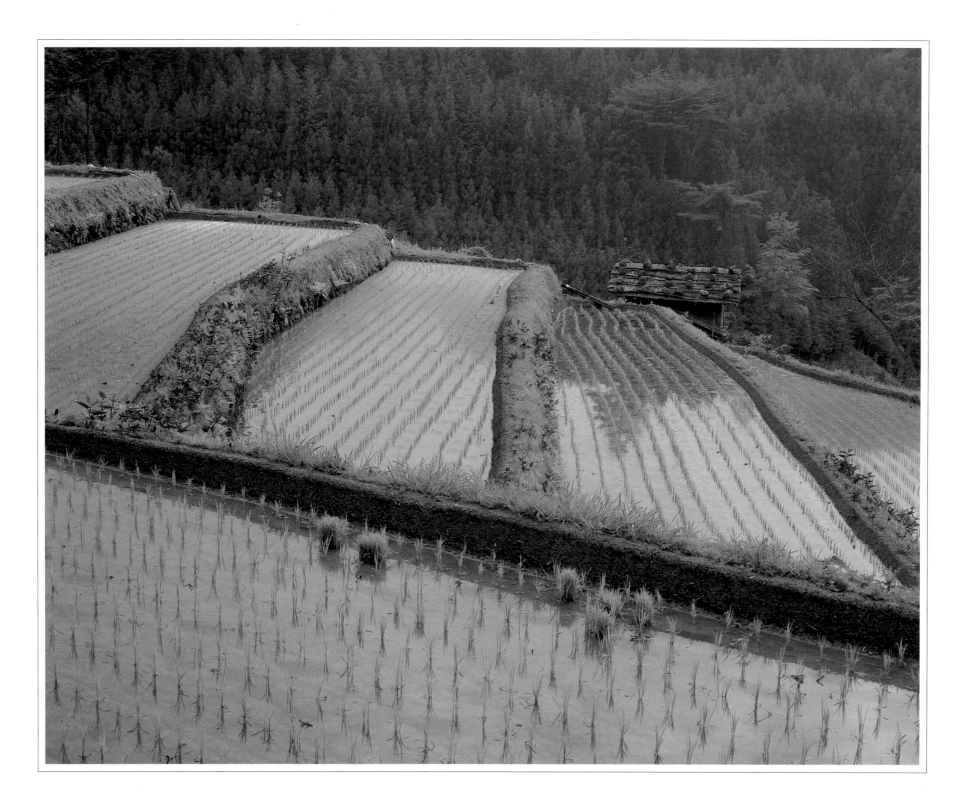

Terraced rice fields. In the midst of the woods, they await the planting of seeds.

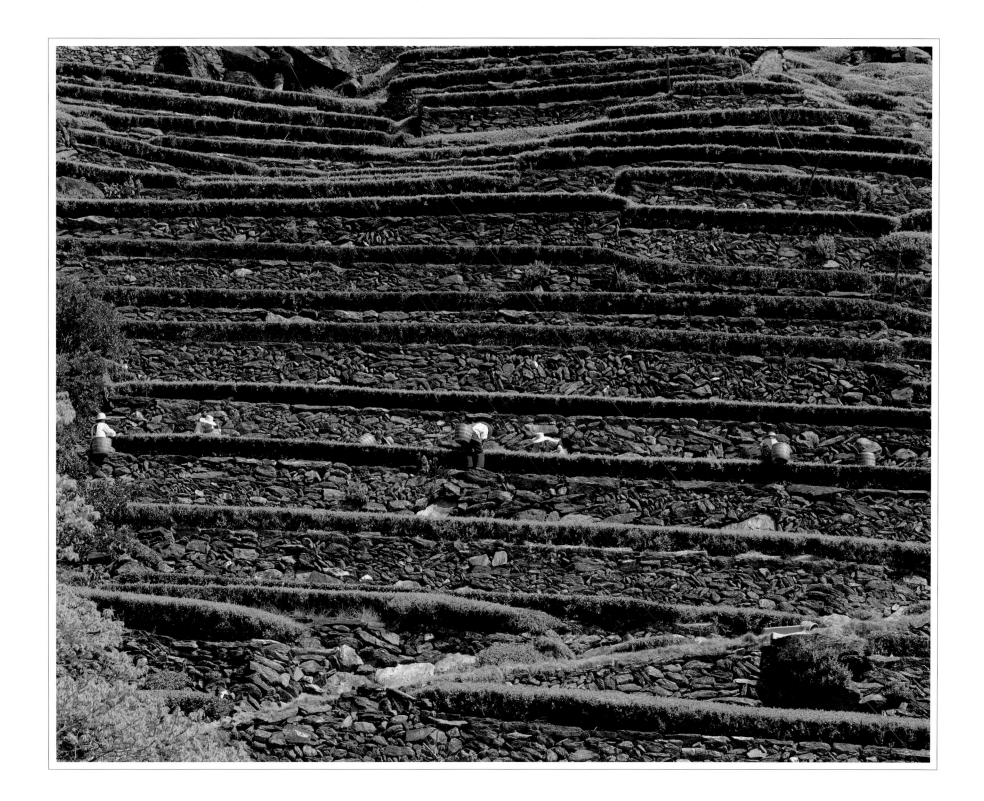

Harvesting tea leaves along the stone wall of a steep hillside plantation.

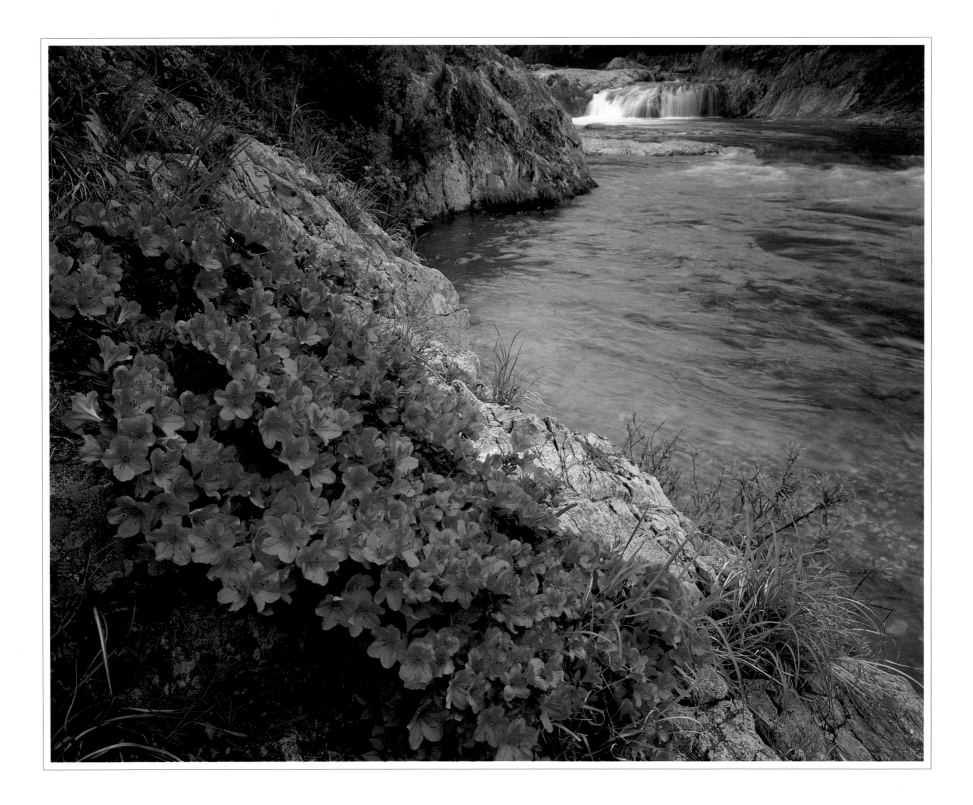

Azalea blossom. Bright reds color the banks of the Ure River near Yuya Hot Springs.

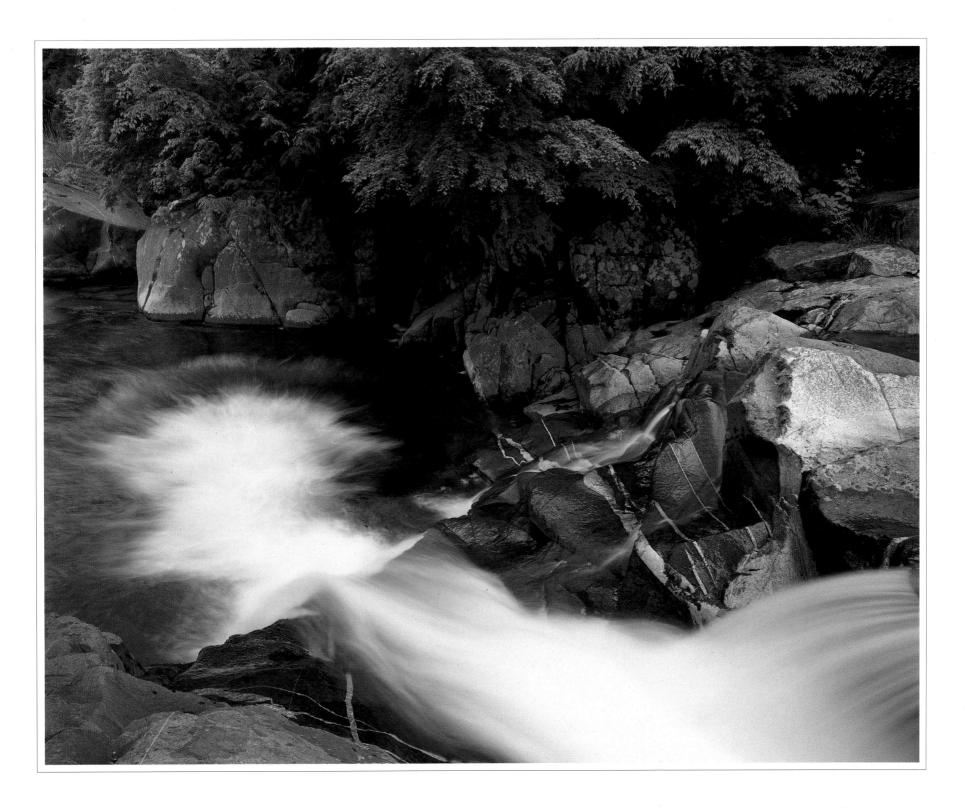

A rushing mountain stream bites its way through a spray-filled gorge.

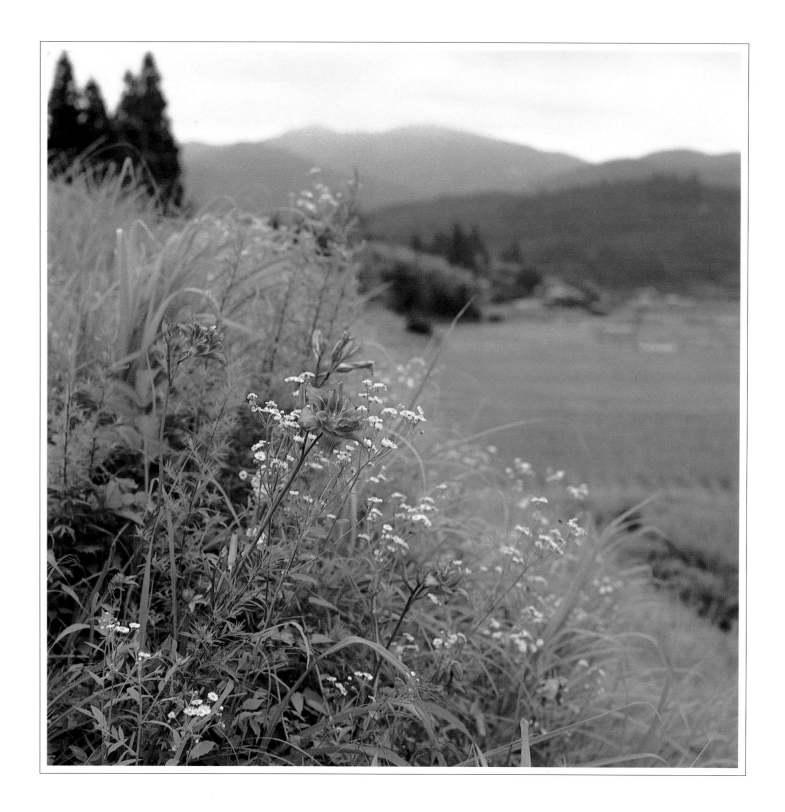

Wild flowers provide a touch of beauty along a footpath through the fields.

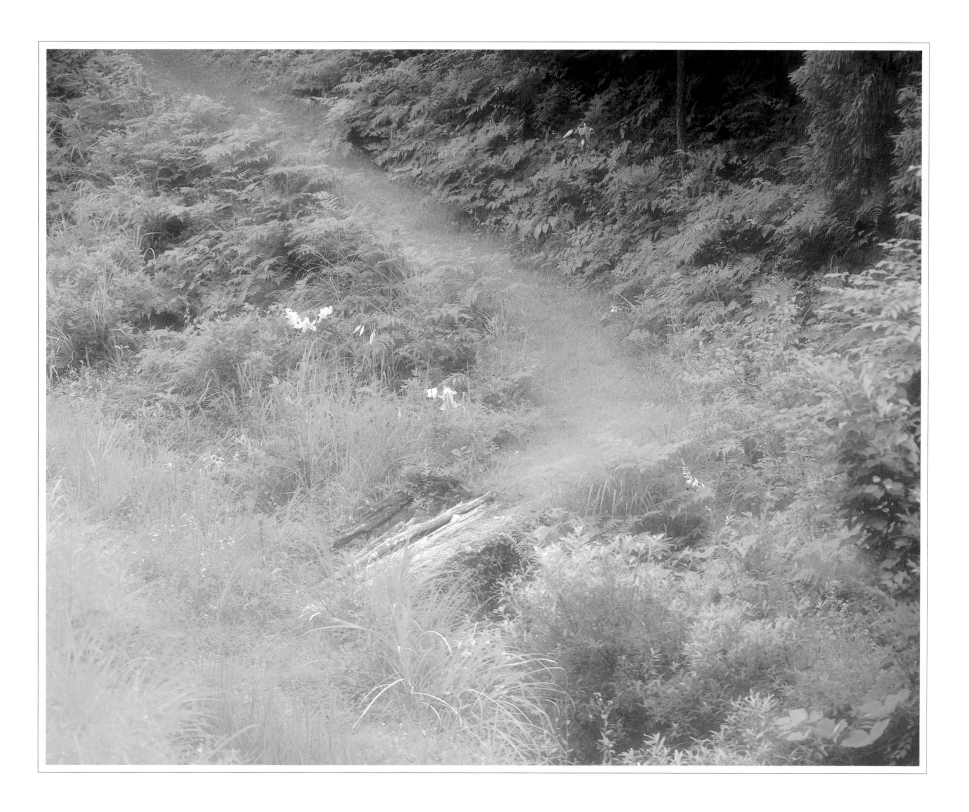

A narrow path lined with gold-banded lilies. Such a sight is rarely seen these days.

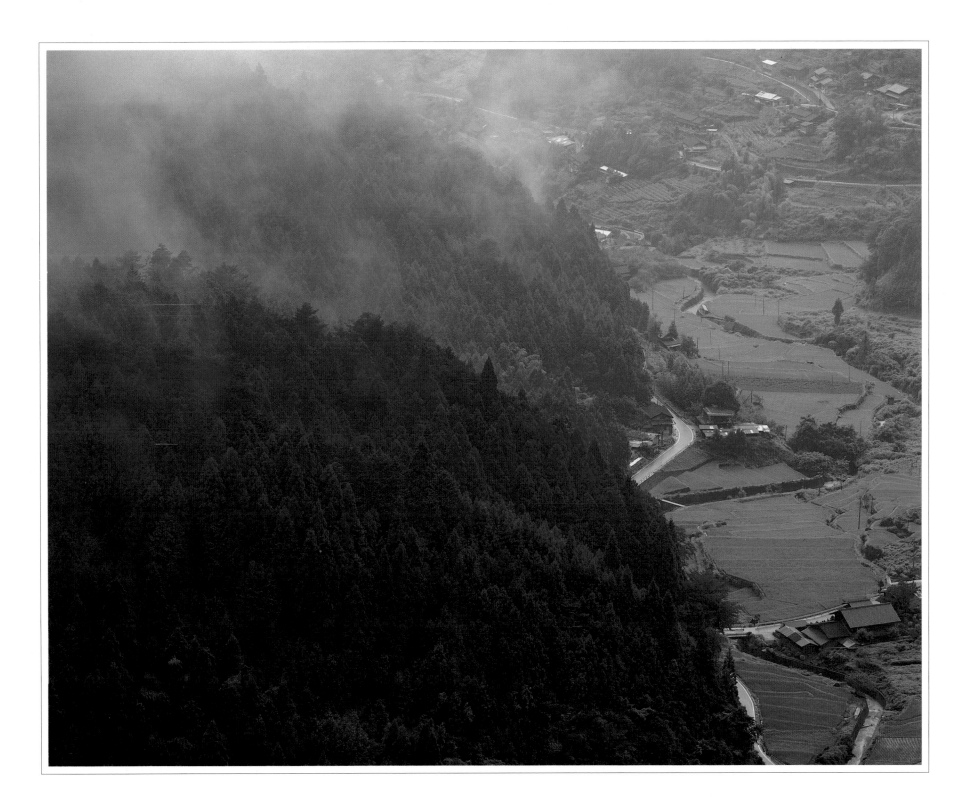

Rain along the Mikawa road, a pleasant route following the Hotokezaka Ridge.

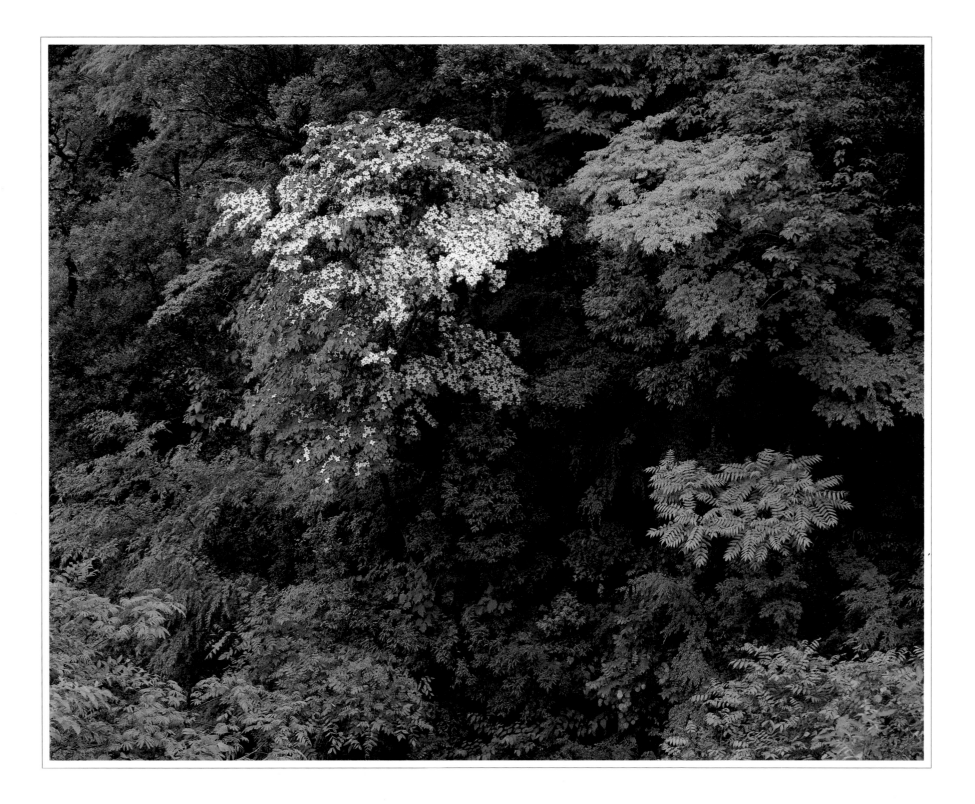

Dogwood blossom. The white flowers stand out against the rich green leaves of late spring.

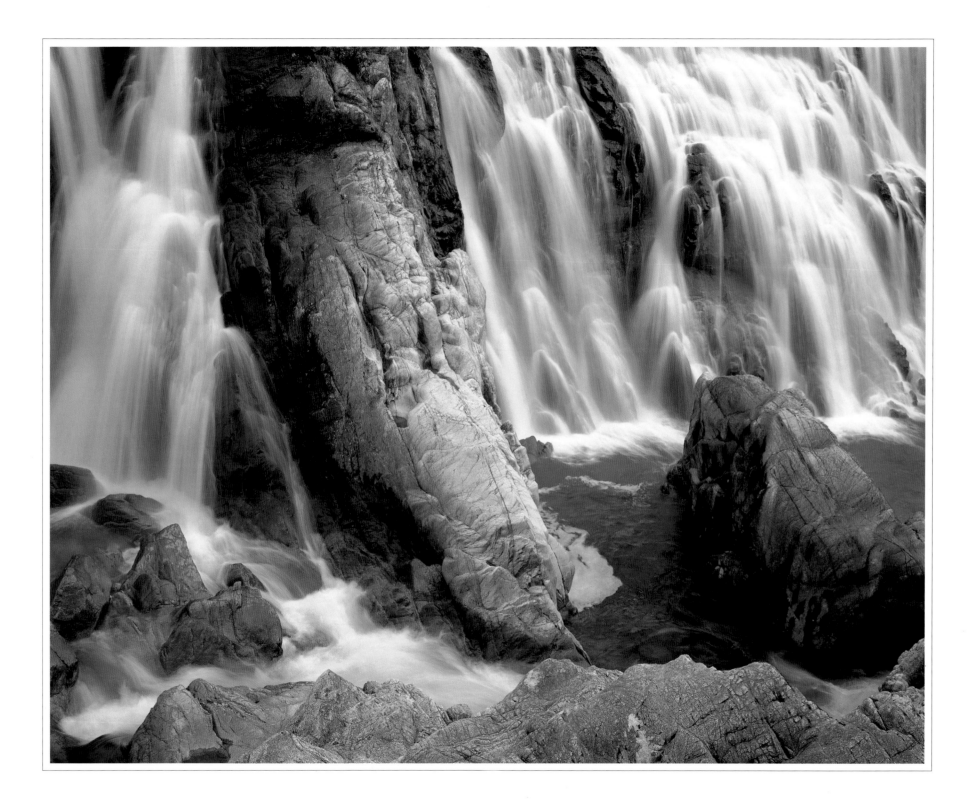

A crystalline waterfall in the Kansakei Gorge. In summer *ayu* fishing attracts many anglers to this area.

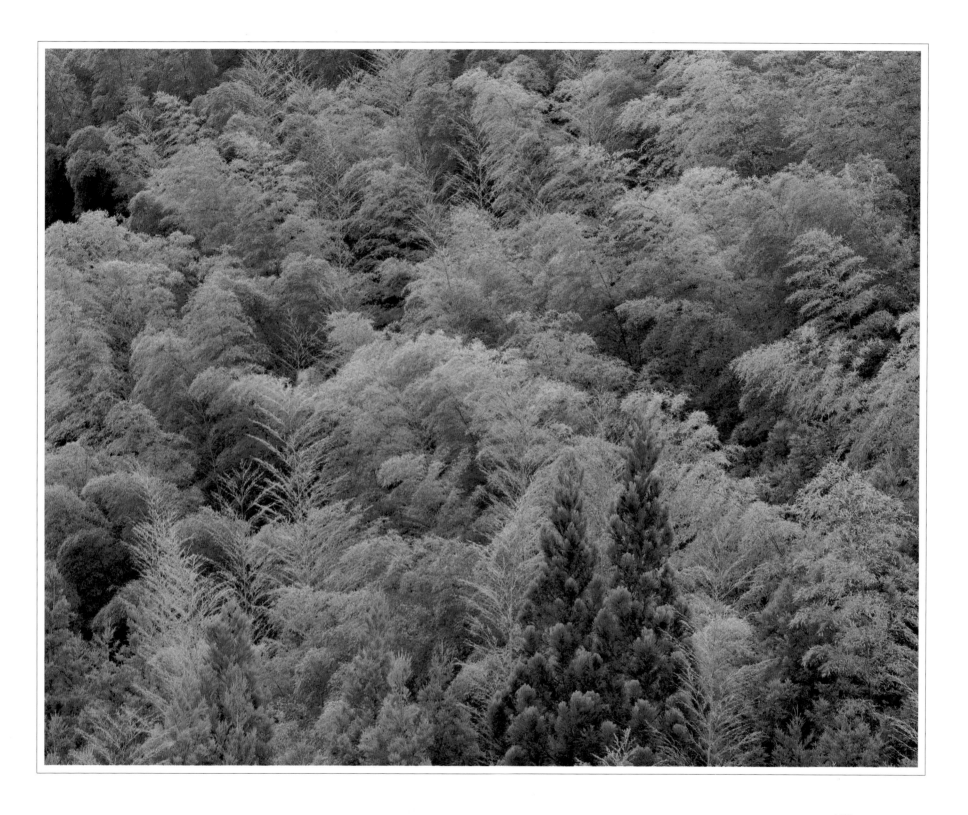

Young bamboo. Cedars are dominant here, but bamboo is found scattered among the other trees.

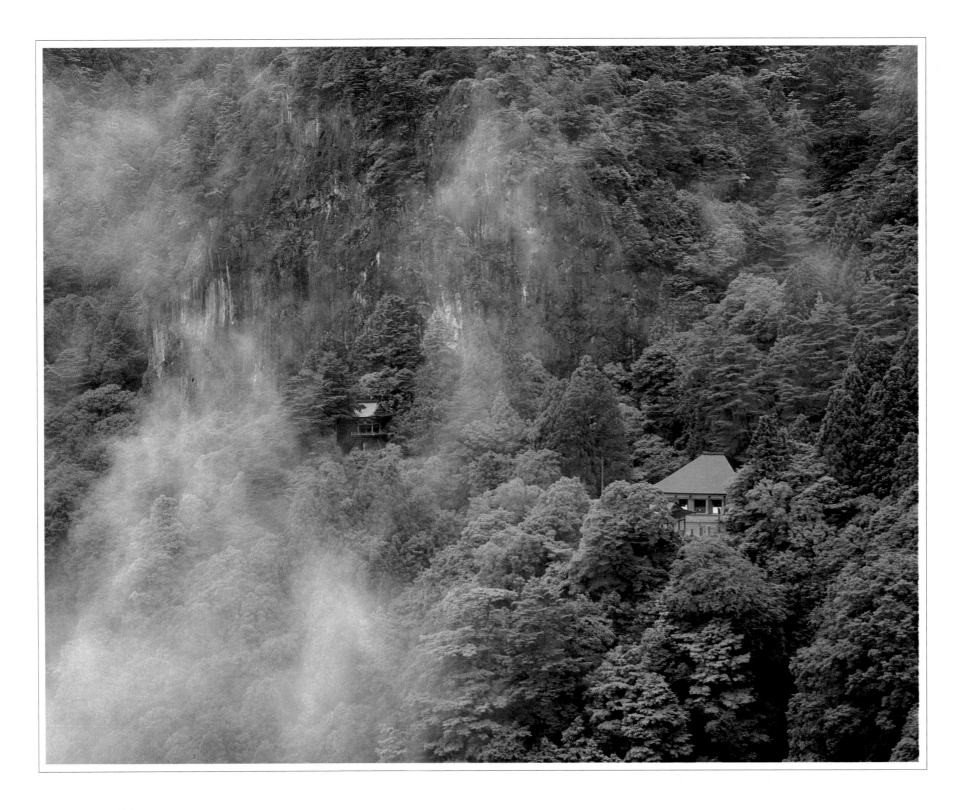

Misty Mt. Horaiji. This, the most famous of the region's peaks, is known as the home of scops owls.

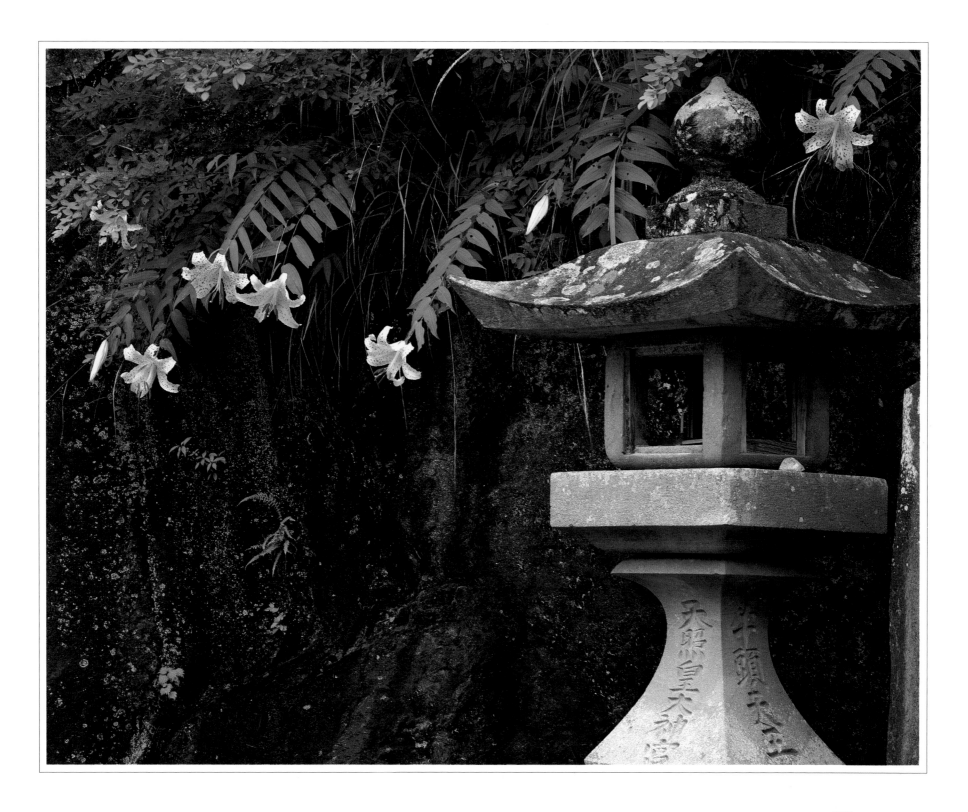

Gold-banded lilies reach out from the shadows by a traditional stone lantern.

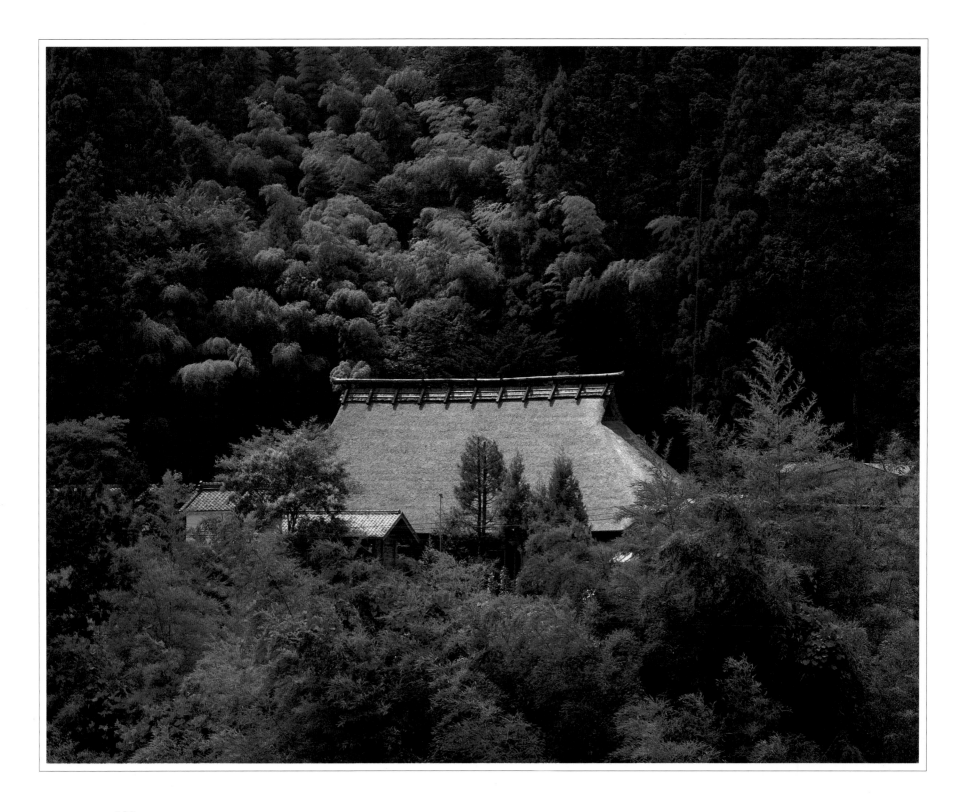

The Kumagais' house in summer. This fine old house has withstood the winds and snows of many years.

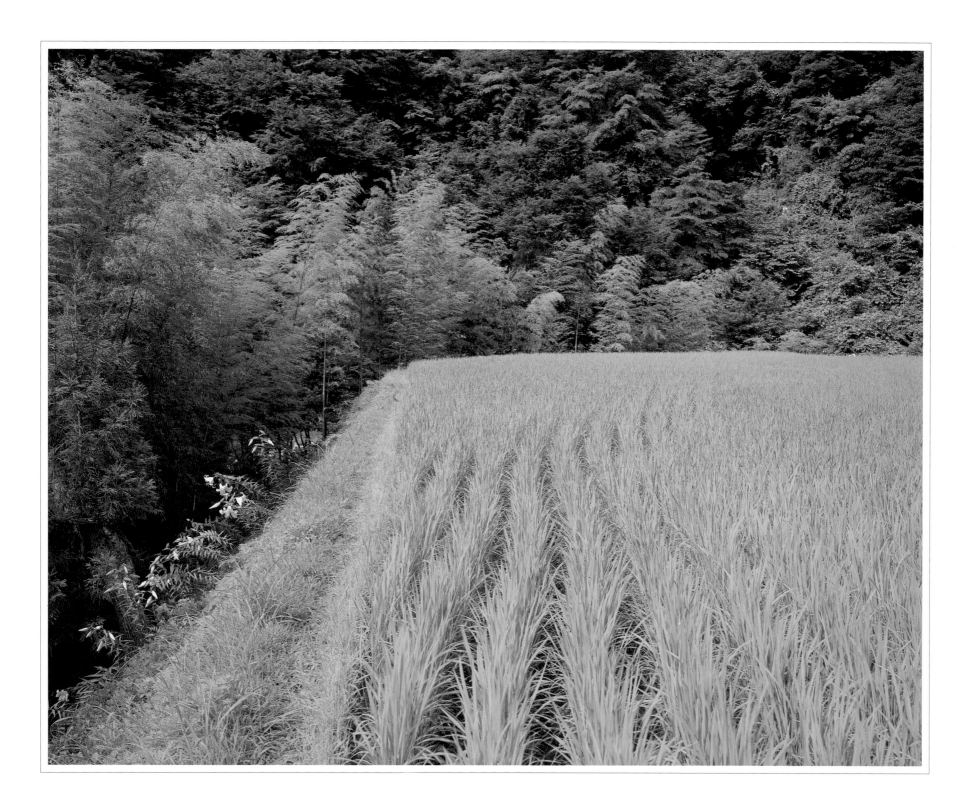

Wild lilies left to grow along a freshly mowed rice field path.

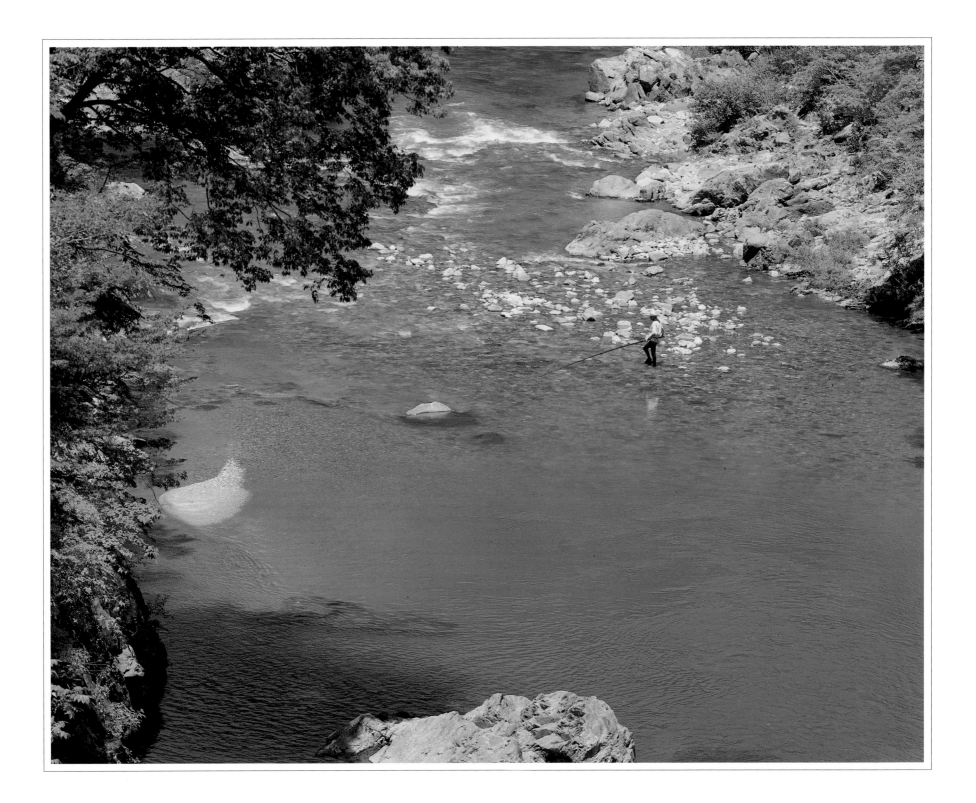

An angler on the Onyu River, one of many who arrive with the opening of the *ayu* fishing season.

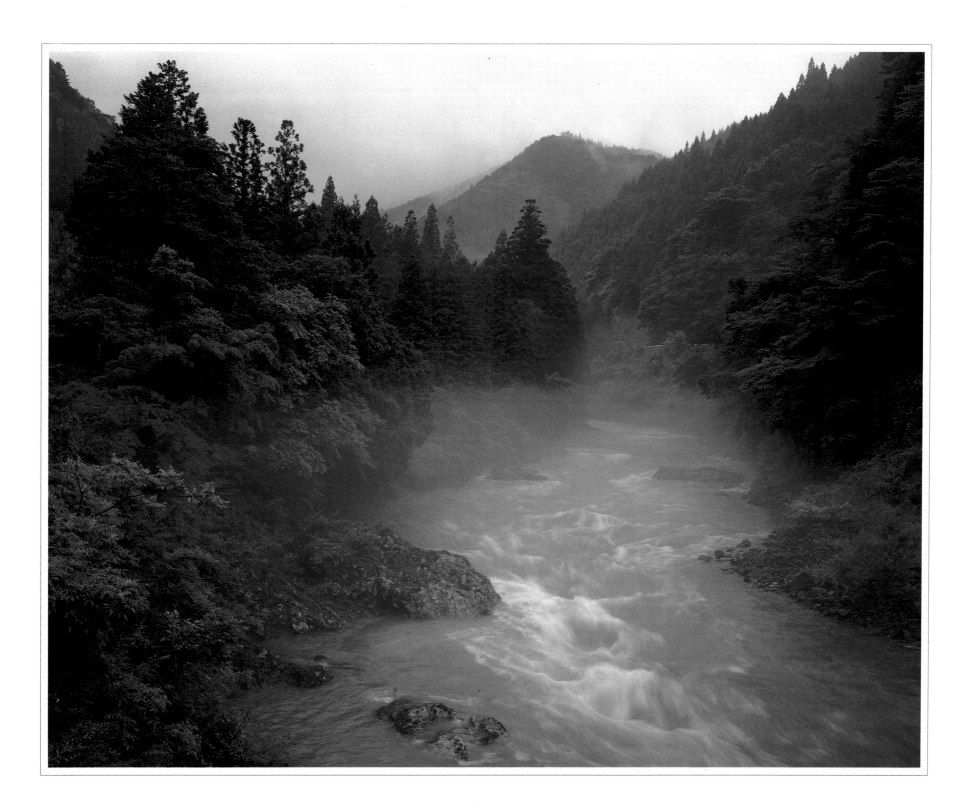

The Onyu River just after a shower. The river has been roiled by a rainy spell.

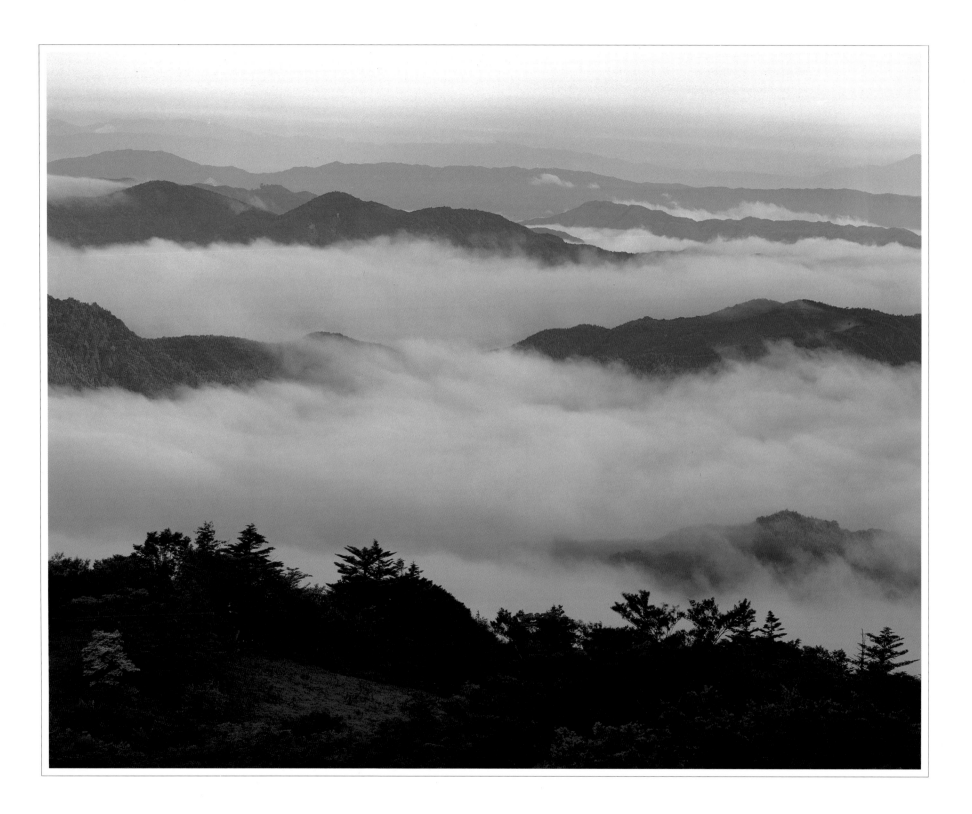

From Mt. Chausu distant ridges loom above clouds and forests that call to mind
a traditional ink painting.

A shower passes through the valley. The humid Okumikawa area is ideal for cedars and cypresses.

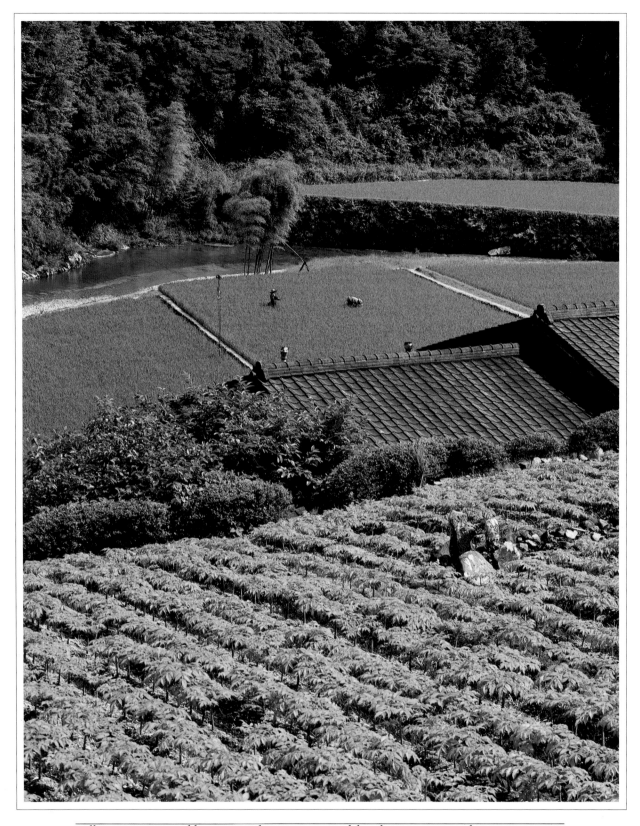

Yellow-green rice paddies, a meandering stream and farmhouses – a typical mountain scene.

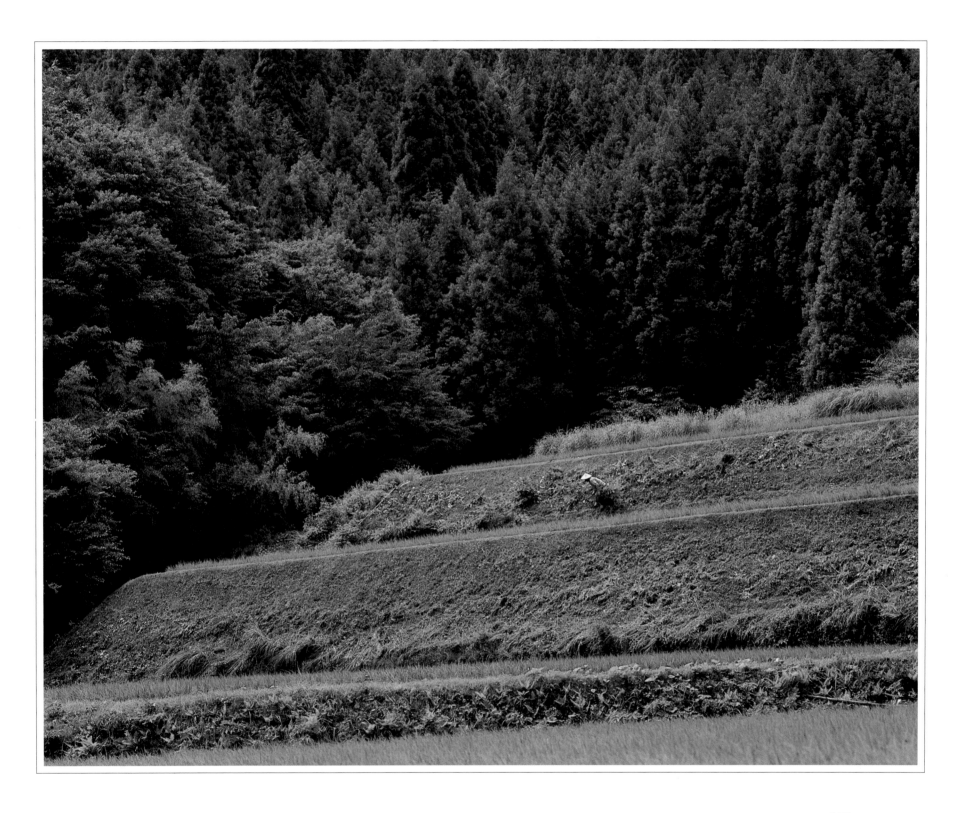

Cutting weeds along a rice field path – a hot difficult part of a farmer's life.

The highland road at dawn. This mountain sightseeing road offers spectacular views for visiting tourists.

Fireworks display at a village festival. A brilliant burst against the soft afterglow left
by an earlier rocket.

Okumikawa – Where the Old Japan Lives On

The highways and roads of modern Japan cross rivers and run parallel to the coastline, but in the old days they generally followed the courses of rivers from their lower stretches up to the headwaters. This is the kind of route taken by the roads of Okumikawa, following the Toyokawa River from Toyohashi to Toei, an area now serviced by the Iida Line of the Japanese National Railways.

The old roads which traversed the Japanese archipelago mostly ran lengthwise from north to south along the steep-walled flowing from the central mountain ranges. Along the way there were many mountain passes and gorges which provided and still provide scenes of great beauty. In the old days there were post towns at the crossings along the routes between villages and the roads served various needs of the area. They were not only used by merchants transporting goods, but by travellers and pilgrims visiting such shrines and temples as Toyokawa-Inari Shrine, Horaiji Temple and the great Zenkoji Temple in the city of Nagano. Towns like Iida prospered so much from their trade with the Nagoya area that, according to one account, Kotaro Hayakawa's "Sanshu Yokoyama Banashi", "one thousand horses came and went in the town every day". The Okumikawa area, however, was not on the main route, and its villages were so isolated and wild that it is said that the horses there got skinny worrying about the wolves in the area. Tomiyama Village, the most isolated in Okumikawa, is said to have been a place of refuge for fugitive warriors during the Feudal Period. Today its claim to distinction is that it is the village with the smallest population in Japan, and in the last three decades the number of resident families has dropped from 190 to 70. On the other hand, Toyone, a neighboring village which was once as isolated as Tomiyama, is now, thanks to a new highway, a bustling jumping off point for sightseeing around Mount Chausu.

Toyone and the neighboring communities of Tsugu and Toei are well known for their Hana Matsuri – Shinto Flower Festival, which the Japanese Government has designated as an important folklore asset. This festival was first introduced to outsiders only 50 years ago when Kotaro Hayakawa, a local folklorist, published his book "Hana Matsuri". Hayakawa was only 13 when he first saw the festival at Kadoya's Horaiji Temple near his hometown of Yokoyama. He recalls the villagers dancing around a cauldron of boiling water on that occasion. Then, at a later date, a "devil dancer" from the festival came to his home to dispel evil spirits.

He never forgot the fear he felt when he witnessed that dance, and later he mentioned his experience to Kunio Yanagida, a folklorist. Yanagida encouraged him to do more research on the subject and in 1926 Hayakawa and another folklorist, Shinobu Origuchi travelled to Toyone Village to see the festival again. From that day forward, Hayakawa's interest steadily increased until he became almost obsessed with the subject. Finally, four years later, he published his classic work on the festival.

According to Hayakawa, the original form of this Shinto Festival of the Gods, which dates back to medieval times, was very much affected by the asceticism of the local mountain priests. The early villagers, he tells us, appeared much like a group of mountain priests as they celebrated the festival. During the three days and nights of the festival, which was held every seven years, it seemed as if these early participants actually brought to this earth the world of the Gods. The original festival, with its sacred Shinto music and dancing, could still be seen at Kamikurokawa in Toyone Village as late as 1857. After that date, the festival underwent changes and assumed the form in which it is seen today.

Kamikurokawa, in Toyone, became the base for Shinzo Maeda's work in Okumikawa, and the photographer came to know Kenichi Kumagai, a wealthy local farmer who offered Maeda the use of one of his houses. It was through Mr. Kumagai's friendship and assistance that Maeda was able to move about freely in the Okumikawa

area. The Kumagai residence, which appears on pages 128, 169 and 181 of this book, was built in a style typical of the homes of wealthy farmers during the late Edo Period. It has been designated an important national cultural property.

There was a book published in the seventeenth century called "Prefectures and the Character of their People". In this book the people of Okumikawa are described as eccentric, strong-minded people who say what they want to say, without waiting to hear the opinions of others. It adds that they are great talkers. I have heard that Mr. Kumagai fitted that description well, and I have a feeling that it was not only the beauty of nature, but the simple, forthright spirit of the local folk that endeared the Okumikawa region to Mr. Maeda's heart. Shinzo Maeda was, himself, born in a mountain village outside Tokyo and spent his boyhood surrounded by nature. It seems that deep insights gained from the experiences of his youth have come into play in his work on Okumikawa, and it may be that the images which lie undisturbed in the man's mind provide some explanation for Maeda's finally bringing man and his culture into his pictures.

Kotaro Hayakawa's book "Hana Matsuri" appears to have two primary objectives. They are (1) to thoroughly explore and gain an understanding of the religious festivals and ceremonies (Buddhist and Shinto) and the folk drama music and dancing which were buried for so long in the isolation of the Okumikawa area, and (2) to introduce this folklore and religion and encourage people to take a fresh look at the festivals and ceremonies that live on in some of the country's isolated areas. I believe that Shinzo Maeda's "Okumikawa" is a classic supplement to Hayakawa's work, a collection of photographs which open our eyes for the first time to the beauty and charm of the land and people in Japan's mountain districts. As mentioned above, Hayakawa felt that the early Hana Matsuri in some ways resembled the dances performed by the mountain priests. Like the priests, the participants in the Hana Matsuri were clad in light, simple costumes and sandals but danced about in a very lively manner. In contrast, the natural environment in which the villagers lived was plain and quiet, though filled with loveliness. Was this because of the character of the people, because of their love of the land? Or was it a blessing from the Gods? No one knows. But we do know that in every season of the year, the natural beauties of the Okumikawa area are a feast for the eyes, and there are dances for each of the seasons, just as there are dances designed for different age groups, some for children, some for youth and some for older folks.

Ever since ancient times, Japanese people have believed that gods and spirits dwelled in the mountains. Because of this, those who penetrated the land's deep mountains, those who tested themselves by climbing lofty peaks and purified themselves beneath icy waterfalls, were thought to possess special spiritual powers and the ability to help village people. And indeed, the mountaineering ascetics, who usually started from the ancient towns of Nara or Kumano often stopped over at villages along the way and helped the local people carve out a living in the rough mountains and valleys.

Shinzo Maeda fully captures the essence of the setting for these human sides of Okumikawa as well as the loveliness of nature which can be found in the regions widest landscapes and smallest manifestations of natural beauty. I believe that the process of creating this book furnished him with a deep understanding of Okumikawa, its people, their land and their culture. This he put into some sort of mutable time frame and filtered through his own sensitivity. Then – silently, painstakingly – he captured it all on film. This book is the final and very beautiful result of his efforts.

Daikichi Irokawa
Historian

Autumn and Winter

Okumikawa, a part of north-east Aichi Prefecture, is a region of mountains which, though not impressively high, are covered with beautiful forest of cedar and cypress. The central part of the area, North Shitara County, is mostly forest. Only 3.8 per cent of the area is farmland. Ninety-two per cent is forested, and of that, seventy per cent is the result of reforestation.

The main rivers and branch streams such as the Onyu and the Toyokawa seem to vie for the honor of being most beautiful as they wind through mountain ravines.

Autumn in this area begins with shining golden rice fields. Soon the maples scattered through the cedar forests or along the brooks and streams become a banquet of color as they reach the climax of their seasonal display. Then one day the leaves start to fall and when the first frost appears in the mountain villages, nature and man begin preparations for the winter. Finally, snow falls on the woods, hills and ravines. The landscape resembles the subtle strokes and washes of a traditional ink painting.

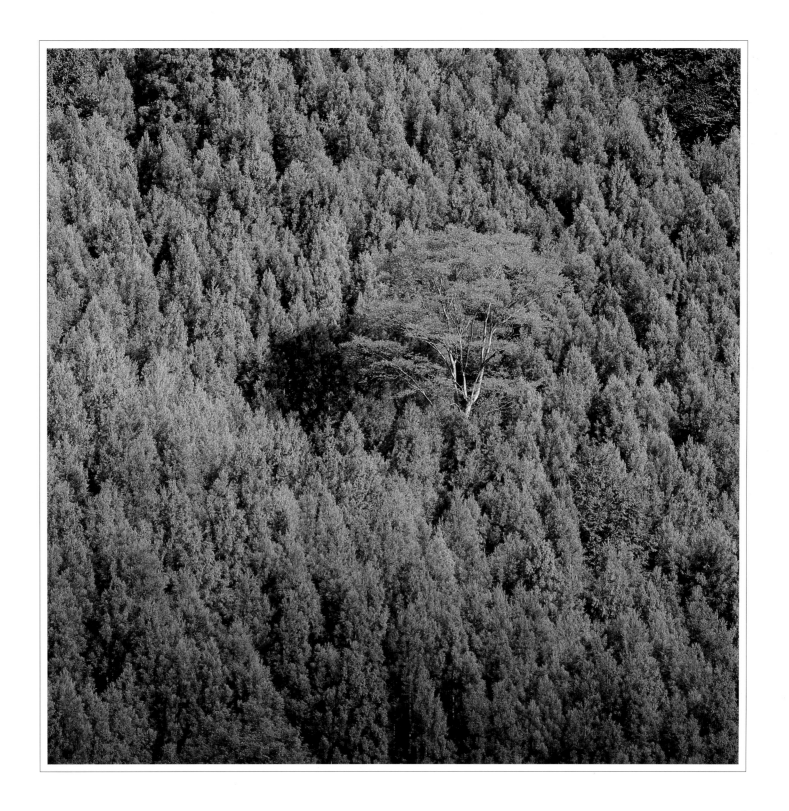

A single yellow tree, alone in the dark shades of a cedar forest.

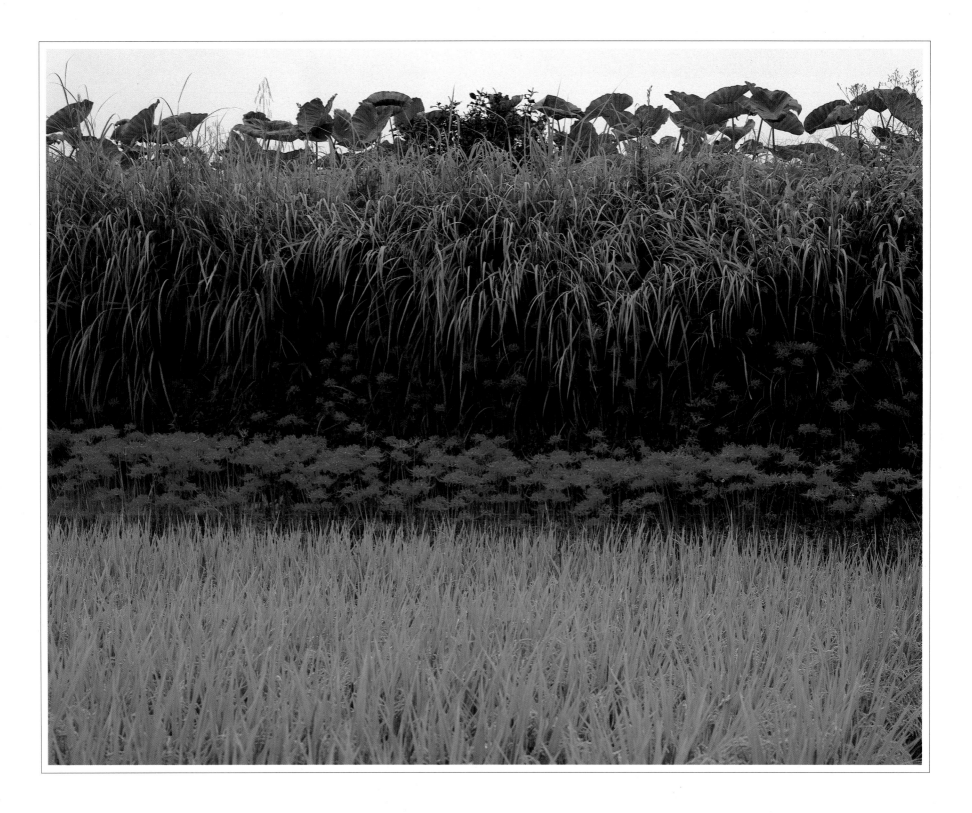

Cluster amaryllis bordering a rice field. Throughout Japan these blossoms appear around the autumnal equinox.

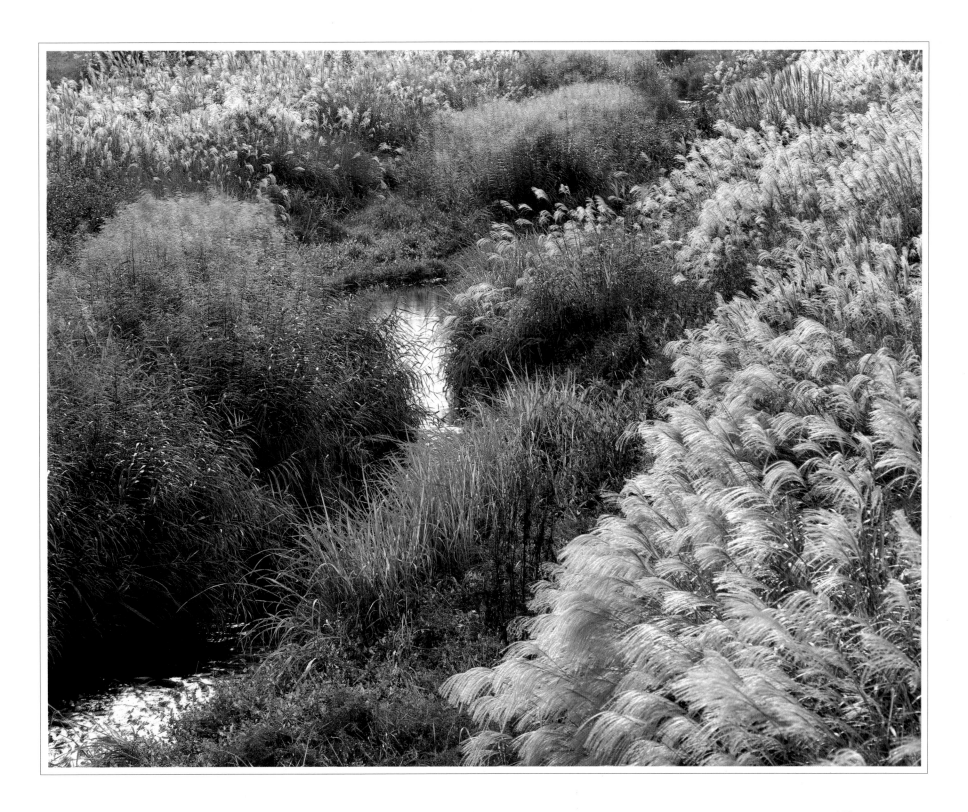

Silver eulalia in the autumn sunlight. Abundant elsewhere, this plant is seldom seen in the Okumikawa area.

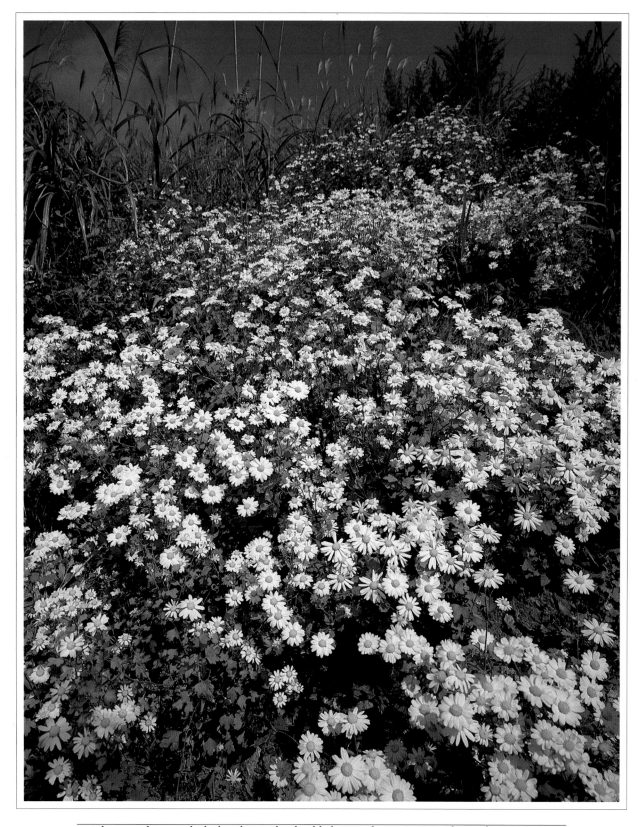

A large and particularly lovely patch of wild chrysanthemums on a slope of Mt. Hongu.

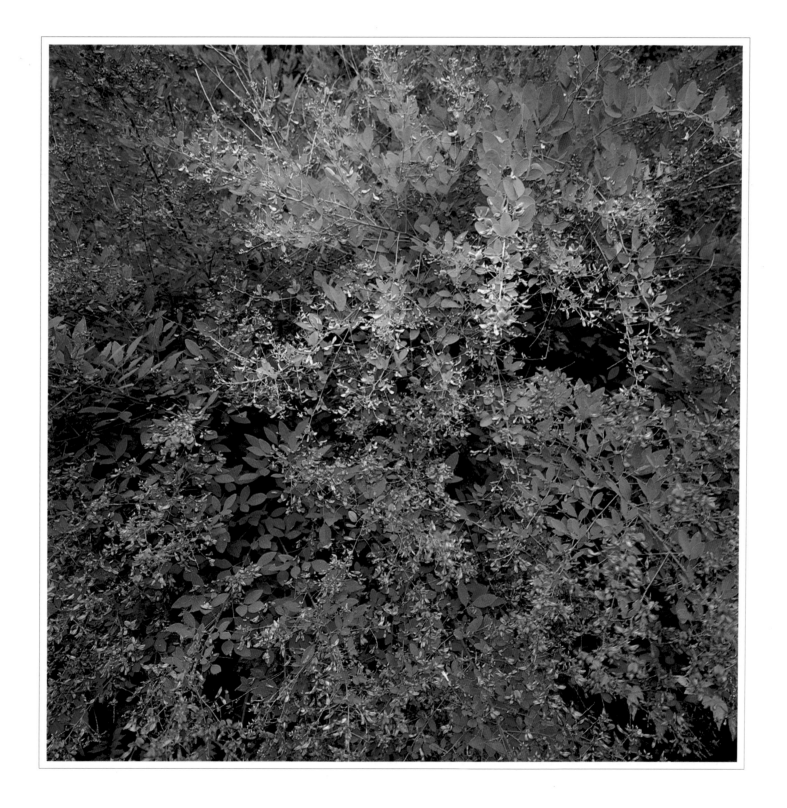

Japanese bush clovers. These pink flowers bloom from the middle of summer until the end of autumn.

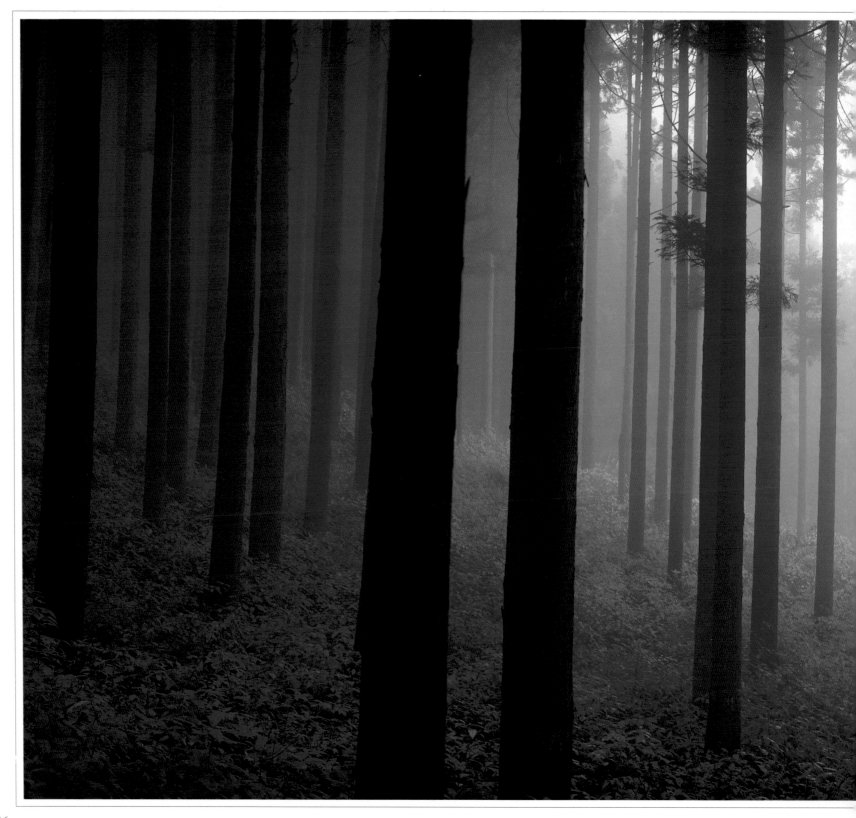

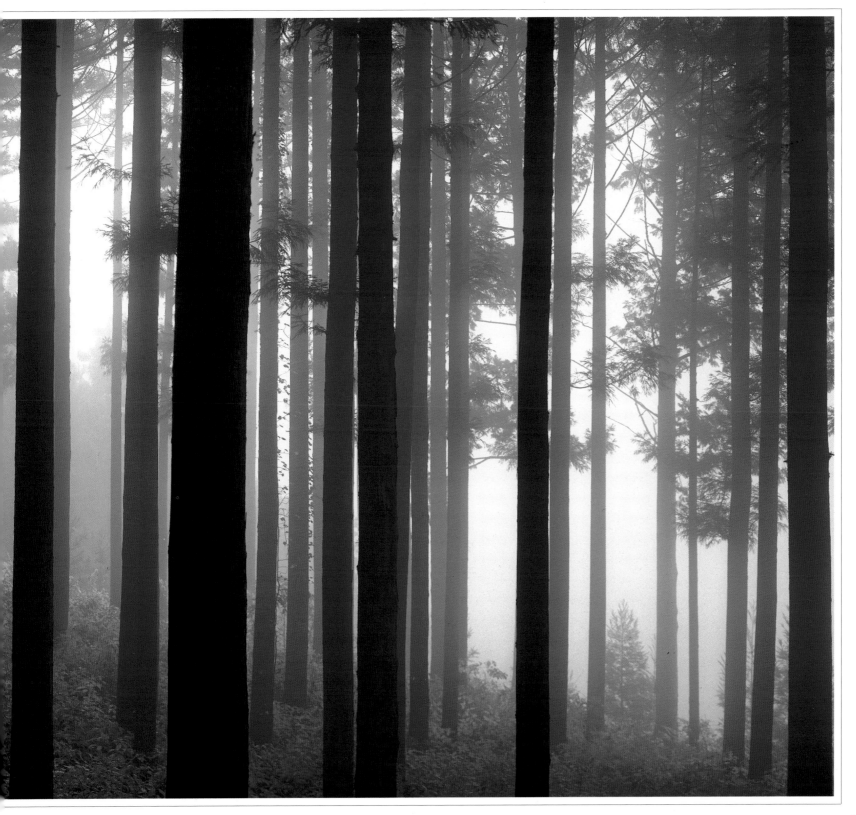

On an early autumn morning, mist follows rain through a solemn stand of cedars.

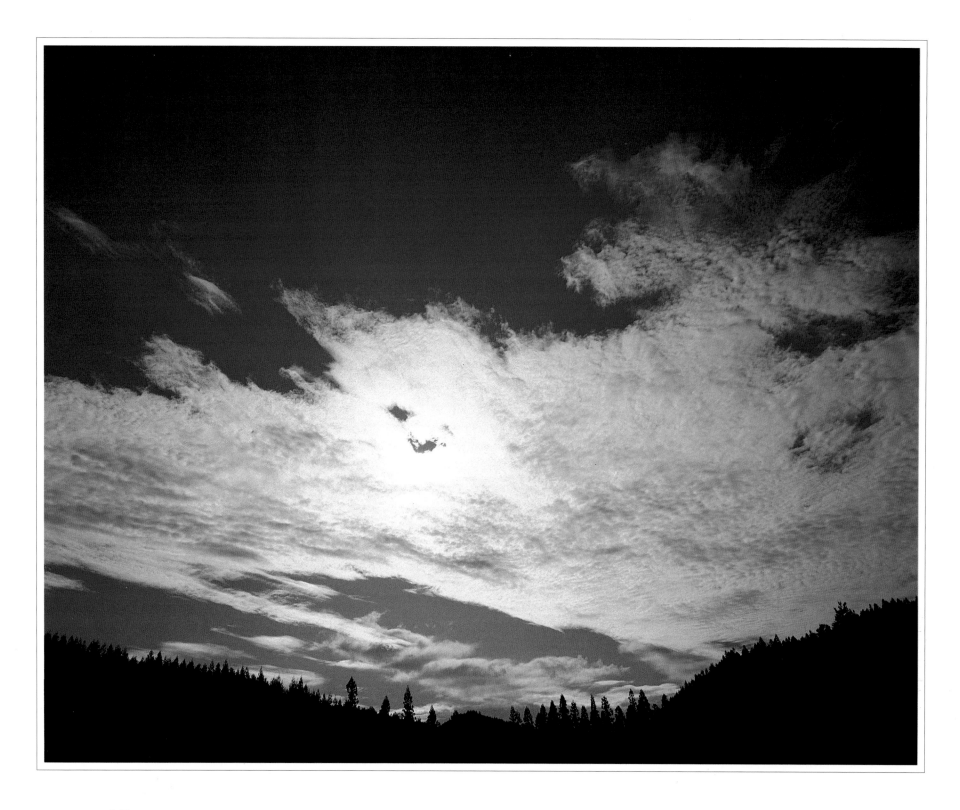

A chill autumn morning with a great white cloud silently passing above the cedar-covered mountainsides.

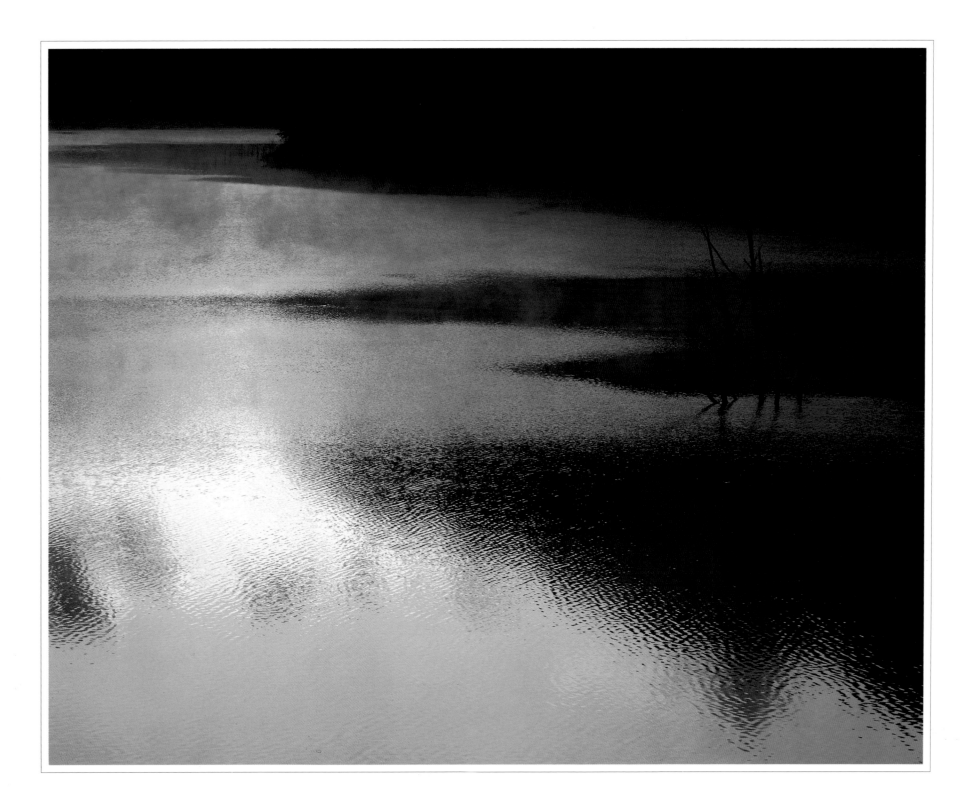

Morning on Lake Midori. Cedars cast their reflections on the dappled surface of the
man-made lake.

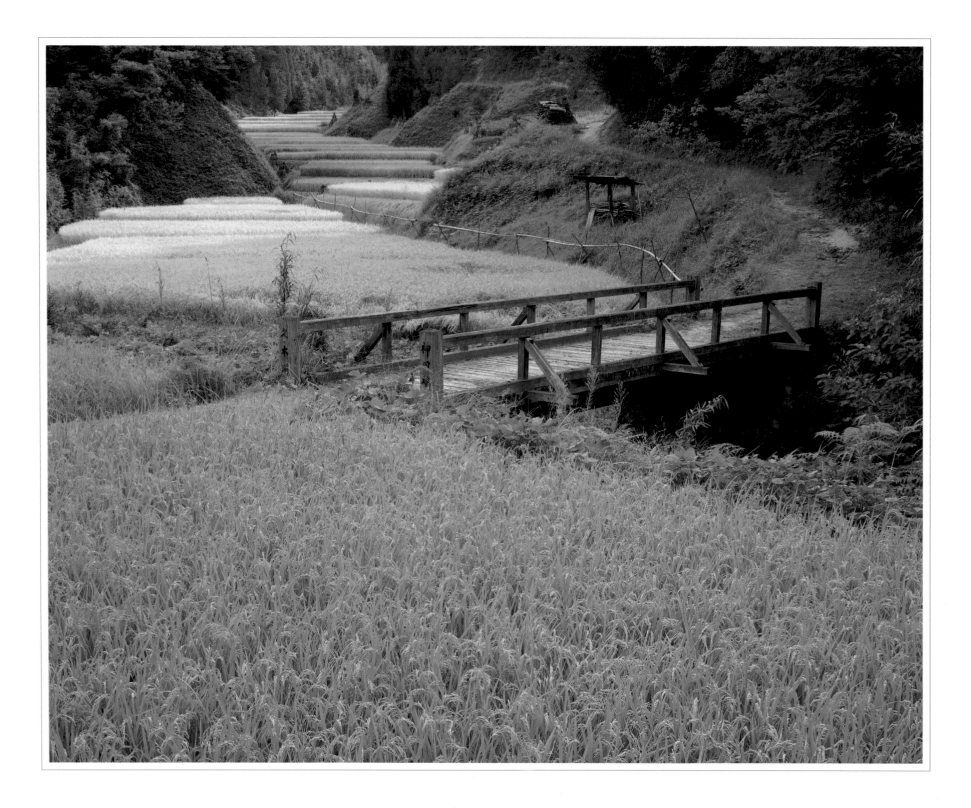

A path through mountain rice fields. Such scenes have been part of Japan since
the olden days.

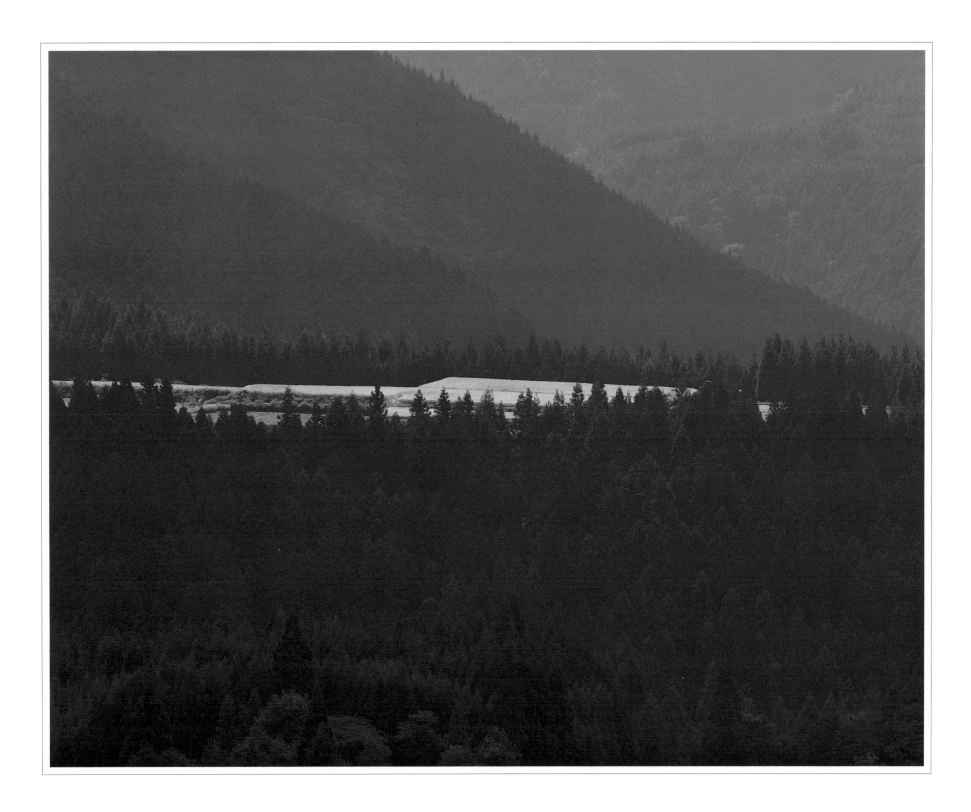

An autumn sun casts golden light on the terraced rice fields between the mountains.

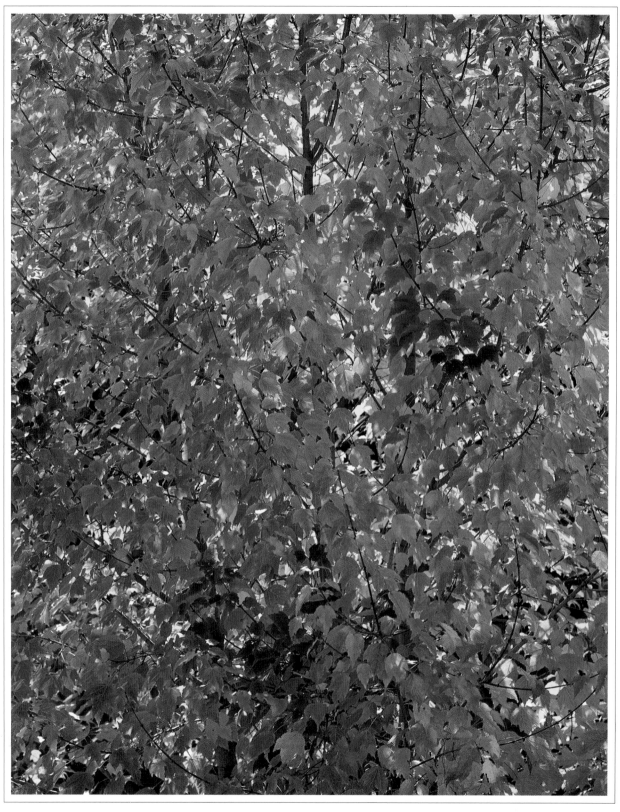

Hananoki, the official tree of Aichi Prefecture. Here it is alive with a pattern of brilliant autumn colors.

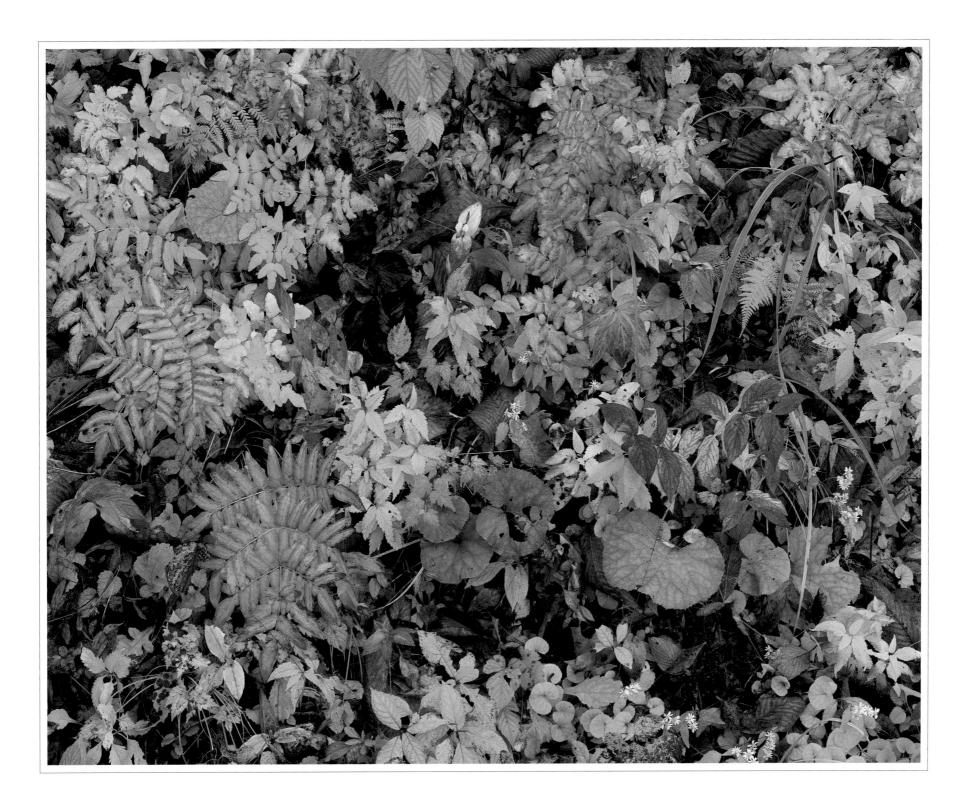

Roadside plants glistening with the extra beauty added by the morning dew.

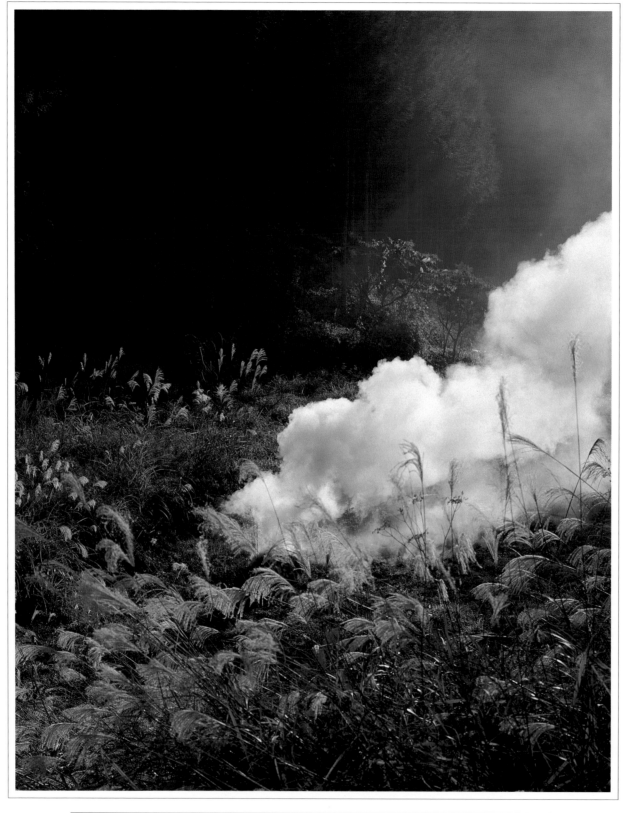

The smoke of an autumn bonfire brings, for Japanese, melancholy thoughts of the season's end.

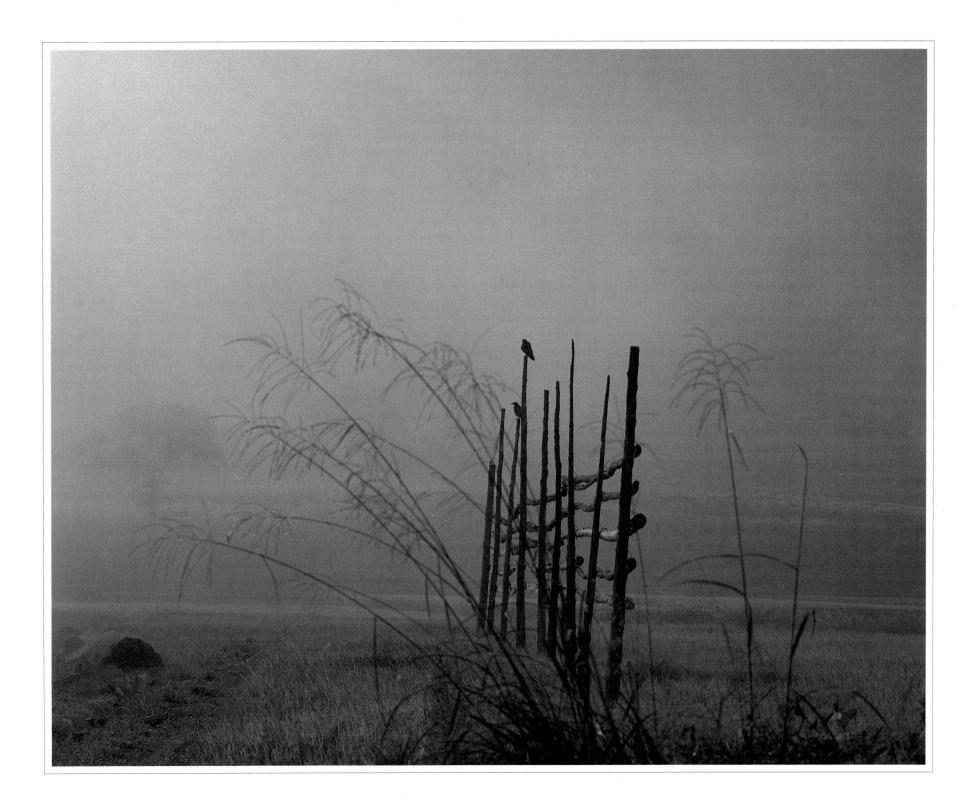

Two crows perch, silhouetted against the mist of a late September morning.

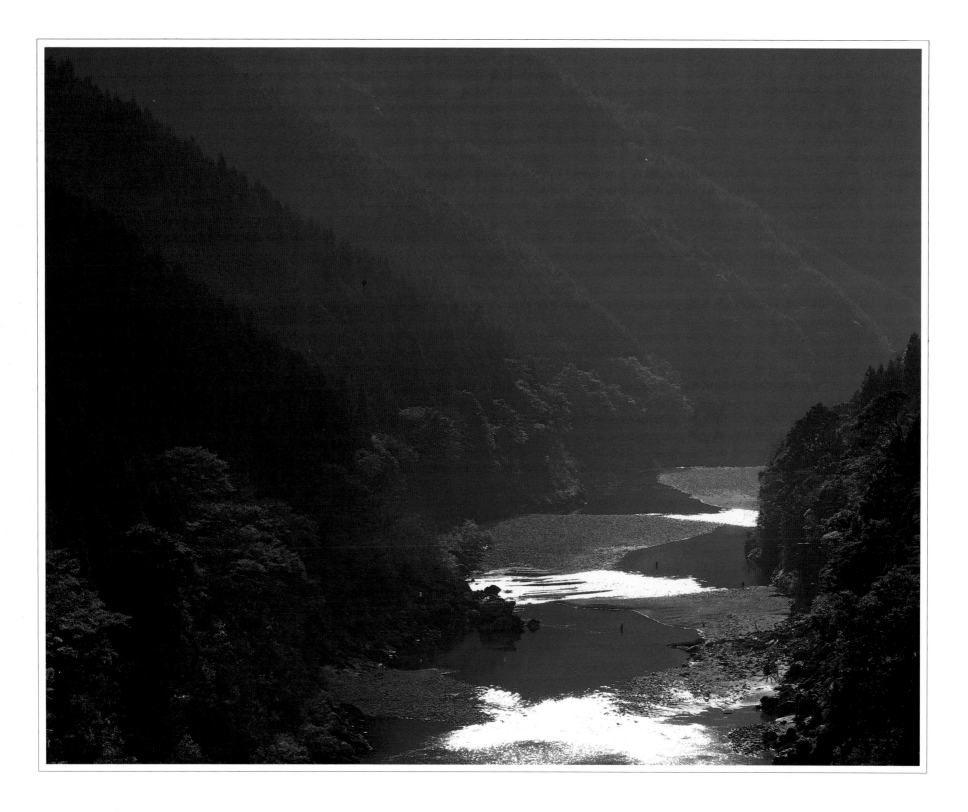

An autumn day on the glistening Tenryu River with fishermen quietly enjoying their sport.

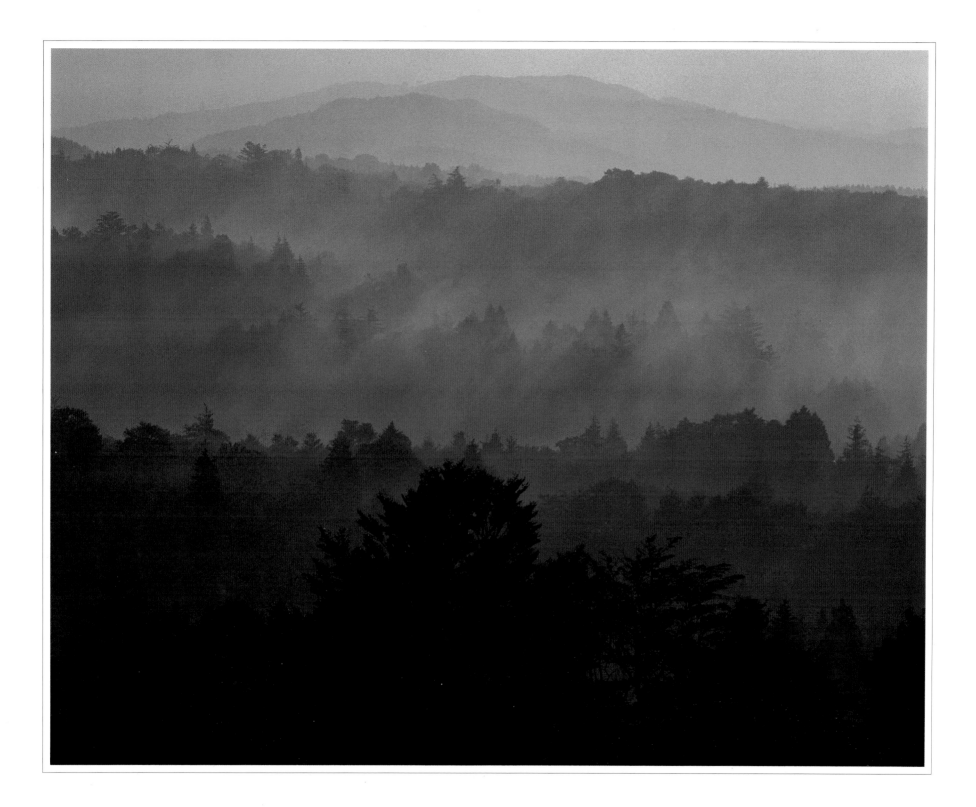

Unexpected beauty glimpsed from a mountain top. A rising sun casts its rays through the morning mists.

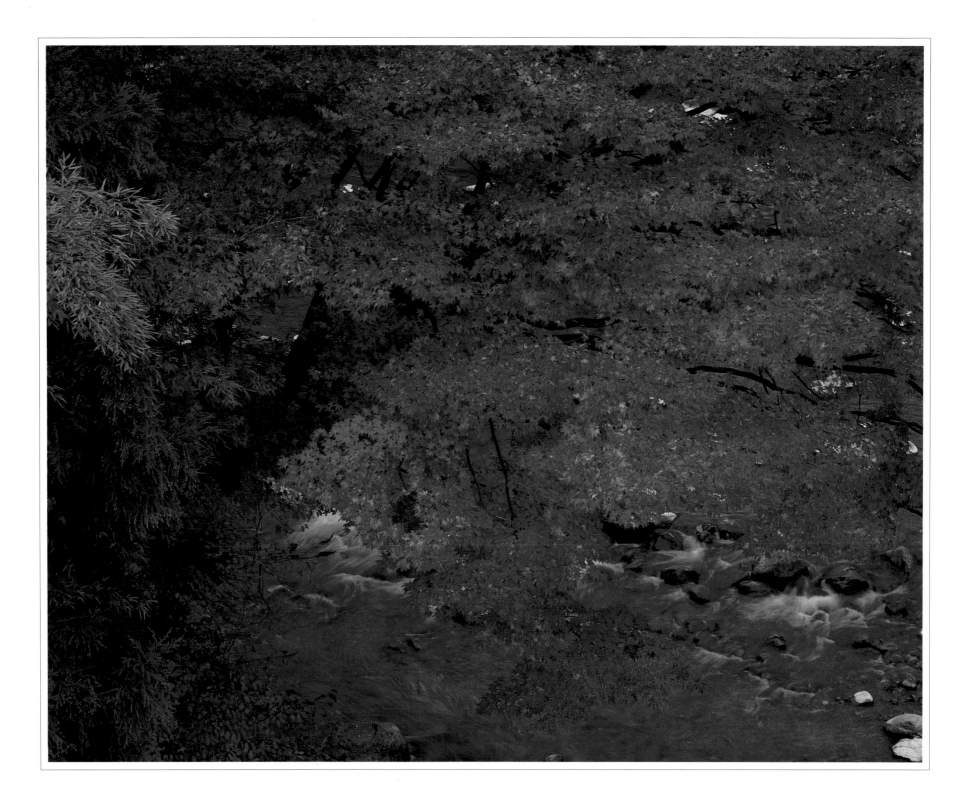

Maples above a mountain stream. Such splashes of brilliance appear here and there among the evergreens.

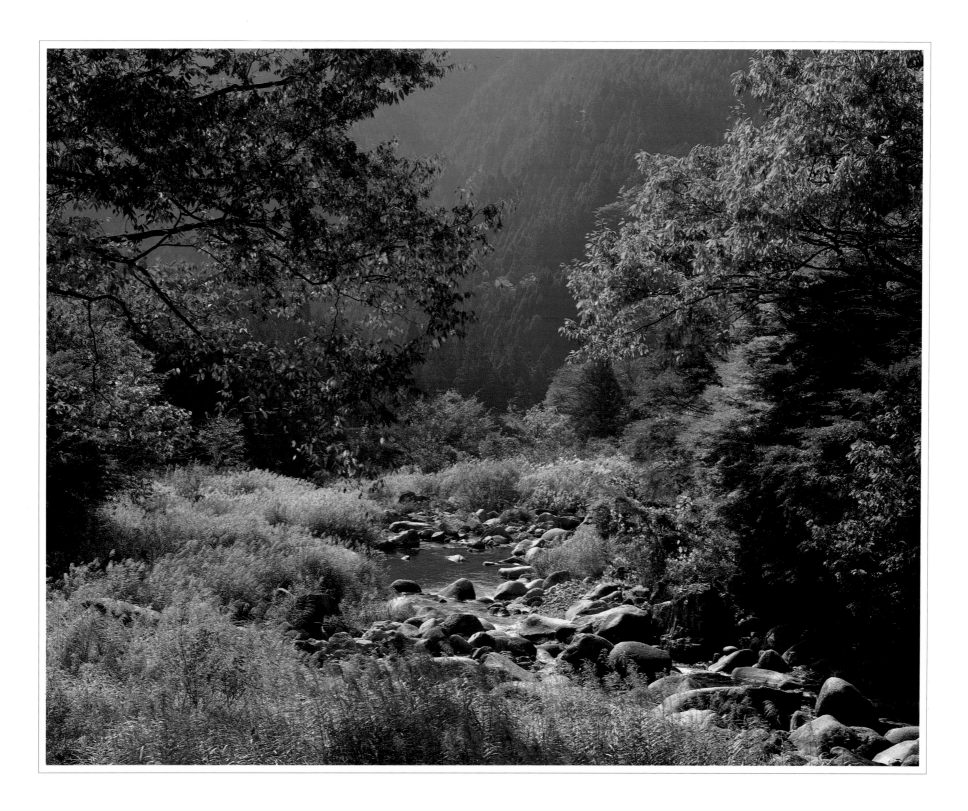

Autumn along the Kansa River. Green cedars and silvery rushes give the area a special loveliness.

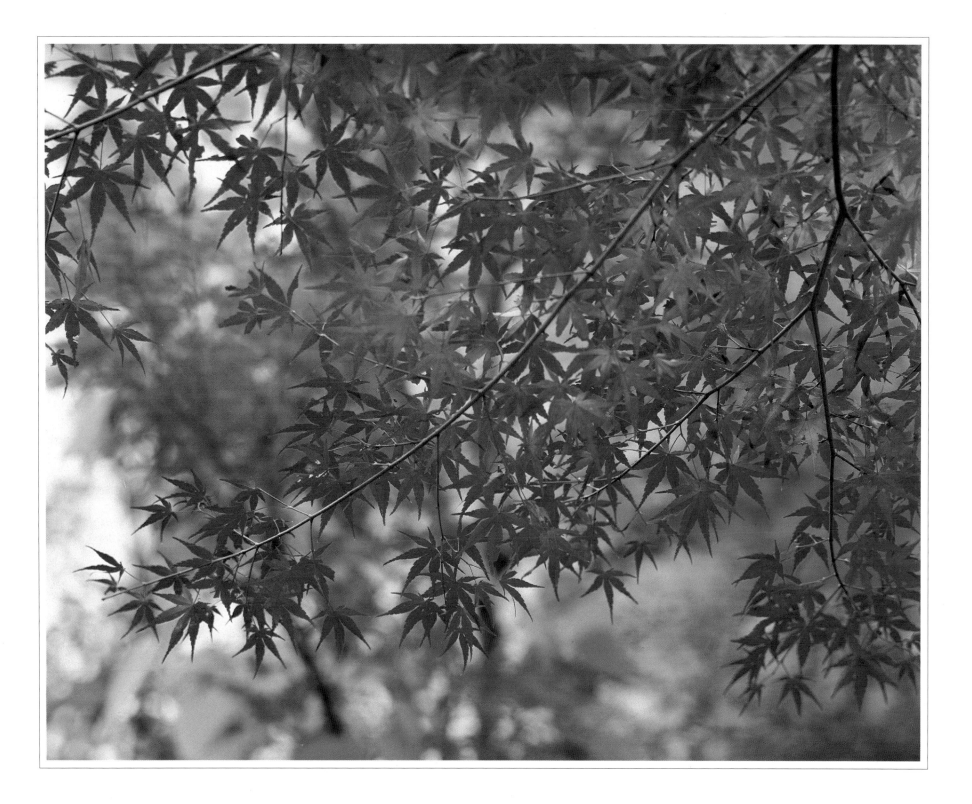

Delicate maple leaves. The beauty of the bright reds and oranges is heightened by the soft autumn sun.

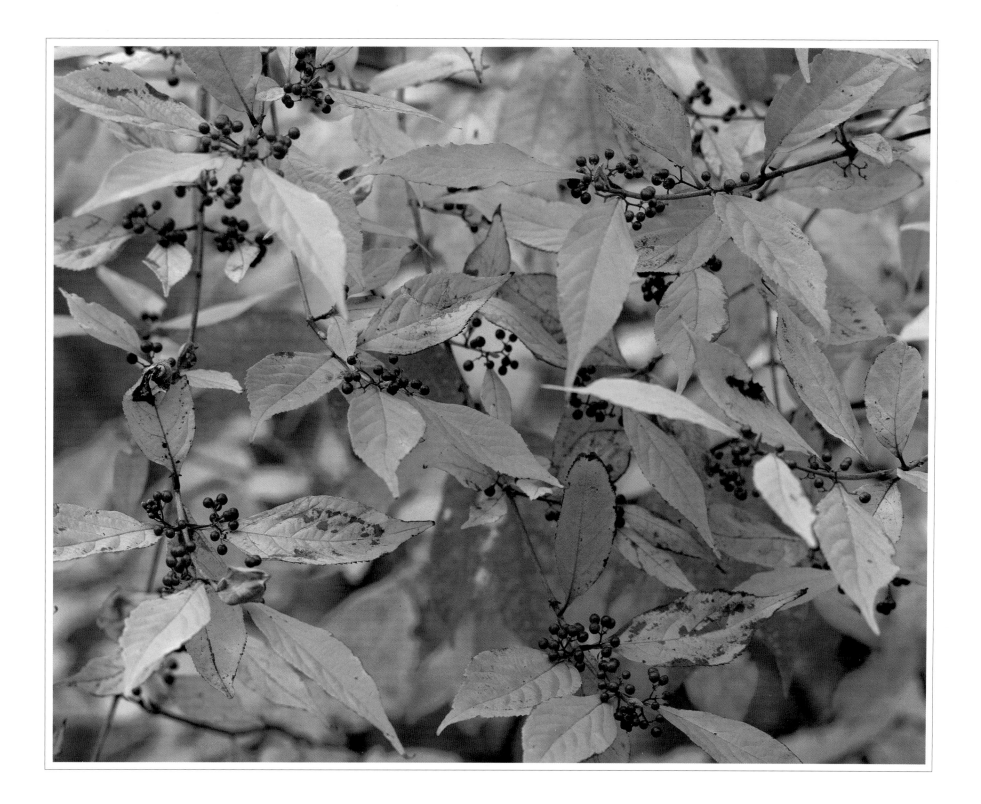

Purple berries and green leaves. The shrub Lady Murasaki sometimes resembles a lovely
pattern of printed silk.

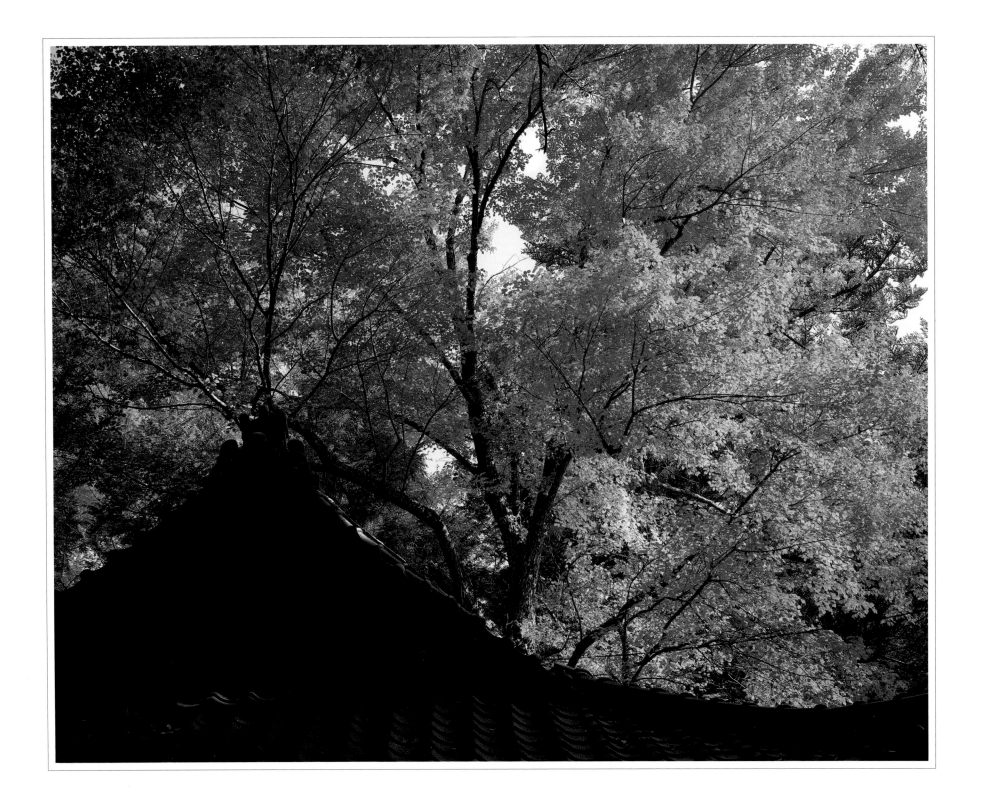

Bright *hananoki* leaves. Aged specimens of this tree are often designated as national treasures.

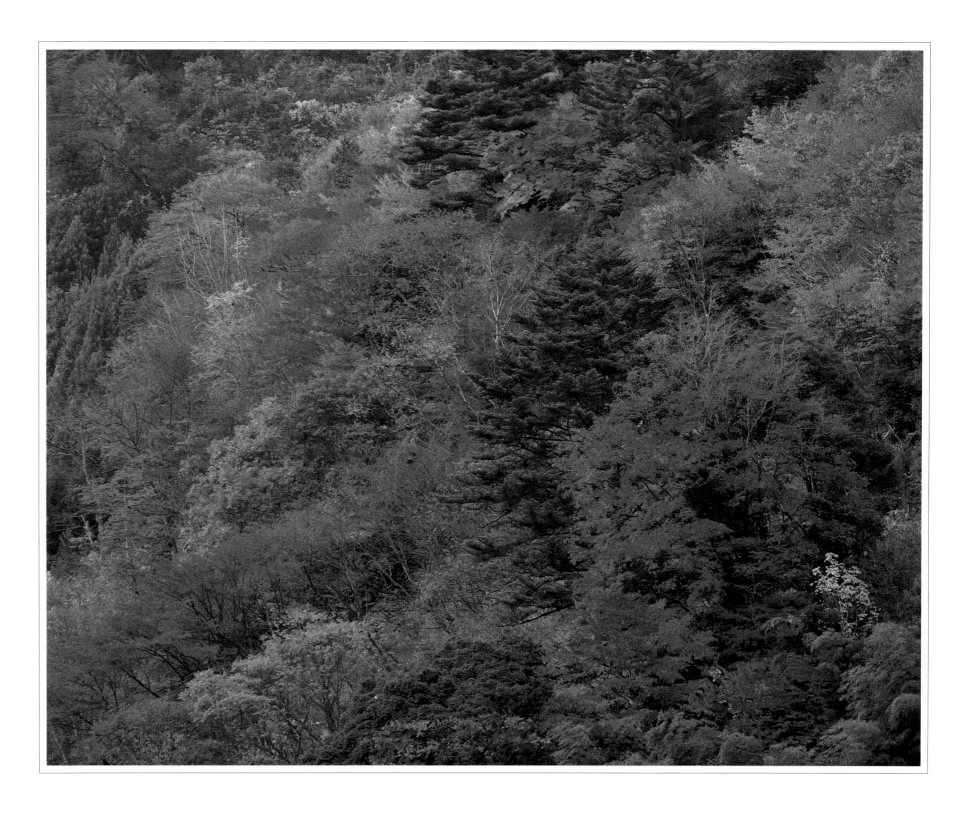

A hillside of mixed maples, cherries, and evergreens, their forms and colors like a natural woodblock print.

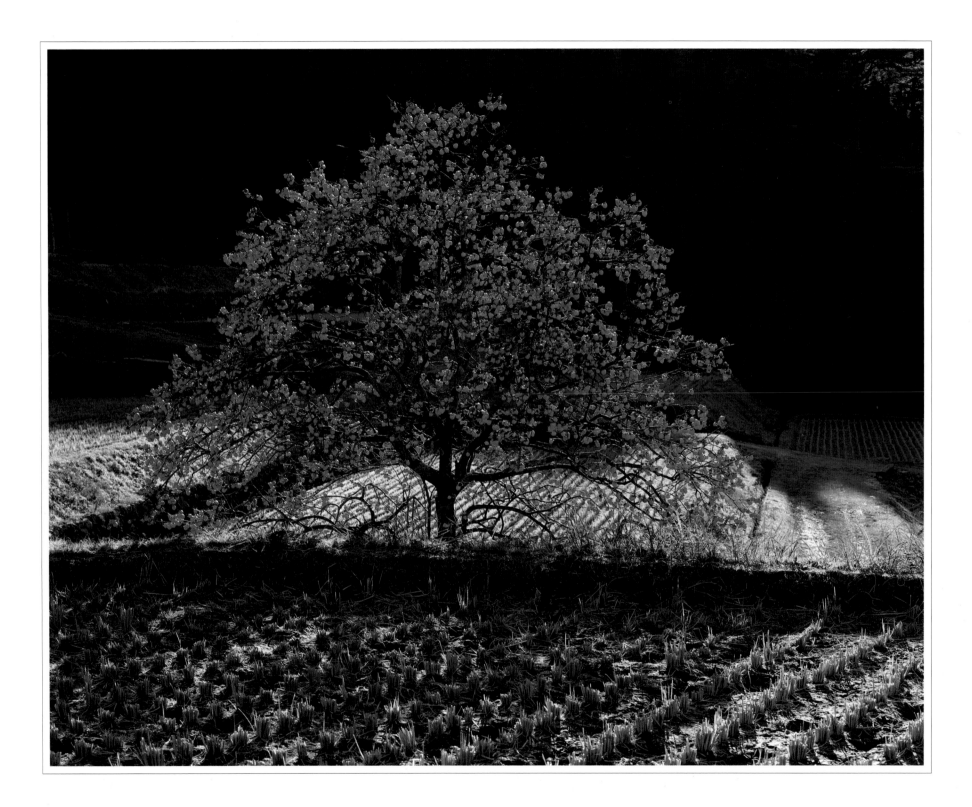

A dazzling spray of persimmons by a rice paddy. This is a typical farm village landscape.

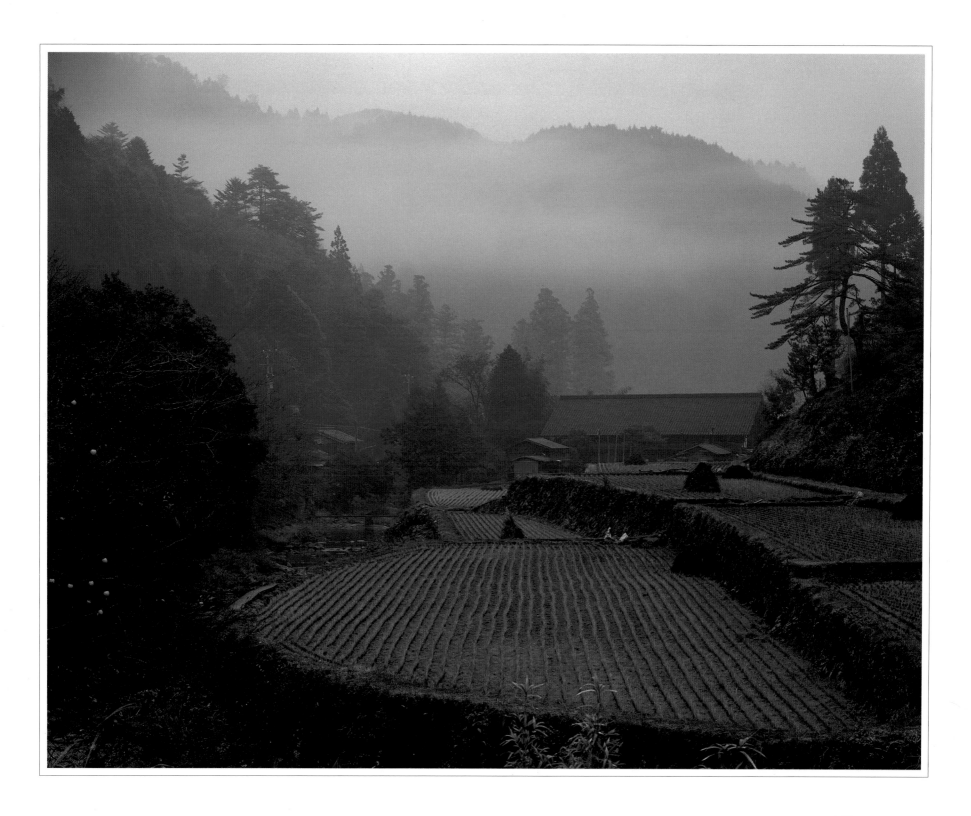

After a rainfall. A soft, wet feeling permeates the Okumikawa landscape.

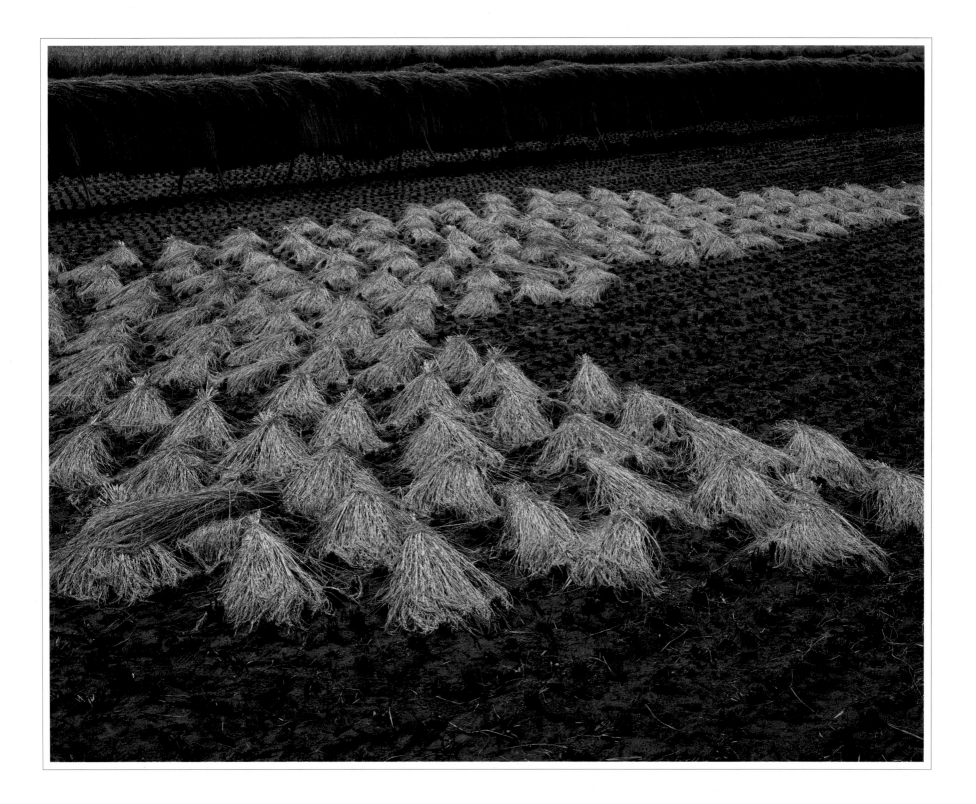

Sheaves of rice, waiting to be hung and dried, form a pleasing design on the cool fields.

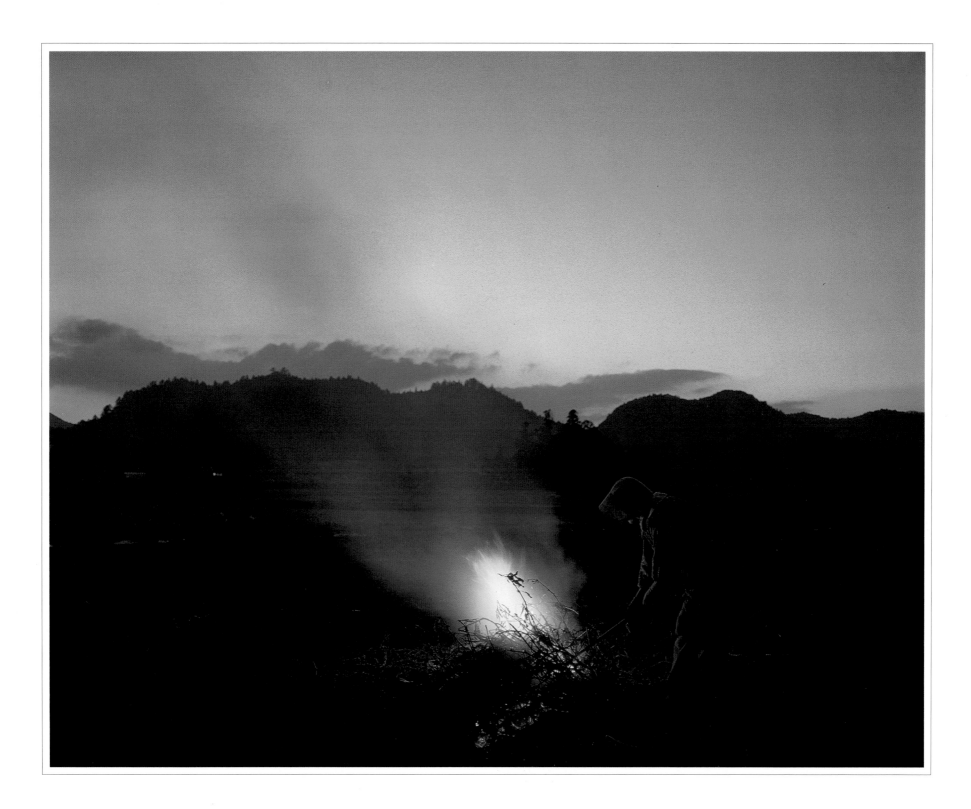

The crop harvested, a farm woman burns rice husks in the late autumn twilight.

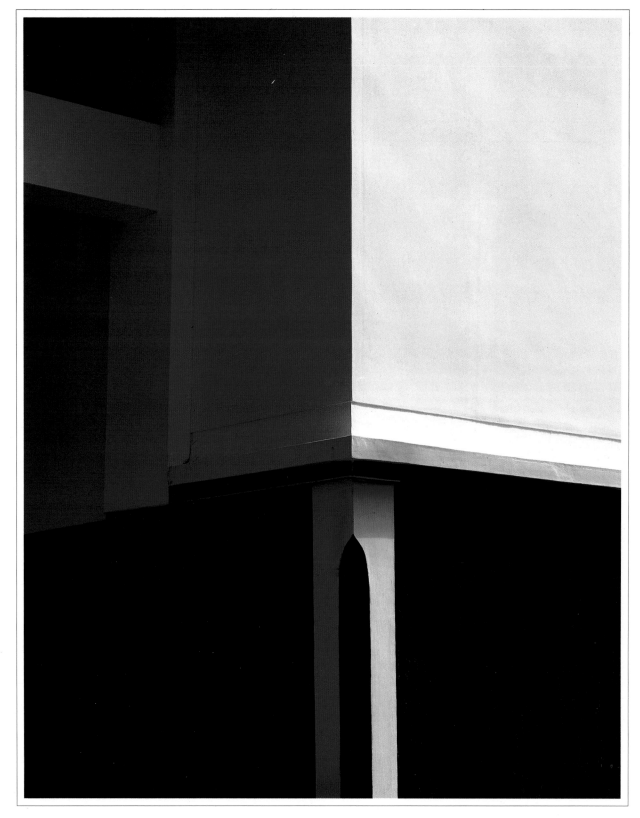

The black and white of a traditional storehouse wall appears classic and yet somehow modern.

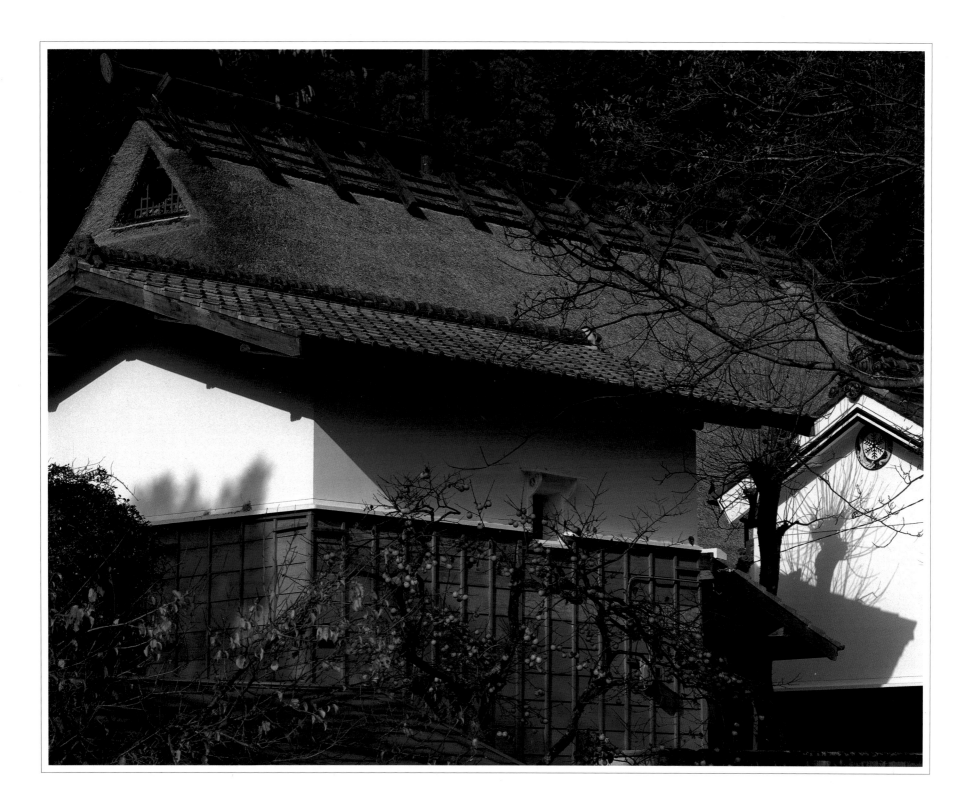

The Kumagais' house in autumn, its white walls dazzling in the bright sunlight.

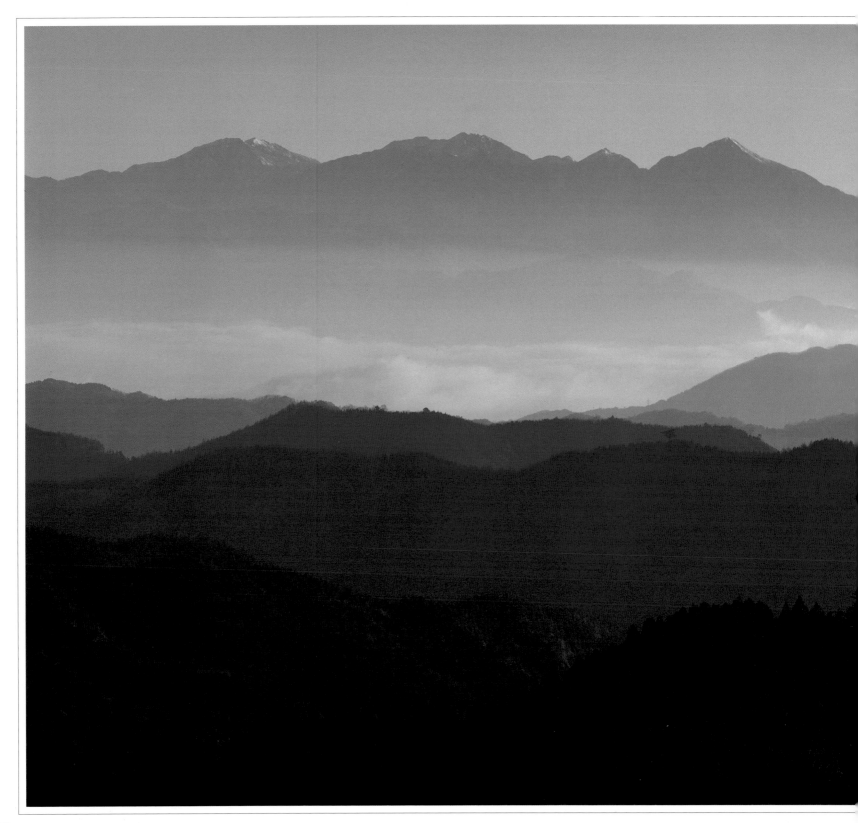

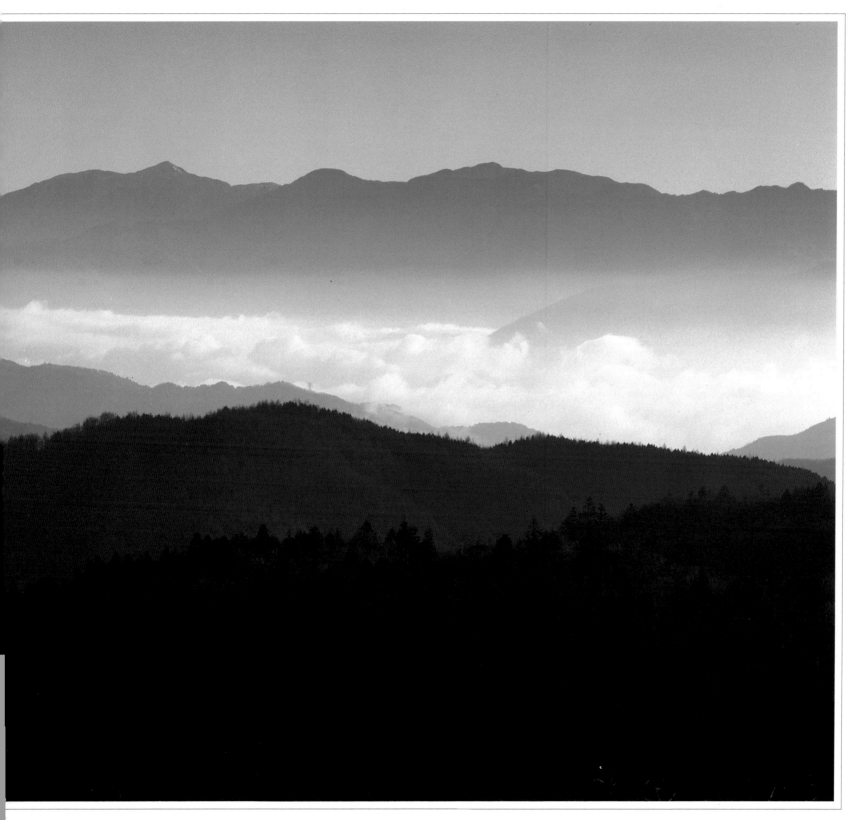

A mountain panorama. In the distance, Mt. Akaishi and other peaks of Japan's
Southern Alps.

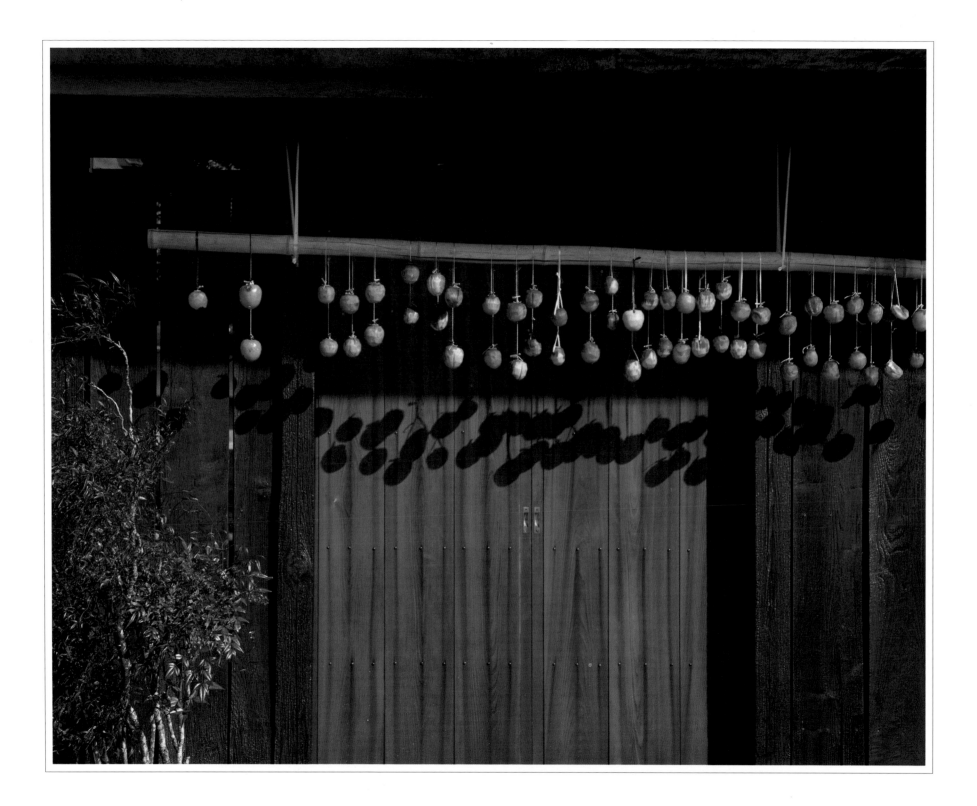

Patterns in the autumn sunlight. Persimmons drying under the eaves of a farmhouse.

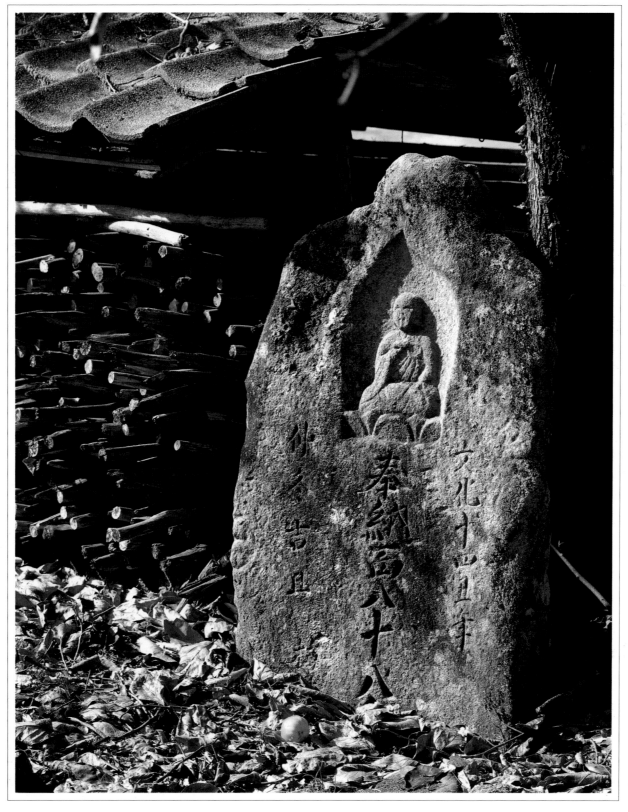

A roadside Buddhist image. Whether small or large, these stone carvings all gaze gently
at passing travellers.

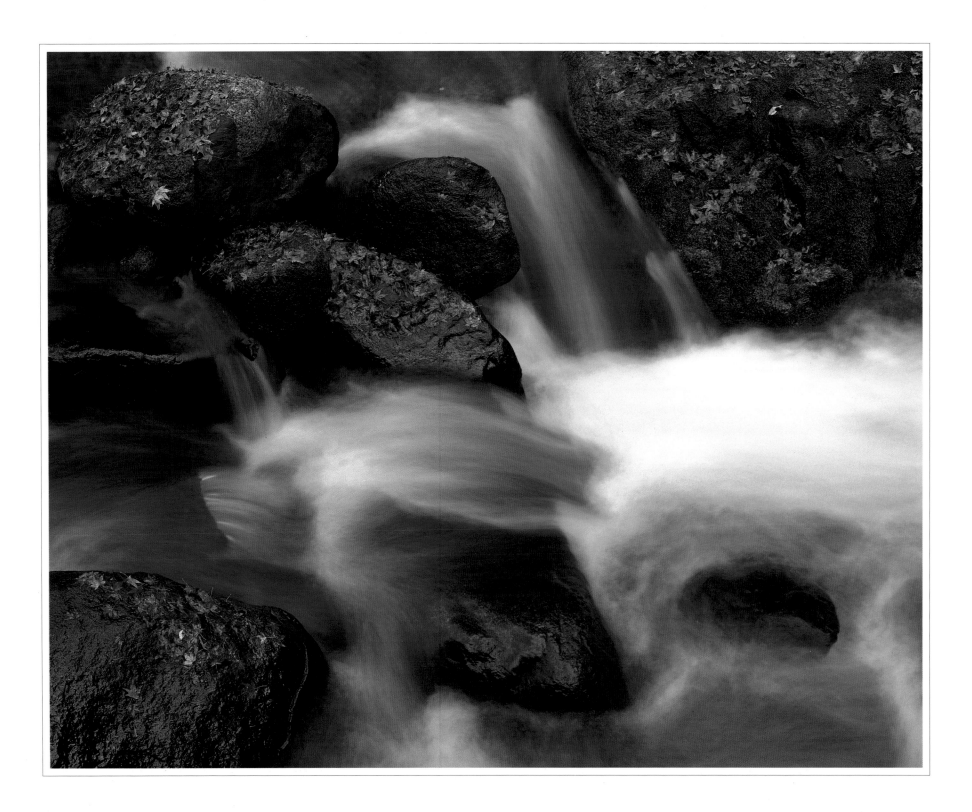

A silvery stream flows swiftly between dark rocks strewn with windblown maple leaves.

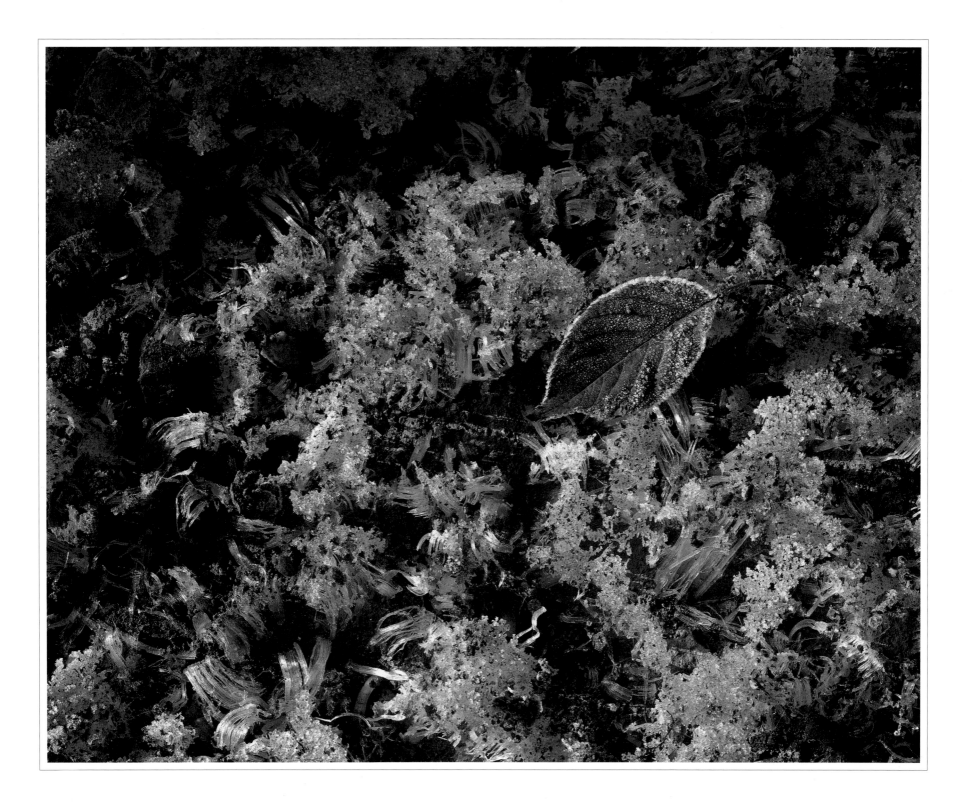

Morning frost. Crisp columns of frost lift a jewel-like leaf from the forest floor.

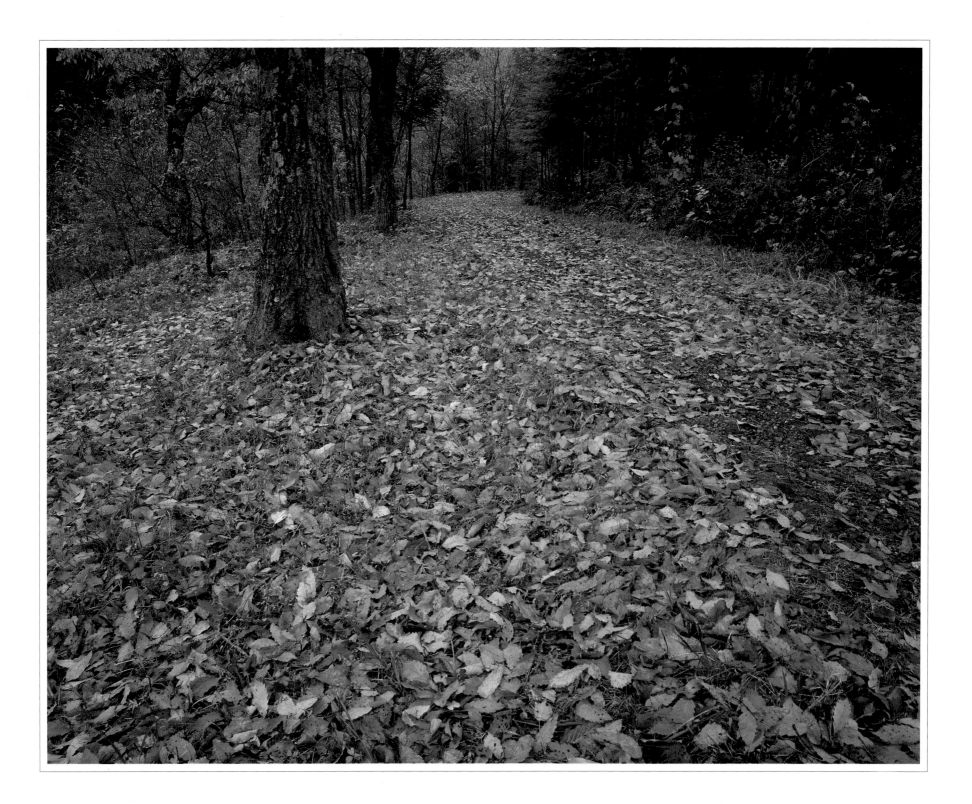

A leaf-carpeted path through one of the few mixed hardwood forests of the Okumikawa area.

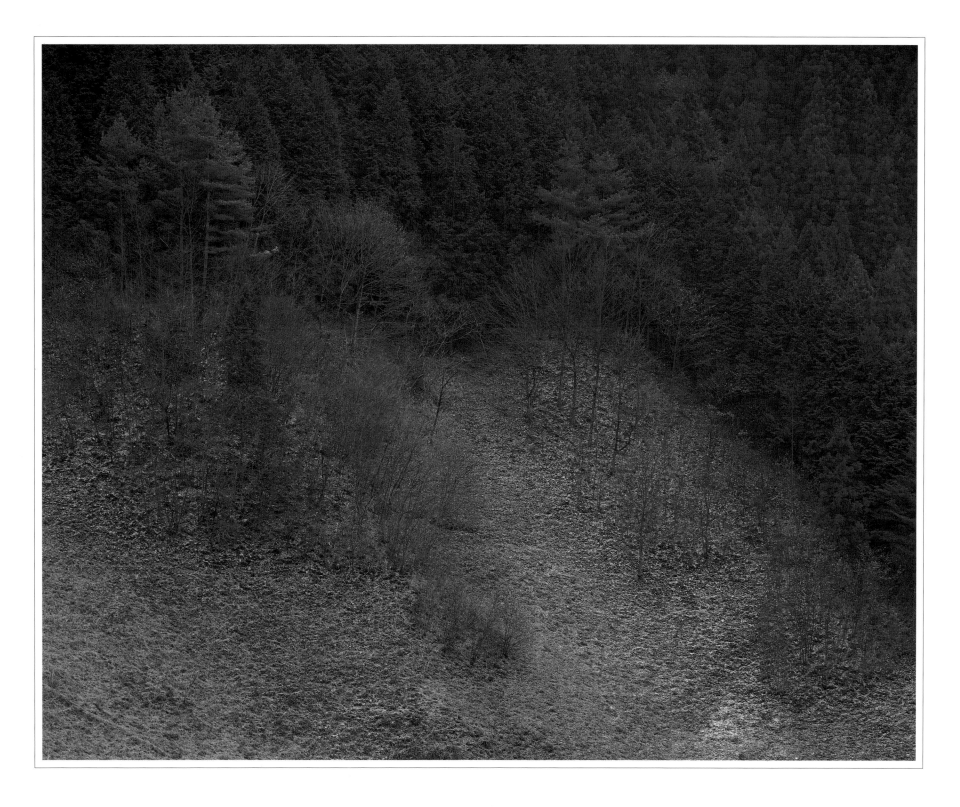

Fresh snow on a sparsely wooded mountainside. It is early winter, the loneliest season in
the mountain villages.

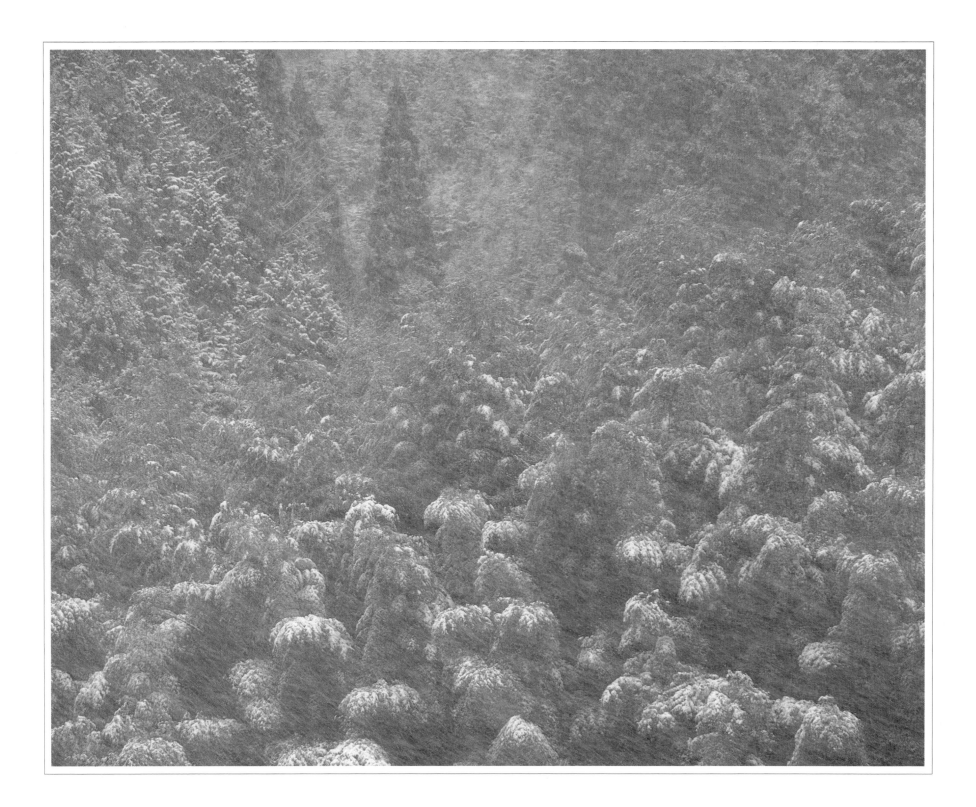

A driving mountain snowstorm. Such storms may start in the morning and last all day.

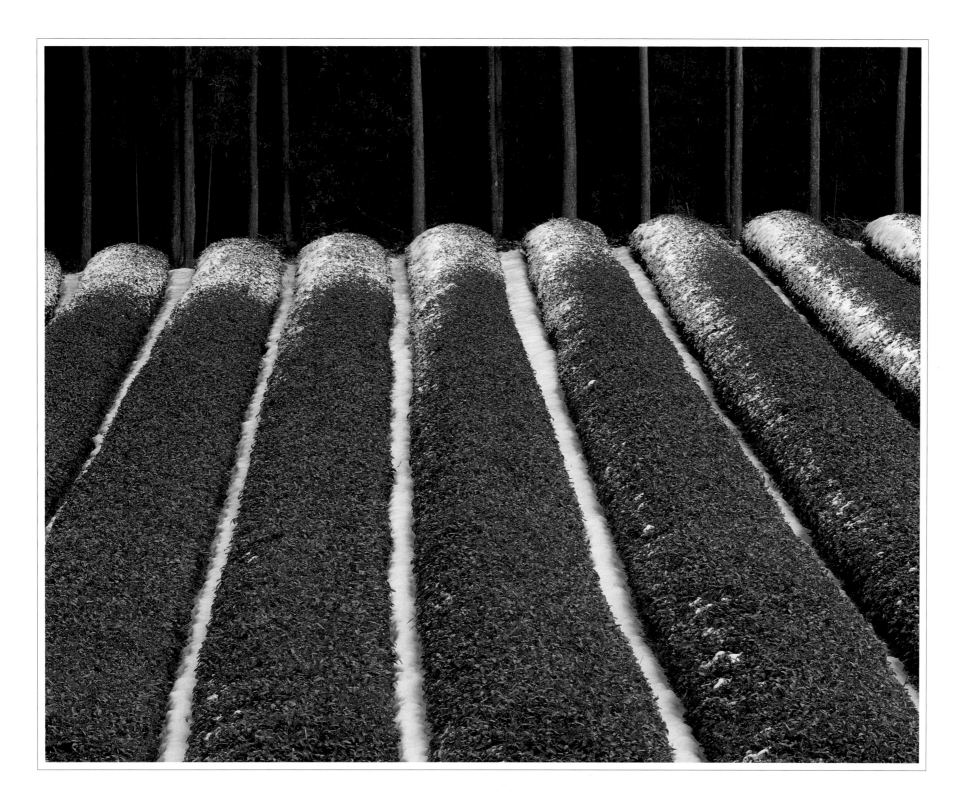

A tea plantation powdered with snow, transforming a drab winter scene into a natural art form.

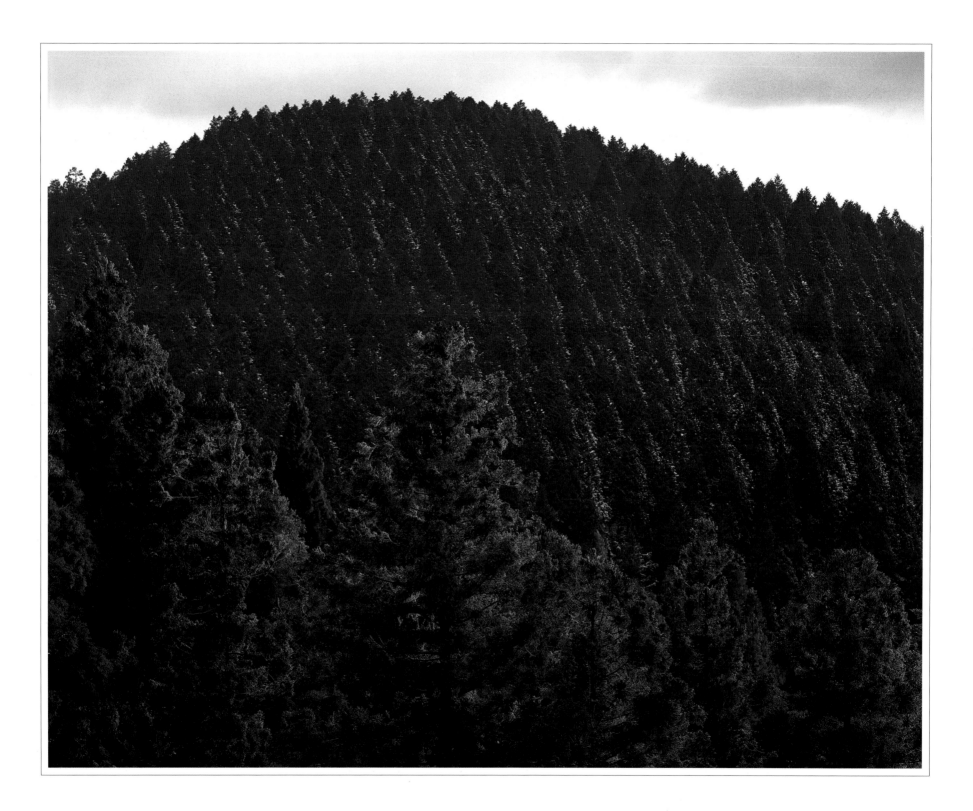

A cedar forest draped with fresh, frozen snow, clinging like hoarfrost on the frigid branches.

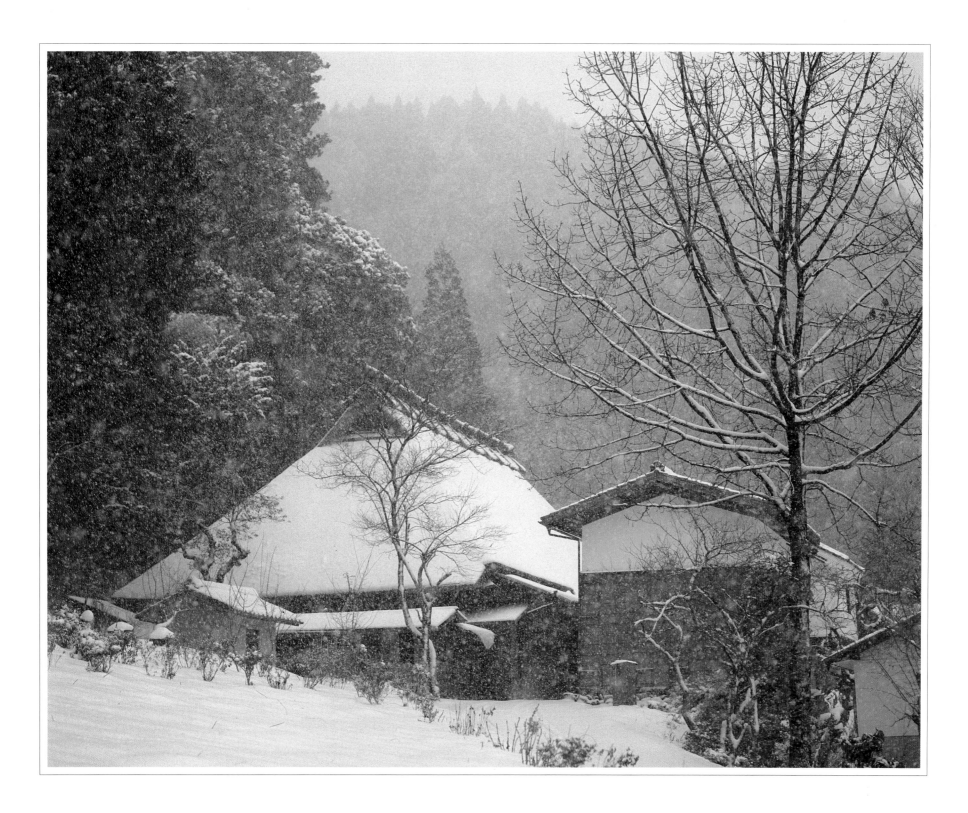

The Kumagais' house. Its beauty is set against a background of snow and cedar woods.

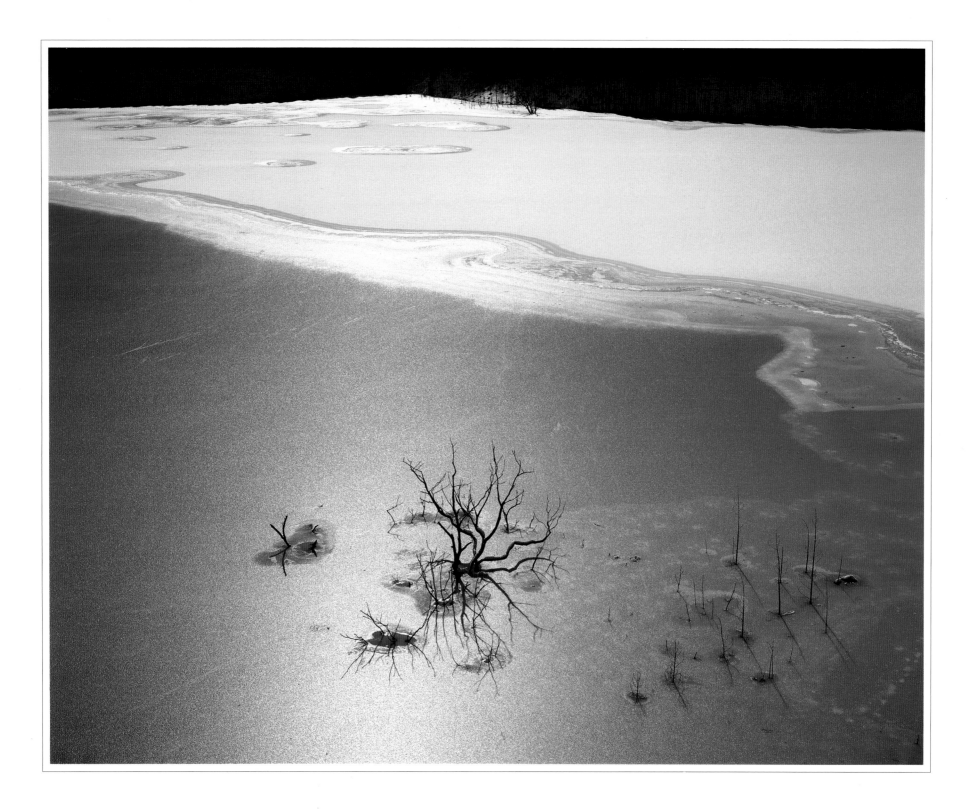

Lake Midori. The frozen lake's picture-like beauty will last even after the ice starts cracking up.

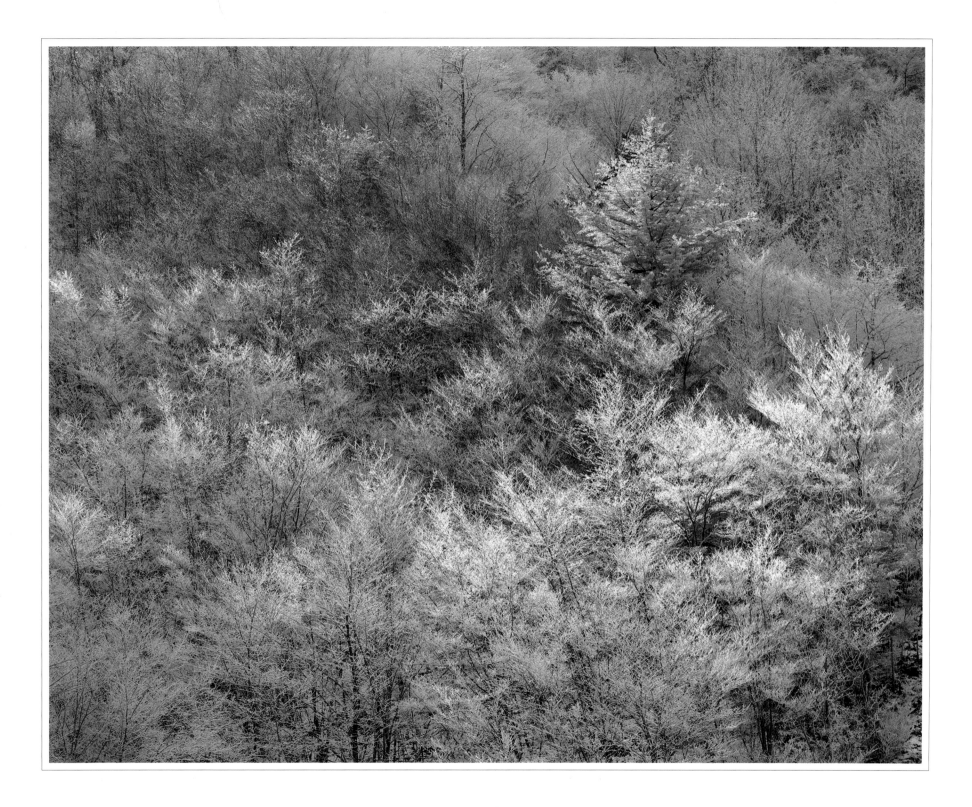

The silver thaw at Tengudana. Light and shadow on a lacy winter landscape.

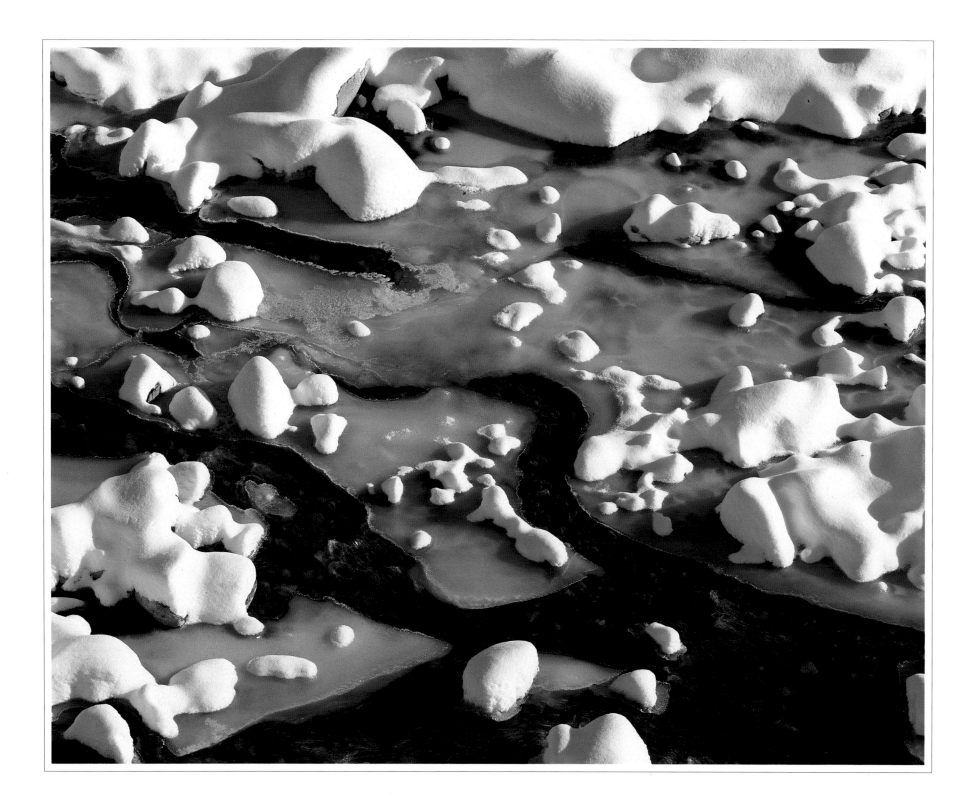

Snow-covered rocks in the Sakauba River. Mounds of pure white glistening in the soft morning sun.

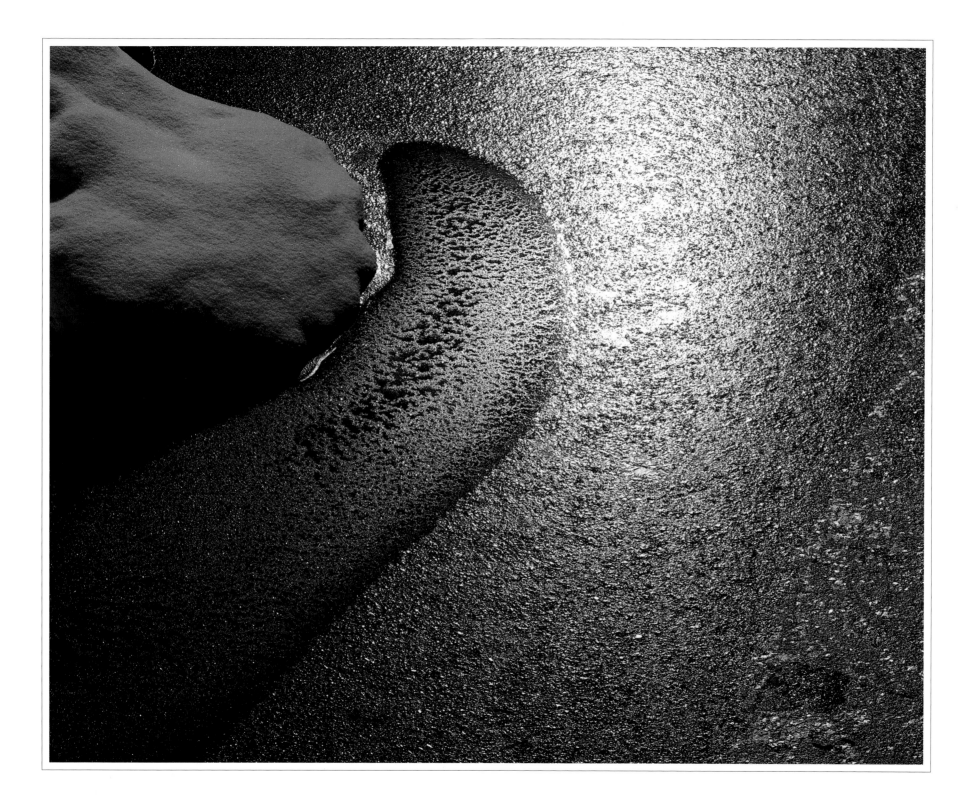

The Onyu River. Its frozen surface is a sparkling fantasy in the light of the newly-risen sun.

185

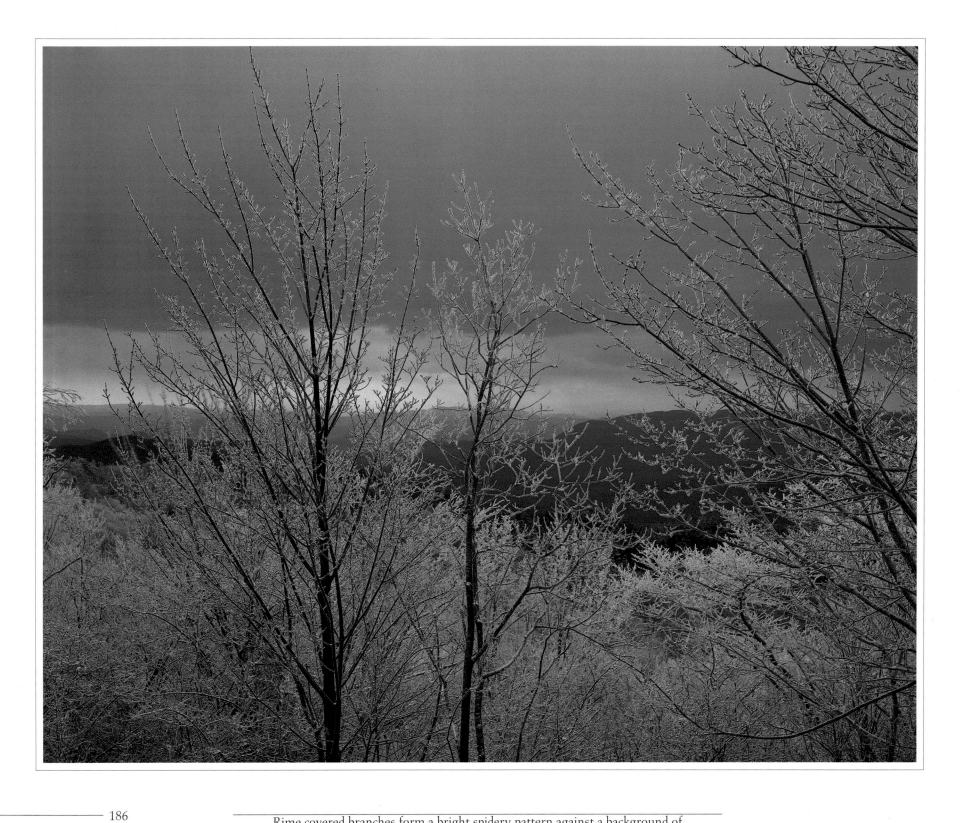

Rime covered branches form a bright spidery pattern against a background of distant mountains.

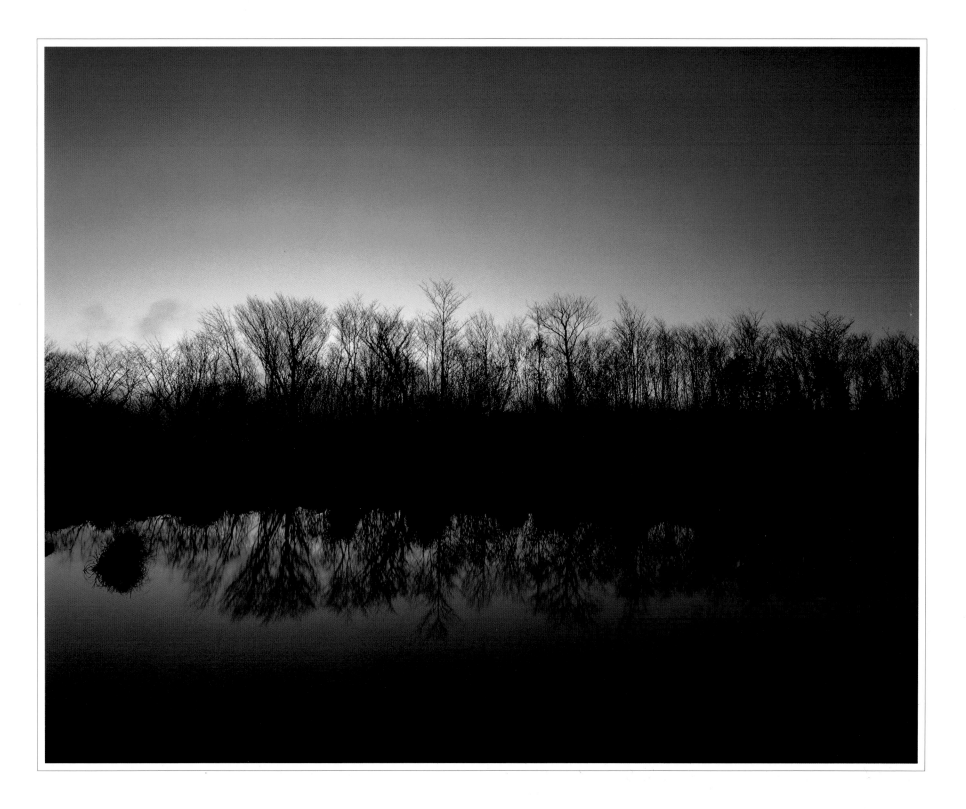

A forest of mixed hardwoods mirrored in a pond dyed by the rising sun.

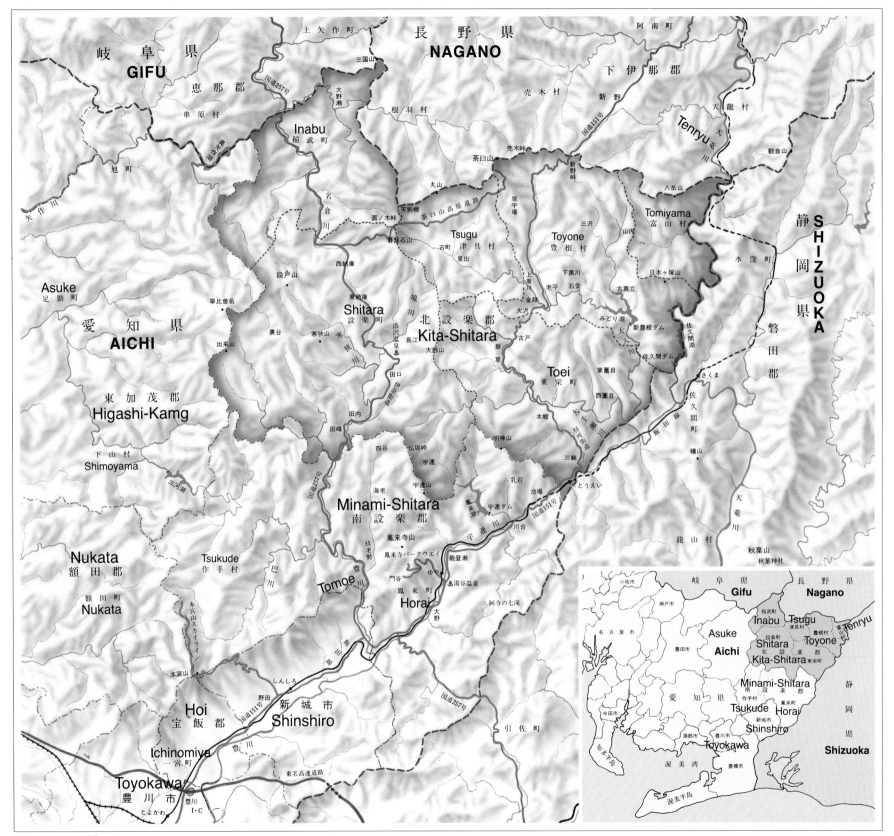

Illustration : Keiji Terakoshi

Afterword

Not many people know the exact location of Okumikawa or even what kind of place it is, and I myself had hardly any knowledge of this area until several years ago. There is no place called Okumikawa listed in any official administrative district. The area is usually called Eastern Mikawa or simply the north-east part of Aichi Prefecture. There is a Tenryu-Okumikawa Quasi-National Park, but this includes a large area along the Tenryu River which is outside the real Okumikawa. So when one mentions Okumikawa, few people really know what area is being talked about.

Then where is Okumikawa? Well, some people say it is the towns and villages of Shitara, Toei, Inabu, Toyone, Tsugu and Tomiyama; others include Asuke, Horai, Tsukude and Shinshiro.

I first passed through the area about fifteen years ago while on my way to Toyohashi in Aichi from Iida Nagano Prefecture. In subsequent years I occasionally travelled through the area on other trips, but since I was only passing through, I didn't pay much attention except to note that the roads were terrible. Perhaps it was my youth, but I found little to attract me in what seemed at the time to be uninspiring landscapes and ordinary mountain villages.

But about ten years ago I happened to meet Mr. Kenichi Kumagai, the head of the distinguished Kumagai family of Okumikawa, and through him I had several opportunities to revisit the area. I found myself gradually becoming interested in that same scenery which had once seemed plain and unattractive. Perhaps it was because at this time I came to sense something original, the characteristic charm of the Japanese countryside. My own boyhood was spent in a small town west of the Tokyo metropolitan area, and though it has greatly changed over the years, it was once a simple mountain village. In Okumikawa I found a place that brought nostalgic memories of my hometown and those days when, as a country boy, I chased wild birds through the fields. The more I visited Okumikawa, the more I was attracted to it, and my visits to the region became more frequent. For the last two years I have rented part of the Kumagai house and become almost a resident of the area.

I feel deep sorrow in noting here that Mr. Kumagai suddenly passed away just before the publication of this book which he had so eagerly awaited. I sincerely cherish the memory of Kenichi Kumagai and I am thankful for what he did for me. I would also like to express my sincere gratitude to Mr. Daikichi Irokawa who wrote the main text for this book and to the many people who helped bring the work to completion.

Shinzo Maeda

Photographic Data

103: Hasselblad 500C/M, Distagon 60mm F3.5, f11 1 sec.
104: Toyo Field 4 × 5, Fujinon 600mm F11, f32 1 sec.
105: Linhof Super Technika 4 × 5, Nikkor 150mm F5.6, f22 $^1/_{15}$
106: Hasselblad 500C/M, Sonnar 250mm F5.6, f32 $^1/_4$
107: Linhof Super Technika 4 × 5, Tele-Xenar 360mm F5.5, f32 $^1/_2$
108: Linhof Super Technika 4 × 5, Nikkor 210mm F5.6, f22 $^1/_{15}$
109: Linhof Super Technika 4 × 5, Fujinon 400mm F8, f16 $^1/_{30}$
110: Hasselblad 500C/M, Sonnar 250mm F5.6, f22 $^1/_{15}$
111: Linhof Super Technika 4 × 5, Fujinon 400mm F8, f22 $^1/_8$
112: Linhof Super Technika 4 × 5, Nikkor 150mm F5.6, f22 $^1/_{15}$
113: Linhof Super Technika 4 × 5, Fujinon 250mm F6.3, f22 $^1/_{60}$
114: Linhof Super Technika 4 × 5, Fujinon 400mm F8, f32 1 sec.
115: Linhof Super Technika 4 × 5, Fujinon 400mm F8, f32 $^1/_8$
116: Linhof Super Technika 4 × 5, Nikkor 210mm F5.6, f32 $^1/_4$
117: Toyo Field 8 × 10, Fujinon 600mm F11, f16 $^1/_{30}$
118: Hasselblad SWC, Biogon 38mm F4.5, f22 $^1/_8$
119: Linhof Super Technika 4 × 5, Super-Angulon 90mm F8, f32 $^1/_4$
120: Hasselblad 500C/M, Planar 100mm F3.5, f11 $^1/_{30}$
121: Linhof Super Technika 4 × 5, Tele-Xenar 360mm F5.5, f11 $^1/_{15}$
122: Linhof Super Technika 4 × 5, Fujinon 400mm F8, f32 $^1/_4$
123: Linhof Super Technika 4 × 5, Fujinon 400mm F8, f32 $^1/_4$
124: Toyo Field 8 × 10, Fujinon 300mm F5.6, f45 $^1/_2$
125: Toyo Field 8 × 10, Fujinon 600mm F11, f45 $^1/_2$
126: Hasselblad 500C/M, Planar 100mm F3.5, f22 $^1/_8$
127: Linhof Super Technika 4 × 5, Tele-Xenar 360mm F5.5, f22 $^1/_4$
128: Toyo Field 4 × 5, Fujinon 600mm F11, f45 $^1/_4$
129: Linhof Super Technika 4 × 5, Fujinon 125mm F5.6, f22 $^1/_{15}$
130: Linhof Super Technika 4 × 5, Fujinon 400mm F8, f16 $^1/_{30}$
131: Linhof Super Technika 4 × 5, Super-Angulon 90mm F8, f16 1 sec.
132: Linhof Super Technika 4 × 5, Fujinon 250mm F6.3, f22 $^1/_{15}$
133: Hasselblad 500C/M, Sonnar 150mm F4, f8 $^1/_{60}$
134: Linhof Super Technika 4 × 5, Nikkor 150mm F5.6, f22 $^1/_{15}$
135: Hasselblad 500C/M, Sonnar 150mm F4, f16 $^1/_{30}$
136: Linhof Super Technika 4 × 5, Fujinon 400mm F8, f11 30 sec.
137: Linhof Super Technika 4 × 5, Nikkor 150mm F5.6, f5.6 5 sec.
141: Hasselblad 500C/M, Sonnar 250mm F5.6, f22 $^1/_{15}$
142: Linhof Super Technika 4 × 5, Nikkor 210mm F5.6, f22 $^1/_8$
142: Linhof Super Technika 4 × 5, Nikkor 210mm F5.5, f22 $^1/_{15}$
144: Hasselblad SWC, Biogon 38mm F4.5, f22 $^1/_{15}$
145: Hasselblad SWC, Biogon 38mm F4.5, f22 $^1/_4$
146: Toyo Field 8 × 10, Nikkor 210mm F5.6, f22 6 sec.

148: Hasselblad SWC, Biogon 38mm F4.5, f16 $^1/_{60}$
149: Linhof Super Technika 4 × 5, Fujinon 400mm F8, f22 $^1/_{30}$
150: Toyo Field 8 × 10, Fujinon 300mm F5.6, f45 $^1/_2$
151: Toyo Field 4 × 5, Fujinon 600mm F11, f32 $^1/_8$
152: Hasselblad 500C/M, Sonnar 150mm F4, f22 $^1/_8$
153: Linhof Super Technika 4 × 5, Nikkor 210mm F5.6, f32 $^1/_2$
154: Hasselblad 500C/M, Sonnar 150mm F4, f16 $^1/_{30}$
155: Hasselblad 500C/M, Sonnar 150mm F4, f16 $^1/_{30}$
156: Linhof Super Technika 4 × 5, Fujinon 400mm F8, f22 $^1/_{30}$
157: Hasselblad 500C/M, Sonnar 250mm F5.6, f22 $^1/_{30}$
158: Hasselblad 500C/M, Sonnar 250mm F5.6, f32 $^1/_2$
159: Linhof Super Technika 4 × 5, Nikkor 150mm F5.6, f22 $^1/_{15}$
160: Linhof Super Technika 4 × 5, Tele-Xenar 360mm F5.5, f8 $^1/_{60}$
161: Linhof Super Technika 4 × 5, Tele-Xenar 360mm F5.5, f16 $^1/_8$
162: Linhof Super Technika 4 × 5, Nikkor 210mm F5.6, f22 $^1/_8$
163: Hasselblad 500C/M, Tele-Tessar 500mm F8, f22 $^1/_4$
164: Linhof Super Technika 4 × 5, Fujinon 250mm F6.3, f32 $^1/_4$
165: Linhof Super Technika 4 × 5, Fujinon 250mm F6.3, f22 1 sec.
166: Toyo Field 8 × 10, Fujinon 300mm F5.6, f45 $^1/_2$
167: Hasselblad 500C/M, Distagon 60mm F3.5, f5.6 1 sec.
168: Linhof Super Technika 4 × 5, Fujinon 250mm F6.3, f32 $^1/_4$
169: Linhof Super Technika 4 × 5, Fujinon 400mm F8, f32 $^1/_2$
170: Toyo Field 8 × 10, Fujinon 600mm F11, f32 $^1/_4$
172: Linhof Super Technika 4 × 5, Tele-Xenar 360mm F5.6, f22 $^1/_8$
173: Linhof Super Technika 4 × 5, Tele-Xenar 360mm F5.6, f32 $^1/_4$
174: Linhof Super Technika 4 × 5, Nikkor 210mm F5.6, f22 1 sec.
175: Linhof Super Technika 4 × 5, Nikkor 210mm F5.6, f22 $^1/_4$
176: Linhof Super Technika 4 × 5, Super-Angulon 90mm F8, f32 1 sec.
177: Linhof Super Technika 4 × 5, Fujinon 400mm F8, f22 1 sec.
178: Hasselblad 500C/M, Tele-Tessar 500mm F8, f22 1 sec.
179: Linhof Super Technika 4 × 5, Fujinon 400mm F8, f32 $^1/_2$
180: Linhof Super Technika 4 × 5, Fujinon 400mm F8, f22 $^1/_2$
181: Hasselblad 500C/M, Distagon 60mm F3.5, f11 $^1/_{30}$
182: Linhof Super Technika 4 × 5, Super-Angulon 90mm F8, f22 $^1/_{15}$
183: Linhof Super Technika 4 × 5, Fujinon 400mm F8, f22 $^1/_{15}$
184: Toyo Field 4 × 5, Fujinon 600mm F11, f22 $^1/_{15}$
185: Linhof Super Technika 4 × 5, Fujinon 400mm F8, f22 $^1/_{30}$
186: Linhof Super Technika 4 × 5, Fujinon 125mm F5.6, f16 $^1/_8$
187: Hasselblad SWC, Biogon 38mm F4.5, f8 1 sec.

Film: Ektachrome, Fujichrome

Contents

The | Kamikochi
Nippon
Alps

The | Kamikochi
Nippon
Alps

Photographs
by
Shinzo Maeda

Foreword

My first visit to Kamikochi was more than fifty years ago. I had started out on a mountain climbing trip beginning at Eboshi and ended up walking the rocky slopes of Hotaka. As I descended toward that paradise we call Kamikochi, I could see below me the mirror-like waters of Taisho Pond. When I reached Dakesawa, I was caught in a shower, but after the rain ceased, the mountain birds began singing their many songs in the woods which now glistened with a myriad of raindrops. I felt as if those shining raindrop ornaments and those bird songs were meant for me. Today, looking back, it is embarrassing to realize how foolish I was in thinking that all that beauty was just for me. But I was so very happy and that is how it seemed at the time. That all happened in the distant days before so many busses and private cars began driving around the Kamikochi area, but the memory remains vivid to this day.

I don't know how many times I have visited Kamikochi since then. I have gone there in the early spring when the frozen snow still remains all around, I have spent long summers camping out in the woods, and sometimes I have visited that lovely area during icy winters when cold winds rolled up and flung about the powdered snow. But perhaps this is not the place to dwell upon details of all those memories.

Most of my Kamikochi memories seem to be concerned with mountain climbing. When the weather held up, we always wanted to go

on with a climb after a brief rest at Kamikochi, but if there was a long spell of rainy weather we would extend our stay, and it was always hard to leave the place and resume our trek. Kamikochi was such a "luxurious" and beautiful base that we just had to linger there for a few days. In my mind, I owned the place and looked upon it as my own private base camp. For that reason I felt very possessive.

In the beginning of the winter of 1983, Shinzo Maeda sent me a book of his photographs, and enclosed was a note saying that he was working on a soon to be completed series of photos of the Kamikochi area. When I read the note, I wondered just what kind of scenery there would be in his book on Kamikochi. I had not visited the region for some time and I wondered about how time might have altered the place. I had heard, for example, that Taisho Pond was quite changed and that only a few dead trees still stood in its waters. One thing, however, I was sure of; Mr. Maeda's photographs would, as always, reveal scenes of beauty that no one had ever noticed before. Beyond that thought, I could not imagine what the book would be like. I decided to stop guessing and just wait for the book to be published. Then, when I had a copy, I would savor it in a leisurely way, enjoying the breathtaking surprises that I knew awaited me.

And what surprises they were. I have always believed I understood and loved Kamikochi very deeply, and have felt a jealousy, perhaps even some resentment over the ever-growing number of sightseeing groups which come to the area. Now, after looking at Mr. Maeda's book, I feel somewhat abashed by the realization that I never completely comprehended the true beauty of Kamikochi. The lovely photographs I have looked at are almost like an admonition for the incompleteness of my love.

Looking at a thing can be a simple act but what we perceive may have endless depths. Some people have a genius for probing those endless depths. Such a man is Shinzo Maeda, and I can't help being envious of his incredible perception.

Over the years I have written various pieces for books of photography, and I enjoy the work because it is constantly stimulating, often in unexpected ways. I have written some of my short articles to accompany Mr. Maeda's photographs. On each occasion, and regardless of the quality of my own work, I end up feeling refreshed and stimulated. Maeda's work leaves me overflowing with a kind of nostalgia for the world of nature revealed in his photographs. I won't try to explain why I respond in this way. Perhaps my emotional response is so intense because it is not diluted by any real technical knowledge of photography. Whatever the reason, I am sure that everyone who looks at this book will share some of my feelings of nostalgia and wonder.

Magoichi Kushida

Kamikochi Past and Present

Kamikochi is part of Azumi Village, my home in Nagano Prefecture. It lies in a flat, narrow basin 1500 meters above sea level and is situated along the Azusa River. The area is somewhat like the inner room of a house. Rising to the north are the Hotakas, a mountain wall 3000 meters high, and to the south, Mt. Yake looms on the horizon, its volcanic cone still puffing plumes of white smoke. Between these peaks flows the clear Azusa; scattered over the landscape are such ponds as Myojin, Tashiro and Taisho.

This is typical mountain scenery, dominated by high peaks and forest-covered slopes, laced with brooks and streams and punctuated here and there with ponds and lakes. The area, famous for its hot springs and as a summer resort, has become a center for sightseeing and mountain climbing in the national parks of Japan's central mountain ranges. However, in the Edo Period, Kamikochi was a village of woodcutters, and for many years the forest resources of the area brought great benefit to the local people.

During those feudal times, Kamikochi was under the rule of the Matsumoto clan and the timber cut in its virgin forests was floated down the Azusa River to the villages below. Logging was, of course, a summer job, one completed before the onset of winter. In those days, the winter forests were still as hushed as in their primeval age, the silence disturbed only rarely by the activity of a small number of local hunters.

There are historical records of this period – documents, a sketchy map of Kamikochi, some drawings and paintings – but there is no logging today, and all cutting has been prohibited in order to preserve the beauty of the forests and surrounding area. These are times when people think of protecting nature, and the preservation of Kamikochi's forests, the conservation of its natural beauty, are things we can all be grateful for.

Outsiders have become familiar with Kamikochi only in relatively recent years. The area had always been the domain of local woodcutters and hunters. In the old days, a road connected Hida and the Hokuriku region with the Shinshu district and the Pacific coast, so there was some coming and going of people and freight, but the road was not open for many years and logging operations ended after the Meiji Restoration.

The first exploration of this ancient and almost unknown land came at the end of the 19th century, and the man who carried it out was not Japanese, he was a British missionary by the name of Walter Weston. In August of 1891, Weston and three guides and porters trekked up to Kamikochi on a seldom used logging road called Shimashimadani. Weston, who had mountaineering experience in the Swiss Alps, was a pioneer in the climbing of the Japanese Alps and peaks in other parts of Japan. He was instrumental in the formation of The Japanese Alpine club, and his book "Mountaineering and Exploration in the Japanese Alps", published in London in 1896, is known as the first book to introduce the Japanese Alps to the world. Weston's memory is still honored on a plaque which The Japan Mountain Climbing Association placed by the banks of the Azusa River, and each year on the first Sunday of June, the local people and visitors to Kamikochi hold a Weston Festival.

Weston, however, was not the person who gave the Japan Alps their name, nor was he, in fact, the first foreigner in the area. That honor must be given to another Englishman, William Gowland, a technician in the employ of the Osaka Mint, who reached Kamikochi by the main route some thirteen years earlier than Weston. Therefore, while Weston is the man whose name is most prominently associated with Kamikochi, it is only fair that Gowland be remembered for his earlier arrival on the scene.

In 1894, Shigetaka Shiga, a Japanese geographer, published his book "Impressions of Japanese Scenery" and in the years that followed,

mountain climbing gained full recognition as an outdoor sport in Japan. In 1902, Usui Kojima, apparently influenced by Shiga's book, travelled to Kamikochi and successfully made the ascent of Mount Yari. In succeeding years, many writers visited Kamikochi, including such people as Juji Tabe, Matsujiro Kammuri, Ryunosuke Akutagawa, Genjiro Yoshida, Kotaro Takamura, Shinobu Origuchi, Utsubo Kubota and Bokusui Wakayama. Each, in his own way, was impressed by the area, but perhaps the best writing on Kamikochi that has come from these men is the poetry of Bokusui Wakayama. In September 1921, Wakayama stopped at Kamikochi on the way down from the Shirahone Hot Springs. As he walked alone along the dry riverbed, he was deeply moved by the sight of Mt. Hotaka, Mt. Roppyaku and the other lofty peaks surrounding them, and from that autumn visit have come these poems.

This view, this beauty
A tear unbidden
Creeps into my eye

My stay is short
But I shall return to this place
If only my life is long enough

Such beauty
Gazing upon it
I hope my years are many

Before me the evening sun
Upon the parapets of Mt. Hotaka
Rising clouds drift back and forth

Such are the feelings captured by the sensitive mind of a poet. At present, Kamikochi attracts visitors only in the summer, but at the peak of the season, there are thousands of visitors. These people come not only for sightseeing or mountain climbing; surely some of them are attracted by the almost spiritual atmosphere of the area. And, if this is so, they should come to Kamikochi in other seasons. Many people struggle to exist and find meaning in this world, those, for one example, who seek understanding through Zen meditation. For such people, one winter at Kamikochi can be a precious experience. But there is hardly anyone to be seen at Kamikochi in the winter. Perhaps a caretaker or two from local inns, but no one else is on the streets of the village. Everyone is inside. This is a season of loneliness in the heavens and on the earth; nothing exists but a world of white and the starry lights that cross in the darkness of the sky.

In the old days, winter was the hunting season in Kamikochi, and the local men went after serow, the native mountain goat. Today the area is a nature protection area, a reserve dominated by those mountain goats, badgers, sable and other wild creatures. There has been, of late, a surge in the popularity of winter mountain climbing, so more young people now come to Kamikochi, but no matter how well-equipped they are, these "civilized" human beings appear strange and out of place in contrast with the wild creatures which now, especially in winter, boldly roam about as if they own the whole region. What a pity that the wild loveliness of Kamikochi's winters has been, at least until now, so sadly unappreciated.

Atsumi Yokoyama
Local Historian

From Spring to Summer

Everything in sight has a refreshing color and brightness; every sound is a song of joy, the celebration of a new life.
It is breathtaking to witness nature when she is in a mood to proudly display herself.
At such moments, man, whose daily life is enmeshed in the complexities of the modern world, suddenly recalls the purity and gentleness of nature, enjoys the silence of it all.
It is then that there comes a feeling of moving with the rhythm of other living things; we are flushed with a pleasant sense of intoxication.
As the seasons move on, the warmth and power of the sun gradually increases, enriching the earth's pale greens.
The verdure deepens, sparkles, grows stronger day by day.
And each morning the leaves frolic with the drifting mists.
Now the mountain ranges begin to shed the rich layers of snow on their slopes; they stand on tiptoe, displaying naked trembling breasts and shoulders.
Flights of chirping birds wheel and flit about with seemingly boundless energy.
Below them, the brooks and streams sing their gently modulated songs.
These things are an overflowing, a rejuvenation on the brink of a climax.
They are eyes searching, ears longing for the sound of a distant bell.

Magoichi Kushida

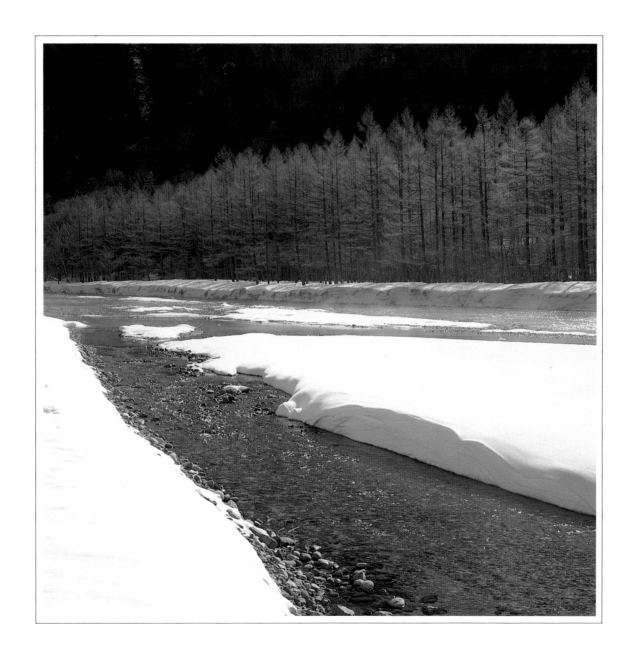

The radiance of early spring

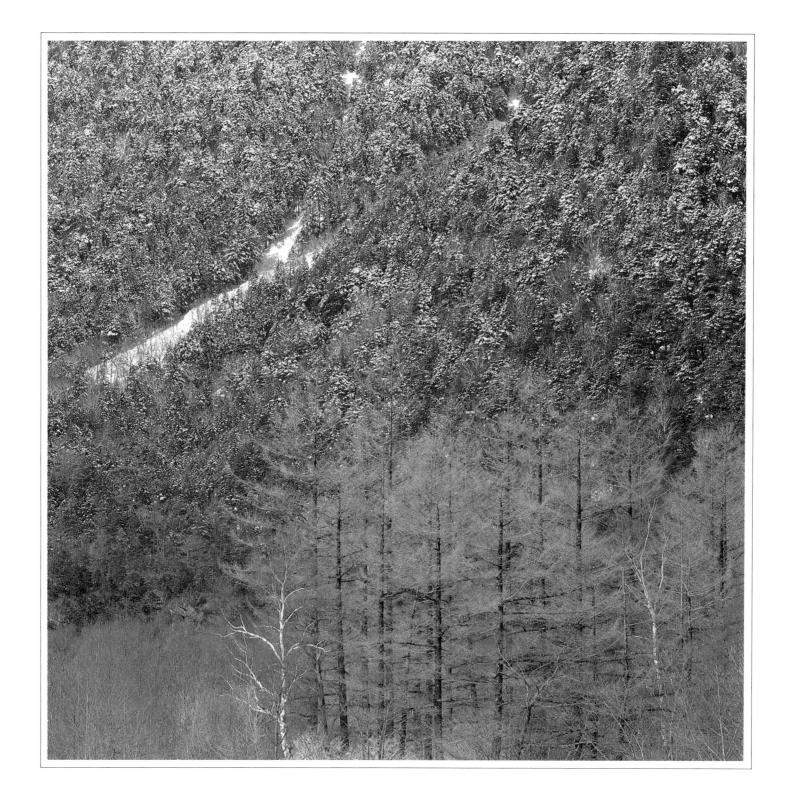

The first breaths of spring

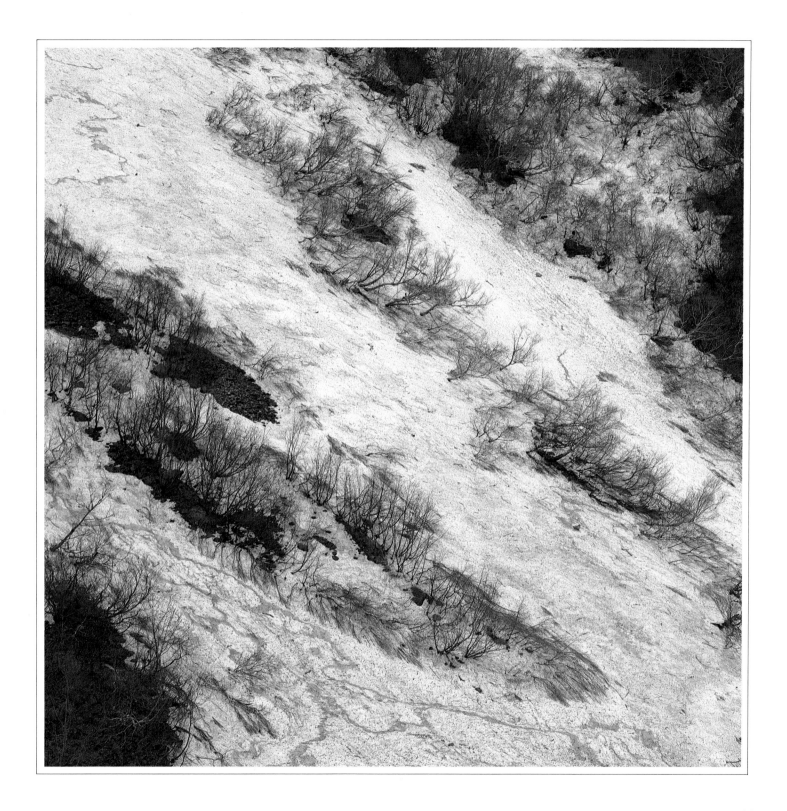

Where snow remains in fleeting patterns

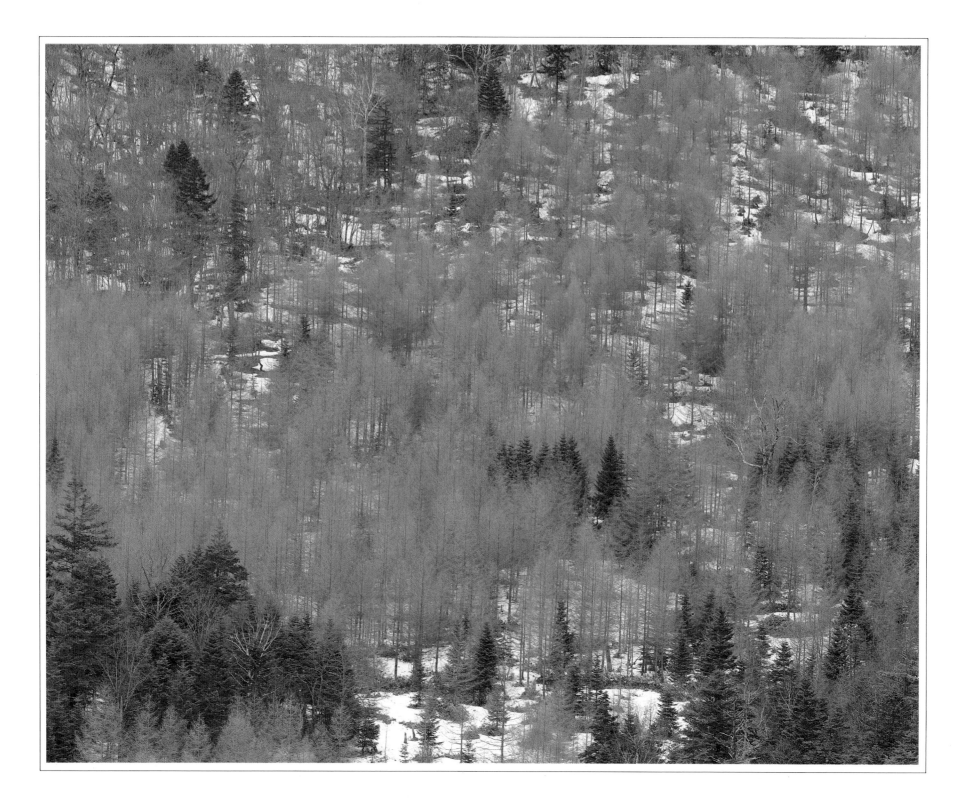

Spring draws near

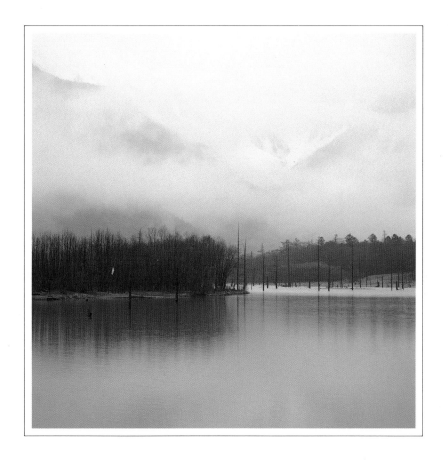

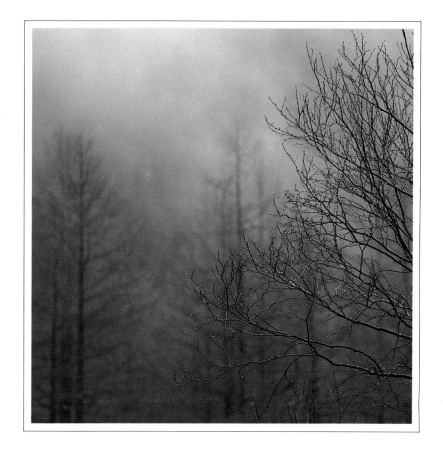

Rain on Taisho pond Treetops in early spring

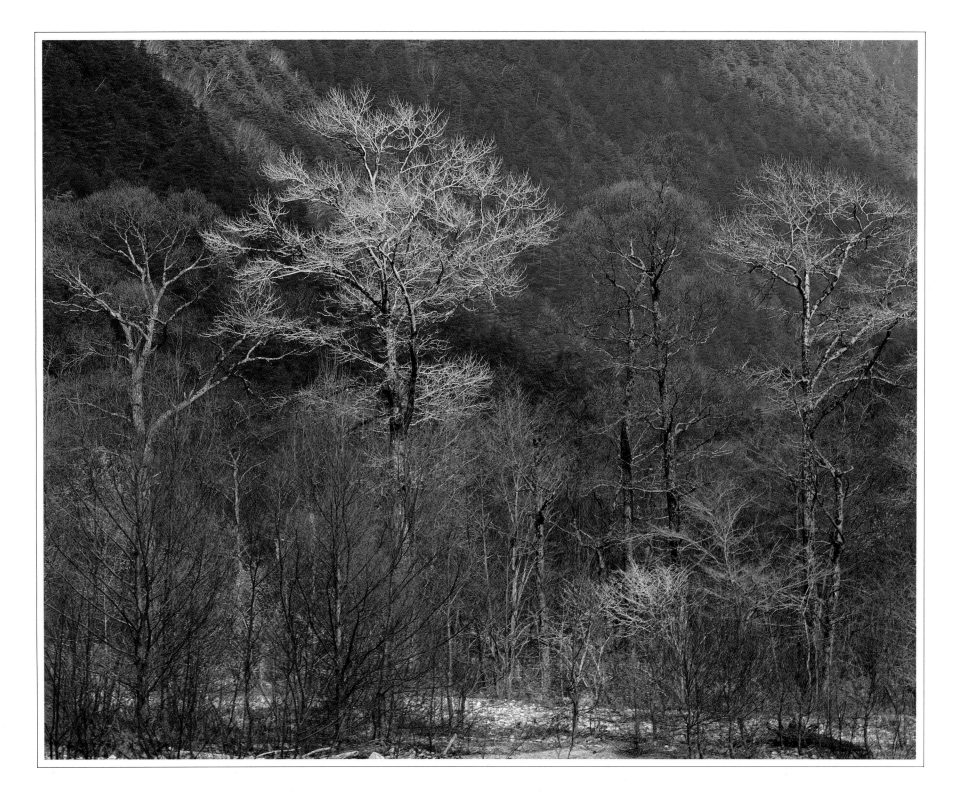

Spring's first young buds

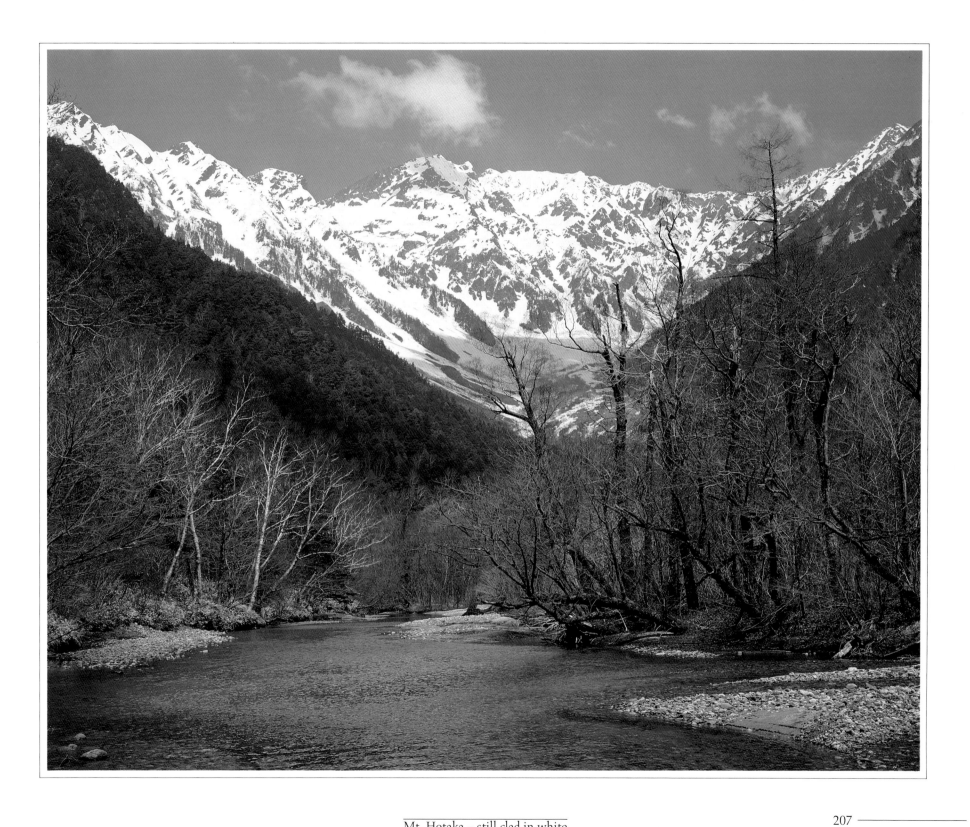

Mt. Hotaka – still clad in white

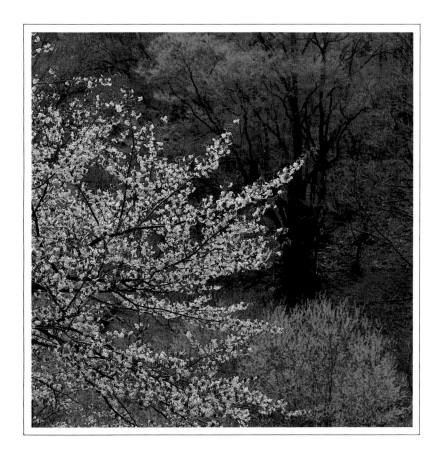

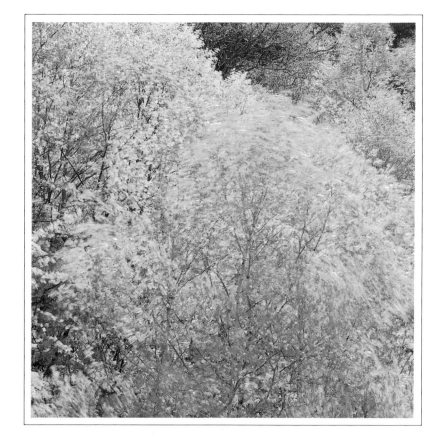

Mountain cherry blossom

Green breezes, gently blowing

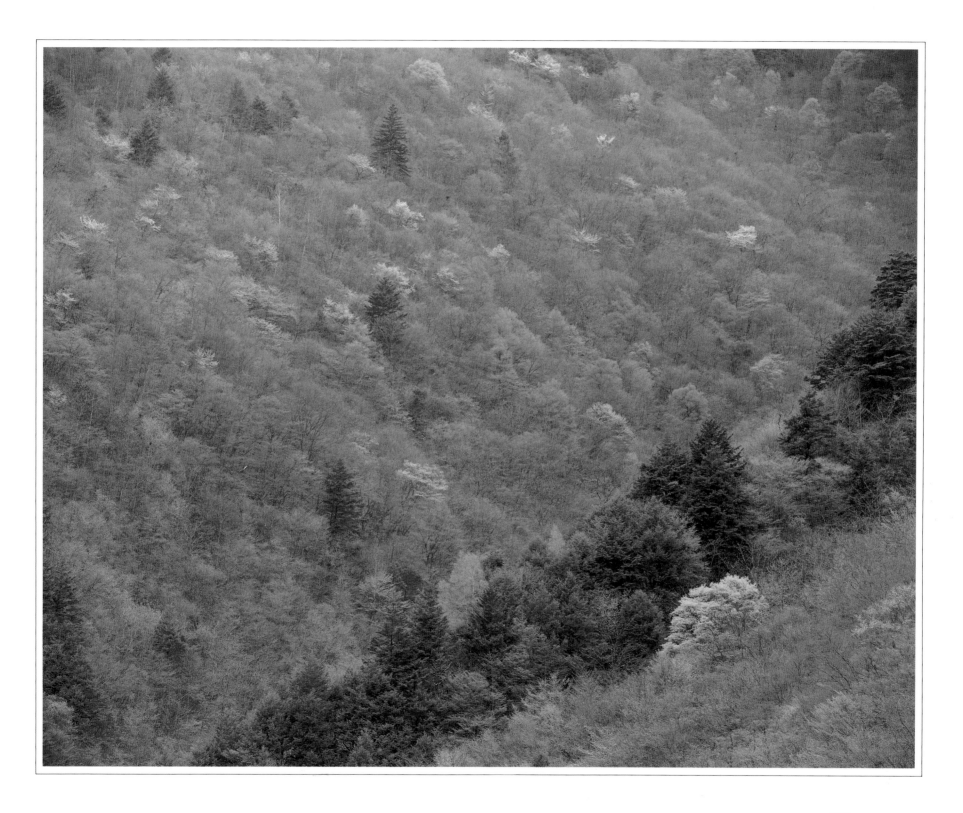

The serenity of a mountain spring

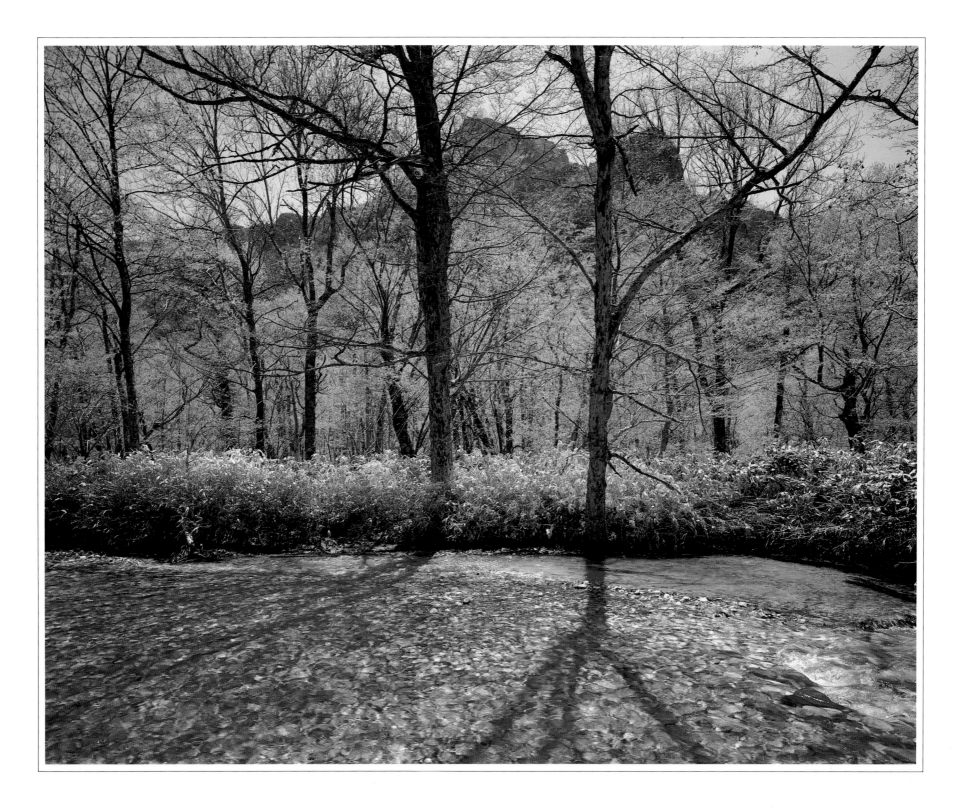

Mt. Roppyaku beyond the woods

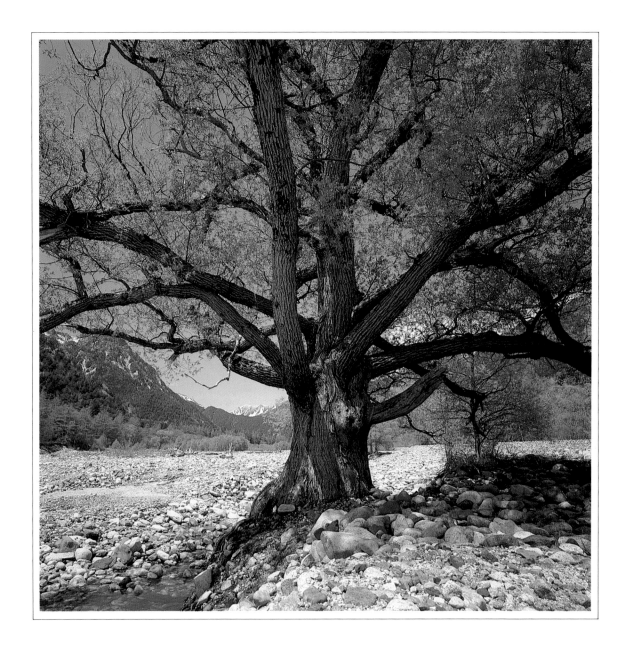

A stately tree by a river bed

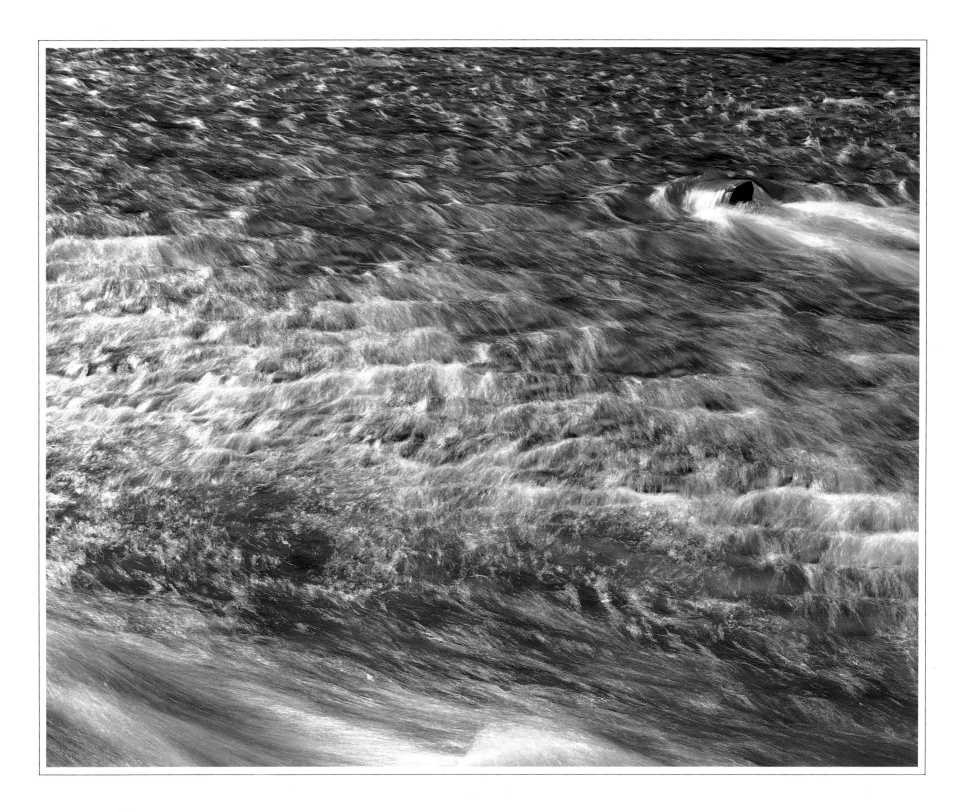

Rippling patterns of light on the Azusa

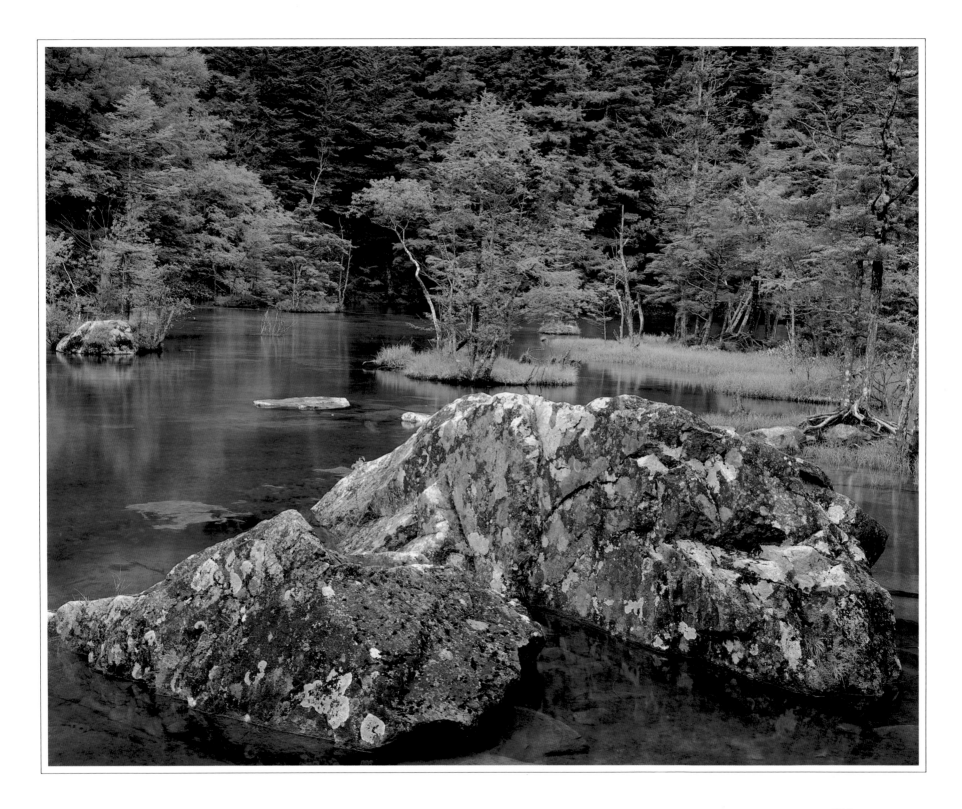

The tranquility of Myojin pond

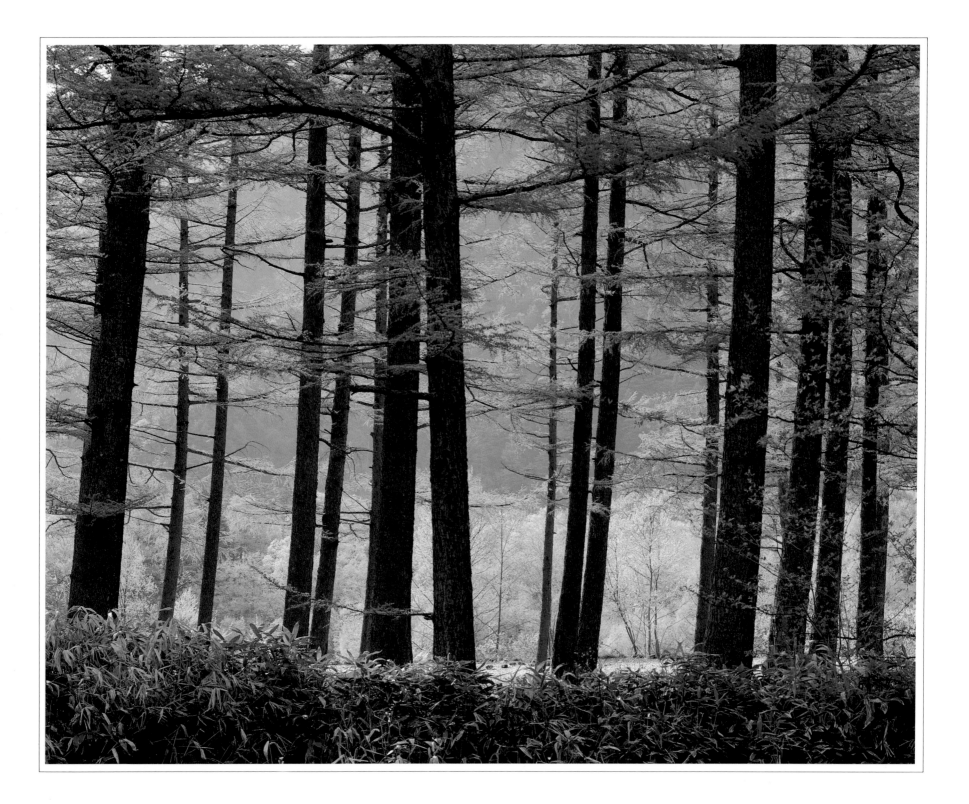

Sunlight and a shady glade

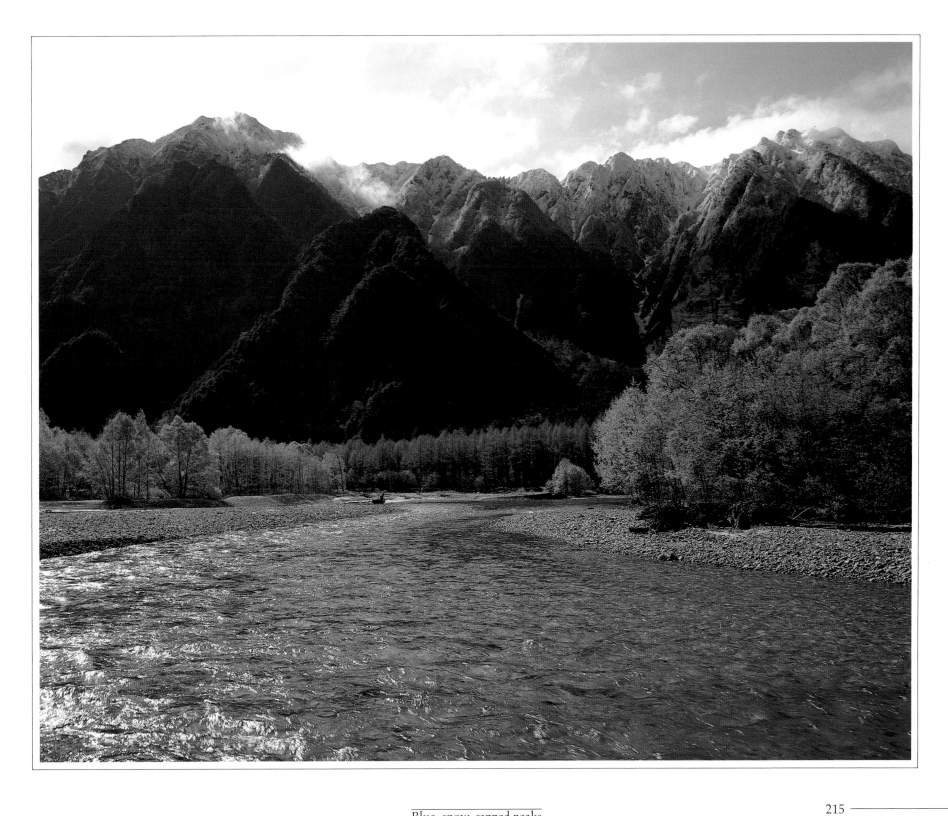

Blue, snow-capped peaks

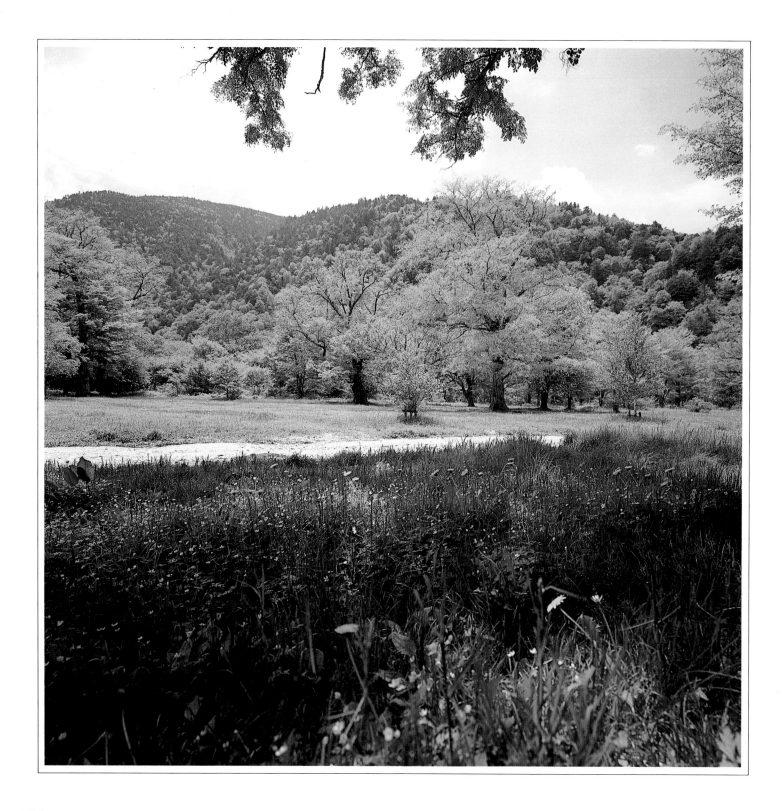

The verdant banks of the Tokusawa

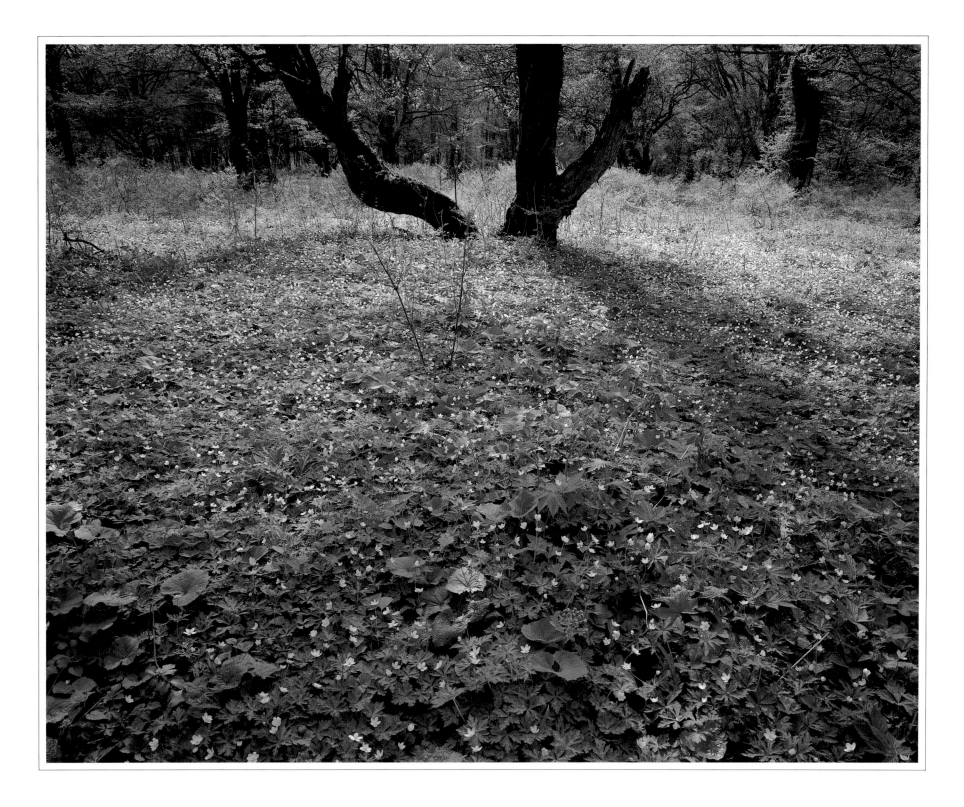

A sprinkling of anemone

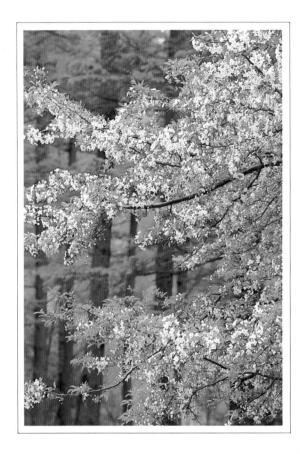

Soft, white crab apple blossom

The majesty of Mt. Hotaka

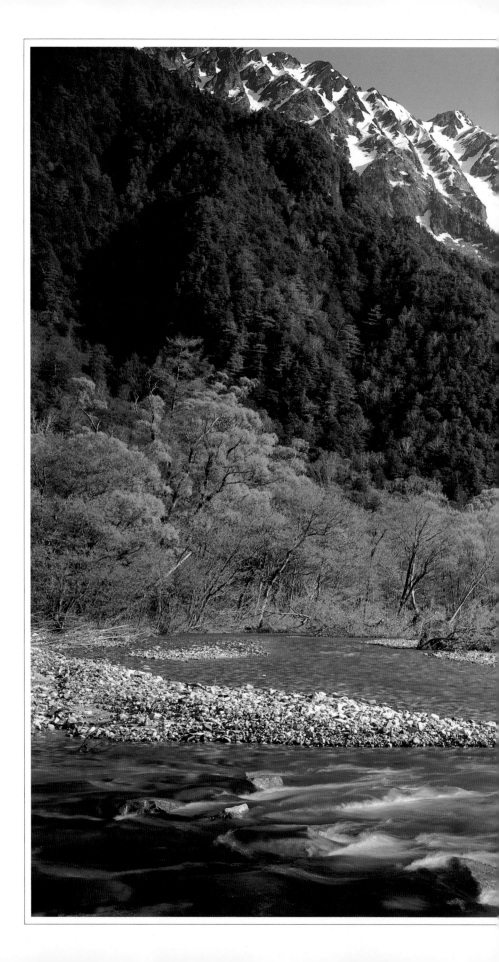

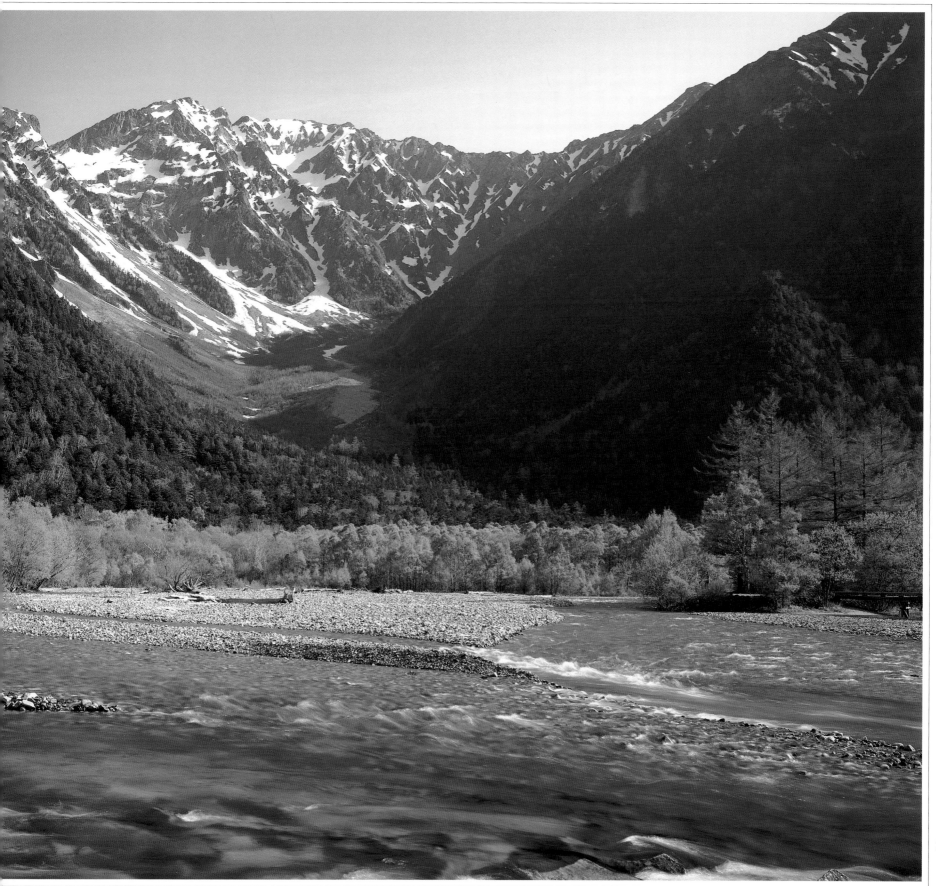

Clear, rippled waters

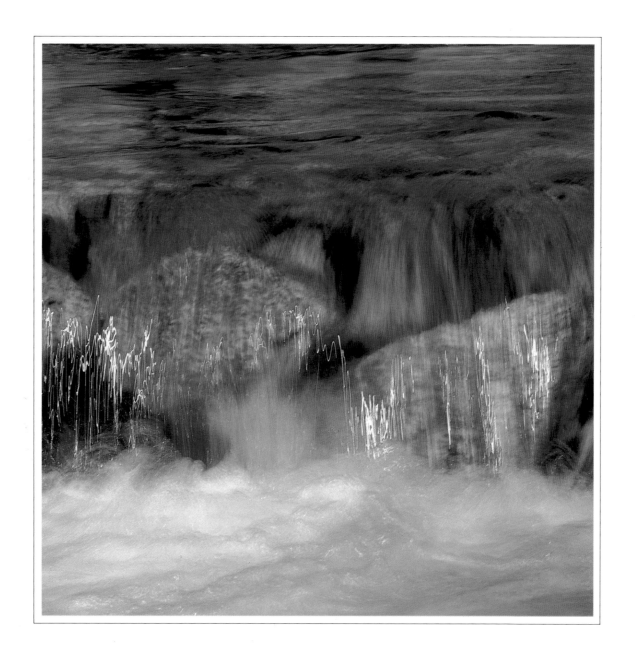

Flickering, dancing light

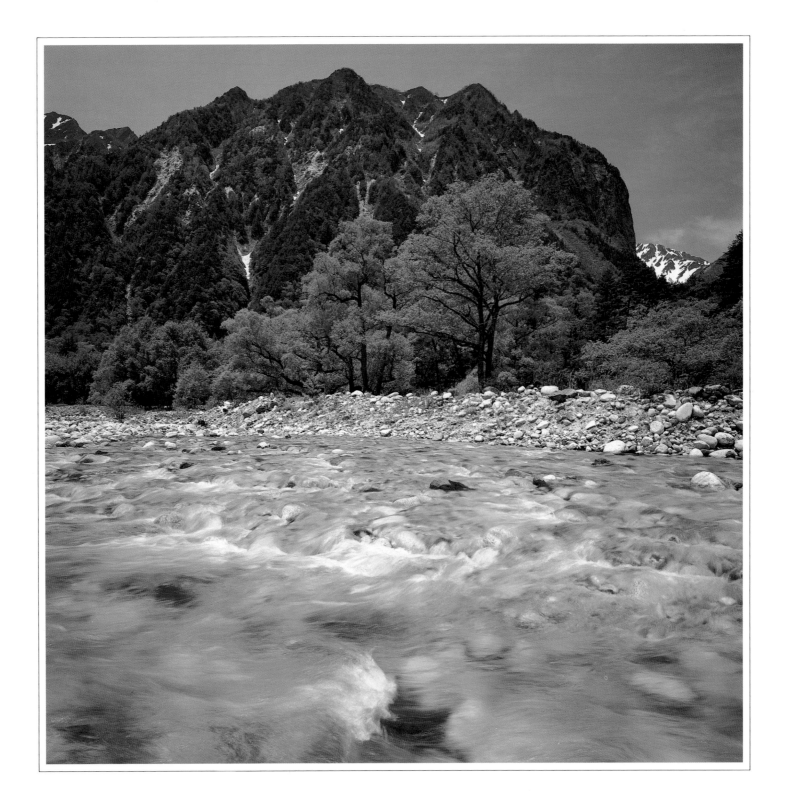

The great parapets of Byobuiwa

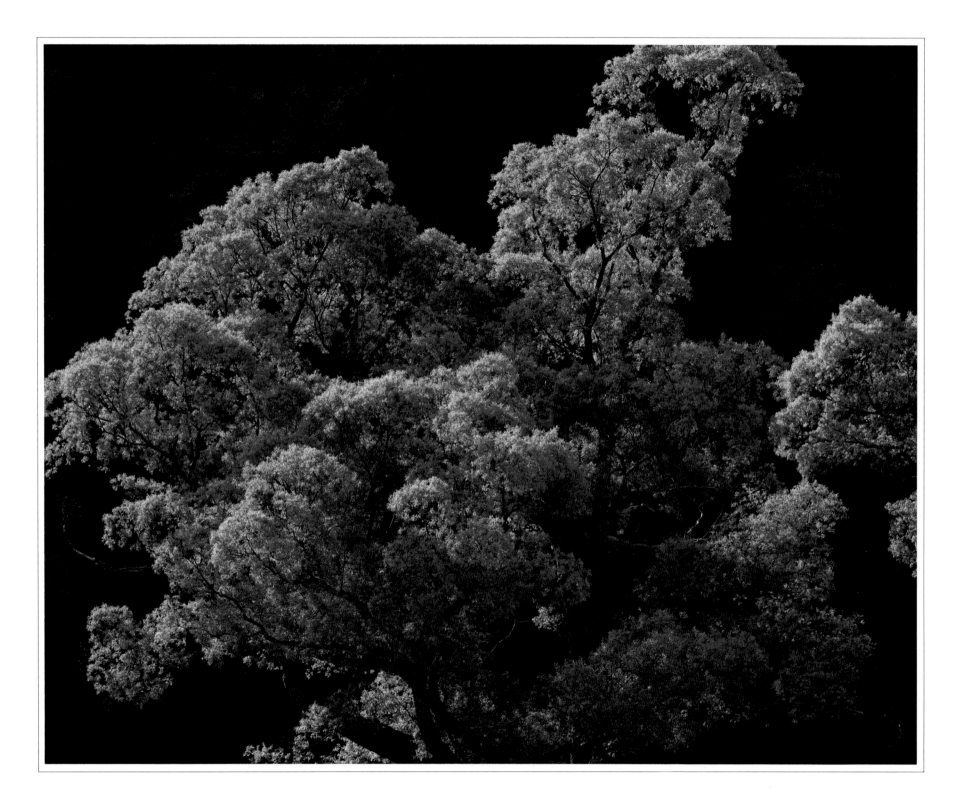

Trees adorned in green

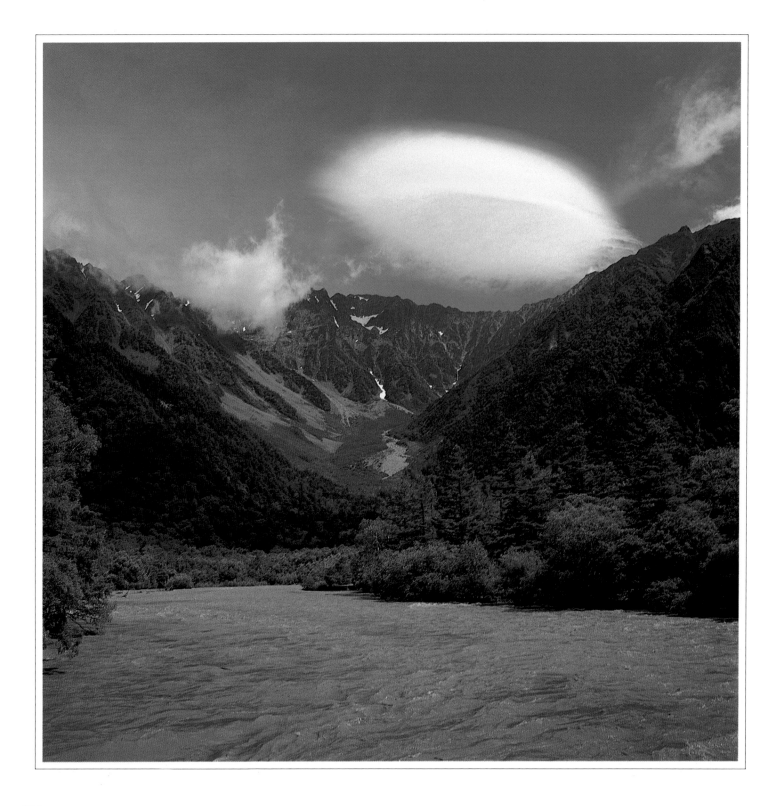

Between showers

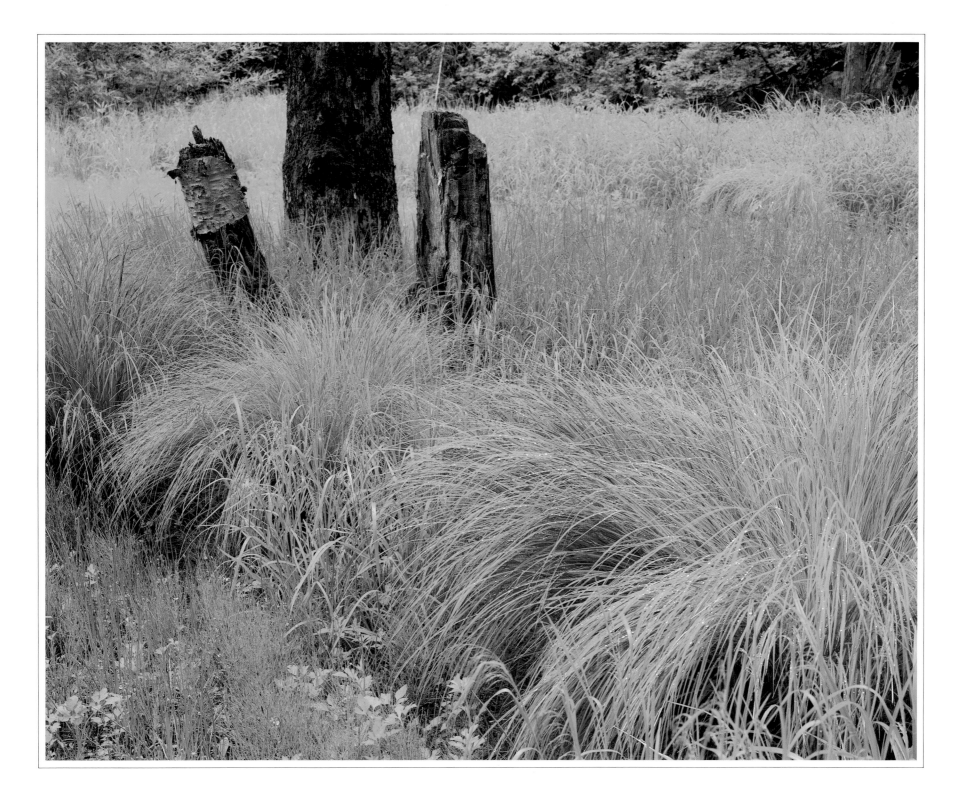

Dewdrops

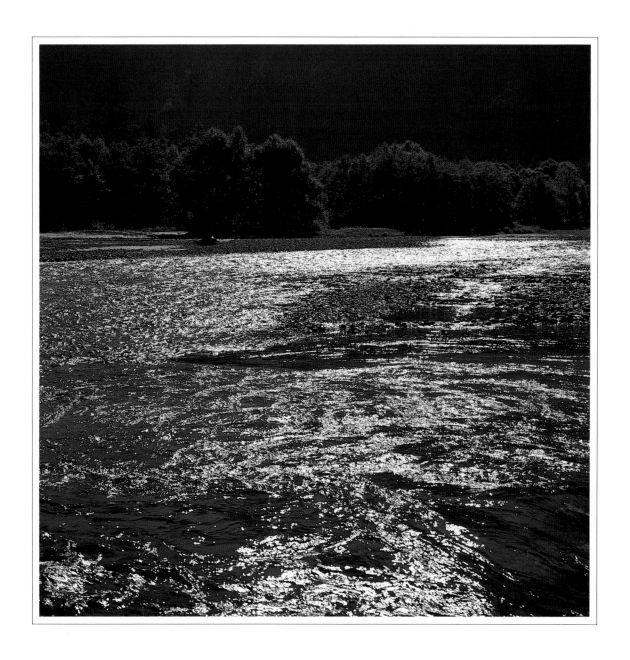

The sparkling Azusa River

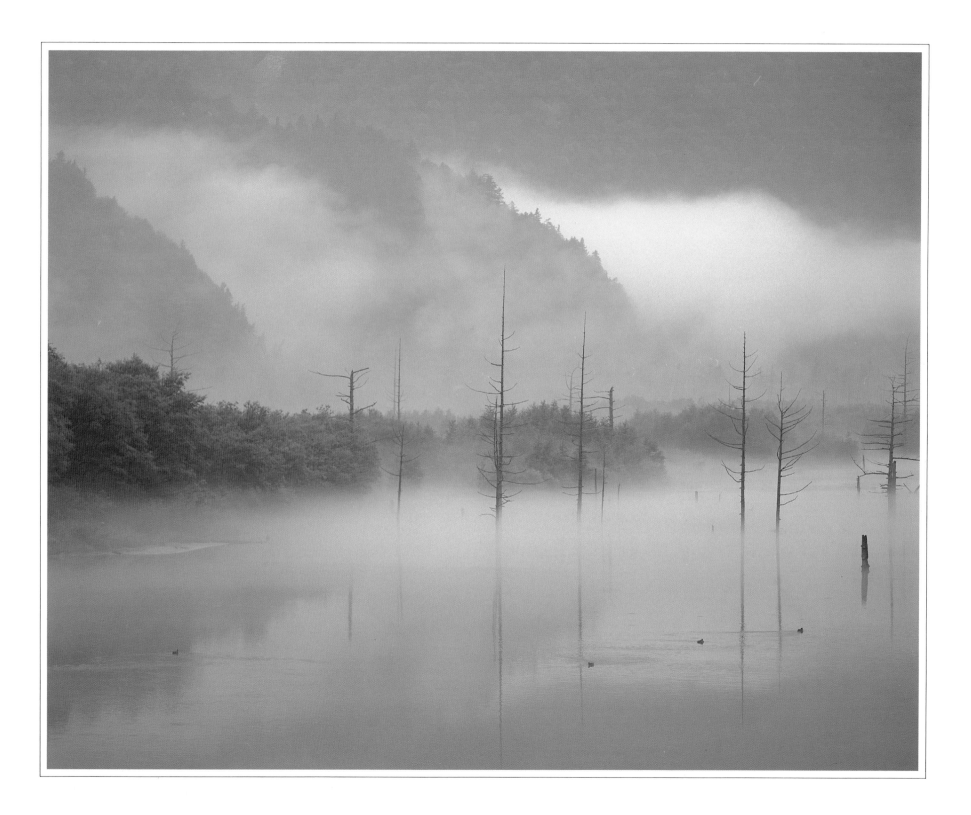

Misty Taisho pond

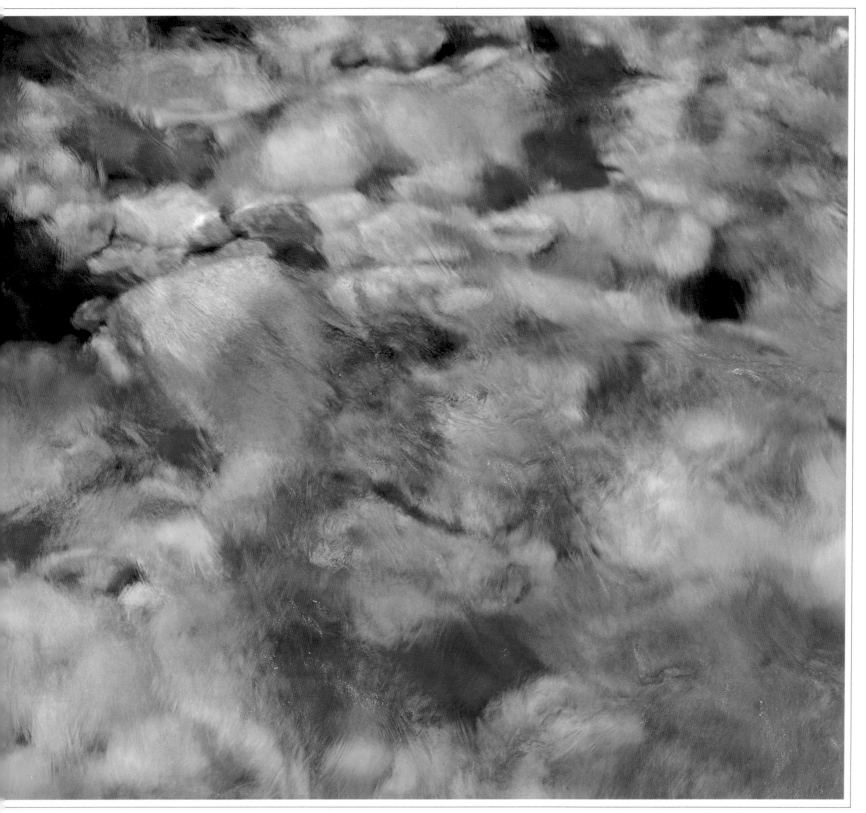

The pellucid waters of the Azusa

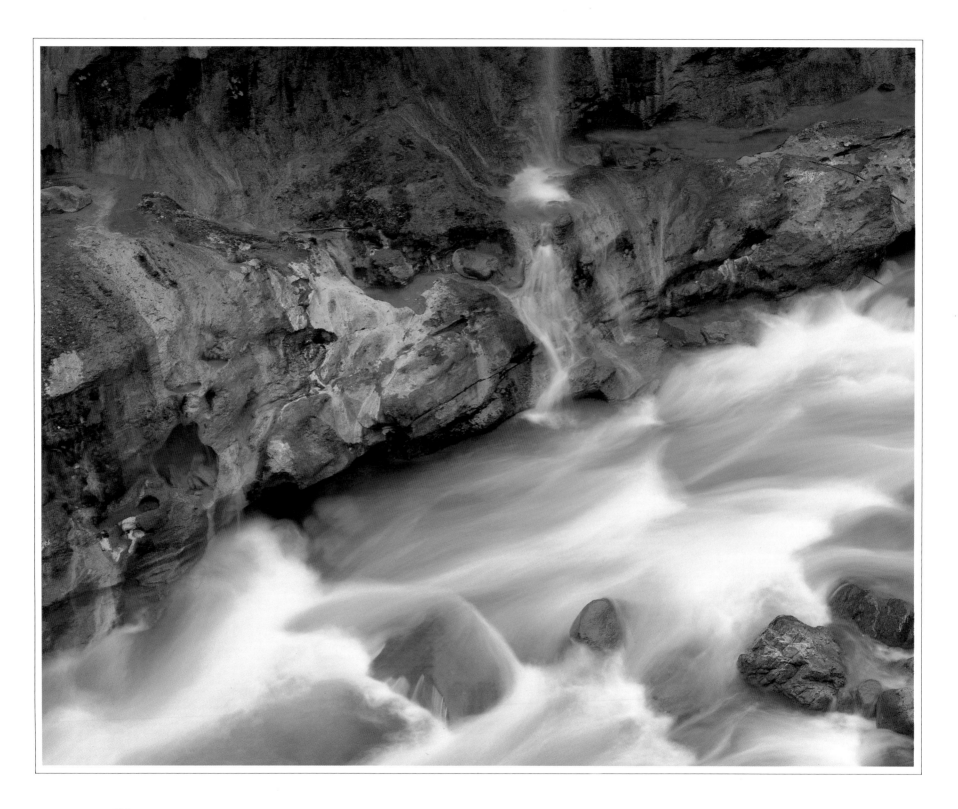

Gnarled rock along a stream

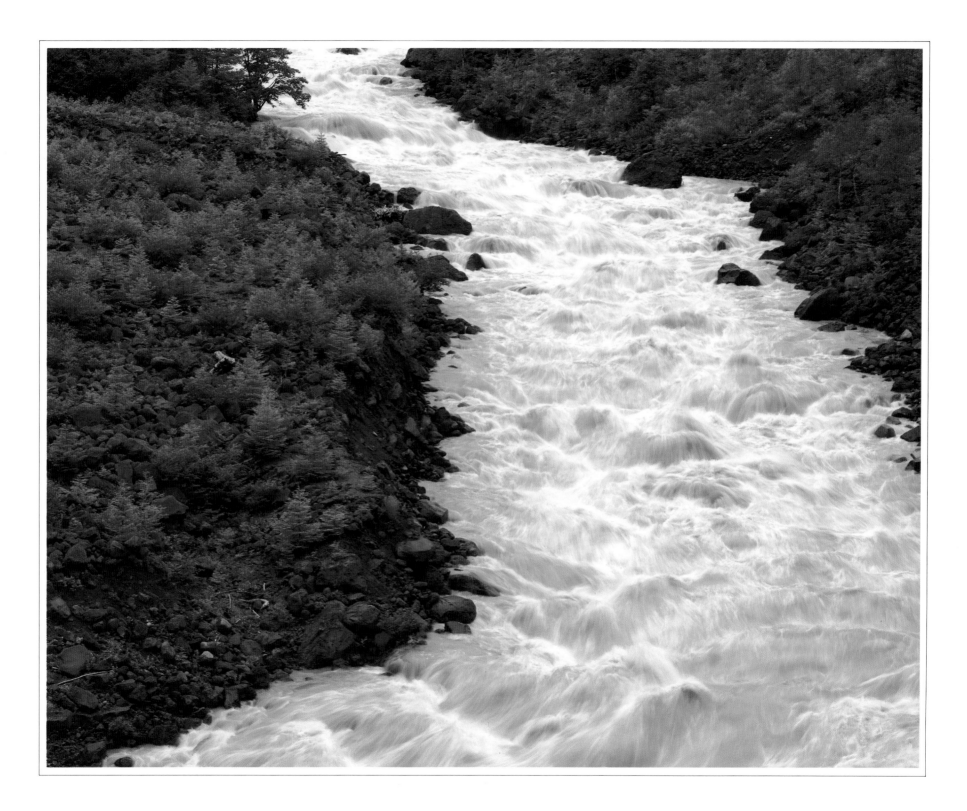

The rain-swollen Azusa

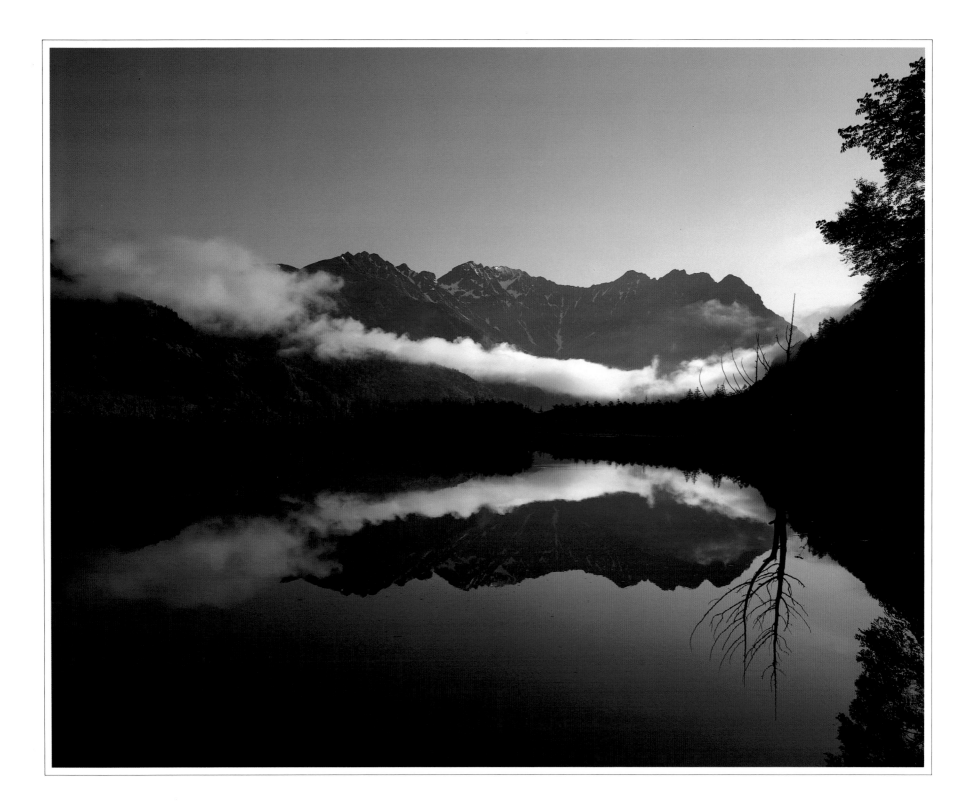

The stillness of Taisho pond

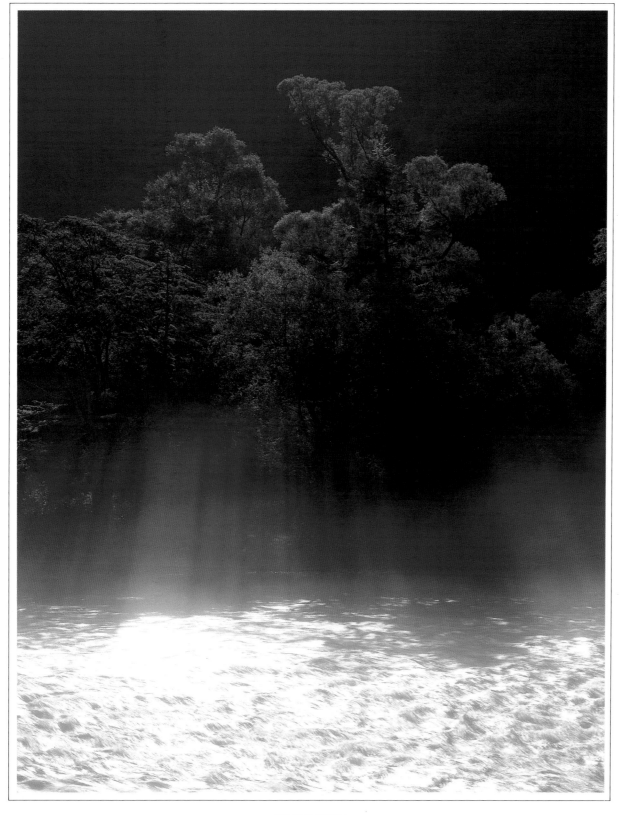

River fantasy

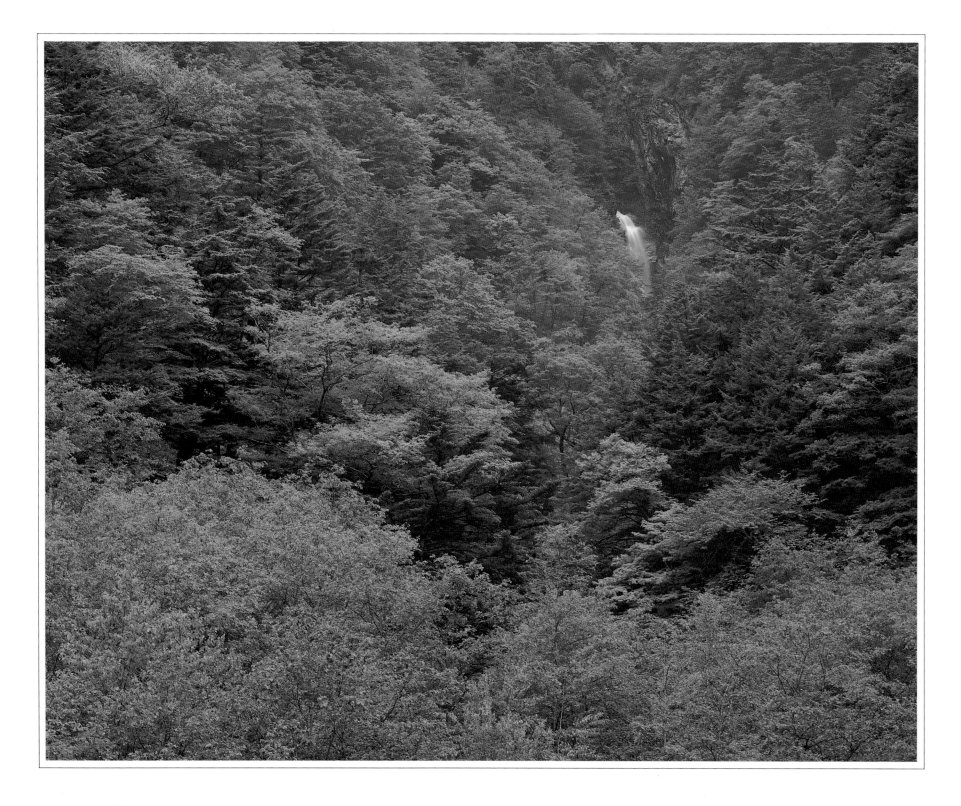

Kumoma Falls

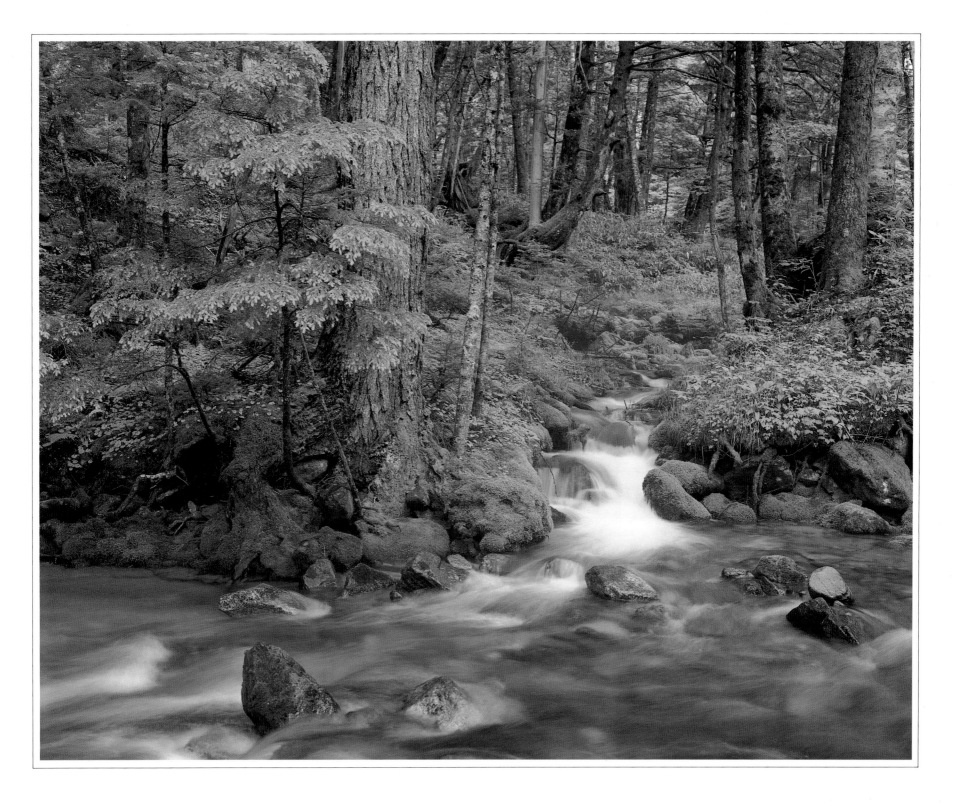

Murmuring brook in a virgin forest

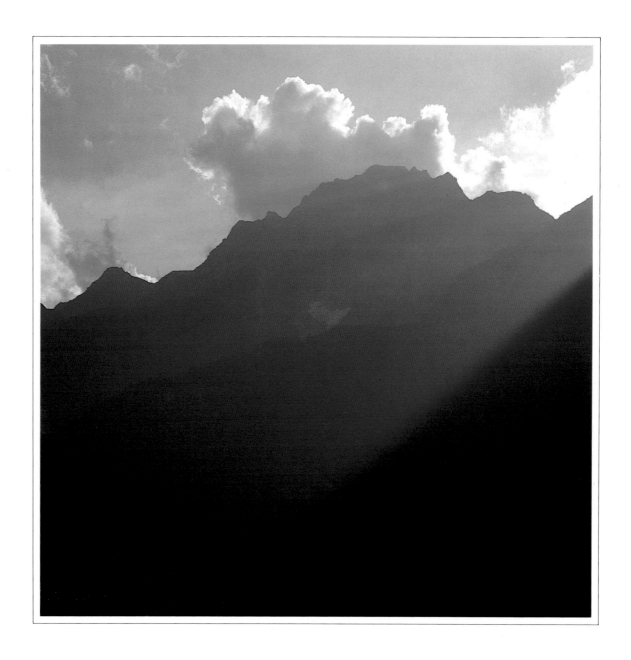

Mt. Maehotaka in late summer

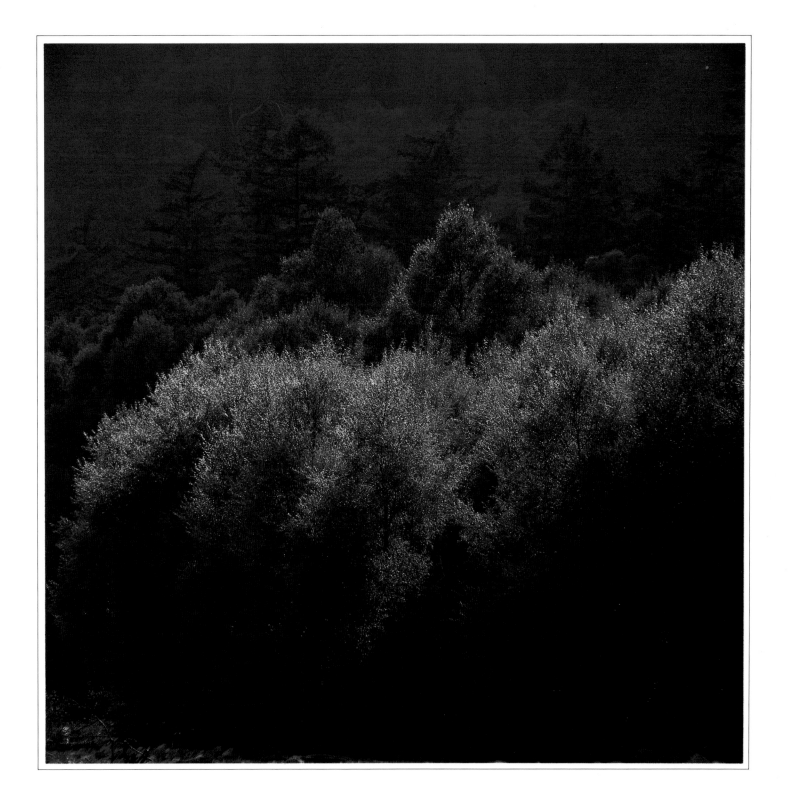

Glittering autumnal air

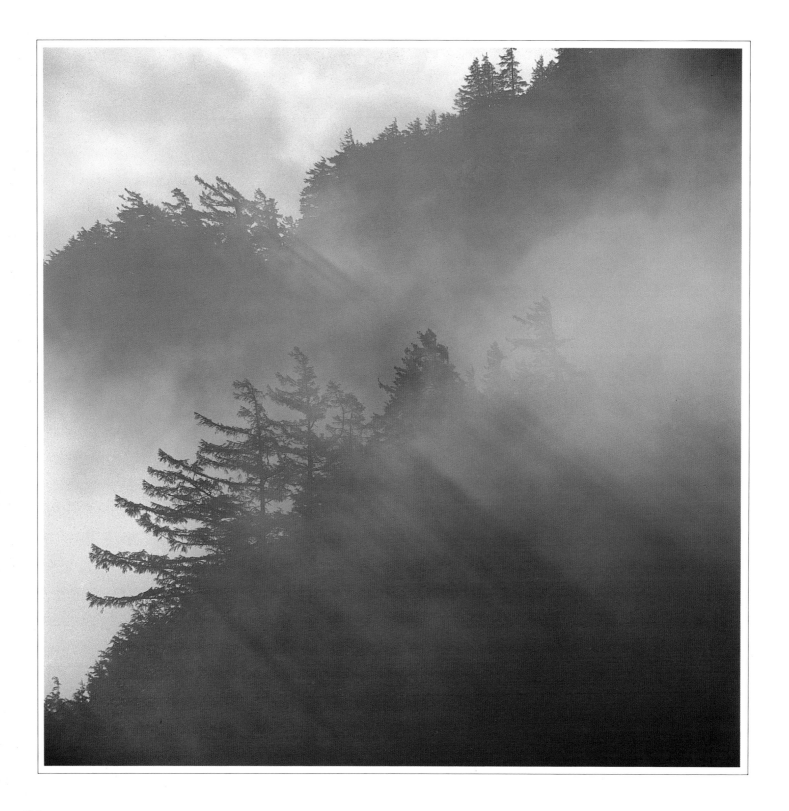

Fog setting in the mountains

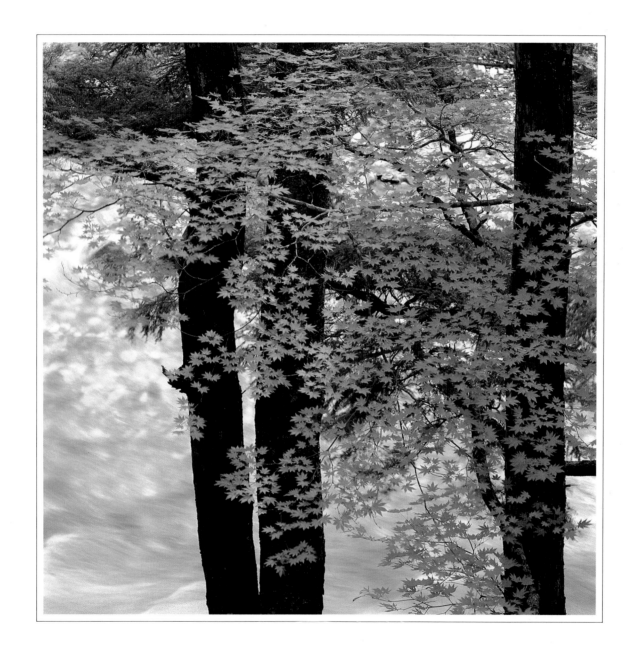

A spray of pale maples

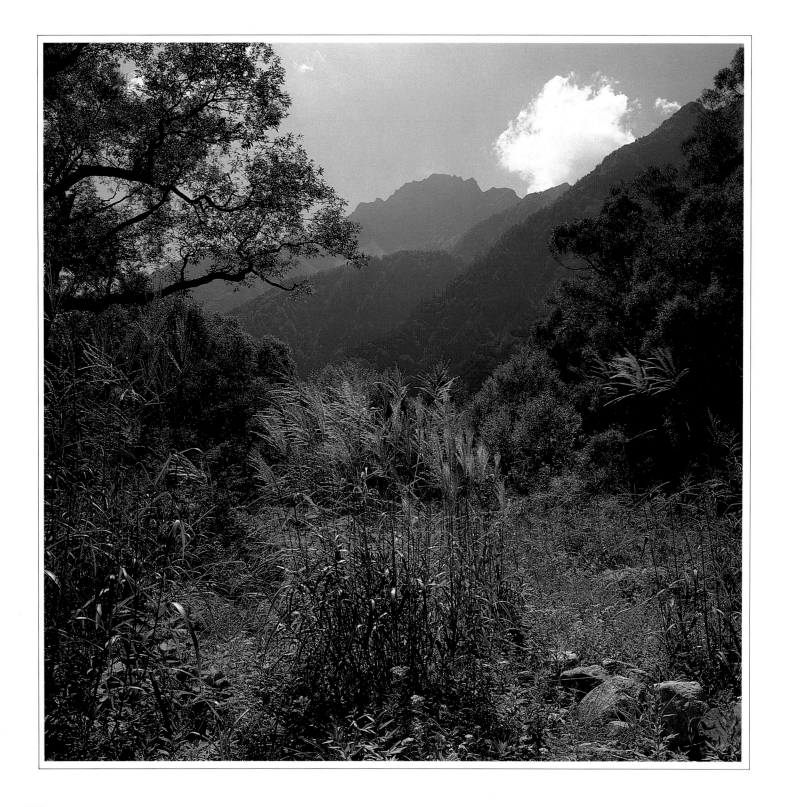

Early autumn in the valley

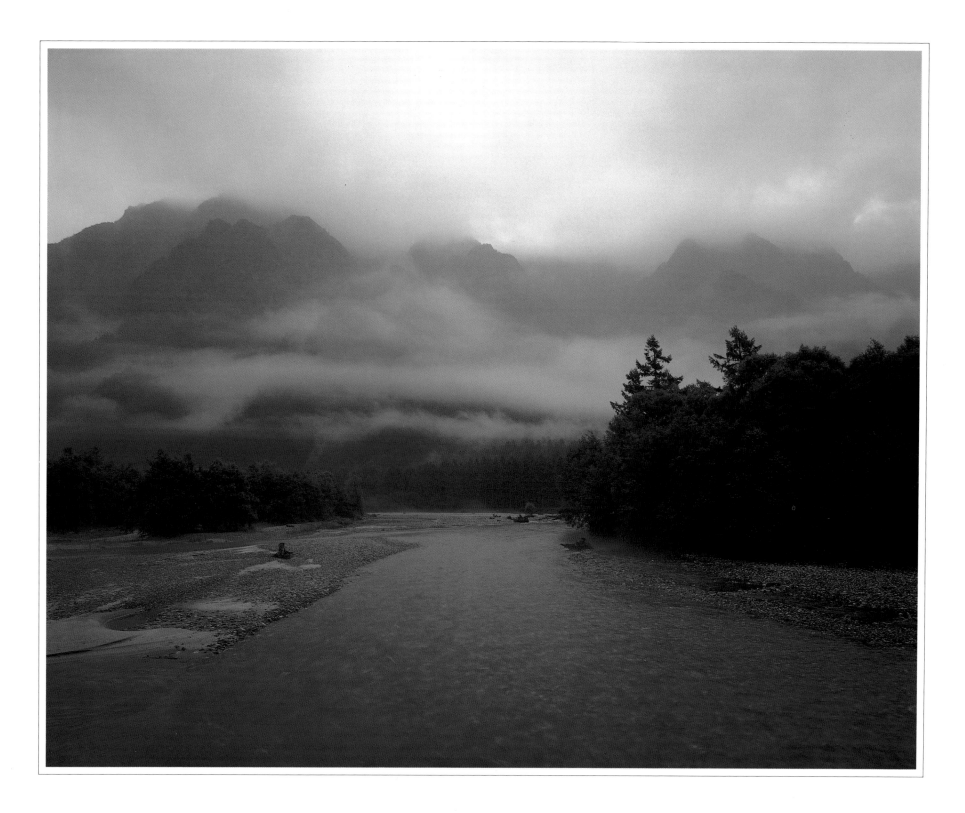

Mountain cloaked in morning mist

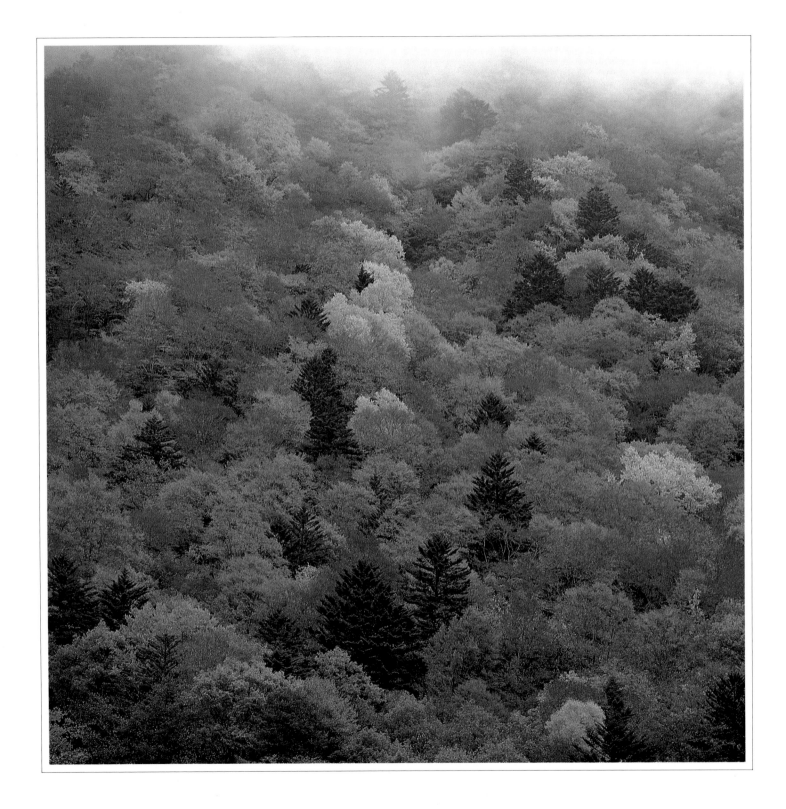

Foggy autumn mountainside

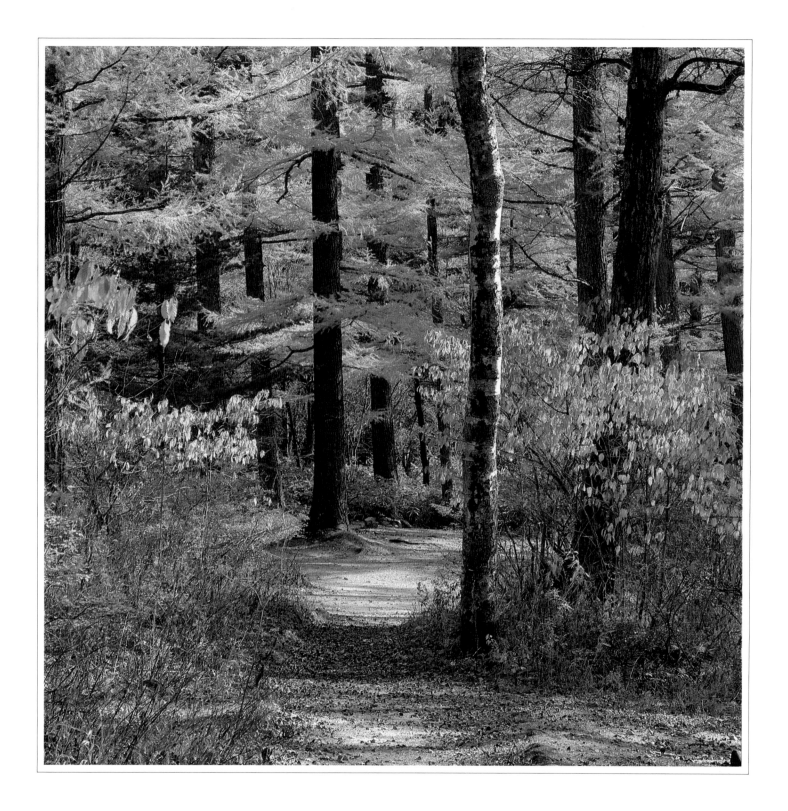

Autumn sunlight at Konashidaira

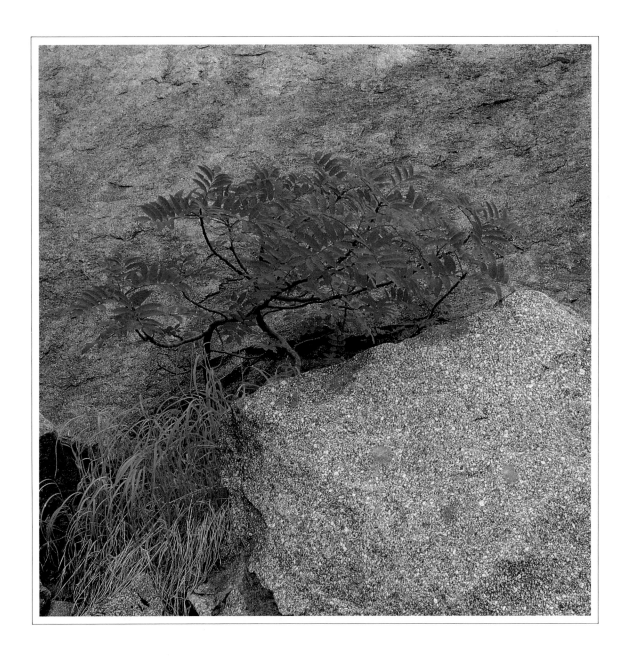

The vivid reds of mountain ash

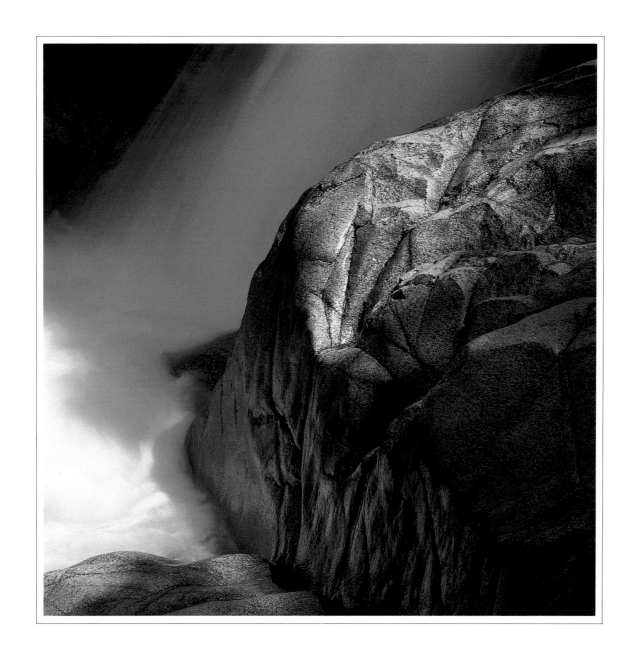

Patterns of light in a gorge

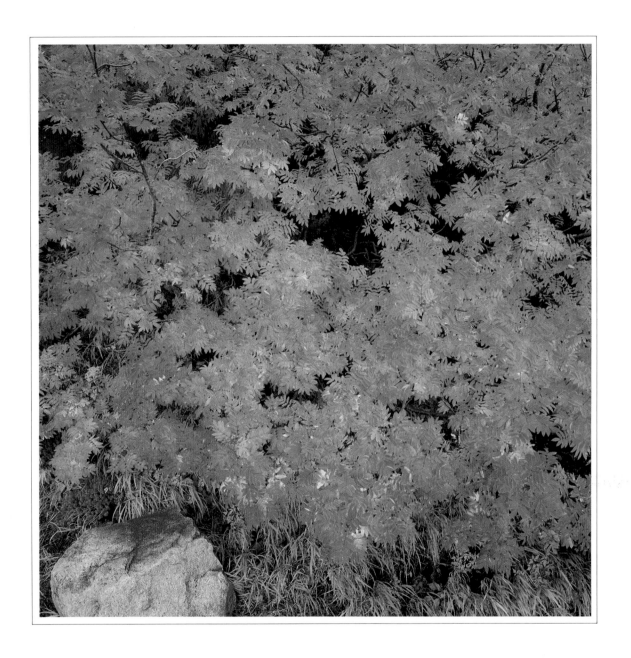

Mountain ash in autumn finery

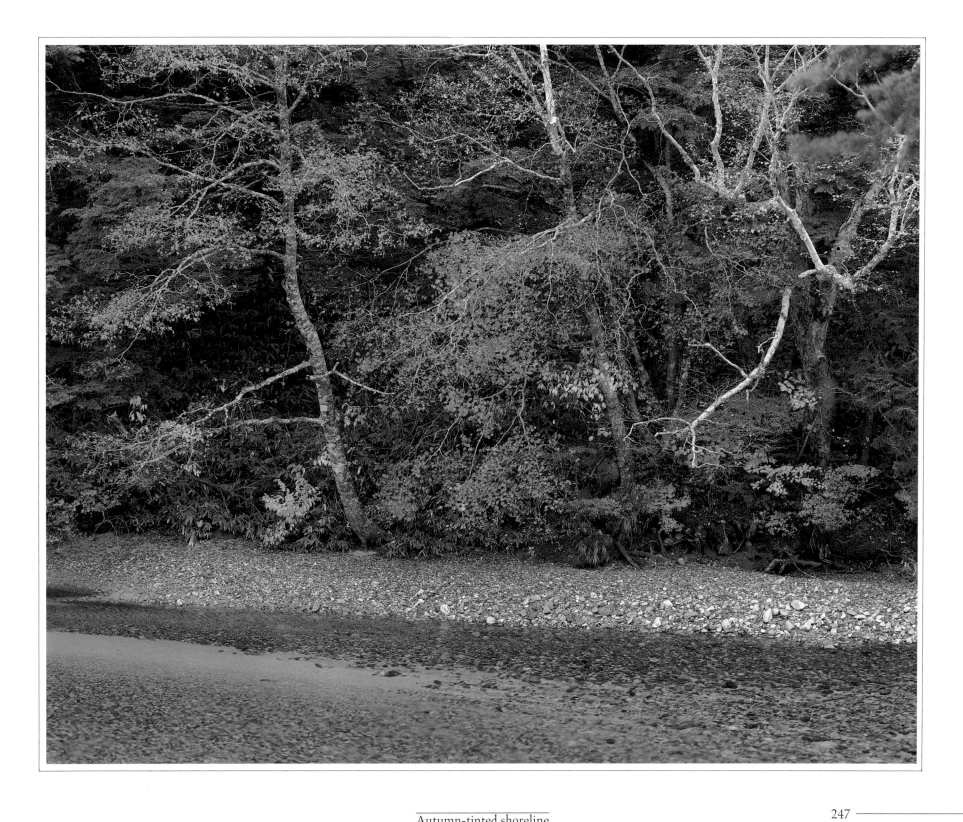

Autumn-tinted shoreline

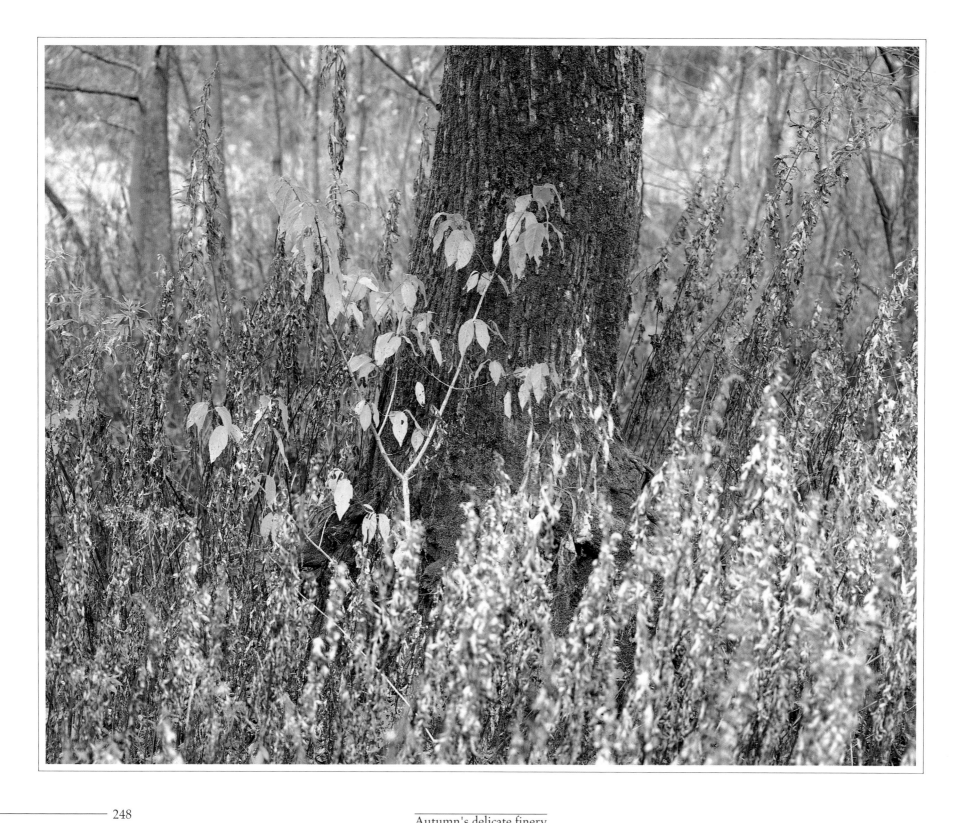

Autumn's delicate finery

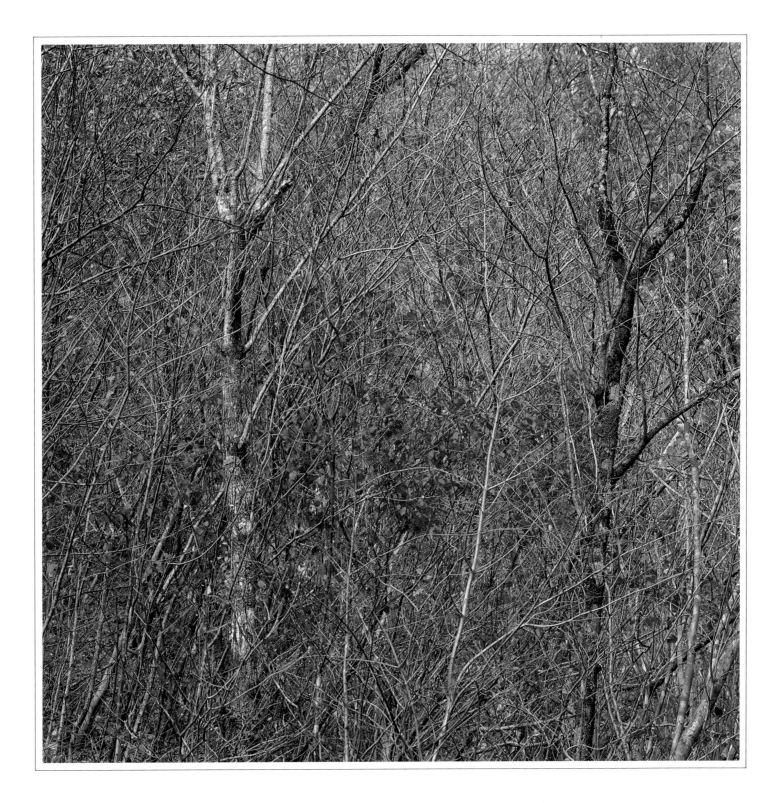

A splash of color among the trees

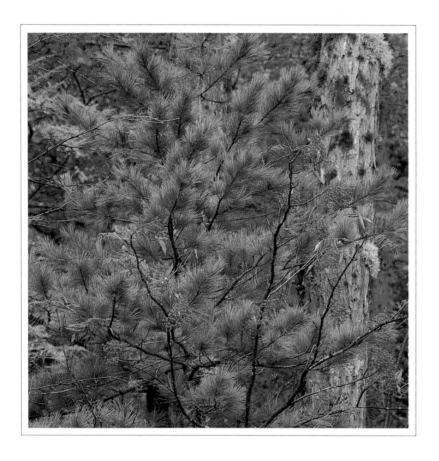

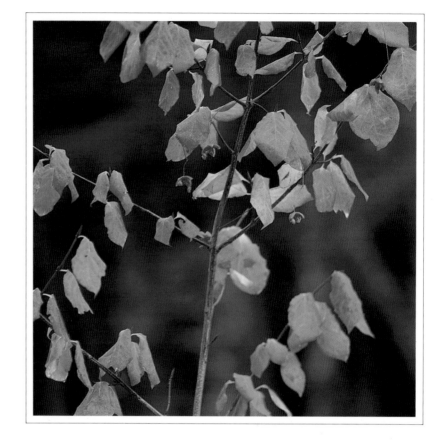

Mountain ash

Dainty Tsuribana

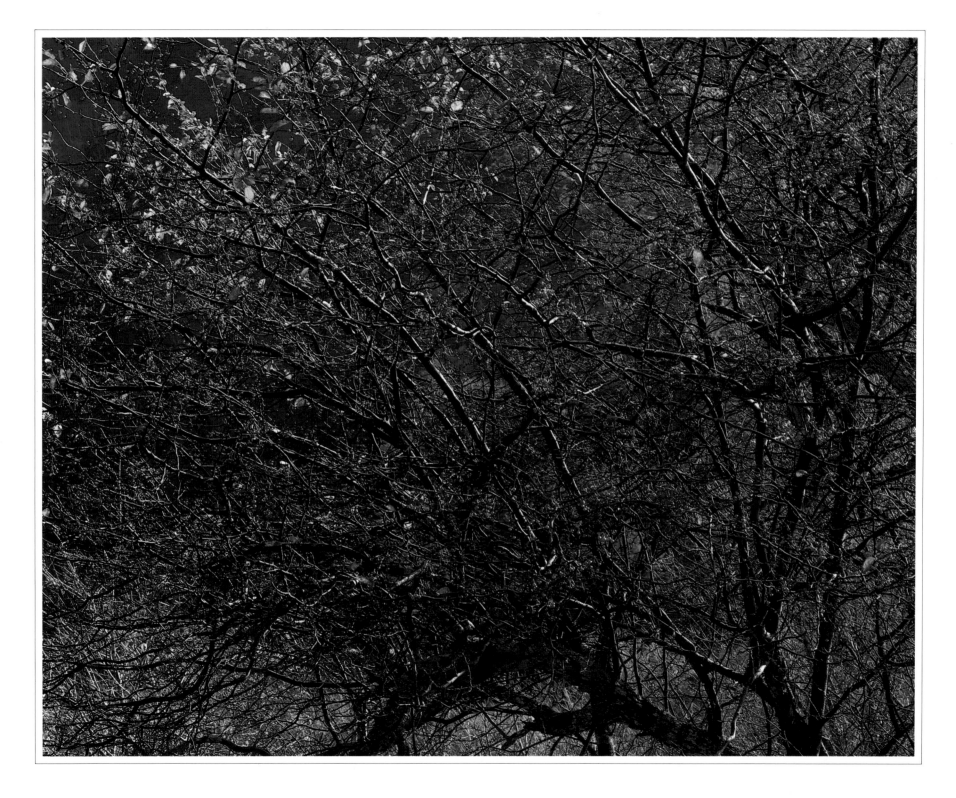

Sunlight on crab apple trees

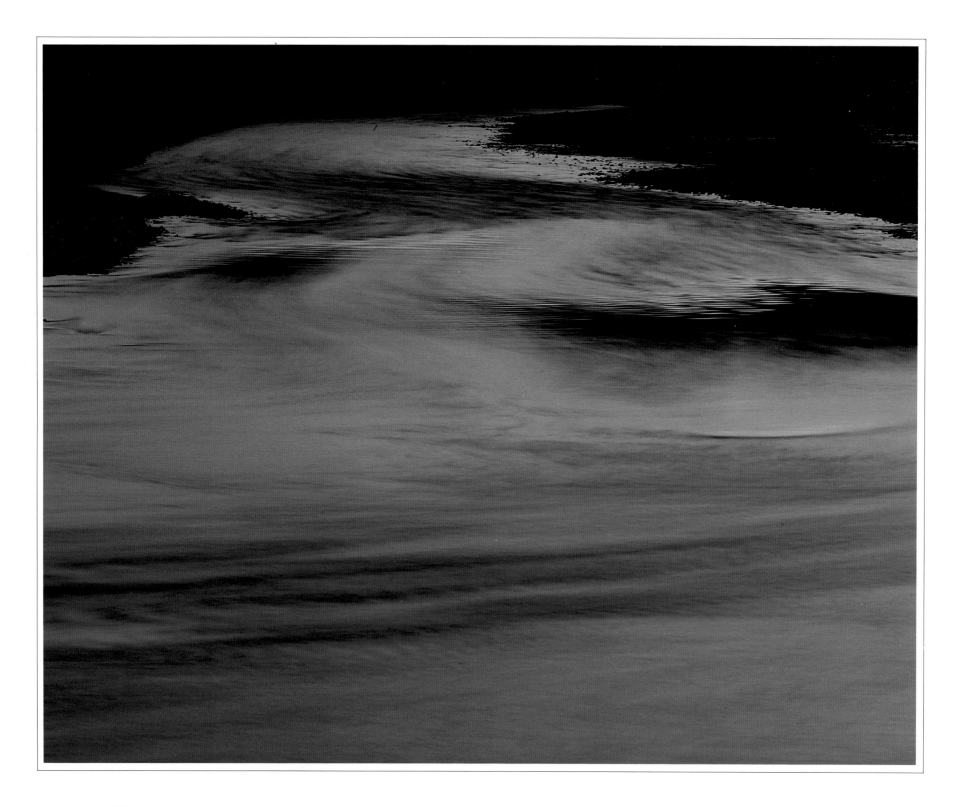

Twilight on the Azusa

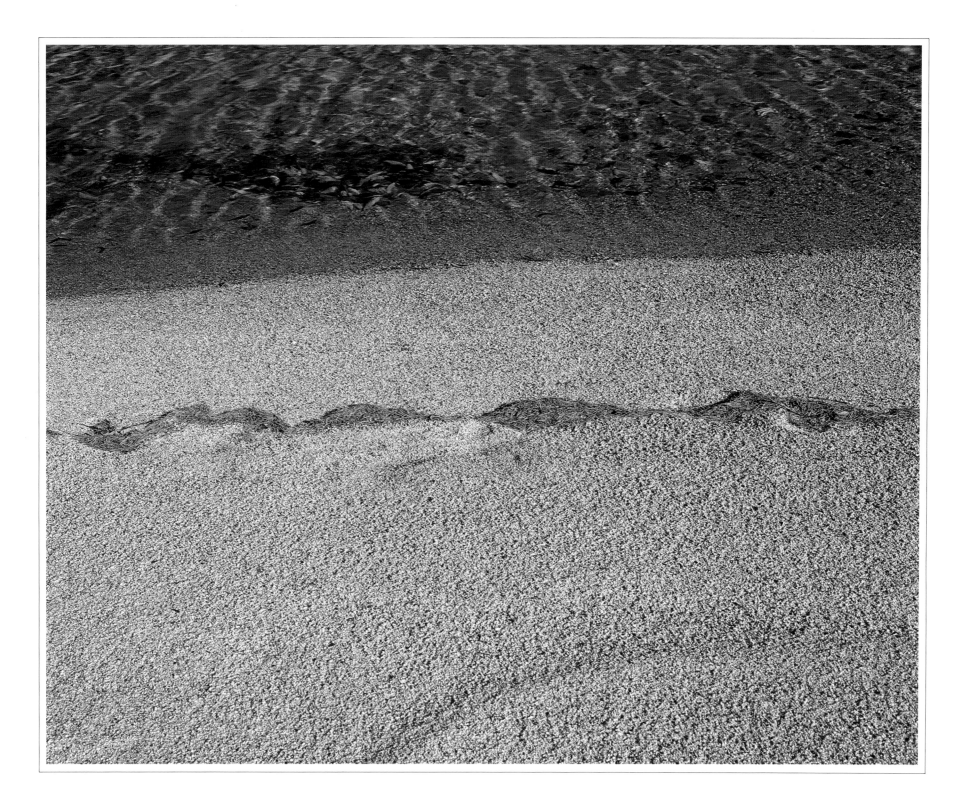

Strands of fallen leaves

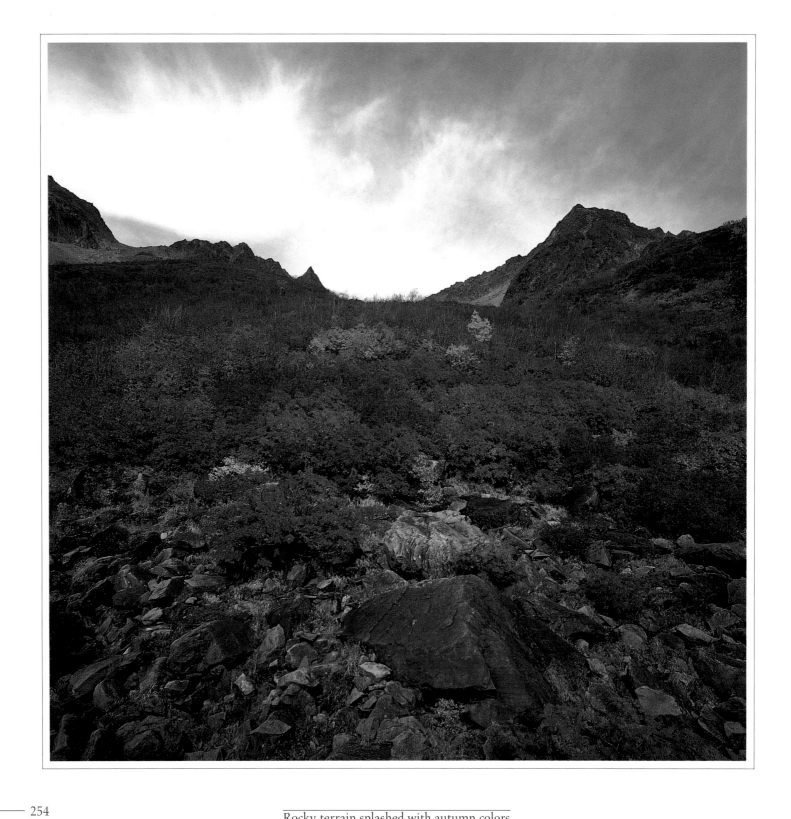

Rocky terrain splashed with autumn colors

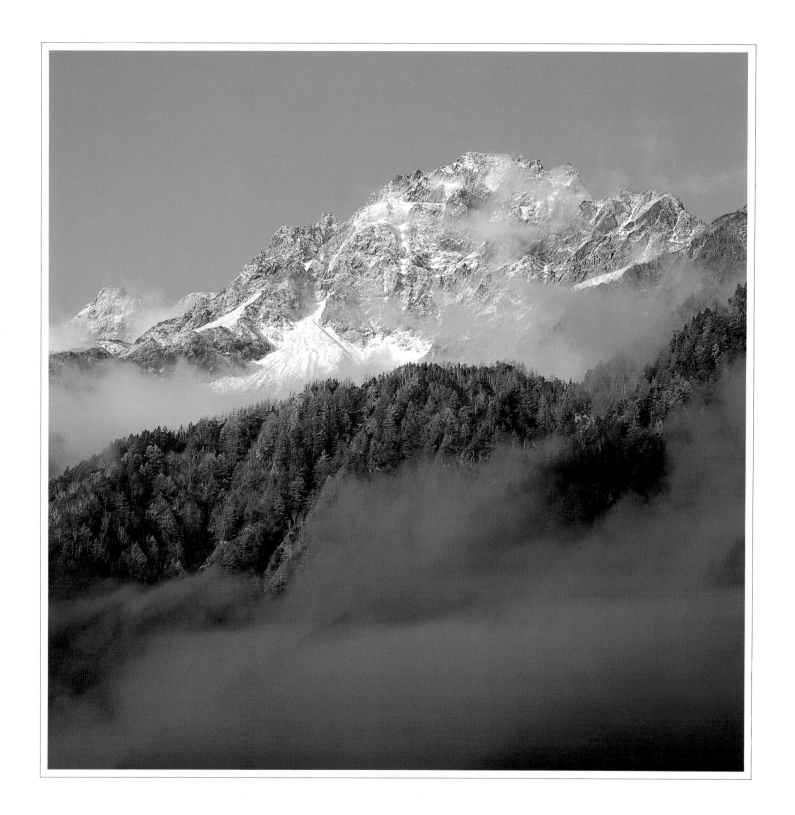

Fresh snow on Mt. Maehotaka

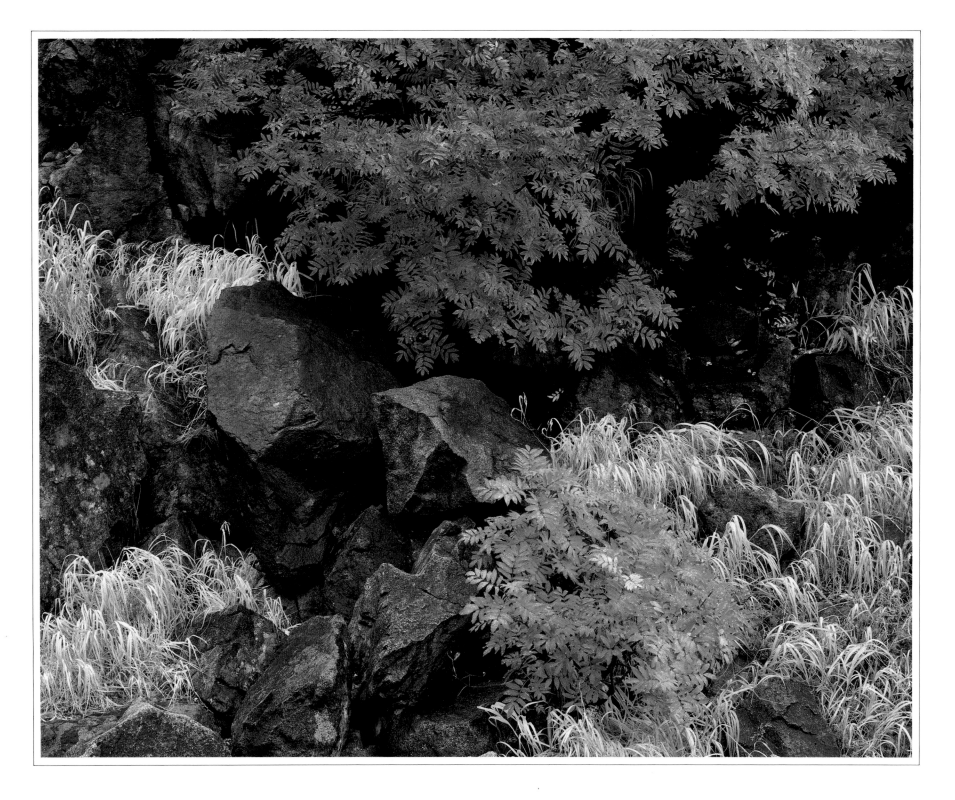

The glory of autumn

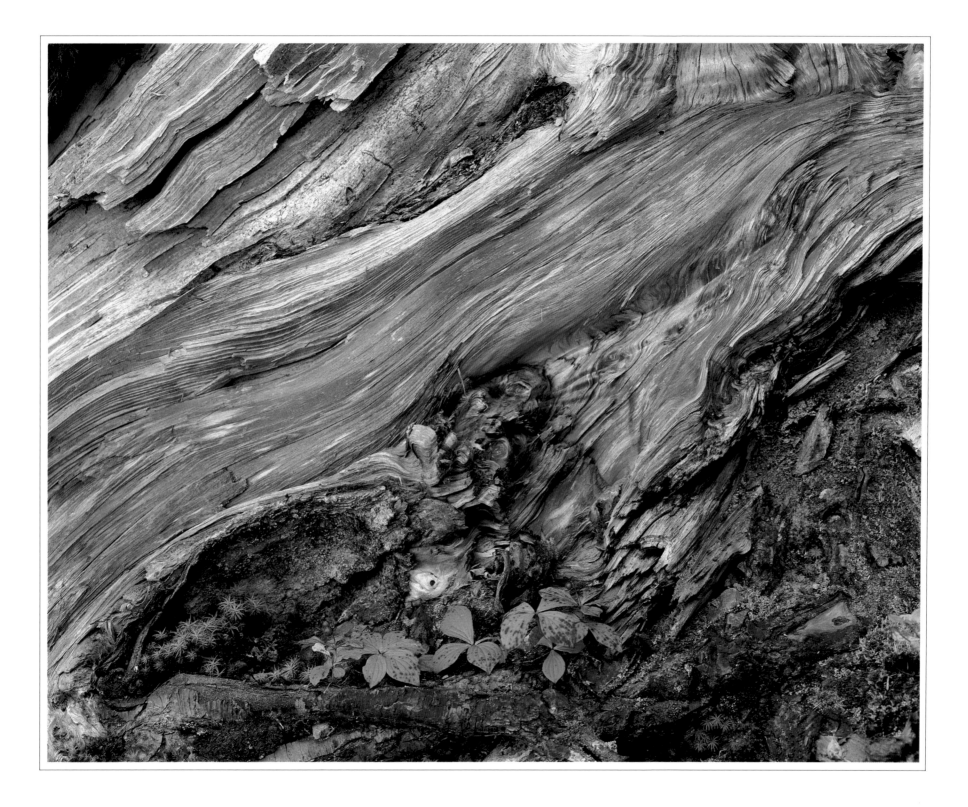

Cowberries nestled under a giant tree

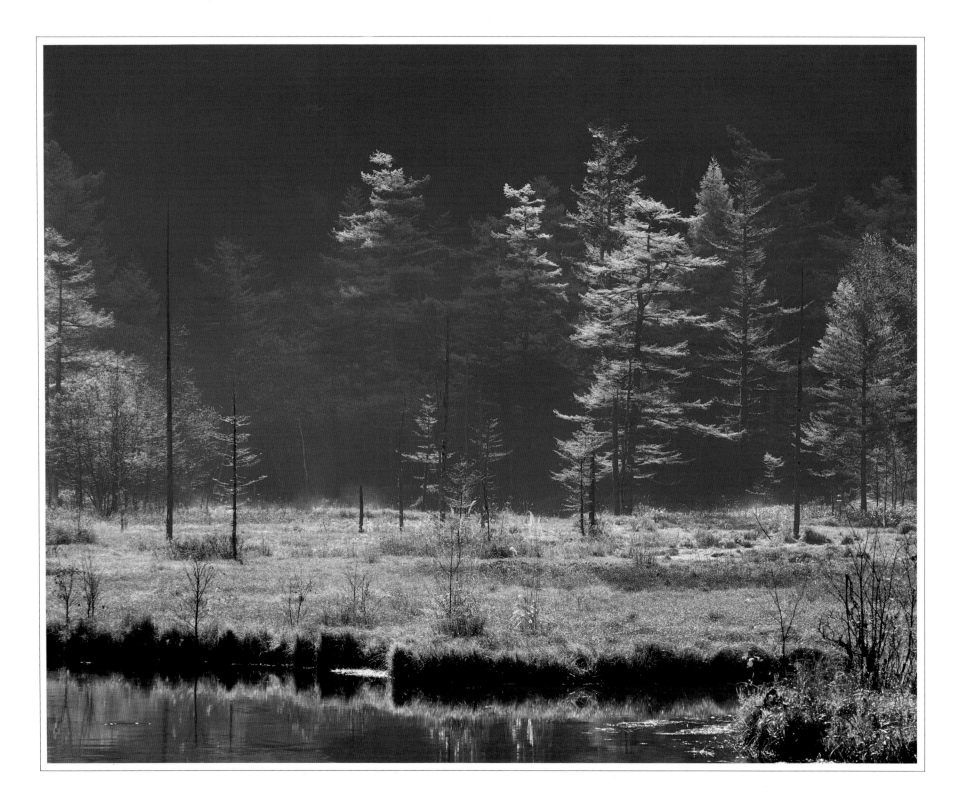

The serenity of Tashiro pond

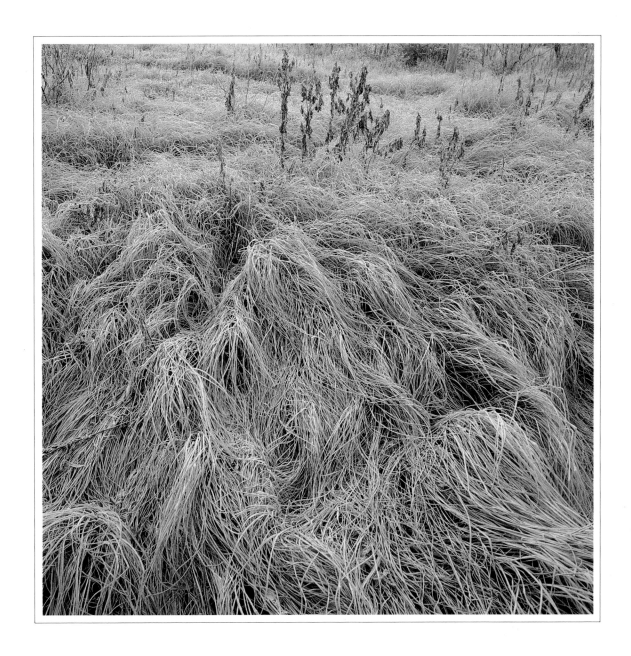

Autumn frost on a marshy field

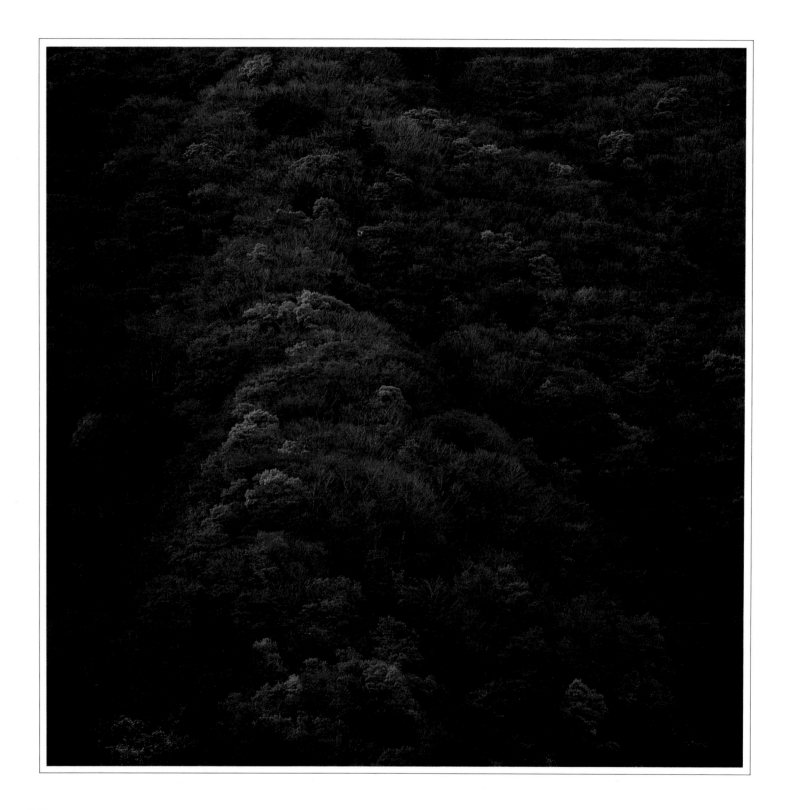

Soft shadows in autumn's final days

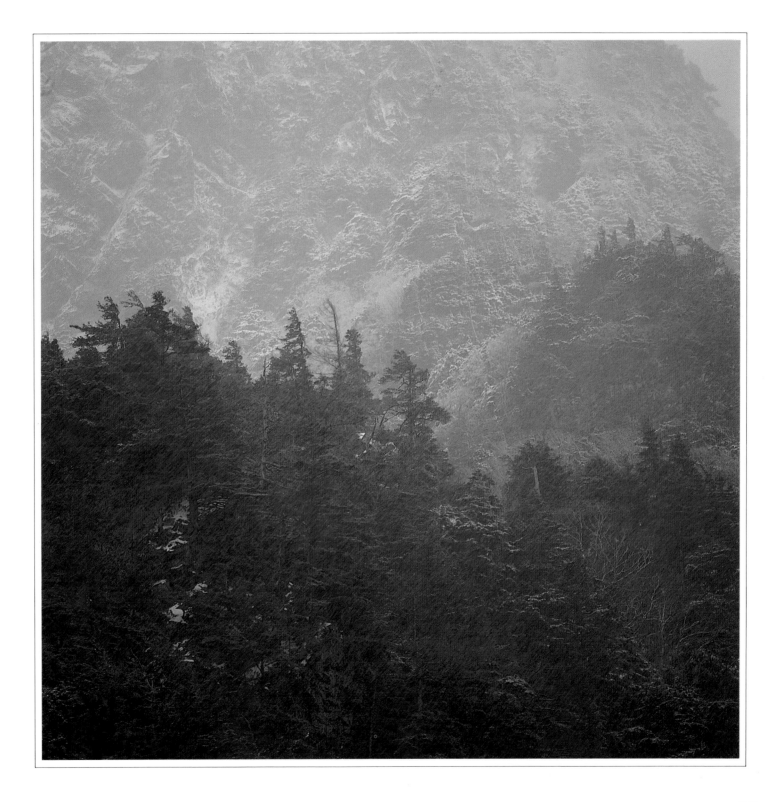

Late autumn – silver sleet

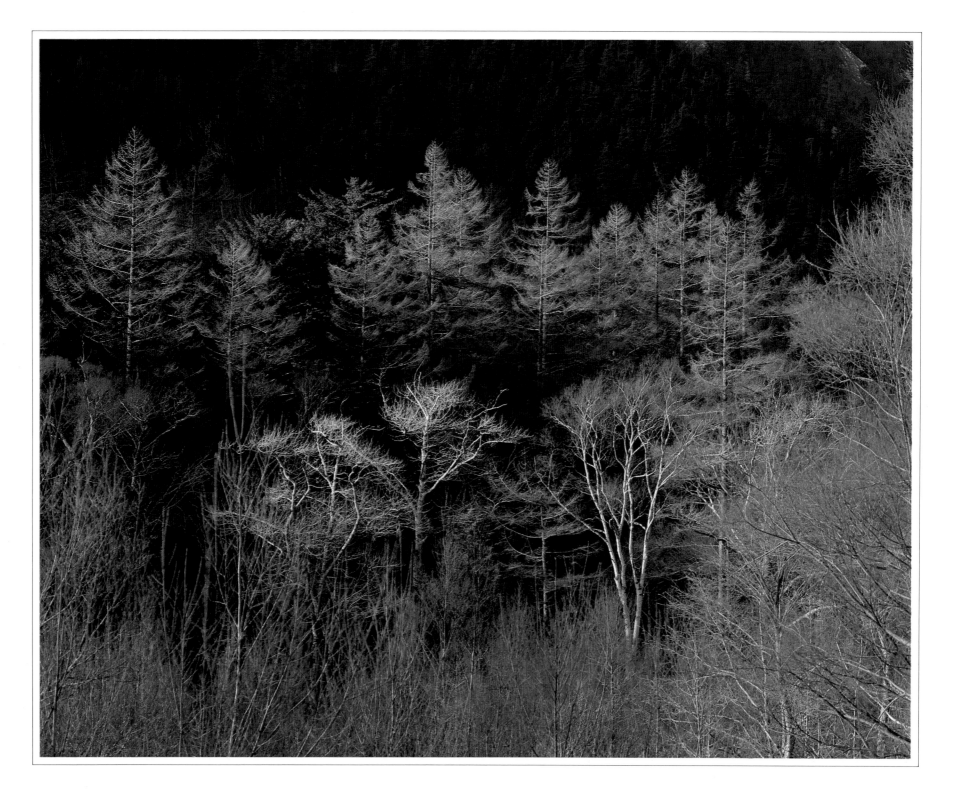

The day's last rays of sunlight

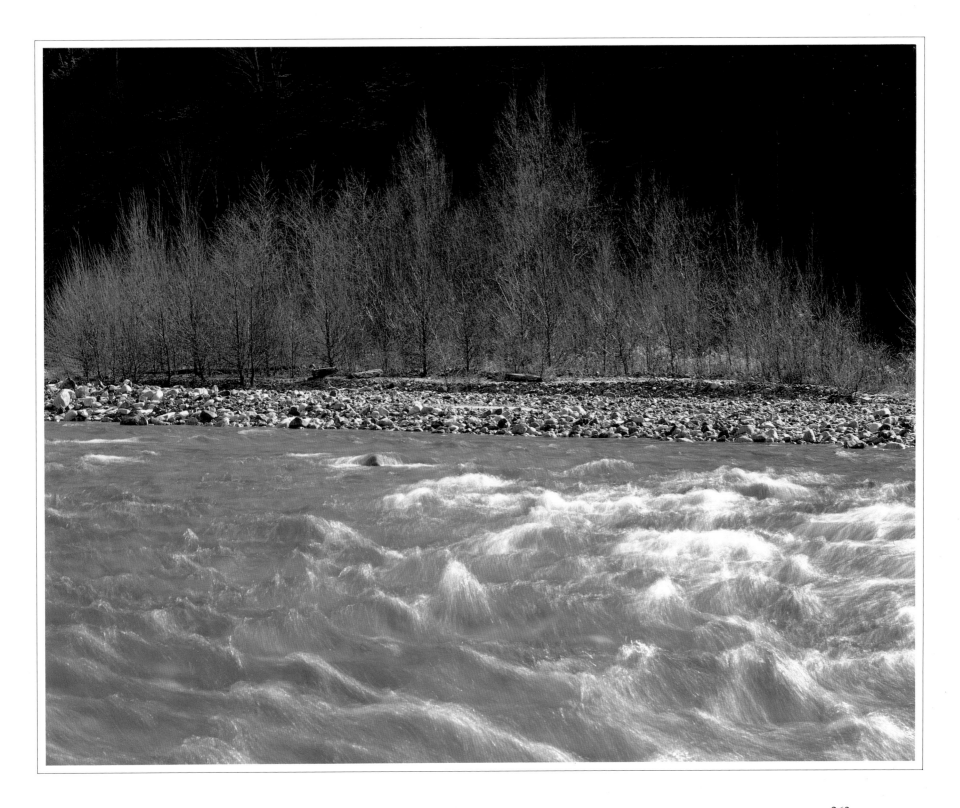

The Azusa in turbulent mood

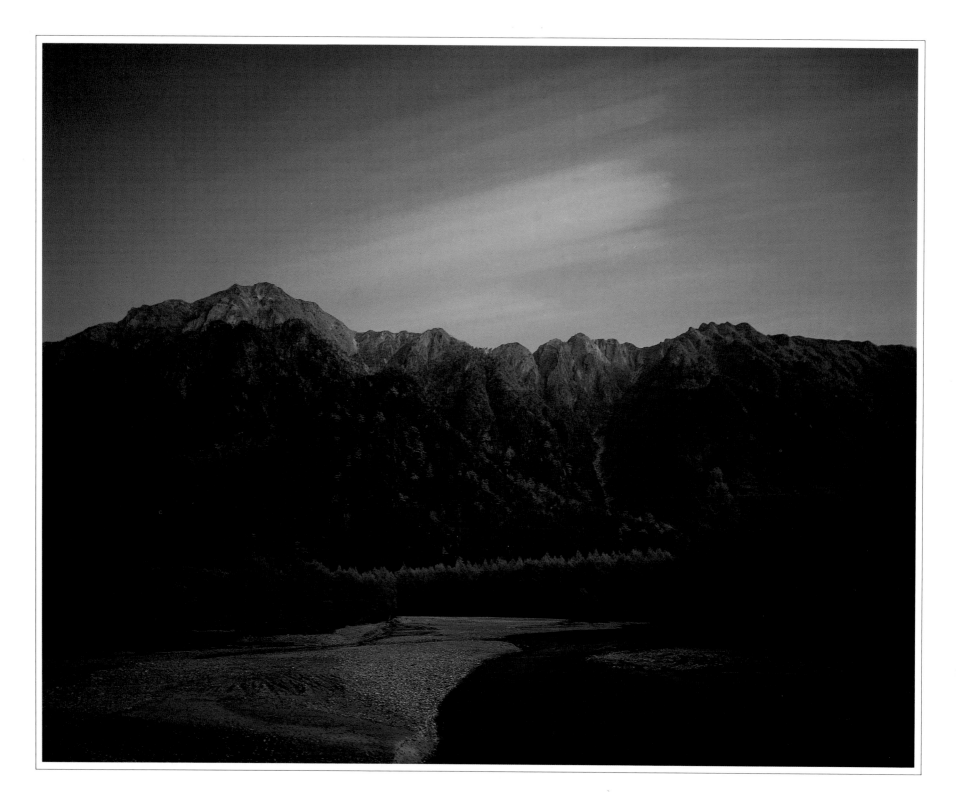

Afterglow on the mountains

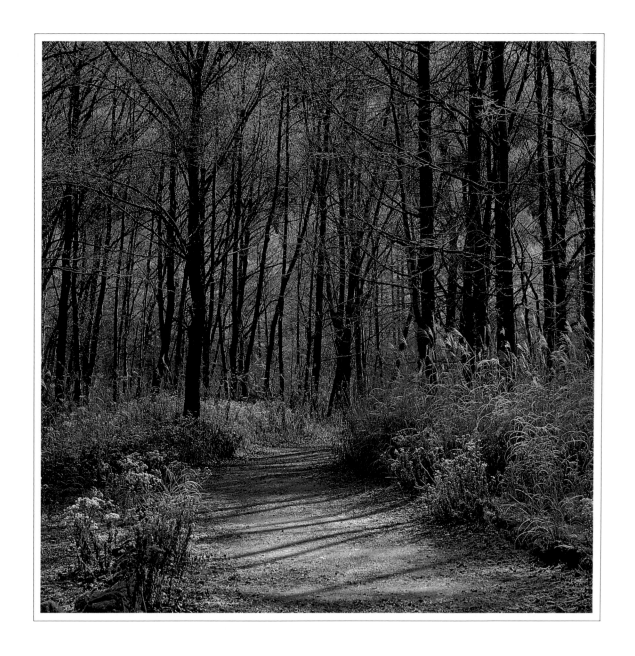

Frost-covered path

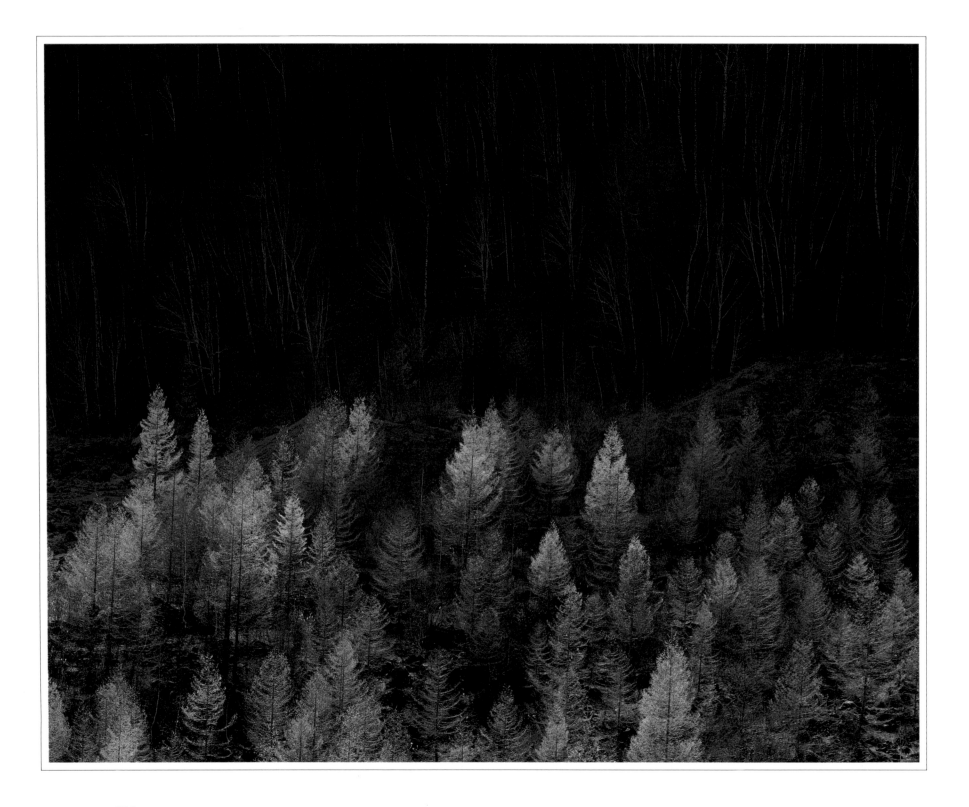

Shadows and sunlight in the valley

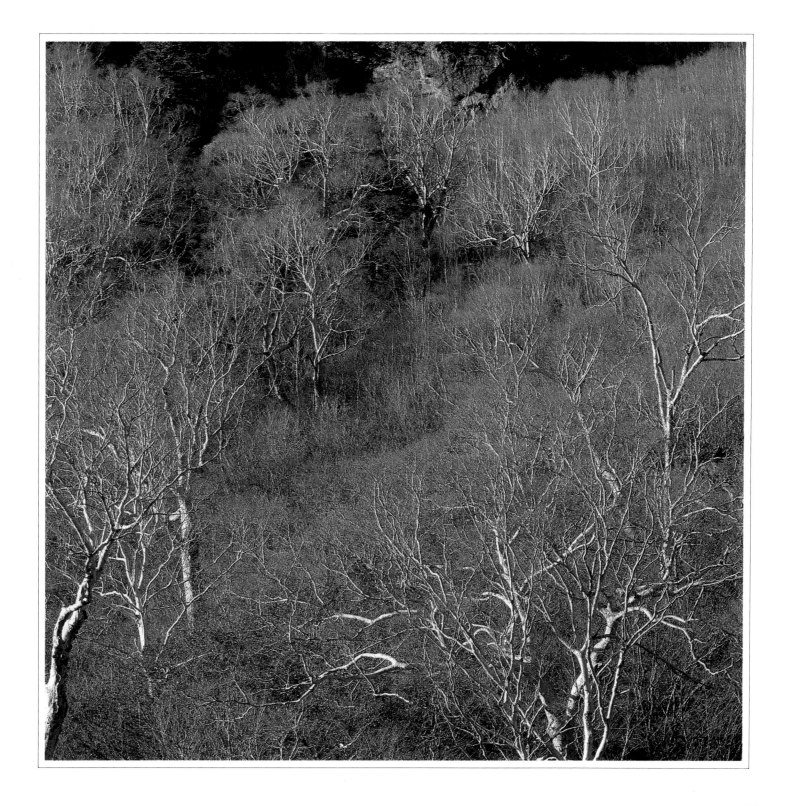

A bright filigree of mountain birches

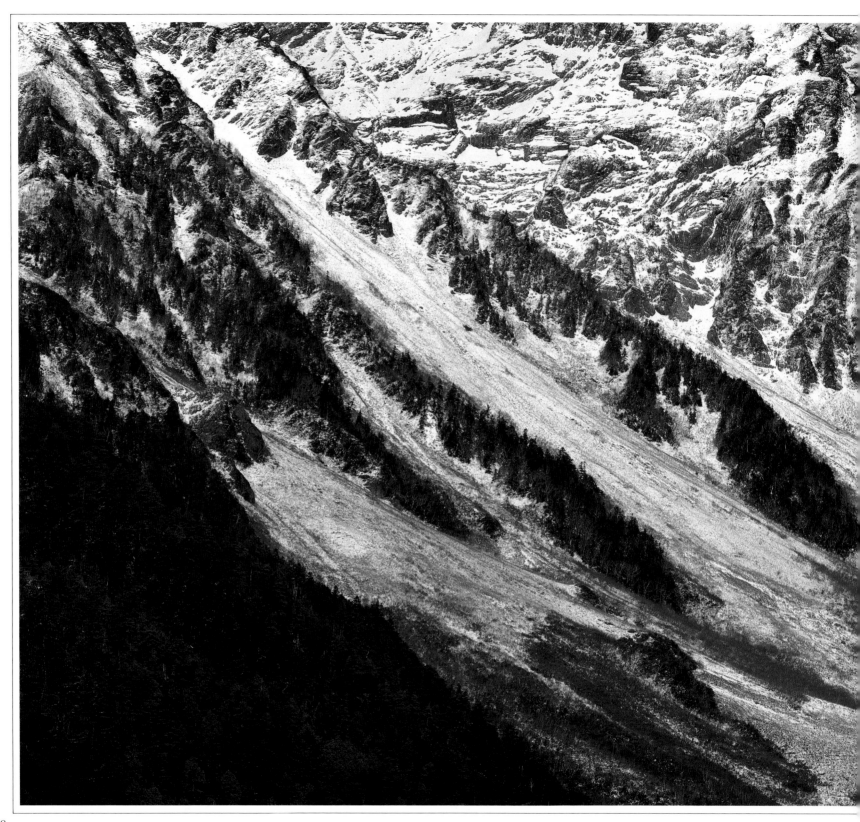

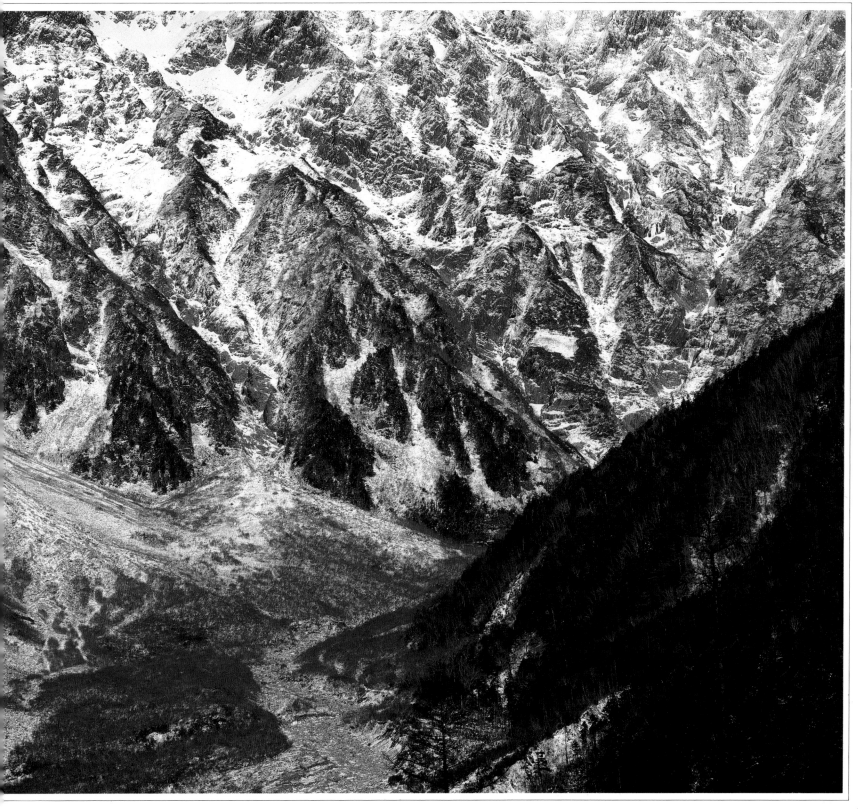

Newly fallen snow on Dakesawa

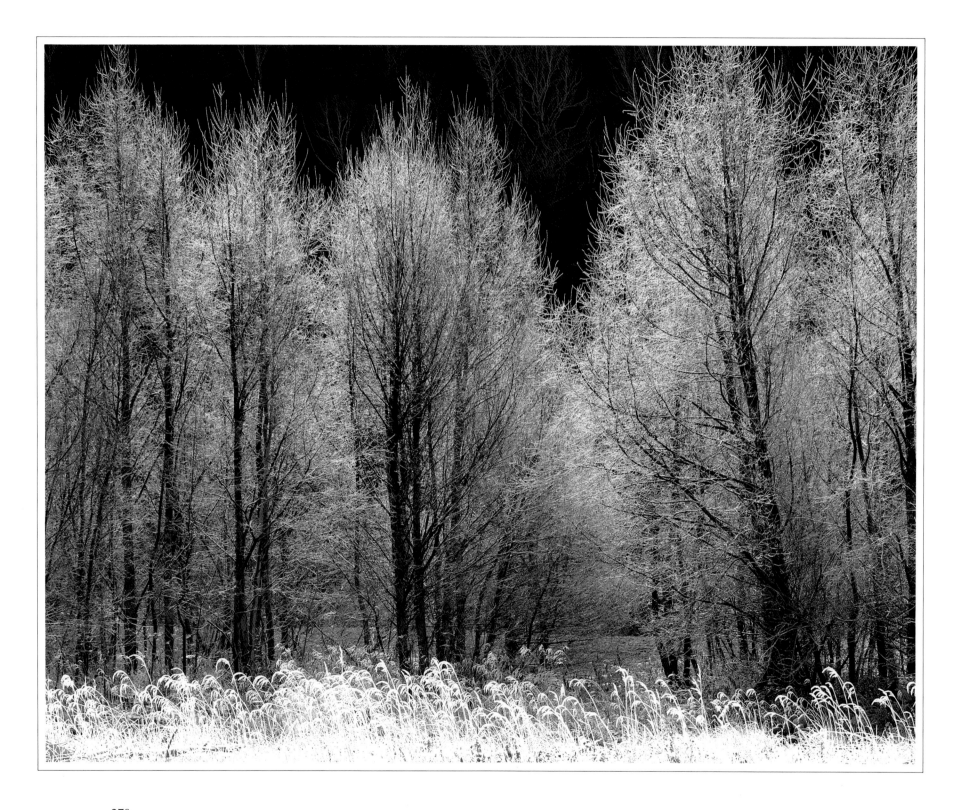

Sparkling woods

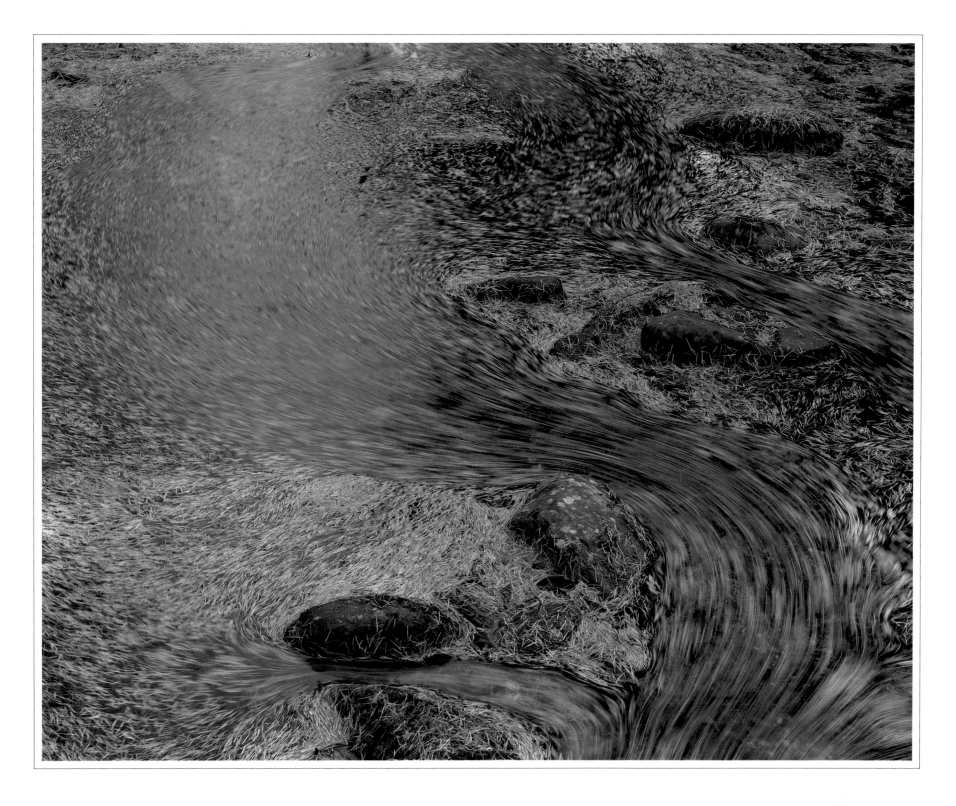

Flowing larch needles

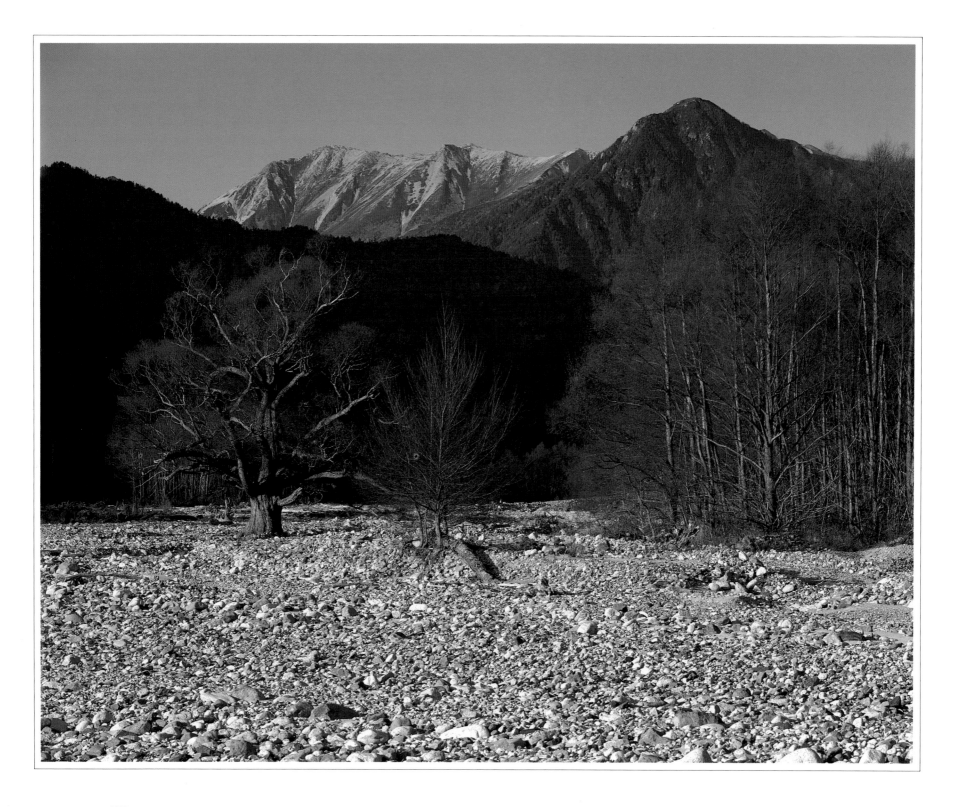

A balmy autumn day

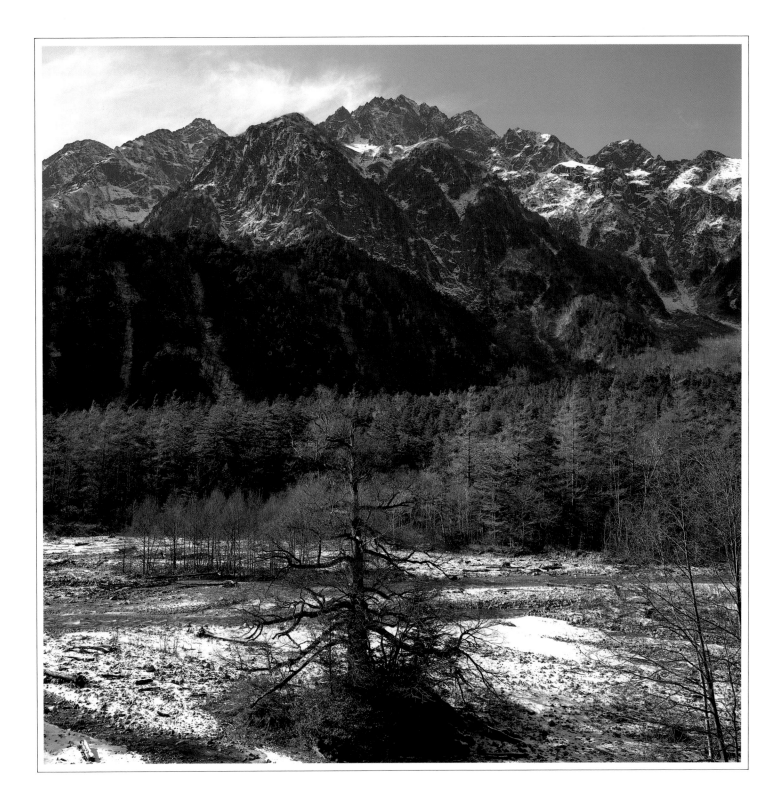

Rugged peaks freshly capped with snow

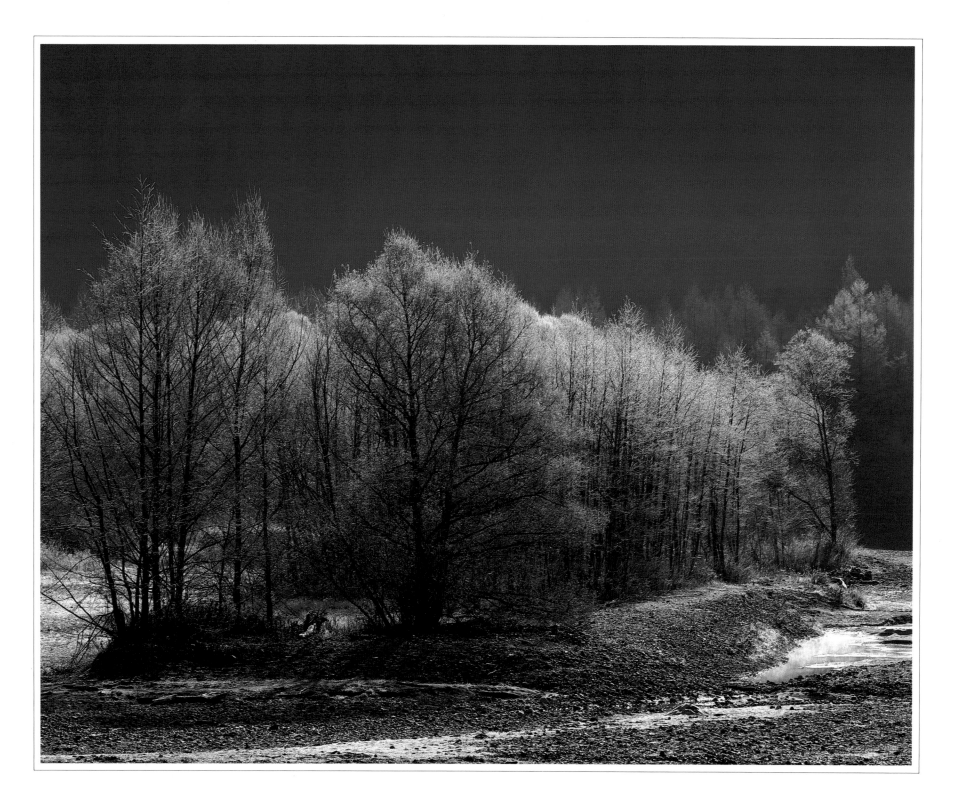

Frosty fantasy

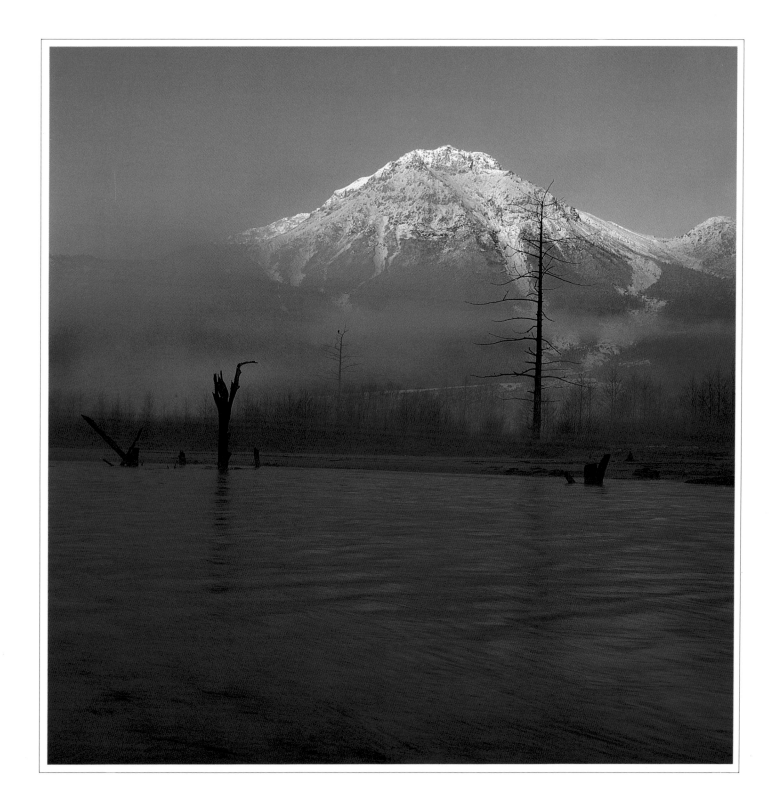

Mt. Yake in the morning mist

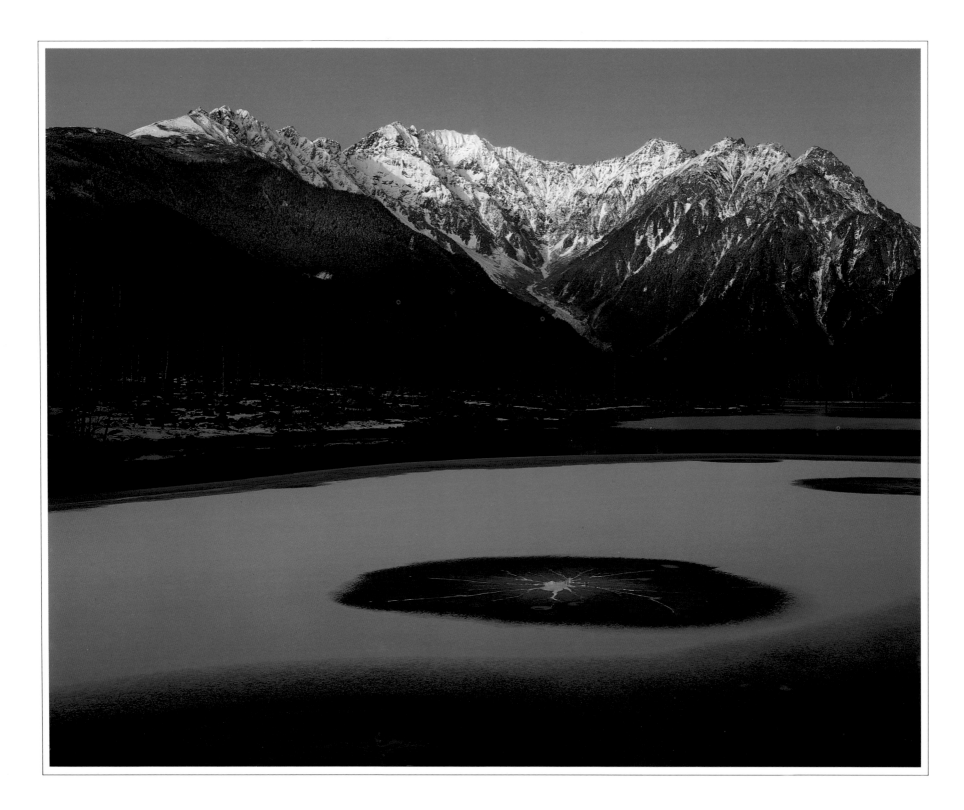

Deep silence on Taisho pond

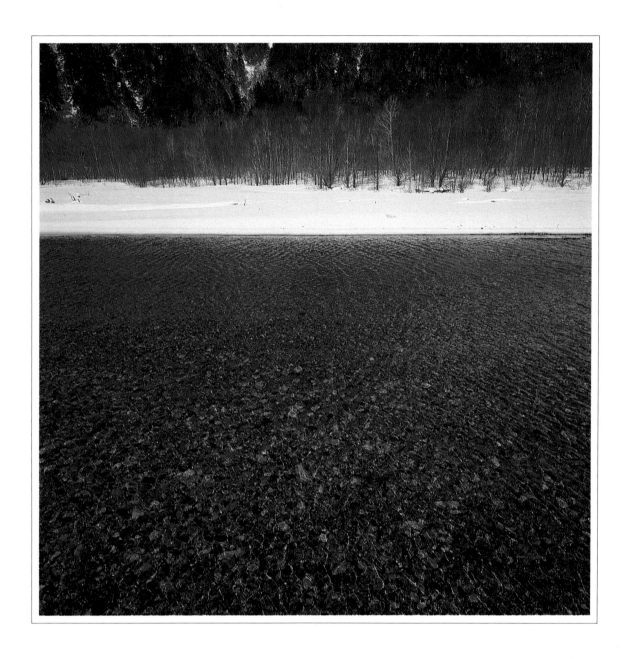

Winter's green and dappled river

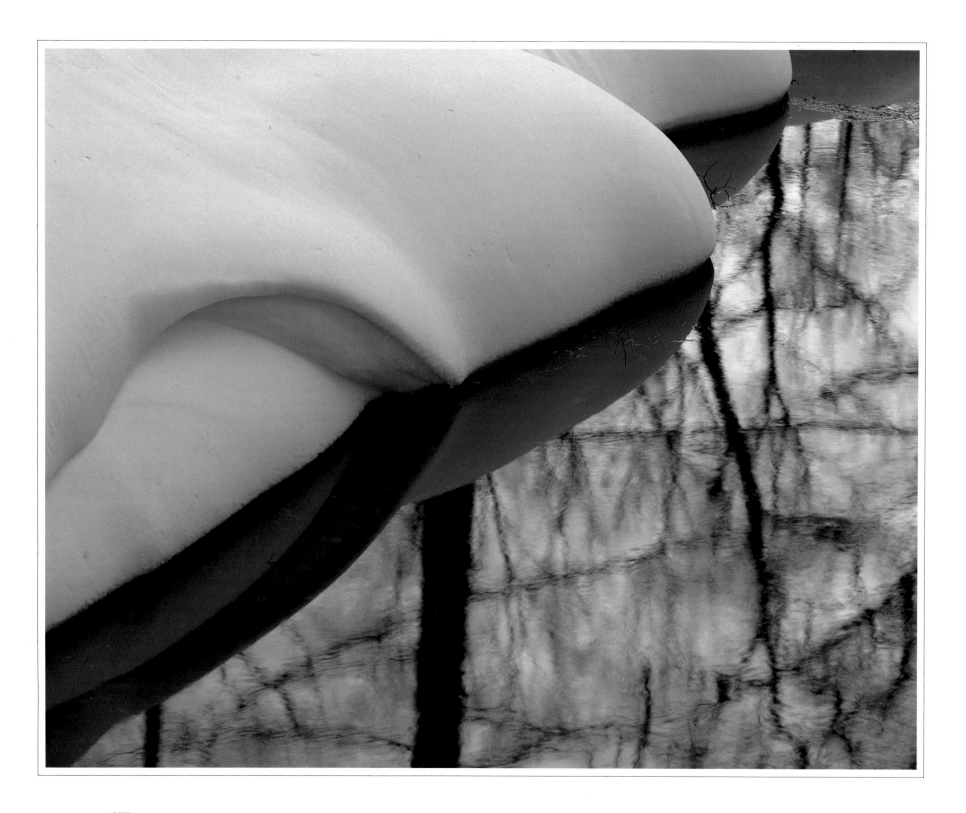

Snow-bordered brook

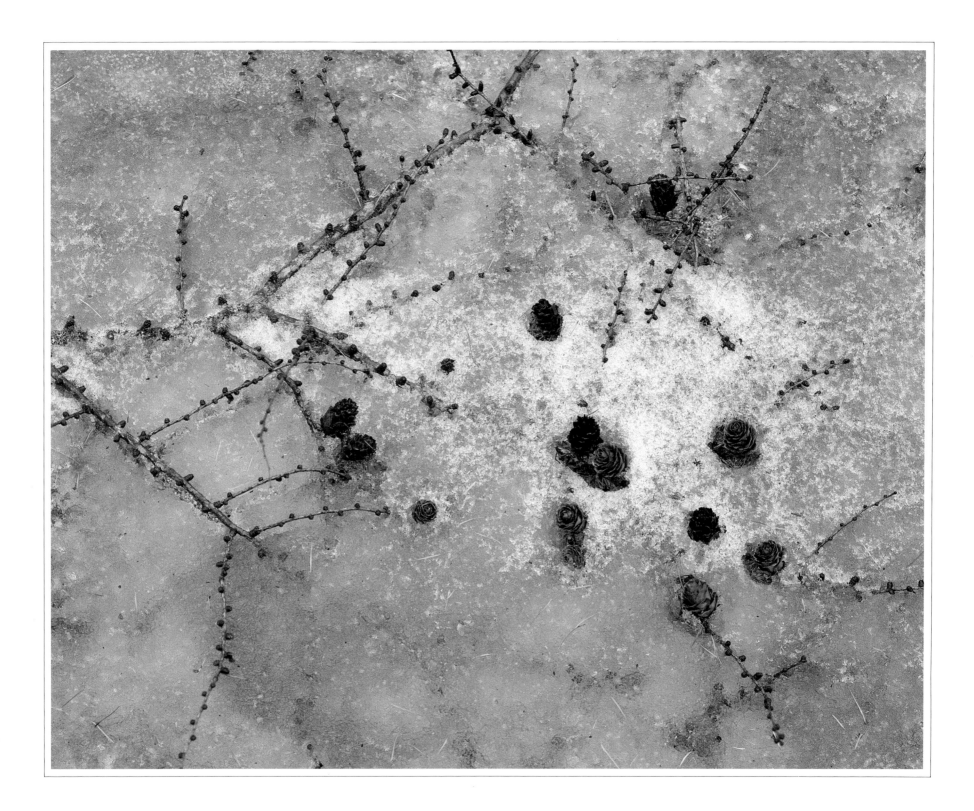

Patterns of ice and snow

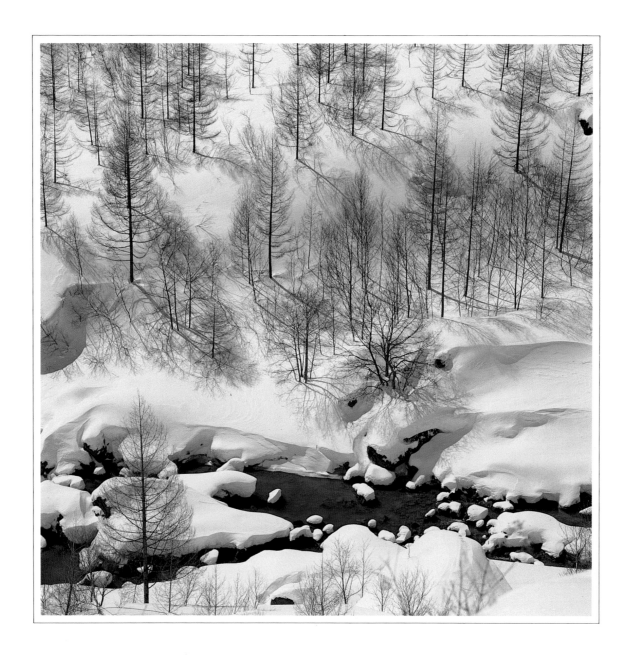

Clear weather between snowfalls

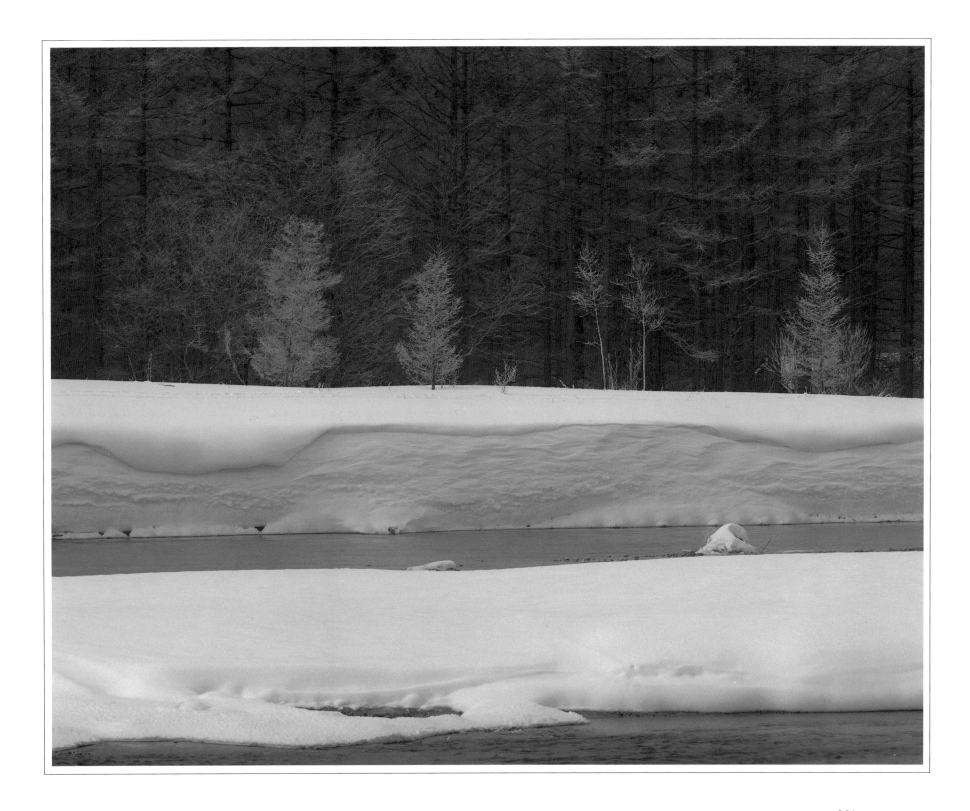

Blue morning

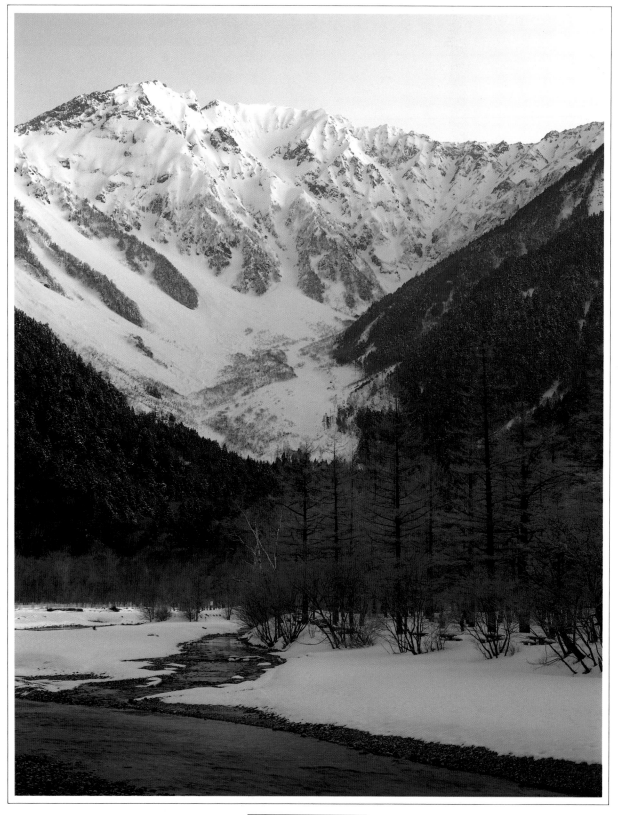

Snow-clad Mt. Hotaka

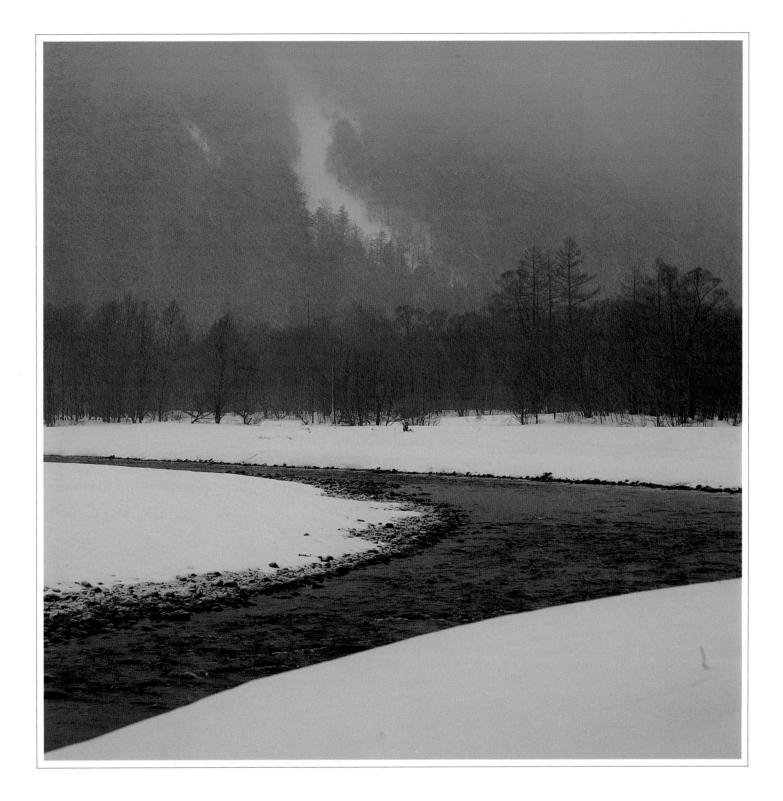

The Azusa on a dark, cloudy day

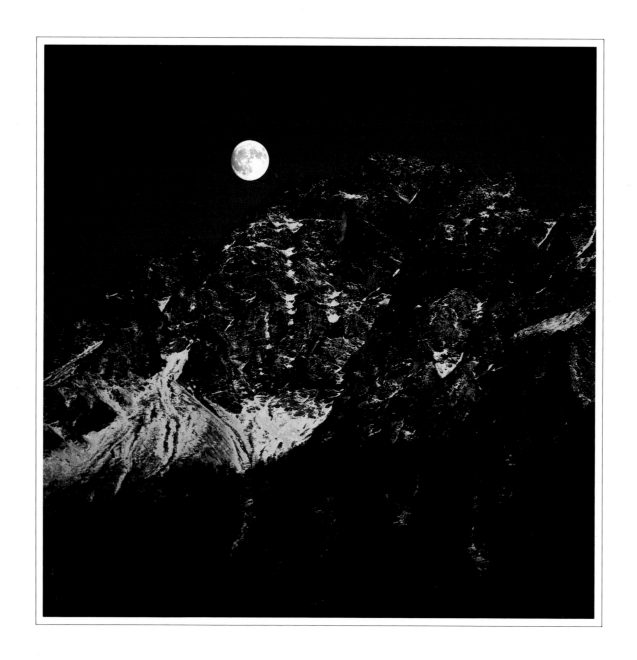

Moon over Mt. Maehotaka

From Autumn to Winter

What makes the trees of autumn, surely exhausted by their growth
and blossoming, first decorate themselves so colorfully and then
shed that very finery they have worked so long to create? And why
do they ornament our shores or even dress up whole mountain-
sides? Why? We know not why, yet we seek the waning beauty of
those landscapes and the feeling of loneliness they bring.
The life span of plants and creatures varies and the seasons exert
their control in various ways.
Man sees this and he ponders the end of life, his mind plays with
that emptiness lying at the bottom of his heart. It is difficult to
stare at those dancing, falling leaves that whirl about in the autumn
winds. But when the end comes – or when it is time for a period of
dormancy – then the water turns to ice, snow falls and accumulates
in drifts, there is the sound of a roaring wind in the distance and the
glitter of all these things becomes something ethereal.
This transfiguration of the world is a miraculous blessing for those
who survive and gaze upon the scene. As we contemplate it, we feel
it entreating us to realize the immutable fact that we live upon a
celestial sphere floating in the universe.

Magoichi Kushida

Photographic data

201: Hasselblad SWC, Biogon 38 mm F4.5, f8 1/$_{125}$
202: Hasselblad 500C/M, Sonnar 250 mm F5.6, f22 1/$_{15}$
203: Hasselblad 500C/M, Sonnar 250 mm F5.6, f32 1/$_8$
204: Toyo Field 4 × 5, Fujinon 600 mm F11, f32 1/$_8$
205: Hasselblad 500C/M, Sonnar 150 mm F4, f8 1/$_{60}$
205: Hasselblad 500C/M, Sonnar 150 mm F4, f11 1/$_{30}$
206: Toyo Field 4 × 5, Fujinon 600 mm F11, f45 1/$_4$
207: Linhof Super Technika 4 × 5, Nikkor 150 mm F5.6, f22 1/$_{15}$
208: Hasselblad 500C/M, Sonnar 250 mm F5.6, f22 1/$_{15}$
208: Hasselblad 500C/M, Sonnar 250 mm F5.6, f45 1/$_2$
209: Linhof Super Technika 4 × 5, Fujinon 400 mm F8, f22 1/$_{15}$
210: Linhof Super Technika 4 × 5, Nikkor 150 mm F5.6, f32 1/$_8$
211: Hasselblad SWC, Biogon 38 mm F4.5, f11 1/$_{60}$
212: Linhof Super Technika 4 × 5, Fujinon 400 mm F8, f45 1/$_8$
213: Linhof Super Technika 4 × 5, Super-Angulon 90 mm F8, f32 1/$_4$
214: Linhof Super Technika 4 × 5, Tele-Xenar 360 mm F5.5, f22 1/$_8$
215: Linhof Super Technika 4 × 5, Super-Angulon 90 mm F8, f22 1/$_{15}$
216: Hasselblad SWC, Biogon 38 mm F4.5, f16 1/$_{30}$
217: Linhof Super Technika 4 × 5, Nikkor 210 mm F5.6, f32 1/$_4$
218: Linhof Super Technika 4 × 5, Tele-Xenar 360 mm F5.5, f8 1/$_{15}$
219: Toyo Field 8 × 10, Nikkor 210 mm F5.6, f45 1/$_2$
220: Hasselblad SWC, Biogon 38 mm F4.5, f5.6 1/$_{125}$
221: Hasselblad 500C/M, Sonnar 250 mm F5.6, f11 1/$_{60}$
222: Linhof Super Technika 4 × 5, Super-Angulon 75 mm F5.6, f22 1/$_{15}$
223: Toyo Field 8 × 10, Fujinon 600 mm F11, f90 1 sec.
224: Hasselblad 500C/M, Distagon 60 mm F3.5, f11 1/$_{125}$
225: Linhof Super Technika 4 × 5, Nikkor 210 mm F5.6, f22 1/$_8$
226: Hasselblad 500C/M, Sonnar 150 mm F4, f16 1/$_{125}$
227: Toyo Field 4 × 5, Fujinon 600 mm F11, f22 1/$_8$
228: Toyo Field 8 × 10, Nikkor 450 mm F9, f22 1/$_8$
230: Toyo Field 8 × 10, Fujinon 600 mm F11, f45 1/$_2$
231: Toyo Field 8 × 10, Nikkor 800 mm F12, f45 1/$_2$
232: Linhof Super Technika 4 × 5, Super-Angulon 90 mm F8, f22 1/$_{15}$
233: Linhof Super Technika 4 × 5, Fujinon 250 mm F6.3, f32 1/$_8$
234: Toyo Field 8 × 10, Nikkor 800 mm F12, f45 1/$_2$
235: Linhof Super Technika 4 × 5, Nikkor 150 mm F5.6, f22 1 sec.
236: Hasselblad 500C/M, Sonnar 150 mm F4, f16 1/$_{125}$
237: Hasselblad 500C/M, Tele-Tessar 500 mm F8, f22 1/$_{15}$
238: Hasselblad 500C/M, Tele-Tessar 500 mm F8, f16 1/$_{125}$
239: Hasselblad 500C/M, Sonnar 150 mm F4, f22 1/$_2$
240: Hasselblad 500C/M, Distagon 60 mm F3.5, f16 1/$_{30}$
241: Linhof Super Technika 4 × 5, Super-Angulon 90 mm F8, f22 1/$_8$
242: Hasselblad 500C/M, Sonnar 250 mm F5.6, f22 1/$_4$

243: Hasselblad 500C/M, Sonnar 150 mm F4, f16 1/$_{15}$
244: Hasselblad 500C/M, Sonnar 150 mm F4, f22 1/$_4$
245: Hasselblad 500C/M, Sonnar 250 mm F5.6, f22 1/$_{15}$
246: Linhof Super Technika 4 × 5, Super-Angulon 90 mm F8, f22 1 sec.
247: Toyo Field 4 × 5, Fujinon 600 mm F11, f22 1 sec.
248: Linhof Super Technika 4 × 5, Super-Xenar 360 mm F5.5, f22 1/$_4$
249: Hasselblad 500C/M, Sonnar 250 mm F5.6, f32 1/$_4$
250: Hasselblad 500C/M, Sonnar 150 mm F4, a–f22 1/$_4$, b–f16 1/$_8$
251: Linhof Super Technika 4 × 5, Fujinon 400 mm F8, f32 1/$_4$
252: Linhof Super Technika 4 × 5, Fujinon 400 mm F8, f8 30 sec.
253: Hasselblad SWC, Biogon 38 mm F4.5, f16 1/$_{15}$
254: Hasselblad SWC, Biogon 38 mm F4.5, f16 1/$_{30}$
255: Hasselblad 500C/M, Sonnar 150 mm F4, f8 1/$_{125}$
256: Linhof Super Technika 4 × 5, Fujinon 250 mm F6.3, f32 1/$_2$
257: Linhof Super Technika 4 × 5, Fujinon 250 mm F6.3, f32 1 sec.
258: Linhof Super Technika 4 × 5, Fujinon 400 mm F8, f32 1/$_8$
259: Hasselblad SWC, Biogon 38 mm F4.5, f22 1/$_8$
260: Hasselblad 500C/M, Sonnar 250 mm F5.6, f8 1 sec.
261: Hasselblad 500C/M, Sonnar 250 mm F5.6, f32 1/$_4$
262: Hasselblad 500C/M, Sonnar 150 mm F4, f22 1/$_8$
263: Linhof Super Technika 4 × 5, Fujinon 400 mm F8, f45 1/$_2$
264: Linhof Super Technika 4 × 5, Super-Angulon 90 mm F8, f8 10 min.
265: Hasselblad 500C/M, Distagon 60 mm F3.5, f11 1/$_{60}$
266: Linhof Super Technika 4 × 5, Fujinon 400 mm F8, f32 1/$_8$
267: Hasselblad 500C/M, Sonnar 250 mm F5.6, f32 1/$_8$
268: Toyo Field 8 × 10, Fujinon 600 mm F11, f45 1/$_8$
270: Linhof Super Technika 4 × 5, Fujinon 250 mm F6.3, f32 1/$_8$
271: Linhof Super Technika 4 × 5, Nikkor 150 mm F5.6, f22 1 sec
272: Linhof Super Technika 4 × 5, Fujinon 400 mm F8, f32 1/$_8$
273: Toyo Field 8 × 10, Fujinon 300 mm F5.6, f45 1/$_2$
274: Linhof Super Technika 4 × 5, Fujinon 400 mm F8, f32 1/$_8$
275: Hasselblad 500C/M, Distagon 60 mm F3.5, f11 1/$_{60}$
276: Linhof Super Technika 4 × 5, Nikkor 150 mm F5.6, f32 1/$_4$
277: Hasselblad SWC, Biogon 38 mm F4.5, f8 1/$_{60}$
278: Linhof Super Technika 4 × 5, Fujinon 400 mm F8, f32 1/$_4$
279: Linhof Super Technika 4 × 5, Nikkor 210 mm F5.6, f32 1/$_2$
280: Hasselblad 500C/M, Sonnar 150 mm F4, f11 1/$_{125}$
281: Linhof Super Technika 4 × 5, Fujinon 400 mm F8, f32 1/$_4$
282: Linhof Super Technika 4 × 5, Nikkor 210 mm F5.6, f22 1/$_8$
283: Hasselblad 500C/M, Sonnar 250 mm F5.6, f22 1/$_2$
284: Linhof Super Technika 4 × 5, Fujinon 400 mm F8, f8 20 min.
Toyo Field 4 × 5, Fujinon 600 mm F11, f11 1/$_{60}$
Film: Ektachrome, Fujichrome

Afterword

People who knew the old Kamikochi may feel that the encroachments of the outside world have diminished its glories, but it remains, unquestionably, one of the finest scenic spots in Japan. Although a comprehensive photographic essay on Kamikochi had long been a dream of mine, I never seemed to find an opportunity to work on it until an old friend, Shizuo Tsukamoto, formerly of the Environmental Agency, became president of the Central Japan Mountain National Park Office. It was then that my idea moved toward reality through his support and that of other old acquaintances such as Kyoei Okuhara of Nishi-itoya-Sanso in Kamikochi, Kokichi Yamada of Yokkoo-Sanso, Gin-ichi Kobayashi of Karasawa Hütte and Sadao Hokari of Yarigatake-Sanso.

Needless to say, the premier attraction of Kamikochi is its magnificent mountain scenery, but it is no exaggeration to add that the area has many other beauties – the crystalline waters of the Azusa River, richly textured forests, lakes and ponds – and these, too, rank with the finest sights in Japan.

The rapidly changing climatic conditions in the mountainous Kamikochi region made it impossible for me to capture everything I wanted within the limited time at my disposal, but my work had to be completed and so I have decided to publish it at this time. Someday, however, I hope to bring out a second and third volume of Kamikochi photographs.

As a nature photographer, I always try to be conscious of the fact that any great landscape is an assemblage of many smaller features of nature. When people gaze upon the great snow-capped peaks of the Hotakas rising above the Azusa River, many of them see only that magnificent view; they often overlook the smaller aspects of nature which surround them. However, it is my belief that we can more fully appreciate nature's grandest scenery if we first take in the smaller-scale loveliness at our very feet. Therefore, it is my hope that this book of photographs will not only display the large-scale majesty of Kamikochi but also lead to a recognition of the smaller forms of beauty that abound there. And it is my further hope that the grander aspects of Kamikochi may be more deeply enjoyed by viewing them through nature's smaller beauties. If people can apprehend the less spectacular, the smaller charms of nature, they may feel a greater sensitivity to the need for the preservation of all nature. If so I will be greatly pleased, and I feel that my pleasure will be shared by all those who have supported me in my work.

In conclusion, I would like to acknowledge a deep debt of gratitude to Magoichi Kushida, who knew the old Kamikochi so well and wrote the foreword to this book, Atsumi Yokoyama, who wrote "Kamikochi Past and Present", and Shizuo Tsukamoto, whose support I have already mentioned above. To these gentlemen and to all those who have helped me, I extend my profound thanks.

Shinzo Maeda

Contents